ART UNDER A DICTATORSHIP

ART

UNDER A DICTATORSHIP

By HELLMUT LEHMANN-HAUPT

OCTAGON BOOKS

A DIVISION OF FARRAR, STRAUS AND GIROUX

New York 1973

Copyright 1954 by Oxford University Press, Inc.

Reprinted 1973
by special arrangement with Oxford University Press, Inc.

OCTAGON BOOKS
A Division of Farrar, Straus & Giroux, Inc.
19 Union Square West
New York, N. Y. 10003

Library of Congress Cataloging in Publication Data

Lehmann-Haupt, Hellmut, 1903-
 Art under a dictatorship.

 Reprint of the ed. published by the Oxford University Press,
New York.
 Includes bibliographical references.
 1. Art and state. 2. Art—Germany. 3. Art—Russia.
 I. Title.
[N8725.L4 1973] 709'.43 73-5521
ISBN 0-374-94896-8

Printed in U.S.A. by
NOBLE OFFSET PRINTERS, INC.
New York, N.Y. 10003

To Rosemarie

Acknowledgments

THIS BOOK IS THE RECORD of personal experiences and observations, out of which certain convictions have grown. It could never have been accomplished without what now seems to me a very large degree of support, both from individuals and from institutions. The debt of gratitude that has accumulated is a correspondingly large one. It is a deep satisfaction to be able to acknowledge this help. The responsibility for the opinions and conclusions contained in this book remains of course my own.

The idea for this book first occurred to me during a tour of duty with the Monuments, Fine Arts, and Archives Section of the U.S. Military Government in Germany.

Thanks are due first and foremost to the Rockefeller Foundation in New York, which gave me a two-year grant for the completion of this study. Mr. Edward F. D'Arms, Associate Director of the Foundation's Division of Humanity, was an ever-patient and wise counselor.

I am grateful also to the New School for Social Research in New York for having accepted the responsibility for the administration of the grant. President Hans Simons and Vice-President Clara W. Mayer have greatly furthered the work, especially by allowing me to develop the ideas arising from this study in a number of seminars and lecture courses given at the New School during the last years.

Professor Erwin Panofsky of the Institute of Advanced Studies in Princeton and Professor Meyer Schapiro of Columbia University gave me important advice and direction when the plan for this work first took shape. Professor Talbot Hamlin of Columbia University read the draft of the chapters dealing with architecture and gave generously of his vast experience. Nikolaus Pevsner, Editor of the *Architectural Review* in London, also made some valuable suggestions.

Dr. G. M. Gilbert, prison psychiatrist in Nuremberg during the war-crime trials, took a lively interest in this work and made sub-. stantial contributions to the clarification of Hitler's artistic impulses.

The very considerable assistance received from Luther Evans, former Librarian of Congress in Washington, from Verner Clapp, Chief Assistant Librarian, Frederick R. Goff, and other staff members in various departments is remembered with special gratitude. The resources of the New York Public Library were used freely and over an extended period of time, during which I met with unfailing courtesy and co-operation. A word of particular thanks is due Mrs. Ina Cassierer of the Library's Fine Arts Department for her help with some of the Russian materials, in the use of which I was also aided by my old friend Simeon Bolan of the Columbia University Libraries. Mr. Naum Gabo in Woodbury, Connecticut, contributed valuable information on the early phases of Soviet art life.

In Mr. Bernard Karpel, Librarian of the Museum of Modern Art, this project found a steady and ever-helpful friend. Professor Paul Zucker in New York also assisted with advice and the loan of material from his library.

I also wish to thank Professor Gordon W. Gilkey of Oregon State College for the loan of his report on 'German War Art'; Mr. Edwin L. M. Taggart, Chief of the Army's Historical Properties Branch, for permission to study the examples of German war art in his care; and Dr. Ralph Elliott Purcell of the Department of State for the opportunity to study his thesis, *Government and Art in the United States*.

Considerable help was extended this project from abroad, none of it more wholeheartedly than by Mr. Kurt Rosenow, the Director of the U.S. Documents Center in Berlin-Zehlendorf, and his staff. My thanks are due also to Mr. Lionel Perry, formerly of the British Monuments, Fine Arts, and Archives Section in Duesseldorf, and Monsieur Eydoux of the French Haut-Commissariat in Mainz.

The invitation by the U.S. Department of State to lecture in a number of its 'Amerika' Houses in Germany, during the fall of

1950, provided many opportunities for gathering material for this study. I wish to express here my thanks for the willingness with which assistance and advice were extended to me by a number of U.S. officials in Germany, including Mr. Melvin Lasky, editor of *Der Monat*.

The list of names of German artists and art historians, museum officials, librarians, and publishers who aided me is a long one indeed. Among many others I should like to mention especially Professor Paul Ortwin Rave, who gave me permission to make full use of his book, *Die Kunstdiktatur im Dritten Reich*, which developed from a lecture given before the 'Prolog' in the spring of 1947; also Professor Carl Hofer, Kurt Hartmann, Dr. Edwin Redslob, Kurt Reutti, Professor Tappert, Dr. Hans Cuerliss, Gerd Rosen, all in Berlin; Dr. Alfred Hentzen in Hannover; Professor Carl Georg Heise, Dr. Eugen Claassen, and Dr. Jess in Hamburg; Dr. G. Busch in Bremen; Professor Hans Schwippert in Duesseldorf; Professor Walter Paatz and Professor Gustav Hartlaub in Heidelberg; Dr. Oscar Paret, Professor Willi Baumeister, and Dr. Petermann in Stuttgart; and members of the Zentralinstitut fuer Kunstgeschichte in Munich.

Mr. Olaf Devik, Director General of the Scientific and Cultural Department of the Norwegian Government, responded generously to my request for information about Nazi art policies in occupied Norway. I must combine my thanks to him with a word of apology for not having found an opportunity to do greater justice to the material he supplied.

The *Magazine of Art*, the R. R. Bowker Company, *Harper's Magazine*, the *Horn Book Magazine*, and the *College Art Journal* have been kind in granting permission to reprint here material that first appeared in their publications.

The dedication of the book to my wife is the best way I know of expressing the innumerable ways in which she has had a share in it.

H.L.–H.

Spuyten Duyvil
March 1954

Contents

INTRODUCTION, xvii

I. PRELUDE

 I. THE LESSON OF HISTORY, 3
 The Discoveries of the French Revolution, 4
 What Did Marx Really Say About Art? 5
 William Morris: Art for the People and by the
 People, 10
 II. THE FALSE PARADISE OF WEIMAR, 16

II. THE NAZI EXPERIMENT

 III. THE CRYSTALLIZATION OF THE NATIONAL SOCIALIST ART
 DOCTRINE, 37
 IV. THE MASTERBUILDER ADOLF HITLER, 45
 V. THE ORGANIZATION OF TOTAL CONTROL, 62
 Ideological Combat, 63
 Experimentation and Co-ordination, 68
 Tightening the Reins, 76
 VI. OPERATION 'DEGENERATE' ART, 78
 VII. NAZI PAINTING: A STUDY IN RETROGRESSION, 88
 VIII. THE PECULIAR MISSION OF THE SCULPTOR, 96
 IX. TOTAL ARCHITECTURE, 106
 The Meaning of Total Architecture, 106
 Party Buildings, 112
 What the People Got, 118
 Corruption and Immunity, 123
 X. GESTAPO IN THE GIFT SHOP: THE STORY OF ARTS AND
 CRAFTS, 127

XI. THE ARCHAEOLOGIST IN SS UNIFORM: PLANTING THE NAZI
TIME BOMB, 137
Art as a Weapon against Christianity, 137
Heinrich Himmler's Ahnenerbe Foundation, 144

XII. ART EDUCATION IN THE THIRD REICH, 160
The Archaeologist outside the SS, 161
The 'Fuehrer Project,' 165
The Greatest Possible Perversion of the Printing
Press, 168
The Battle of the Type Faces, 170
Strait Jackets for the Youngsters, 173

III. SOVIET INSISTENCE AND WESTERN DILEMMA

XIII. THE POSTWAR SITUATION, 185
Respite from Tyranny, 186
The Unpleasant Surprise, 191
Cultural Policies of the Western Allies, 196

XIV. GERMAN ART BEHIND THE IRON CURTAIN, 200

XV. ART IN SOVIET RUSSIA, 216
Was Nazi Art Typically German? 216
The Mésalliance between Modern Art and
Communism, 219
Retarding Influences in Soviet Cultural
Dictatorship, 223
Formulation of Official Demands, 226
The Tightening of the Reins, 229
The Battle against 'Formalism' and the Gospel of
Social Realism, 231

CONCLUSION: THE CHALLENGE TO DEMOCRACY, 236

NOTES, 249

INDEX, 269

List of Plates

1. A drawing by Adolf Hitler. From Adolf Hitler, *Aquarelle*, Berlin, Heinrich Hoffmann, 1935.
2. Hitler's reading marks in the margins of *Der Meister*. From the copy in the Hitler Library, now in the Rare Books Division, Library of Congress.
3. Hitler and his architect, Paul Ludwig Troost. In the Prints and Photographs Division, Library of Congress.
4. Model of the House of German Art. Photograph in the Library of Congress.
5. Albert Speer's model for the new Assembly Hall in Berlin. Photograph in the Library of Congress.
6. A typical Nazi town plan. From *Die Baukunst. Die Kunst im Dritten Reich*, March 1939, p. 143.
7. The Walschmuehltal Bridge on the Autobahn. In the Library of Congress.
8. Albert Speer's new Reichs Chancery in Berlin. From Albert Speer (ed.), *Neue deutsche Baukunst*, Berlin, 1941, p. 44.
9. A landscape by Werner Peiner. From Bruno Kroll, *Deutsche Maler der Gegenwart*, Berlin, 1937, p. 110.
10. Center panel from Adolf Ziegler's *Four Elements*. From Bruno Kroll, *Deutsche Maler der Gegenwart*, Berlin, 1937, p. 158.
11. A landscape by Karl Schmidt-Rottluff. From a color reproduction.
12. Carl Hofer's *Beggar Girl*, 1938. From Adolf Jannasch (ed.), *Carl Hofer*, Potsdam, Ed. Strichnote, 1946, no. 31.
13. Georg Kolbe's *The Lonely One*, 1927. From Georg Kolbe, *Bildwerke*, Leipzig, Insel-Verlag, n.d., no. 10.
14. Georg Kolbe's *Young Warrior*, 1934. From Georg Kolbe, *Bildwerke*, Leipzig, Insel-Verlag, n.d., no. 20.
15. Josef Thorak's Monument for the Workers of the Autobahn. From *Die Kunst im Dritten Reich*, January 1939, p. 16.
16. Arno Breker before Hitler: *Head of Nugochi*. From Heinz Grothe, *Arno Breker*, Königsberg, 1943.
17. Arno Breker under Hitler: *Comrades*. From *Die Kunst im Deutschen Reich*, April 1940, p. 104.
18. Poster for a Thorak exhibition, Salzburg, 1950. In the author's collection.

19. Soviet Monument in Treptow Park, Berlin, 1949. From Ya. B. Belopol-skii, *Pamyatnik Voinam Sovietskoi Armii Pavlim v boyach s Faschis-mom*, Moscow, 1950, no. 41.
20. Fritz Klimsch's *Gazing Woman*. From Uli Klimsch, *Fritz Klimsch*, Berlin, 1938, p. 77.
21. Reappearance of the *Gazing Woman* in Udo Wendel's painting: *The Art Magazine*. From *Die Kunst im Deutschen Reich*, August-September 1940, p. 242.
22. *At the Art Exhibition*, from a color photograph by Ernst Baumann. From Walter Heering (ed.), *Im Zauber der Farbe*, Harzburg, Heering-Verlag, 1943, p. 66.
23. The 'Saar-Pfalz-Halle' at the 'Strength through Joy Town,' Berlin, 1936. Photograph in the Prints and Photographs Division, Library of Congress.
24. Olympic Games, Berlin, 1936. From an official catalogue, Berlin, 1936.
25. Streetcar operators in an art class. Photograph in the Library of Congress.
26. Christmas tree and manger in a children's book, 1932. From Hertha v. d. Knesebeck and Else Wenz-Viëtor (illus.), *Weihnachten*, Oldenburg, 1932.
27. Christmas tree without the manger, 1945. From Wolfgang Stumme and Ilse Kollmann-Gümmer (illus.), *Bald nun ist Weihnachtszeit*, Berlin, 1945.
28. Wolfram Sievers of the Ahnenerbe Foundation. Photograph in the U.S. Documents Center, Berlin-Zehlendorf.
29. Hermann Goering. Photograph in the Library of Congress.
30. Clan chest for an SS Leader by Klara Ege. From *Die Kunst im Deutschen Reich*, April 1940, p. 125.
31. Ceramics from the Staatliche Majolika—Manufactur, Karlsruhe. From Hermann Gretsch, *Gestaltendes Handwerk*, Stuttgart, c.1941.
32. Double spread from Schultze-Naumburg's *Kunst und Rasse*, Munich, 1928, pp. 92–3.
33. Details from the exhibition, 'Degenerate Art,' Munich, 1937. From Paul Ortwin Rave, *Kunstdiktatur im Dritten Reich*, Hamburg, 1949.
34. *SA men*, drawn by a Berlin child. In the author's collection.
35. *War*, as seen by a Berlin schoolboy. In the author's collection.
36. 'All Roads Lead to Hitler.' From an exhibition of the Autobahn Project. Photograph in the Library of Congress.
37. Hitler Youths admiring the Labor Heroes of the Autobahn construc-tion. Photograph in the Library of Congress.
38. Josef Thorak in his studio. Photograph in the Library of Congress.
39. Troost's Party Buildings in Munich. Photograph in the Library of Congress.
40. Detail from the Soviet Monument in Treptow Park, Berlin, 1949. From Ya. B. Belopolskii, *Pamyatnik Voinam Sovietskoi Armii Pavlim v boyach s Faschismom*, Moscow, 1950, no. 45.

41. The State Library in Moscow. From *Sovietskaya Architektura*, Moscow, 1950, no. 35.
42. Abstract painter, Theodor Werner, Berlin, 1948. Photograph by Gnilka, Berlin.
43. Gouache, 1944, by Theodor Werner. Photograph by Gnilka, Berlin.
44. Abstract sculptor, Karl Hartung, Berlin, 1950. Photograph by Usa Borchert, Berlin.
45. Torso, 1947, by Karl Hartung. Photograph by Gnilka, Berlin.

1. A drawing by Adolf Hitler made on the western front during World War I.

2. Reading marks by Adolf Hitler in the margins of Josef Ponten's *Der Meister*.

Aber vom ‚Künstler‘ darf ich reden? Was kann dieser er? Gotisch von romanisch kann er unterscheiden und noch , was er auf den Schulen gelernt hat. Aber das Geringste, in den Schulen nicht gehabt hat, das kann er nicht. Wenn , daß mein kleiner Zeh mehr denkt als sein ganzer Dom= isterkopf, dann bin ich noch sehr bescheiden. Oh, welchen abe ich gegen diese beamteten Dummköpfe! Gegen diese schinder und Pfründenfresser! Gegen die betitelte Un= it! Da sagen sie zu ihren Untergebenen: ‚Macht das so und wißt schon! Werdet's schon recht machen!‘ Dabei ist ihnen Kopf leer wie der Sack dem Bettler. Und sie lassen sich ige Zeichnung reichen, sie kritteln ein wenig dran herum, ihnen doch der Verstand stillsteht vor Staunen. Sie hier und da einen überflüssigen Strich hin, dann schreiben und frech darunter: ‚Invenit X. Y. Bestellter Dombau= .‘ Der Herr darf Zins vom Geiste nehmen, weil er der . Haha! So will unser erleuchteter Baumeister mich be= Er möchte meine Schrift haben, die ich über die Wieder= ung des Chores geschrieben habe, würde sie durchblättern, Komma streichen, dort ein ‚und‘ einfügen, und dann da= reiben: ‚Neue Vorschläge für eine dauernde Wieder= ung des Chores Unserer Lieben Frau. Aufgesetzt, erfunden eichnet von Dombaumeister Gottschalk. Einer Hohen Re= und einem Hochwürdigen Kapitel in schuldiger Ehr= berreicht.‘ Und ich würde dastehen mit langer Nase, und hlstein würde drüber zu Staub zerfallen, ehe sie mich iefen und mich frügen: ‚Was hast du an dem Entwurfe eitet, Gottfried?‘ Und wenn ich mich selbst meldete, so ch der Regierungsrat für das Bauwesen durch den Pfört= der Stiftspropst durch den Sakristan hinauswerfen, Baumeister würde aufgefordert werden, den frechen Knall und Fall zu entlassen.“

he, du wirst nicht mehr lange hier bleiben, mein lieber Freund“, sagte der Schweizer betrübt.

„Nein, so kommt's nicht, sag ich dir! Nein! Sondern der Bau= meister wird nicht mehr lange hier bleiben, mein lieber alter Freund Schweizer! Das schwöre ich dir! Ich werde den glimmen= den Brand ins Freie zerren, daß er Luft bekommt und Flamme schlägt! Wenn ich Meister wäre, ich würde mich doch schämen, mei= nen Namen unter etwas zu setzen, das ich nicht gemacht hätte. Und wenn der Regierungsrat es mir beföhle, so würde ich sagen: ‚Das kann ich nicht! Das Papier müßte doch rot werden, die Tinte versiegen und die Feder zerbrechen, wenn ich eine solche ge= meine unverschämte Lüge niederschriebe.‘ Jemandem seinen Geist stehlen ist schlimmer, als ihm sein Geld stehlen. Denn Geld kann man immer wieder erwerben, aber ein künstlerischer Einfall, das ist ein Geschenk! Und warum geht es mir so? Nur deshalb, weil ich nicht die berühmte Schule habe besuchen können, sondern alles aus mir habe schaffen müssen. Weil meine Eltern so ge= wissenlos waren, mich als Waise in der Welt zu lassen, und sich zu früh von dieser Bühne der Narren und Verbrecher wegstahlen. Weil ich mich nicht mit dem Titel Baumeister konnte stempeln lassen. Und weil es mir widerstrebt, mich in den Röcken der Toch= ter zu verstecken und auf einem krummen Wege über den Schwie= gersohn zum Baumeister zu kommen. Ich will meinen Fall herauszerren aus der Verborgenheit und meine Angelegenheit zu einer allgemeinen machen!“

„Sieh mal an, ein so ernstes Gesicht hat die Sache?“ sagte der Alte. „Ja dann, freilich. Und ich glaube, du hast recht, Junge. Ich glaube sogar, du hast sehr recht. Und zwar nicht nur von we= gen deiner vielen Haare...“

„Dann will ich fordern, daß sie uns beide einschließen, den Bau= meister und mich, jeden in einer Klause. Sie sollen uns eine Auf= gabe stellen, zwölf Stunden sollen sie uns einschließen und uns keine Hilfsmittel geben. Und ich will mir ausbedingen, die Klause, in welcher der Baumeister sitzt, durchsuchen und in seine Taschen greifen zu dürfen, ob er nicht doch eine Eselsbrücke versteckt hat. Und dann los! Ich brenne darauf! Ich kenne keine größere Freu=

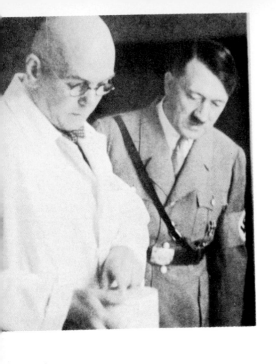

3. Hitler and his architect,
 Paul Ludwig Troost.

4. Model of the House of German Art, car-
 ried by half-disguised storm troopers.

5. Albert Speer's model for the new
 Assembly Hall in Berlin.

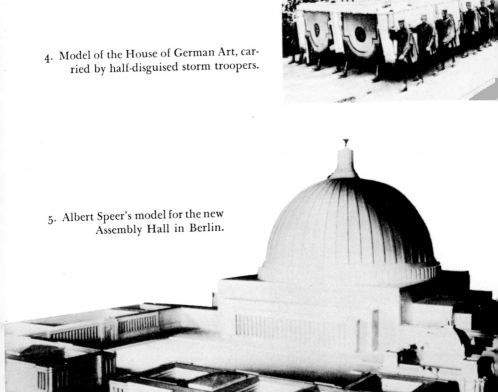

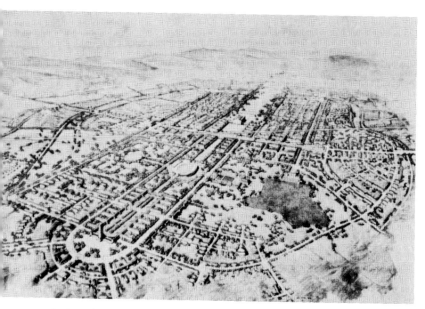

6. A typical Nazi town plan, for the Stadt der Hermann-Goering-Werke.

7. The Walschmuehltal Bridge
on the Autobahn.

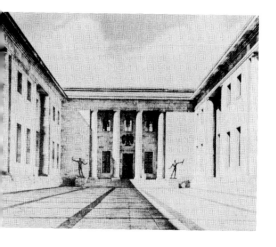

8. Albert Speer's new Reichs
Chancery in Berlin.

9. A landscape by Werner Peiner.

10. Center panel from Adolf
Ziegler's *Four Elements*.

11. A landscape by Karl Schmidt-Rottluff.

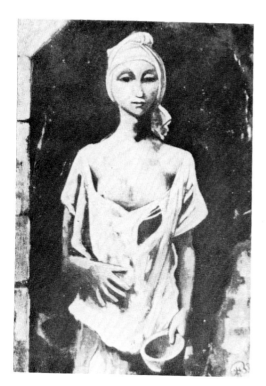

12. Carl Hofer's *Beggar Girl,* 1938.

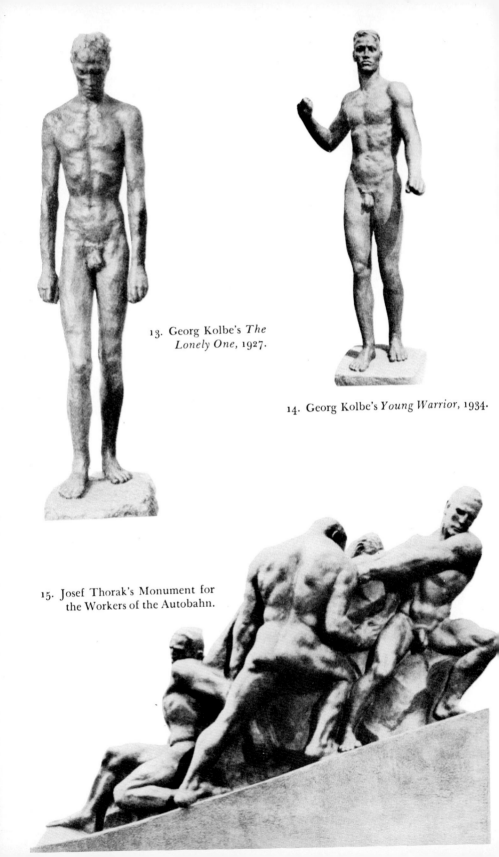

13. Georg Kolbe's *The Lonely One*, 1927.

14. Georg Kolbe's *Young Warrior*, 1934.

15. Josef Thorak's Monument for the Workers of the Autobahn.

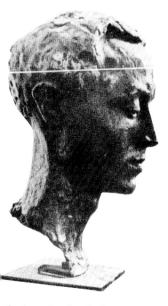

16. Arno Breker before Hitler: *Head of Nugochi.*

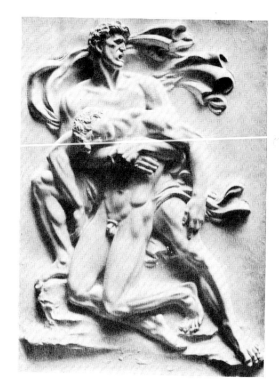

17. Arno Breker under Hitler: *Comrades.*

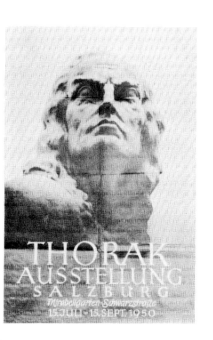

18. Poster for a Thorak exhibition, Salzburg, 1950.

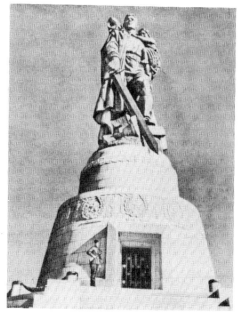

19. Soviet Monument in Treptow Park, Berlin, 1949.

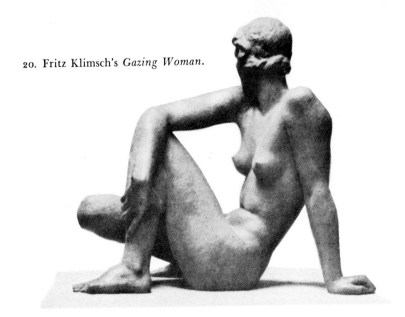

20. Fritz Klimsch's *Gazing Woman*.

21. Reappearance of the *Gazing Woman* in Udo Wendel's painting: *The Art Magazine*.

. *At the Art Exhibition*, from a color
photograph by Ernst Baumann.

23. The 'Saar-Pfalz-Halle' at the 'Strength
through Joy Town,' Berlin, 1936.

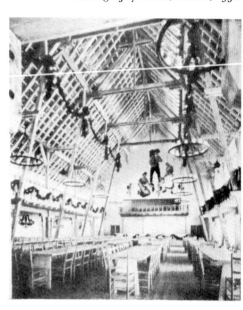

24. Art-Sport-Eugenics. Olympic
Games, Berlin, 1936.

25. Streetcar operators in an art class.

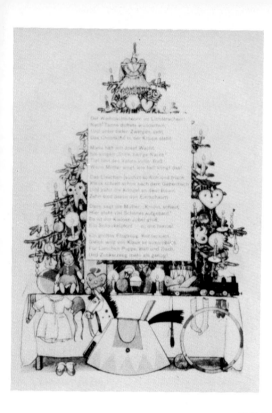

26. Christmas tree and manger in a children's book, 1932.

27. Christmas tree without the manger, 1945.

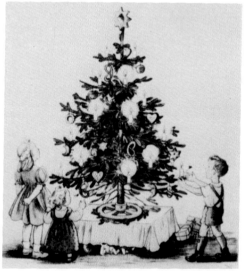

28. Wolfram Sievers of the Ahnen-erbe Foundation.

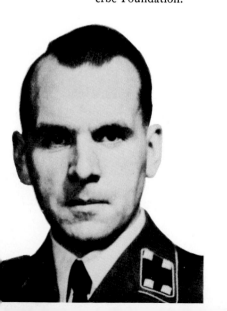

29. Self-deification before the new cross: Hermann Goering.

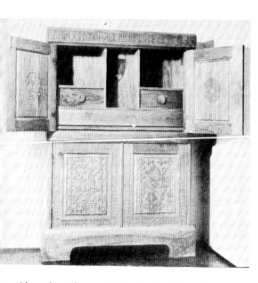

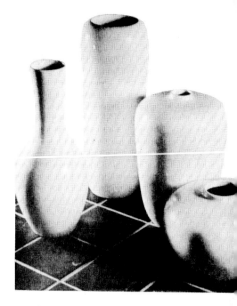

30. Clan chest for an SS leader by Klara Ege.

31. Ceramics from the Staatliche Majo-
lika-Manufaktur, Karlsruhe.

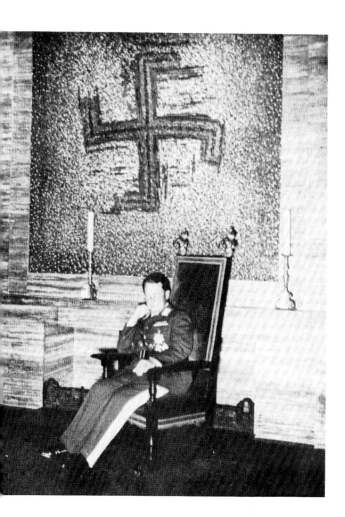

32. Double spread from Schultze-Naumburg's *Kunst und Rasse,* Munich, 1928.

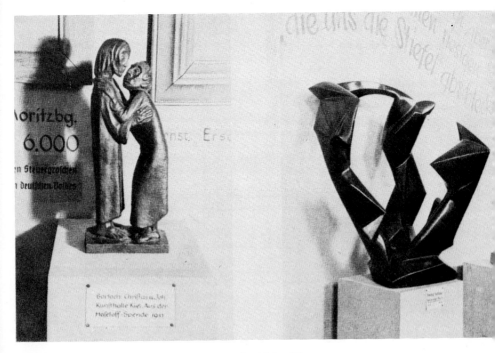

33. Details from the exhibition 'Degenerate Art,' Munich, 1937.

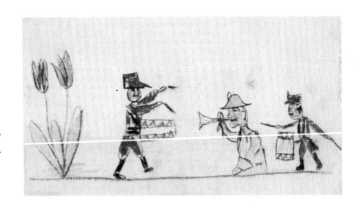

34. *SA men*, drawn by a Berlin child.

35. *War*, as seen by a Berlin schoolboy.

36. 'All Roads Lead to Hitler.' From an exhibition of the Autobahn Project.

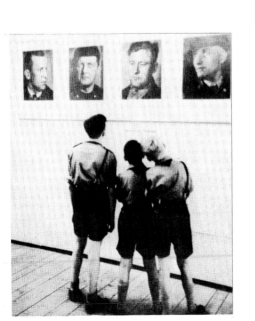

37. Hitler Youths admiring the Labor Heroes of the Autobahn construction.

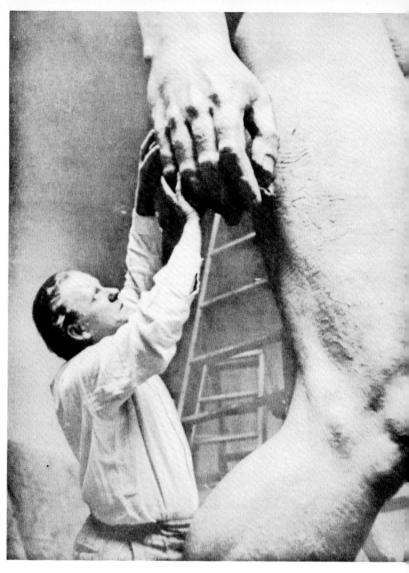

38. Illusion of grandeur: Josef
Thorak in his studio.

39. Nazi architecture: Troost's
Party Buildings in Munich.

10. Detail from the Soviet Monument in Treptow Park, Berlin, 1949.

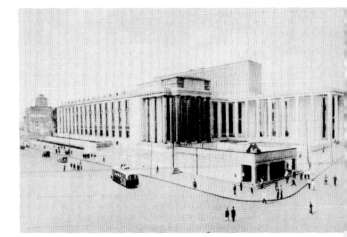

11. Soviet architecture: The State Library in Moscow.

43. Gouache, 1944, by Theodor Werner.

42. Abstract painter, Theodor
Werner, Berlin, 1948.

44. Abstract sculptor, K
Hartung, Berlin, 1

45. Torso, 1947, by Karl Hartung.

Introduction

————

IN CONTEMPLATING THE ROLE of art in totalitarian society I never cease to wonder at three things:

First, at how powerful ideas can be which have very little, if any, foundation in truth; how the fact that concepts do not logically hang together does not seem to prevent them from materializing into very hard and solid reality.

Second, at the extent to which the true nature of the totalitarian claim on every form of artistic and aesthetic experience has remained concealed to observers in the democratic world, and how relatively small the circle of such observers has remained through the years.

Third, at the degree of persistence of this formidable new alliance of authoritarian society and the arts.

I am deeply convinced that it is necessary to face these facts and to realize their full meaning. Why? Because what has happened in the second quarter of the twentieth century is a new thing, something that has never happened before in the history of our society, and because there is the danger of further, vigorous growth and of repetition. These phenomena are by no means confined in time, or, indeed, in space. They can happen anywhere.

The art doctrines of the totalitarian state and the resulting art policies and practices are an inseparable part of its innermost structure. That is a simple truth which may be easy to accept as a statement of fact but extraordinarily difficult to visualize as an inescapable part of everyday reality. We need to understand these connections because it is entirely possible that the things we have witnessed so far are nothing but a prelude to what is yet to come. This is not a pleasant prospect. But to ignore or to minimize such a possibility is shortsighted. It would be an excellent way to aid the

further growth of these very potent threats to cultural freedom.

One of the reasons so many people find it difficult to take these things seriously is an ingrained indifference to art, a traditional reluctance to accept art as a direct social force of extraordinary magnitude. The dictators in authoritarian states have understood this fact far more promptly and more thoroughly than any of the leaders of democratic societies.

We must learn to understand that no dictator can ignore the arts. He cannot ignore any manifestation of life, private or public, personal or institutional. There must not be a vacuum anywhere. Loose ends and fuzzy edges are dangerous; they must be tied up. But the arts play a special role.

Most of us who live in a democratic country have understood the art policies of Nazi Germany or of Soviet Russia, for example, mainly as a form of especially rigid censorship and of extremely thorough propaganda. That is only part of the story. There is more to it than that. What we must realize is the central role assigned to the arts by the modern dictator. He does not think of art as a luxury or a pastime, a pleasant embellishment of life. He always sees it as a vital part of the very nerve center of the social organism. He has a very healthy respect for it. That is why he must control it absolutely, must mold it into a completely subservient instrument. He uses art to integrate every single individual into the fabric of the state, and with it he builds the triumphant symbols of his conquest.

He knows that there is hardly a better way of getting hold of a person — not only of his conscious mind and his reasoning but also of his inner life, of the subconscious, hidden personality — than through art. The language of art speaks most eloquently to the individual.

In order to survive, the totalitarian state must draw the individual away from himself, absorb him into a communal scheme of life that tolerates growth and development of the personality only along narrowly prescribed lines. Art that is the expression of individual search, of experiment, of intuitive play, art that penetrates the surface of the visual world, that is prophetic, sensitive, apprehensive, art that challenges the individual, that demands concentra-

tion, effort, art that heightens perception, sharpens the eye, nour-
ishes thought — that art cannot be tolerated by the dictator. He
must eliminate it. In its place he must put art that requires no
visual effort, that is easily read by all, easy on the eye and on the
mind, unproblematic. He must demand art that creates the illusion
of a secure, serene world, that hides the sinister motives and the
terror. The dictator wants his artists to promote a feeling of belong-
ing; they must promise security through identification with the
community; they must glorify the collective aims of society and
propagate complete faith in the methods of the totalitarian leaders.

The dictator must both please and dominate through the arts. If
he seeks and finds a language understood by all and pleasing to
many, he has solved his problem — but only in part. He still has to
make his lesson stick. Repetition, of course, is one possibility. But
he also needs authentication, or — which amounts to the same thing
— the illusion of authentication. This he must bring about through
appeal to a power beyond him, an established authority already
recognized without reserve by the public at large. And where does
he find this mysterious power? In classicism, of course. Classicism is
made to order for the purposes of the modern dictator. Its very
nature is assertion of validity through appeal to a universally ac-
cepted culture — that of ancient Greece and Rome. Its own in-
trinsic merits have proved themselves in time — and so there is the
added authentication of antiquity.

The fact that the adoption of classicism clashed violently with
other demands did not bother the dictators to any noticeable ex-
tent. This is worth remembering. Underestimation of the power
of the dictator because of the obvious shoddiness of his intellectual
procedures has contributed significantly to his success.

A good deal has been written about the relationship of art and
society in the totalitarian state; but so far there has been no attempt
at a thoroughgoing investigation and an integrated presentation
of the rich available evidence. This is, of course, no easy task. It is
not sufficient to say that the dictator needs the artist, that the totali-
tarian state cannot exist without his services. How does the dictator
realize this need? In what form, through what processes do the arts

become a part of his planning? What are the ideological sources of his doctrines? The fascinating process of the birth of these ideas, their gradual crystallization into a program, their translation into the law of the land — that is the pattern of evolution we must try to trace.

How do these policies affect the arts, what is the response of the various types of creative activity to these new demands? What happens to the artist? How does the public react? What is the effect on various classes and groups of society, on various age levels, on the individual personality? How do these demands affect the existing art life of the community to which they are applied? What do they do to general education, to the teaching of art?

How successful can the dictator be in terms of his own objectives? How far can he penetrate? At what point does he meet resistance? Is there an incorruptible cure of creative integrity? Can the artist escape regimentation, and if so, how? Again, what is the over-all effect of such a program on the growth of the arts? Which are the elements that are stimulated, which are suppressed? And what is the meaning in terms of the future, for our own society?

These are the most important questions that present themselves for an answer. Here, indeed, is a formidable challenge. The reason the task should be attempted is obvious. If we can find answers for some of these questions we should gain valuable, concrete criteria for the evaluation of a number of important conflicting concepts concerning the place and function of the arts in the contemporary world. We should be able to apply these criteria toward the solution of some basic questions about the value of the creative individual and the nature of his freedom in a democratic society. Also, our conclusions should help in defining more clearly the cultural opportunities and obligations of the United States in its present position of world leadership.

Stated in these terms the project is too large for a single individual to handle with any hope of profitable results. Obviously, there has to be a reduction to manageable proportions. This is possible, it seems to me, without serious curtailment of the validity of the re-

sults. To include all the arts — literature, music, the theater, dance, motion pictures — together with all the so-called fine or plastic arts, in the scope of this study, while theoretically desirable, is a practical impossibility. I shall therefore confine myself to the fine arts, namely to painting, sculpture, architecture, the arts and crafts, and to certain aspects of the study and the teaching of these arts.

Wisdom also demands limitation in another direction, namely in the geographic area to be subjected to detailed scrutiny. For a number of reasons I propose to pursue the story of art mainly in Nazi Germany, in Soviet-occupied Germany, and in Soviet Russia proper.

To be sure, in the eyes of the Western world at large, German art is neither very popular nor especially significant. Yet it enjoys one unique distinction: it is the only twentieth-century art that was subjected to the full measure of totalitarian direction over a sizable stretch of time and then suddenly delivered from it. Twelve years of complete cultural dictatorship and airtight isolation from the outside world, followed abruptly by the period of occupation, have turned German cultural life into a proving ground of rival policies dictated by widely diverging ideologies. Here is a ready-made case history, a laboratory specimen with almost ideal control features, fairly begging to be read.

We should also take advantage of the fact that Germany offers some of the best opportunities available today for a close study of Soviet art policies. Their own zone of occupied Germany presented to the Soviet authorities the need for clearly enunciated policies and for a machinery of enforcement. It was necessary to undertake a fresh definition and translation into terms understood and appreciated by the Germans in the Eastern zone, so recently escaped from another form of cultural dictatorship. The Soviet policies had to be justified through references to their sources in the basic doctrines of Marxist ideology as practiced in the USSR today. The proximity of the center of the Soviet Military Government in the Eastern sector of Berlin to our own centers in Western Berlin made it easier here than elsewhere for us to penetrate the Iron Curtain.

Also, the German press reflected very clearly the Soviet policies and the resulting events, which could be read easily if one knew where to look.

A combination of fortunate circumstances has enabled me to take advantage of these rich opportunities to study the relationship of art and dictatorship. Over three years of war and postwar duty in German affairs for the United States government and a two-year research grant from the Rockefeller Foundation to complete the study — these were the conditions under which the work was conceived, planned, and completed.

There were opportunities for hundreds of interviews, discussions, and meetings with private and official representatives of both Eastern and Western German cultural life; opportunities for visits to the studios, the galleries and museums, the art schools and academies, for conferences with Allied art authorities on repeated rounds of field trips extending to all four zones of occupation, all of which afforded a wonderful accumulation of first-hand observation and experience of the impact of dictatorial art policies. Insight into the vast structure of the Nazi cultural empire was gained through access to hitherto classified documents, especially the official files of the Nazi Propaganda Ministry's Chamber of Art and of the SS at the U.S. Documents Center in Berlin-Zehlendorf, and to the rich collections brought to this country by the Library of Congress Mission soon after the end of hostilities.

A vast amount of printed literature and pictorial documentation, published with lavish disregard for cost by the innumerable organs of the Nazi and Soviet States, was subjected to careful and prolonged study. Continued correspondence with important exponents of German art life and a field trip to Germany undertaken in the fall of 1950 for the purpose of additional observations and the gathering of further material provided continued contact with important postwar developments.

I

PRELUDE

The Lesson of History

T HE ABSORPTION OF ART into the structure of the state in twentieth-century totalitarian society is without precedent. We can search in vain for a historical example of the art policies of Soviet Russia and Nazi Germany. Such complete monopolization of the entire creative potential of a people, of every aesthetic instinct, such subjugation of every current of its productivity and its capacity for artistic experience to the purposes of the leaders of collective society does not exist before the present century.

This does not mean that there were not certain historical experiences and certain formulated ideas a dictator could draw on, some lessons he could learn. We should allow ourselves at least a brief glance at some of these experiences.

In order to achieve its objectives, authoritarian society, in the person of its dictator, must of course both dominate and please. The wooing of the masses through the medium of art has clearly visible roots in the eighteenth century. The thought that one might define the beautiful as that which pleases the greatest number of people was voiced by the German painter Anton Raphael Mengs,[1] who with Winckelmann was one of the heralds of classicist aesthetics. The work of the French painter Jean Baptiste Greuze (1725–1805), acclaimed by Diderot as 'your painter and mine,' furnishes a perfect example of response to mass taste: a mixture of realism and sentimentality, of narrative and morals.

Appeal to popular taste became an economic necessity for the artist, what with the steady decline of individual patronage and the increasing unreliability of the sponsorship of the crown.[2] Also from then on, the possibilities of mass appeal of the visual arts were enormously increased through the technological revolution,[3] even before the invention of photography in 1839, but of course especially through the resulting perfection of a host of reproduction processes.

THE DISCOVERIES OF THE FRENCH REVOLUTION

The leaders of the French Revolution had recognized the possibilities of popular participation in artistic experience on a new level. They were quick to sense that if it was possible to have something new here, it was necessary that action should be taken and that they, the leaders of the new social order, should be the ones to bring these things about.

The most important and effective of all the artistic media employed for revolutionary propaganda was the festival or pageant. During the Revolution this technique reached the highest development as a method of social control that it was to attain until our own time. The best artists of the period, including David, were employed to combine painting and sculpture with the emotional appeal of colorful pageantry and ceremonial, parades and music, slogans and symbols, poetry and oratory, together with official processions, theatrical programs and pyrotechnic displays . . . The most original feature of the festivals was the mass participation: The people themselves were active participants as well as interested spectators. Flattered by the feeling of importance thus engendered, the masses tended to identify their interest with those of the new national state.[4]

In the great state festivals of the French Revolution the process of monumentalization includes the masses of humanity. Centered around the cubic altar the military and the populace are welded together into mighty geometric blocks in lifeless rigidity: For the first time in the management of these acts of state the transformation of man into mass becomes visible.[5]

Here was the first large-scale demonstration of the new social function of the arts. All available evidence shows that the artists of France, with negligible exceptions, accepted their new role as

teachers and priests with alacrity. Individually and in groups they identified themselves with the cause of the Revolution, which they served both through the medium of their art and as active thinkers and leaders, often in positions of considerable authority. The paradox of a situation that necessitated ideological identification of the artist with the demands of the state at precisely that moment in history when the concept of the artist's individual freedom in the modern sense of the word was born [6] did not become apparent in the initial phases of the Revolution. In the art of our own time this conflict has assumed almost overwhelming proportions. It has become the crucial mid-century dilemma of artists in many parts of the world. That it did not become immediately apparent is one essential characteristic of the process, as we shall have ample opportunity to observe.

The example of the French Revolution is a far more direct anticipation of the totalitarian use of the arts both in Germany and in Russia than are the teachings of Marx and Engels. Great efforts have been made by contemporary Marxist writers in Soviet Russia to link the current art doctrine of 'Social Realism,' which is a completely totalitarian device, with the teachings of the founders of communism.[7] An objective examination of what Marx and Engels wrote about art shows only remote connections with the current doctrines and practices. In fact one is led to suspect that Marx would have been very much surprised and probably not a little chagrined by the demands the communist state makes upon art and the artist today.

What Did Marx Really Say about Art?

There is nothing in the relatively sparse and usually incidental comments on art that one finds here and there in the writings and the correspondence of Marx and Engels which could be directly connected with such dominant features of the current doctrines as the insistence on an immediately and easily comprehensible message, the demand for a completely realistic style, and the limitation to a narrowly prescribed range of content. The plain truth of the matter is that Karl Marx did not know very much about art, nor was

he really much interested in it except as an abstract category of philosophical and aesthetic speculation necessary for his thinking processes. A student of German classicist aesthetics, he saw art mainly in terms of Greek sculpture and in the achievements of the Italian High Renaissance, a typically academic approach. As a young man he wrote some very bad poetry; there is no indication that he really observed what was going on in the art life of his own time.

What did Marx really say about art? There has been no objective attempt to answer this very important question. Of course, it is not an easy matter to settle. Marx did not leave behind him an integrated system of aesthetics; his remarks are in the main incidental references, scattered throughout his works. One would have to make a thorough search of the very considerable body of his writing and correspondence in their original formulation, to collect everything of importance, and to interpret this material with a real understanding of its context. This obviously lies outside the scope of the present study. The only practical alternative is to examine briefly some of the remarks that have been collected, translated, and interpreted by contemporary Marxist commentators.

The results of such an inquiry are quite surprising. Not only is it impossible to find here any connecting links with some of the most important elements of the current Marxist art doctrines; there is actually a good deal in these statements of Karl Marx that directly contradicts the teachings of his mid-twentieth-century followers. Also, there are some ideas and attitudes expressed by Marx that one finds later on far more clearly reflected in the Nazi art doctrines than in communist ideology. Only certain of Karl Marx's ideas can be seen as the original sources of modern communist aesthetics.

Perhaps the most important contradiction is Marx's belief in the freedom of the creative individual and in his right to choose his own medium of expression. He was primarily interested in the freedom of the writer, but he clearly included the artist in his thinking.

The first thing that strikes us is to see freedom of the press brought under the heading of freedom of craft. Yet we can not reject the speaker's view forthwith. Rembrandt painted the Mother of God as a Dutch peasant woman; why should not our speaker paint freedom in a form with which he is familiar? [8]

He expressed the same elsewhere:

The truth is universal. It does not belong to me but to everybody. It possesses me, I do not possess it. My possession is the *form,* which constitutes my spiritual individuality. *Le style, c'est l'homme.* And how! The law permits me to write, but on condition that I write in a style not *my own!* [9]

Marx did believe in a mass participation of the people in artistic creation. But, he said,

even if in certain social relations everyone could become an excellent painter, that would not prevent everyone from being also an original painter.[10]

That Marx did not demand, as do his current followers, that the artist must speak in a manner easily comprehended by the broad masses is clear from the fact that he abstracted the following passage from Friedrich Theodor Vischer's *Aesthetik:*

That the enjoyment of the beautiful is immediate, and that it requires education would seem to be contradictory. But man becomes what he is and arrives at his own true nature only through education.

More than once Marx explained that he did not wish to foster mediocrity.

His attitude concerning the future of the arts is rather contradictory. While he did believe that a new kind of mass culture would result from the Communist Revolution, there runs through his writings a constant thread of general skepticism regarding the fate of the arts in the machine age.

Is Achilles possible side by side with powder and lead? Or is the *Iliad* at all compatible with the printing press and steam press? Does not singing and reciting and the muses necessarily go out of existence with the appearance of the printer's bar, and do not, therefore, disappear the prerequisites of epic poetry? [11]

In this same vein, he expresses a similar thought elsewhere:

> Whereas the decline of former classes — such as knights, for instance
> — could furnish material for magnificent tragic works of art, the petty
> bourgeoisie naturally provides nothing but weak manifestations of fa-
> natical malice, nothing but collections of Sancho Panzian sayings and
> maxims.[12]

The Buddenbrooks, The Forsyte Saga, his own contemporary
Daumier, they obviously lay outside the realm of what he saw
or foresaw.

Only in certain instances is Marx's feeling of disillusionment
coupled with an indictment of capitalism and bourgeois society as
the direct cause for this unfortunate situation of the arts in his
own time:

> 'Capitalist production is hostile to certain branches of spiritual pro-
> duction, such as art and poetry.' And: 'Even the highest forms of spirit-
> ual production are recognized and forgiven by the bourgeoisie only
> because they [namely the artists and intellectuals] are represented and
> falsely labeled as direct producers of material wealth.' [13]

There is actually only one rather general idea in Marx's writings
which can be considered a major source for the current teachings
on the role of art in communist society. It is the concept that in
popular abbreviation is known as 'art for the people and by the
people.'

Marx was interested in this postulate in connection with his
concern over the division of labor, which played a major part in his
economic philosophy. His most important statements, from which
a portion has already been quoted (see page 7), occur in a critique
of Max Stirner's *The Ego and His Own,* where an attempt had been
made to differentiate between 'human' work, which lends itself to
collective organization, and individual work, which cannot be so-
cialized. A good deal of what Marx and Engels wrote in this con-
nection deals with fundamental truths which have been generally
accepted in all democratic societies and which are widely recognized,
for instance, as basic tenets in modern education:

The division of labor does not become an actual division until the division of material and spiritual work appears . . . Together with the *division of labor* is given the possibility, nay, the actuality, that spiritual activity and material activity, pleasure and work, production and consumption, will fall to the lot of different individuals . . .

In this connection it is interesting to notice that in the field of the arts the division into manual crafts and liberal arts was consciously and deliberately promoted in the middle of the eighteenth century by the cultural officers of the French Crown.[14]

Karl Marx was not content to diagnose symptoms; he went further. He drew conclusions from his observations which must indeed be recognized as of fundamental importance to the formulation of totalitarian art doctrines:

The exclusive concentration of artistic talent in certain individuals, and its consequent suppression in the broad masses of people, is an effect of the division of labor. Even if in certain social relations everyone could become an excellent painter, that would not prevent everyone from being also an original painter, so that here too the difference between 'human' work and 'individual' work becomes a mere absurdity. With a communist organization of society, the artist is not confined by the local and national seclusion which ensues solely from the division of labor, nor is the individual confined to one specific art, so that he becomes exclusively a painter, a sculptor, etc.; these very names express sufficiently the narrowness of his professional development and his dependence on the division of labor. In a communist society, there are no painters, but at most men who, among other things, also paint.

Here, indeed, is the seed of the doctrine of the total integration of art and society.

The connection between some of Marx's attitudes and the art teachings of the Nazis seems to have escaped his commentators. Yet there are quite unmistakable resemblances. Like the Nazis in general, and Adolph Hitler especially, Marx considered classical art 'the standard and model beyond attainment.' His materialistic interpretation of Greek sculpture strikingly foreshadows the Nazi interpretation of these monuments as reflections of a biological law.

If we consider the gods and heroes of Greek art *without religious or aesthetic prejudices,* we find in them nothing that could not exist in the pulsations of nature. Indeed, these images are artistic only as they portray *beautiful human mores* in a splendidly integrated form.[15]

The Nazi condemnation of primitive art as a crude and barbaric manifestation of mankind on an inferior level of evolution is similarly foreshadowed in some of Marx's studies of fetishism,[16] in his interest in the idea that 'lack of artistic workmanship' was a necessary prerequisite to the religious effectiveness of the ancient 'crude' stone carvings.

It could perhaps be argued that these ideas of Karl Marx are really nothing more than reflections of classicist aesthetics still current in his day. To a certain extent that is true, but not wholly so. The important thing is that they are fused in a characteristic fashion with his unique social and economic theories. In this process they assume new significance and — as history has shown us — a rather special and aggressive vitality. They needed first, however, to be interpreted and given the kind of reality they hitherto had lacked.

WILLIAM MORRIS: ART FOR THE PEOPLE AND BY THE PEOPLE

The real prophet of 'art for the people and by the people' was William Morris. There is no question that his ideas had a profound influence upon the art doctrines of twentieth-century totalitarianism. But there is also no question that these ideas were thoroughly corrupted and perverted in the process of practical application. William Morris was exhorting people to greater independence, greater freedom, and greater sensitivity. The dictators wanted and they still want uniformity and enslavement.

Curiously enough, the relationship between William Morris and totalitarian aesthetics has not been recognized in the many current discussions of the relations of art and society. Nevertheless, it was the John Ruskin disciple William Morris more than anyone else in the nineteenth century who propagated the gospel of *'art made by the people, and for the people, as a happiness to the maker and the user.'* He fought for this idea directly, simply, with the entire

force of his conviction and the wholehearted devotion of his power-
ful personality. It dominated his thinking as strongly as it did his
creative energies. Here lies the chief difference between his in-
fluence upon art and that of Karl Marx. Marx came upon art de-
ductively, by way of speculative aesthetics, which he projected into
his blueprint for the society of the future. William Morris re-
sponded with his creative instincts as well as with his mind. He
accepted the doctrine of the division of labor as the prime factor
in the disintegration of art in the industrial world. He proceeded
to demonstrate reintegration of art and craft both by personal ex-
ample and by a forceful and well-planned campaign of writing and
lecturing. His convictions were expressed in a series of carefully
prepared lectures delivered on various occasions from the end of
the 1870's to the 1880's, during the last years of Marx — who died
in 1883 — and when Morris himself was in his forties and early
fifties.

It is not necessary to read more than one or two of his lectures [17]
in order to understand what he meant by 'art for the people and
by the people.' He had thought things through until he found an
answer to the problems that he felt stood in urgent need of solu-
tion, until it was clear to him what he wanted and what he, as a
single individual, could accomplish. Once he had reached this
point, in the fullness of his manhood, he was no longer interested
in the further development of ideas. He wanted to teach and to put
into practical reality what he had recognized as the truth. His
lectures, therefore, all say the same thing, with relatively unim-
portant variations, simply and vigorously.

His belief in the oneness of life and art is the foundation of his
teaching: 'In my mind, it is not possible to disassociate art from
morality, politics and religion.' 'The arts . . . are necessary to the
life of man.' 'That thing which I understand by real art is the ex-
pression by man of his pleasure in labor. I do not believe he can
be happy in his labor without expressing that happiness . . .' 'You
can not educate, you can not civilize men, unless you give them a
share in art.' 'Nothing can be a work of art which is not useful.'

Division of labor and commercial competition have, in William

Morris' eyes, forced apart the unity of the arts and interrupted the great historic tradition of genuine popular art.

'History (so called) has remembered the kings and warriors because they destroy; art has remembered the people, because they created . . .' The things we treasure in our museums, 'they were made by "common fellows," as the phrase goes, in the common cause of their daily labors.' These are the things 'by means of which men have at all times more or less striven to beautify the familiar matters of every-day life.' But the division of labor has 'pressed specially hard' on the arts: 'The lesser so-called Decorative Arts . . . it is only in latter times, and under the most intricate conditions of life, that they have fallen apart from one another . . . the greater arts, namely architecture, sculpture, painting . . . unhelped by the lesser, unhelped by each other, are sure to lose their dignity as popular arts, and become nothing but dull adjuncts to unmeaning pomp, or ingenious toys for a few rich and idle men.'

The 'defacements' of our big towns, the 'unutterable rubbish' in London houses, their 'ugliness and inconvenience,' are the products of 'unhuman work, burdensome and degrading,' the result of 'the system of organization of labor, which is the chief instrument of the great power of modern European commerce.'

Fundamentally, Morris felt, there was 'something wrong about the root' of art in his time. 'Art is not healthy, it even scarcely lives, it is on the wrong road, and if it followed that road will speedily meet its death on it.' Again and again, he speaks of the general indifference to art among the leading classes of society. He complains of the 'prevalent habit of thought that looks upon art as at best trifling,' of 'that sickness of repulsion to the arts.' 'The leaders of modern thought do for the most part sincerely and single-mindedly hate and despise the arts . . .' 'Languid complacency is the general attitude of cultivated people toward the arts . . .'

'Is art,' he must ask, 'to be limited to a narrow class who only care for it in a very languid way, or is it to be the solace and pleasure of the whole people?' 'I do not want art for a few, any more than education for a few, or freedom for a few.' 'That art goes hand

in hand with, is much the same thing as luxury . . . is an idea false from the root up . . .' 'It can not be that she will live the slave of the rich, and the token of the enduring slavery of the poor . . .' 'Rather than art should live this poor thin life, among a few exceptional men . . . I would that the world should indeed sweep away all art for awhile . . .'

William Morris thundered against art for art's sake, ' . . . a piece of slang that does not mean the harmless thing it seems to mean — art for art's sake. Its fore-doomed end must be, that art at last will seem too delicate a thing for even the hands of the initiated to touch; and the initiated must at last sit still and do nothing — to the grief of no one.'

He spoke passionately of what he wanted to accomplish and of what he wanted others to accomplish with him:

Tis we ourselves, each one of us, who must keep watch and ward over the fairness of the earth . . . I wish people to understand that the art we are striving for is a good thing that all can share, that will elevate all; in good sooth, if all people do not soon share it there will soon be none to share; if all are not elevated by it, mankind will loose the elevation it has gained . . .

A reintegration of all the arts is a necessary part of this. Architecture 'neither ever has existed nor ever can exist alive and progressive by itself, but must cherish and be cherished by all the crafts.' Architecture, indeed, occupies the key position: 'It is this union of the arts, mutually helpful and harmoniously subordinate one to another, which I have learned to think of as Architecture . . .' From this will come 'simplicity everywhere, in the palace as well as in the cottage.' 'In no private dwelling will there be any signs of waste, pomp, or insolence, and every man will have his share of the best . . .' 'Men will then assuredly be happy in their work, and that happiness will assuredly bring forth decorative, noble *popular* art. That art will make our streets as beautiful as the woods . . .' Thus will come about '. . . real art, the expression of man's happiness in his labor — *an art made by the people, and for the people, as a happiness to the maker and the user.'*

William Morris said these things three quarters of a century ago. He was heard by many. His influence has been so great that it is virtually impossible to measure it with any hope of accuracy. What he said in such forceful repetition and what he attempted to put into practice himself was observed, listened to, tried out, modified, translated, to the point of almost complete absorption. His teaching lies solidly behind the whole of modern architecture and city planning; behind all the arts and crafts that have withstood the impact of industrialization and have long since taken what can now be recognized as a vigorous new lease on life, which in turn has revitalized vast areas of industrial design and production.

That these teachings also reached the twentieth-century dictators there can be no doubt. Nor can there be any doubt that the dictators used these ideas as they pleased, selecting arbitrarily what suited their purposes, disregarding everything that conflicted with their aims and practices. The connection between the art doctrines of William Morris and those of the Nazis, for instance, can be understood as part of the relationship between socialism and National Socialism.

It is not necessary to assume that the creators of the cultural ideologies from which the art policies of Nazis, Fascists, and Soviet Marxists evolved literally studied the writings of William Morris. Some of the essence of his beliefs could have been conveyed by any one or several of the innumerable channels through which his ideas were given currency. Is it necessay to say that this essence became subjected to many modifying influences in the process, that many other elements were combined with it?

Nothing shows so clearly the significant contrast between the creed of William Morris and the totalitarian doctrine as his own attitude toward the creative freedom of the individual. It is the opposite of the dictatorial concept of the artist as the servant of society. William Morris was aware of the dangers of isolation, he found it perplexing and deplorable, but he was very careful not only to guard the right but also to underline the duty of the artist toward himself:

The artists are obliged to express themselves, as it were, in a language 'not understanded of the people'; nor is this their fault; if they

were to try, as some think they should, to meet the public halfway, and work in such a manner as to satisfy only those prepossessions of men ignorant of art, they would be casting aside their special gifts, and would become traitors to that cause of art which it is their duty and glory to serve: They have no choice save to do their own personal work without any hope of being understood as things now are; to stand apart as possessors of some sacred mystery, which, whatever happens, they must at least do their best to guard . . .' [18]

A cardinal principle of totalitarian aesthetics is the condemnation of many forms of individualistic expression as 'degenerate.' It will probably surprise a good many readers that the issue had already become acute in William Morris' time. We owe to none other than George Bernard Shaw some brilliantly illuminating passages on William Morris' attitude toward 'degenerate' art. They leave no doubt whatsoever about where he stood. Shaw was admired by Morris as a literary man, but was somewhat mistrusted when it came to matters of art.

An accident [writes Shaw [19]] enabled me to gain his confidence on the artistic side . . . It happened that a sensation was made by a stupendously pretentious German writer named Max Nordau, who, having made himself famous by a book called *The Conventional Lies of Civilization,* followed it up by a Jeremiad called *Entartung* (Degeneration), in which he maintained that all modern art is pathological: Wagner's music, Rossetti's poems, Morris's wallpapers and the paintings of the Impressionists being symtoms of mental dissolution and corruption . . . [I devoted myself] to the destruction of Nordau . . . the easiest one since Macaulay slated Robert Montgomery . . . It was child's play to slice him into a thousand pieces. But I seized the occasion to state the general case for the sanity of art . . . and its necessity as both an instrument and an object of culture.[20]

[William Morris] had read the English translation of *Entartung* . . . and witnessed its absurdly respectful reception with a disgust that was quite independent of Nordau's insulting and idiotic reference to himself; and when he saw the insult, not to himself, but to fine art generally, fearfully avenged by my hand, the petulant veteran disappeared; the real Morris took me as one who knew; and I soon discovered that he knew as much about Whistler as he did about Van Eyck.

There seems to be very little doubt about what Karl Marx and William Morris did and did not contribute to the formulation of totalitarian art doctrines.

The False Paradise of Weimar

THE TWENTIETH-CENTURY dictator seizes upon art not so much as a medium of propaganda but as an instrument of social integration. This is the central idea which dominates his cultural program. Art in the totalitarian state is not merely one among several other media for the propagation of certain themes. This is of course one of its functions, but beyond it art is recognized in its potential role as a powerful symbol of the future society, the supreme expression of its mythology; it becomes the tangible materialization of the will of the dictator and the focal point of the people's collective mentality.

Behind all this lies a shrewd realization of the opportunities presented by the social crisis of art since the political and industrial revolution of the nineteenth century, a fact the dictator did not have to discover for himself. The isolation of the artist in the modern world, his uncertain economic status, his apparent separation from the aims of the community at large, these are all matters that have been discussed for a long time and that are still passionately argued today. But these problems have never been solved.

A tremendous reservoir of untapped energy was accumulating. The synthetic art experiences provided by various popular substitutes never seriously drew on these unused forces. The totalitarian leaders clearly anticipated the mighty surge of emotional and spiritual currents that would break forth if only these frustrated, stored-up energies could be reached. That they should be released

was not only profitable but a matter of necessity. It was essential to the success of the program that they be caught up, controlled, and directed to its purposes.

Karl Marx and William Morris, each in his own characteristic way, had felt and expressed their despair of the role of art in their time. They had pointed out certain remedies with which to bridge the gap and re-establish a healthy relationship between art and society.

How practical was the solution proferred by nineteenth-century socialism? Why and how did it fail? And why was this failure grist for the mills of the modern dictator?

The first real test for the socialist art program came toward the end of World War I, with the Russian Revolution of 1917 and the German Revolution of 1918. It is not necessary in this connection to trace in any detail the development of the socialist art program since the time when William Morris so forcefully had demanded 'art for the people and by the people.' A typical example of the reformulation of his ideas by the socialists of the European continent is the declaration made during a party convention in Gotha in 1896 by one Edgar Steiger:

We want the working people to take the lead in all fields of life, but not through the destruction of former cultures, so that we then create out of nothing; rather, we want to take over everything good and beautiful, and the capacity to enjoy these good and beautiful things, from the former societies. We want to place them on the table of the working people, so that they can take over today's cultural heritage as the great champions of today's culture, equal to the great tasks awaiting them, so that they may not wither away in serfdom and so that we may all of us become whole human beings.[1]

The first steps in translating such demands into a practical program were taken in Soviet Russia, soon to be followed by the German experiments in the Republic of Weimar. The developments in the two countries, although somewhat related to each other,[2] should not be looked upon as closely interdependent. For this reason it is not only possible but actually better to treat them separately.

The German Revolution of 1918 produced an exceedingly interesting document. Following the example first of the rebelling sailors and soldiers and then of organized labor, the progressive artists of Germany formed an autonomous organization of their own, called the Working Council for Art (Arbeitsrat fuer Kunst). It declared that it had been organized 'not in order to add to the number of already existing artists associations; rather, it sees the justification and necessity of its existence in the creation of a working community of all artists engaged in the visual arts, in order to re-establish the unity of the disrupted arts.'

The program of the council was signed by over a hundred men and women, including such painters as Max Pechstein, Emil Nolde, Karl Schmidt-Rotluff, Lyonel Feininger, Heinrich Campendonck, Heinrich Nauen, and Erich Heckel; the sculptors George Kolbe, Gerhard Marcks, and Richard Scheibe; architects Walter Gropius, Erich Mendelsohn, Hans Poelzig, Bruno and Max Taut, and Paul Zucker; Alfred Flechtheim the art dealer; August Griesebach the art historian; the museum director Carl Georg Heise — truly a representative assembly of the leaders of the country's art community.

During the turbulent early months of 1919 a questionnaire was sent to the members of the council, from which significant answers were published in November of that same year.[3] These were the questions:

I.
TEACHING PROGRAM
What measures are considered appropriate to bring about the thorough reform of training for all activity?

II.
STATE SUBSIDY
On what basis should the socialist state provide means for artistic matters and for the support of artists? (Purchases, regional art commissions, museums, schools, exhibitions, et cetera.)

III.
HOUSING
What demands are to be directed at the leaders of the State in order

to vouchsafe in the years to come the development of housing projects according to farsighted cultural view-points?

IV.

MIGRATIONS OF THE ARTISTS TO THE MANUAL CRAFTS

How can the broad masses of the art proletariat be recruited for the manual crafts and how can they escape annihilation in the impending economic catastrophe?

V.

THE ARTIST IN THE SOCIALIST STATE

VI.

ART EXHIBITIONS

What new methods can be employed to reawaken the interest of the people in the unified work of art — architecture, sculpture, and painting in mutual integration? State Experiment Stations instead of Salon Exhibitions?

VII.

How can the artists in the various fields of artistic creation be merged into an alliance and brought into unity?

VIII.

COLOR TREATMENT OF CITY FAÇADES

Thoughts on color treatment of the cities, bright house paint, repainting of façades and interiors, abolition of framed paintings.

IX.

DESIGNING OF PUBLIC BUILDINGS BY ARTISTS

What practical demands are to be made of the State which will result in the creation of public buildings by artists and not, as heretofore, by technicians and building officials?

X.

HARMONY WITH THE PEOPLE

What are appropriate measures to bring the efforts of modern artists into contact and harmony with the people?

XI.

What preparations are necessary for the public proclamation, at the right moment, of the quietly prepared materials?

Preparation of newspaper articles, lectures, exhibitions, finding a sufficient number of press channels for this purpose.

XII.

What should be done in order to establish the closest possible contact with like-minded foreign artist groups?

XIII.

Opinion on the anonymity of the artists in their work. Mark instead of signature.

It is easy today to see the essential shortcomings of this program. The very formulation of the questions betrays a fundamental misgiving about the nature of the state. In the minds of those who framed these questions the state looms large as a hostile power, an authority that has to be fought against, from which things have to be demanded. It is by way of concession that this state must grant the things these artists feel so strongly to be necessary and desirable. These questions read as though the artists were addressing themselves to the representatives of the very government that has just collapsed. They do not recognize themselves as important members of a constituent body within the framework of a new self-governing society.

The published answers to the questionnaire show complete agreement only on the need for a return to the crafts and the apprentice system as the only acceptable training method in the arts. There is also some agreement on the need for the participation of artists in public building, but on the question of state sponsorship of the arts in general opinion is strongly divided. The majority, in fact, is strongly opposed to and openly suspicious of any kind of state intervention. A certain amount of skepticism is also expressed about the feasibility of confronting the leaders of organized labor with modern art. 'Organized labor is not ripe for expressionism' is a typical formulation.

A note of utopian idealism and phantasy dominates almost all the answers. Again and again there is the demand for the 'blue street,' the 'red street,' the 'golden street,' for the Crystal Cathedral that crowns the city of the future as a symbol of religious ecstasy and dedication. There are demands for colorful celebrations and open-air carnivals, for the brotherhood of artists and of all men.

Almost all the answers demonstrate an overwhelming lack of contact with reality, everyday reality and the realities of political life. Walter Gropius, whose statement is exceptionally rational and contains the fundamental ideas from which his Bauhaus grew into one of the strongest realities of those years, recognizes this: 'We are suspended in space,' he writes, 'and we do not as yet know the new order.' In other documents of that period one finds the same rather special atmosphere of challenge, of idealism, and of helplessness in the face of a fluid situation.[4]

Nothing is farther from the truth than the concept that these progressive artists were a group of well-indoctrinated and trained political activists. They were posthumously cast in that role by Adolf Hitler and his ideological propagandists. This concept has become widely accepted and is still frequently used in the ideological battles of our time. For this reason the problem needs to be more carefully examined.

We shall have to start with the truism that art and society are related and dependent upon each other. Social upheaval is inevitably reflected in the content and style of art, and in many instances the artist is extremely sensitive to the hidden pressures and secret storm signals that precede violent change. His seismographic response to latent currents carrying within them the forces that will mold the destiny of man can reach the form and significance of prophecy. In this sense the artist may influence the actual course of events — at certain times and in certain situations. But this does not mean that every progressive artist seeks political influence or considers his creative activity as a direct means of effecting a social or political change. The artist is primarily concerned with his art, he has been, he still is, and he will be in time to come.

The question whether or not the revolutionary artist is *ispo facto* a political and social radical can be approached from another angle. The answer depends directly and inseparably upon one's basic concept of the nature of art. There is no universally accepted definition of art and there is no need to attempt such a definition here. It is of fundamental importance, however, whether one considers art as an autonomous force or whether one believes it to be

subordinated to other forces, such as religion, society, the state, science, or economics. If one believes art to be essentially a means toward an end, then the progressive artist will almost automatically appear in the role of the political radical. If on the other hand one believes (as I do) that art is an autonomous force, related to other forces but not subordinated to any of them, then the role of the progressive artist will appear in a different light.

A mobile by Alexander Calder, it seems to me, is an excellent symbol of the relation of art to the other elements that mold and express man's existence in the universal scheme of life. All the elements are connected, their relationship is a sensitive balance. Every impact on one of the units of this organism is reflected and vibrantly reacted upon by all the other units. The balance is a delicate one, but also astonishingly flexible. A good deal of pressure, even a violent impact on one element can be absorbed by the entire organism and the equilibrium is again and again re-established. But there is a limit to the amount and duration of onesided pressure which can thus be absorbed. Beyond a certain point the function of the whole is disturbed and it loses its very essence and identity as an organism.

The role of art can vary considerably in its relation to the other expressions of human existence, but if it is weighted down for too long a time with too many demands foreign to its nature, it ceases to function harmoniously and the disturbance is inevitably translated to the entire social organism.

Many of the German artists who joined forces in 1918–19 and sought to identify themselves with the cause of the revolution were veterans in the battle for a new art. Among those who signed their names to the program of the Working Council for Art were the painters of the 'Bruecke' movement, the prewar pioneers of German expressionism,[5] and many of the artists who had years ago rallied round the banner of Herwarth Walden and his *Sturm*.[6]

These men and women, strong and independent individuals, were united in their conviction that naturalism in art had become an empty shell. They were also dissatisfied with the solutions offered by the impressionist school of painting. They fervently

desired a new start, a return to strong, primitive form and color as a direct means of expressing the essential elements of the world around them in its impact on their inner selves. What they wanted could not be achieved without a fierce battle against existing conventions and prejudices. In their field they were hardened warriors.

When the old empire broke down at the end of the First World War and the November Revolution of 1918 swept away its symbols and administrative mechanisms, they heard the call of social duty and sensed, vaguely, that their hour might have come. Actually, the union of the political and the artistic revolutionary lasted but a brief moment in history and it was fraught with misunderstanding.

The utopian quality of the program must have been obvious to many even then. A high tide of fantastic architectural plans and city-planning projects welled up in the magazines and books,[7] but it did not reach any farther. One idea was rapidly executed: the bright paint applied to the façades of petty-bourgeois houses in German provincial towns, to hide the shame of their structural disgrace and the emptiness of their eclectic ornamentation. It was a brave gesture but, of course, not a remedy.

Other experiments failed at once. Late in 1918 and early in 1919 some of the leading expressionist painters were commissioned by the new authorities to produce a series of political posters. These posters failed so promptly and utterly to serve the purpose for which they were intended that the same slogans and themes were turned over to a group of ultra-conservative painters. In the appeal to the masses the academicians carried the day even in this unique situation.

The inability of the German expressionist painters of 1918 to assume the role of radical activists must also be understood on an entirely different level. Expressionist painting has often been denounced, and it still is, as an antisocial force, a fateful step toward the final dissolution of form and of human dignity. When the noted art historian, Professor Wilhelm Worringer, lectured in October 1920 before the Munich Chapter of the German Goethe Gesell-

schaft,[8] he spoke of the crisis and the end of expressionism. Strongly influenced by Oswald Spengler, he called the movement a luxury function of artistic phantasy and a last revolt against the increasing sociological dissolution of the plastic arts. One important thing he either was unable to see or deliberately refused to acknowledge: the strongly religious quality of German expressionism. This is something that is becoming increasingly evident to us today who look back upon this phase of Western painting. It was also quite evident at the time. Another German art historian, Professor Gustav F. Hartlaub, published a book in 1919 [9] in which he examined the possibilities for a new religious art. He emphasized the intensity and directness of Van Gogh's and Gauguin's religious paintings and the ecstatic, visionary sincerity of Beckmann and Nolde, of Barlach and Schmidt-Rottluff. After the Second World War, Hartlaub published another book, an anthology of German expressionist woodcuts, lithographs, and etchings.[10] The selection was made not with any special reference to religious themes but as a cross-section of characteristic work of the 'twenties. The strong religious devotion of many of the artists represented in this work is evident.

There is of course no basic incompatibility between religious belief and a dedication to the cause of social progress; quite the contrary, they often go hand in hand. What I am trying to show is that many of the revolutionary artists of 1918 were more concerned with metaphysics than with practical political reality. At the moment of overthrow of the old political authority they appealed to a higher authority beyond the physical world. Their attitude was one of ecstasy and vision rather than of action. The architects at that moment saw before them not the practical housing development or the new city plan but the 'Stadtkrone,' the towering cathedral reaching heavenward from among the lowly dwellings of the people.[11] We shall see later what became of this concept of the city crown in the hands of the Masterbuilder Adolf Hitler.

Determined efforts to place religious expressionist art into the current of community life were made in several places, notably in the city of Luebeck.[12] The wooden crucifix by Professor Ludwig

Gies, one of the most powerful images of the suffering Christ attempted in modern times, was placed in the Luebeck Cathedral in 1921. At the St. Katharinen Church an exhibition of the religious paintings of Emil Nolde was held, and it was for the façade of this church that Ernst Barlach made a series of beautiful sculptures.

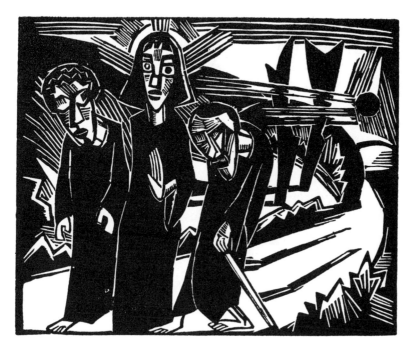

Christ and Disciples on the Road to Emmaus. Woodcut by Karl Schmidt-Rottluff.

Another signer of the 1918 program, the graphic artist Ludwig Meidner, wrote down the following words in 1923:[13]

I pray to you Heavenly Father, who has placed me into this transitory world as a painter and draughtsman, that you may guard me in this profession, that I may not unduly raise myself, and that I may make the right use of this earthly gift, so that I will not employ it for loose and dubious purposes. Rather, oh God, lead my spirit that I may serve the Holy Name also in my worldly profession, so that in my pictures, too, I may seek foremost your glory, your splendor, your wisdom, and may be called your faithful and obedient servant. Amen.

In the light of the things that were going to happen to progressive German art under the Nazis it is important to understand the nature of the alliance between political and artistic revolutionaries during the initial phase of the Republic of Weimar. Once again it should be emphasized that this alliance was of exceedingly brief duration; it never saw any practical realization; it included among the artists who supported the program only very few men of strong political convictions and training.

Such men did of course exist and they exerted a considerable influence which extended far beyond the limits of Germany. Otto Dix and George Grosz have had such a profound effect upon observers of the contemporary scene that their work has been interpreted as the most characteristic expression of German art during the Weimar Republic. There can be no doubt that both these men stated their opposition to the catastrophe of war and their accusation of those elements of society which they believed responsible for the disaster, in the most forceful and direct manner.

One could perhaps also say that in the work of George Grosz the peculiar atmosphere of the period was mirrored with particular acuteness and a frightening degree of veracity. The underlying political dilemma, the readiness, to compromise with continuing reactionary forces, the ultimate disaster of inflation, unscrupulous profiteering, the frustration of unemployment, large-scale corruption, cynicism and despair, all this was caught up in the very essence of the style of George Grosz. It should be remembered that George Grosz came into violent conflict with the established authorities and that his famous *Ecce Homo* portfolio, for instance, was officially banned from circulation.

One other artist with strong political convictions achieved particular success and something approaching popular mass appeal during those years, namely the socialist Flemish woodcut artist Frans Masereel. His picture novels, sequences of boldly carved-out black and white images, which were published in fairly large and inexpensive editions, were 'read' and discussed by many during those years.[14] There is nothing surprising about the fact that an artist from another country should have become famous in Ger-

many. The atmosphere was decidedly cosmopolitan, with an eager reaching out to foreign lands, and international co-operation, soon so firmly denounced by the Nazis, was the solution of the hour.

George Grosz and Otto Dix spoke out strongly and it was difficult not to hear what they had to say. But it would be a great mistake to believe that they were typical of any large or small groups or that they were pursuing a deliberately planned political program. They were speaking as individuals.

It is not difficult to demonstrate how completely the progressive artists of Germany as a group had turned their back upon politics. In the summer of 1926 an exhibition of abstract expressionist art was held in Berlin and the published catalogue [15] contains brief statements by the leading participants in the event, including, together with native Germans like Willi Baumeister, such internationally famous figures as Wassily Kandinsky, Jan Lurçat, and Laszlo Moholy-Nagy. The important thing to us, whatever else these expressions of belief may mean today, is their almost complete disregard of political significance or social intention.

Art and state in the Weimar Republic were going separate ways, as they had done before the revolution. This observation at once needs to be qualified by the reminder that German art life traditionally has been subjected to a far greater degree of governmental patronage, directive, and financial support than was ever the case in the United States. In Germany, the Federal Ministry of Culture and the Foreign Office and corresponding agencies in the numerous political subdivisions of Germany have always had considerable influence upon museum administration and art education at various levels; their sponsorship of officially representative exhibitions has been an important factor in the art life of the country.[16] Architecture in Germany has always been the subject of elaborate legislation and administrative control. In this regard there was one significant change. The demands for a greater participation of artistically trained architects in the official building program, hitherto the exclusive prerogative of rather unimaginative government officials, were fulfilled. Through the process of open competition city planning was elevated from a bureaucratic to an

artistic level. But it is necessary to say that on the whole the change of political system from the constitutional monarchy of the Hohenzollerns to the democratic Republic of Weimar brought no appreciable change in the range and only relatively slight changes in the quality of governmental concern with the arts. The socialist program for a new integration of art and society was, as we have seen, quickly abandoned.

There was only one tangible extension of governmental responsi-

(*Left*) The German Eagle as used 1871–1918. (*Right*) The German Eagle as redesigned by Schmidt-Rottluff, 1920.

bility, and that was of a rather mild nature. It was the creation in 1919 of a new post of Federal Art Officer, the 'Reichskunstwart,' at the Ministry of the Interior. It was occupied by Dr. Edwin Redslob, who distinguished himself after the Second World War in the creation of the new Free University in the American-occupied sector of West Berlin. Edwin Redslob concerned himself with a thorough aesthetic reform of all the emblems, flags, insignia, the currency, coins, and stamps of the Federal Republic of Weimar.[17] To anyone familiar with the stubborn refusal of the United States Government Printing Office and the Bureau of En-

graving and Printing to admit any outside influence upon the design of its products and to allow even the slightest deviation from the most stodgy official taste it will seem as though Dr. Redslob performed miracles.

Dr. Redslob exerted his influence also in other directions. He saw to it that deserving artists received commissions to portray top government officials. He helped to prevent the reckless sale of works of art from public collections during the inflation period. He established contacts between young progressive artists and distinguished visitors from abroad. He encouraged the arts and crafts, by effecting their exemption from the luxury tax and by getting them exhibited at the various trade fairs. He was especially interested in the graphic arts, and was an admirer of the great Rudolf Koch and his Offenbach School and workshop. He insisted on the use of handmade paper for official documents, thereby contributing greatly to the survival of an ancient and noble craft. When George Grosz was threatened with imprisonment for his *Ecce Homo* portfolio, Reichskunstwart Dr. Redslob appeared in court to give expert testimony. He strongly supported George Grosz. This alone would have been sufficient to get him fired when the Nazis came to power. He hastened his dismissal by refusing to shake hands with Hitler at the 'Day of the Book' when Hitler had been in power only seven days.

This was a fine record for a one-man office, but it was a far cry from the kind of state responsibility the socialist program had envisaged. Official concern with the art life of the country was strongest not in the hands of the federal government or in the governments of the several states. It was on a quite different level that new forms of co-operation between artist and society were developed, namely in the numerous large and small municipalities all over Germany. The culture of Weimar can be called an urban culture. It was on this level that artistic creation of a genuinely democratic character became a forceful reality. Community building was the key concept.[18]

Municipal functions found direct expression in the building of city halls, labor offices, hospitals, administration offices for

socialized medicine, general health offices, community centers, municipal theaters, concert halls and exhibition halls, sports buildings and public baths, outdoor and indoor swimming pools and stadiums, and a broad variety of schools and training centers. There were also many new churches and synagogues, youth hostels and vacation centers, railroad stations and hotels. The model housing developments in the large cities, although not always a direct municipal responsibility, were always planned in close co-operation with the city administrations.

What these buildings had in common was a great simplicity of style, the absence of superfluous ornament, a form directly derived from function, and the emphasis on a strict geometric arrange-ment of the masses. The flat roof became the symbol of the new style.

One of the strongest influences behind the new German ar-chitecture of the 'twenties was a unique institution, the Bauhaus of Walter Gropius in Weimar, later moved to Dessau.[19] Associated with him was a group of men of exceptional caliber, vision, and courage, including at one time or another Wassily Kandinsky, Paul Klee, Oskar Schlemmer, Lyonel Feininger, Joseph Albers, Herbert Bayer, Gerhard Marcks, and Laszlo Moholy-Nagy.[20] It is important to remember that the 'Bauhaus Movement' was not confined to architecture; it engulfed the entire field of interior decoration and the arts and crafts. It also found its reflection in a strong new functional style of typography.

As we look upon the whole of German art life between the end of the First World War and the beginning of the Nazi regime, it is impossible not to be confused by the many contradictory trends that seem to be combating each other. On the one side we see a boundless searching for new values, a violent upsurge of emo-tional abandon; on the other the most bitter scorn and irony. We find the ecstatic vision of the expressionist paintings here, and the cool, mathematical precision of the new architecture and interior decoration there. We cannot help but ask how such violent extremes could exist side by side in a relatively confined space and within a brief span of years. Were these divergent

tendencies constantly competing for supremacy of expression? If so, should they not have canceled each other out? Or do we have before us a succession of impulses, driving first in one direction and then in the other? It would seem that the latter was the case, that conditions favored first one, then the other tendency, without ever quite subduing either.

The situation of the architect is an excellent explanation of these confusing trends.

The frightful experiences of the war [explained Walter Behrendt] resulted in a flight from reality, and the artists who had lived through it abandoned themselves to the impulses of their agitated sentiments . . . Condemned to involuntary leisure by the stagnation of building activity, the architect at his drawing-board plays with his roaming fancy. Aroused by the potentialities of modern building technique, thinking of its unlimited means not fully utilized as yet, he visualizes the coming of a world building master capable of shifting mountains . . . Driven by his social consciousness, he thinks about the most urgent and actual problem of the time, how to get housing, how to change the earth into a pleasant abiding place worthy of mankind . . .[21]

With a gradual improvement of economic life commissions began to arrive and the architect found himself faced with the challenge of practical demands. It was in the field of public housing that the most startling progress was made. 'It became manifest,' to quote further from Walter Behrendt's eyewitness account of these crucial developments,

that the housing problem is not a technical or building problem only, but also, and in a predominant sense, an economic and political problem . . . The crisis of thought following the world war brought about a new social concept bringing home to public opinion the idea of social responsibility, of social control and readjustment . . . It became possible to deviate from the principles of private economy and to enact such restrictions and amendments of public law as were needed for social housing. Moreover, with the political revolutions following the war in such countries as Germany, Austria and Russia, the influence of the working class was strengthened to such a degree that they could finally realize their just claims, so long entirely neglected, to a dwelling type of their own . . . There was stagnation of private building in the belligerent countries . . . keeping on in the first years after the war be-

cause of the lack of building credits . . . followed by a general decline
of speculative values. This historical moment was used in such countries
as Germany and Austria to establish a new housing policy . . . housing
declared a public utility, in the same sense as education, water supply,
fire and police protection . . . [There arose] a new concept of town
planning . . . revealing the structural ideas of organic order with its
attempt to restore to the city the natural world of open landscape.
[Abandoned were] the esthetic ideas of town planning, inherited from
Renaissance and Baroque times. The street, now regarded as a mere
organ of traffic, is freed from the esthetic function of representing the
idea of architectural space. And the blocks, no longer supposed to form
with their façades the enclosing walls of this architectural space, are
simply placed within the open space of the urban scene, and grouped
according to the demands of exposure and the needs of light and air.

There is no better way of demonstrating the connection be-
tween political and aesthetic doctrine than to point out that the
Nazis promptly returned to precisely this traditional concept of
the street façade as a major architectural element. As Dr. Redslob
once remarked, their buildings were designed as backdrops for
parades, effective when seen from a passing motor car but ex-
tremely boring to the eyes of a pedestrian. The Nazis turned their
back on the architecture and the city planning of the Weimar
regime, thereby denouncing one of the greatest contributions to
the development of modern building, one that has won permanent
and undisputed international recognition.

Tokens of the unreserved international recognition of these
achievements were the holding of an early exhibition of modern
housing at Stuttgart's Weissenhofsiedlung in 1927;[22] the meeting
of the Second International Congress for Modern Architecture at
Frankfurt in 1929; and the invitations extended to Stadtrat May
and other pioneers to undertake important city planning projects
in foreign countries.

We shall see later how the Nazis managed to appropriate every
single element of the culture of Weimar that they found indispen-
sable to their purposes, and which had to be absorbed and utilized
by them in spite of an ideologically objectionable provenance. In
this process, corruption was the inevitable consequence of adop-
tion.

Art education furnishes a good example. Progressive art education in the Germany of the 'twenties and early 'thirties was developed into a powerful movement. The many years of struggle for a recognition of the child's own characteristic form of expression and of the value of unspoiled, spontaneous articulation were at last bearing fruit. Based on the work of such pioneers as Georg Kerschensteiner — who long before the First World War had laid the scientific foundations of the new pedagogy [23] — the teaching of art in the schools of Germany underwent a thorough reform. Painful copying from plaster casts and stuffed animals, the whole academic treadmill of naturalistic indoctrination gave way to a free spirit of experimentation and imaginative play.[24]

It is interesting that in this field, too, there was a gradual shifting from an early spontaneous and enthusiastic abandon to a more sober and rational attitude. This is clearly reflected in the literature of the period.

The leading theoretician of art pedagogy was Gustav Britsch, who died prematurely in 1923. He believed that the study of children's drawings would provide a key to the pattern of artistic creation at the dawn of each cultural cycle. In a brilliant analytical system he described his findings as the laws which govern the child's artistic formulation at each stage of development.[25] He founded a special school for art pedagogy in Starnberg outside Munich, where he exposed his findings to the test of experience.

His theoretical teachings and practical experiments were carefully studied and reapplied by a group of progressive art pedagogues who published the results of their efforts in the late 'twenties and early 'thirties.[26]

One notices in these writings a growing tendency toward skepticism of the earlier enthusiasm, a weariness of 'the sentimental abandon which for a time was practiced as the alpha and omega of art education.' Understandable as the natural reaction against a period of senseless drill, it 'can by no means be approved by the objective theoreticians. The naïve optimism, which accepts as salvation everything that comes from the child, is exposed to every influence of chance, and since it is without its own opinion, it

cannot even distinguish the genuinely childlike from the merely
assimilated . . .' [27] While the new schools 'as a matter of principle
paid homage to the boundless free creation of the child, there fol-
lowed of necessity a return of the schools to the search after
principles and concepts of an external and internal order . . .' [28]

The significant thing about this reaction is that it was expressed
by men who were not consciously connected with the rising tide of
National Socialism, who still considered themselves the exponents
of progressive methods, and who were by no means aware of the
extent to which they had already been influenced.

How thin the borderline between a conscious totalitarian and a
conscious democratic attitude can become is demonstrated with
astonishing clarity here, in the field of art education, toward the
end of the period of Weimar.

The very establishment of a law governing the gradual unfolding
and developing of the child's creative ability in a series of fixed
and mutually interdependent steps was seized upon by the Nazis
as a means toward new regimentation. This was of course the last
thing the liberal pedagogues of Weimar had intended.

The Search after the road along which the creative powers of the
child are moving in its mental development are therefore of the great-
est importance for art education, because this is at the same time the
road on which it must travel. [But caution was still being used in the
practical application of these laws.] . . . It is the special task of the art
educator thus to direct the creative forces in their growth, that they can
unfold logically; that no violence is done to the intellectual stage of the
young human being, so that the growing person can develop its forces
according to the law which lies within him . . . [29]

Obviously, not much persuasion was necessary to turn these
teachings to the purposes of the coming dictator. The corruption
of art education is an especially interesting chapter in the to-
talitarian appropriation of the arts. It depended of course upon
a clear realization of the dictatorial potentialities of art, which in
turn necessitated the crystallization of a totalitarian art doctrine
and the establishment of a machine for its enforcement.

II

THE NAZI EXPERIMENT

III

The Crystallization of the National
Socialist Art Doctrine

THE SPECIAL IMPORTANCE to the Nazis of a rigidly formulated art doctrine lies to a considerable extent in the fact that these ideas grew out of and in terms of the most important single concept with which they operated: Racism.

The rise of the concept of the Aryan superman is pretty generally known today. Count Gobineau (1816–1882), Houston Stewart Chamberlain (1855–1927), and, later, Alfred Rosenberg are clearly recognizable as the successive creators of the myth of the blond, blue-eyed Nordic hero who is presented in these teachings as the fulfillment of the destiny of Western, Hellenic civilization.

Racism achieved growing popularity soon after the First World War. Entire social classes felt the sting of military, political, economic defeat. The new doctrine was balm to the rampant inferiority complex.

Dr. Hans F. K. Guenther was the prophet of the new cult.[1] In his *Rassenkunde,* first published soon after World War I, he explained that

the Hellenic image of beauty is absolutely Nordic. Greek sculpture shows again and again the pure Nordic race . . . One could demonstrate the history of Greece as the conflict of the spirit of the Nordic upper stratum with the spirit of the lower stratum of foreign race.

He added an appendix containing a discussion of the Jewish race. Success made him more aggressive. In a seventh edition, published in 1925, we find a chapter 'The Task,' which contains such phrases as 'degeneration,' 'de-Nordification,' 'protection of the Nordic race,' 'Nordic mission,' coupled with the demand for a higher birth rate of the Nordic and near-Nordic elements of the German population.

Similar doctrines were propagated by Dr. Ferdinand Clauss; [2] the peculiar teachings of Theodore Lothrop Stoddard [3] were made available in a German translation.

In the mid-'twenties racism and art were deliberately linked for the first time, in a fraudulent union that was to prove lasting and effective. It was in his *Rasse und Stil* that Dr. Guenther tried to prove that the style of a work of art was determined by the race of its creator. Dr. Guenther's teachings and with them the entire edifice of National Socialist aesthetics rest on the basic denial of the autonomy of art, which was being assigned an extremely limited function. Art becomes nothing but a representational reflection of the image of man. This perversion of the humanist ideal is the final stage of aesthetic materialism, the ultimate consequence of nineteenth-century academic naturalism. It is this fundamental misunderstanding of the nature of art that lies at the bottom of the entire totalitarian art doctrine. When Marx made his significant remark about Greek sculpture (pages 9–10), he anticipated these developments.

The attempts to classify humanity into various types and to demonstrate the reflection of these types in artistic creation was undertaken with scientific thoroughness. A study by Ottmar Rutz,[4] published in 1921, tried to explain works of art as the result of certain definable temperamental and psychological human categories and as an emanation of the physical characteristics resulting from their character traits. All that Guenther had to do was to substitute his racial categories. His efforts to project his four dominant racial types into the history of European art resulted in some of the most patent nonsense ever passed off in scientific garb. In discussing Albrecht Duerer, for instance, he asks:

Was it the dinaric blood in the Nordic-dinaric Duerer which opened up in him the southern art will, the dinaric blood, which is inclined to facilitate the transition of the soul across the Alps to Upper Italy?

The important thing to us is not that this was obvious rubbish but that it was widely accepted and that its influence was so strong. Guenther himself furnished targets for the agressiveness that his writing provoked. 'Impressionism,' he taught, 'tended toward de-Nordification because it accepted ugliness as eternal 'reality.' He went on to link the 'exotic distortions' of expressionism with the Jewish blood of its creators, a blatant distortion of fact.

While Dr. Guenther's *Rasse und Stil* marked the discovery of art by the racist, the discovery of race by the artist was heralded by the appearance of Professor Schultze-Naumburg's book *Kunst und Rasse,* published in 1928.[5] The author of this volume was a noted architect, and landscape architect, who up to that time had done some quite valuable work in teaching and practicing the integration of building and landscape. His *Gestaltung der Landschaft,* a three-volume work describing, as he phrased it, 'the changes of the earth's surface through cultivation by humanity,' was a sort of practical application of many of the teachings of William Morris. With encyclopedic thoroughness it dealt with almost every conceivable type of building structure in relation to its surroundings. It was completely free from any political bias.

It seems as though this man must have been struck quite suddenly with racism and its political implications, to a degree that blinded his perception and his reasoning. He became obsessed with the notion of hereditary determinism. In his eyes environment had lost all meaning in the life of the individual and the group. Inherited racial characteristics dictate not only physical appearance, but the political, intellectual, and spiritual structure of personality, society, and nation. The artist cannot help but reproduce his own racial type in his creations; through them he also expresses his own biological desires, again determined by his own race. The reception of his work in the eyes of the beholder is similarly determined by race.

We have to understand the practical demands resulting from Professor Schultze-Naumburg's concepts of racism:

> Hygiene, the doctrine of health, teaches us the measures which man has to adopt to achieve the most favorable conditions of life. When a people adopts such measures it does it not only to safeguard its survival, but to provide for the production of the most perfect individual specimens out of which the community is composed.
>
> Every living being strives with all means in his power to propagate its kind and to manifest its own kind also in art. Art is capable of expressing not alone its physical principle, but it also tries to secure supremacy in every way for its own spiritual law. The battle of 'Weltanschauung' [6] to a large extent is fought out in the field of art.

In sentences such as these we witness the actual forging of art into an aggressive weapon for the dictator on his road to world conquest. It can easily be seen what the function of the artist in the coming Nazi society is going to be: he will become chiefly an illustrator of ethnological specimens, furnishing approved biological models for the eugenic breeding program of future warriors for the party.

Professor Schultze-Naumburg, whom Adolf Hitler must have read quite carefully (even though he later dropped him), is the tailor of a very tight-fitting strait jacket indeed. In his doctrine any deviation from the accepted norm of classical beauty must be interpreted as the product either of an artist of an inferior racial strain or of one mentally or physically diseased. This is the aggressive resumption of the concept of degeneration in art that was first created late in the nineteenth century by Max Nordau.[7] Nordau had thundered against fin de siècle mysticism, against the Pre-Raphaelites, the Symbolists, against Tolstoy, Richard Wagner, against Ibsen, Zola, and Nietzsche. George Bernard Shaw thought he had finished him off once and for all but he was mistaken. The target changed, but the basic concept and the strategy of its application lived on. In Schultze-Naumburg's writings, the concept 'degenerate art' became part of the Nazi creed.

To prove this point, Schultze-Naumburg reproduced side by

side examples of modern painting, sculpture, and graphic art with their supposed human models, all tragically deformed or diseased. The appalling thing is how little relation his exhibits actually have with each other. Obviously, it was not the artist who suffered from deteriorated vision, but the Professor, whose blinding hatred and prejudice imagined such connections (fig. 32).

One of the members of the Schultze-Naumburg circle was a man by the name of Dr. Walter Darré, who later rose to the rank of Minister for Food and Agriculture. 'He was an influential initiator of the National Socialist demand, that art should serve eugenic racial selection and the promotion of the birth rate.' [8] His teachings were elevated to the rank of official party doctrine only two years later, when Alfred Rosenberg's *Myth of the Twentieth Century* [9] first appeared in print. Rosenberg, who hailed from the Baltic states and had started out as a student of architecture, had come to Munich in 1919. He was also engaged in the painting of uninspired and boring little landscapes.[10] Early in the 'twenties he founded his Kampfbund fuer deutsche Kultur (Combat Association for German Culture), which substituted the concepts 'Nordic' and 'Aryan' for 'German.' It is generally known that his *Myth* became the accepted Bible of Nazi ideology; but there our knowledge ends. How many people realize the enormous importance that was assigned to art in this book? Almost one third of the work was devoted to a discussion of the function of art in society. This is a fact that deserves to be thoroughly appreciated, because it furnishes tangible proof of the significance of art in totalitarian thinking.

What Alfred Rosenberg actually had to say about art is relatively unimportant. Like the other Nazi ideologists he is rational up to a point, but logic suddenly breaks down at decisive junctures and he becomes obsessed with his 'myth.' He is fairly well informed on the history of art and is familiar with the trend of thought of his time. Much of his book reads like the tediously drawn out dissertation of a perennial Ph. D. student. Rosenberg knows but does not love the structure of twentieth-century culture. His under-

standing is that of an expert wrecker. He knows every column, every beam and support, the better to tear down the whole edifice, to sweep up the rubble, and to put something else in its place.

A very few excerpts will be sufficient to enable the reader to form his own opinion of the quality of Rosenberg's understanding of art:

> In art there are three organic conditions, upon which in future all genuine aesthetics of Europe must rest, if art is to become a serving member in the life of the awakening Nordic Occident: The Nordic-racist ideal of beauty, the inner dynamic of European art, and hence content as a problem of form, and the recognition of aesthetic will . . .
> The claim of 'general validity' of a verdict of taste can be based only on a racial, folk-determined ideal of beauty and it applies only to those circles, which, consciously or unconsciously, carry in their hearts that same idea of beauty . . . With this fundamental discovery all other still existing 'general' aesthetics have forever lost their justification.

Like other Nazi ideologists Alfred Rosenberg felt obligated to apply his doctrines to the dimension of history. This created constant confusions and embarrassments that would be amusing if they had not had such tragic consequences. According to the orthodox Nazi creed, Greek sculpture, German Gothic, and Italian Renaissance were all emanations of the same Aryan Nordic genius. One is reminded of the old story of the man who had to cross a river with a wolf, a goat, and a head of cabbage, in a boat that would hold only two of them beside himself. His solution of traveling back and forth, leaving behind on either shore only the mutually compatible members of the little group, was exactly the one that Rosenberg had to adopt, in an effort to create at least a semblance of logical consistency.

The real importance of the treatment Rosenberg gave to art in this *Myth of the Twentieth Century* does not lie in his long-winded, pseudo-scientific ramblings. Although edition after edition was published and copies of his work were on the book shelves of every self-respecting Nazi, he was not read very carefully. During the Nuremberg trials Rosenberg was subjected to the humiliating experience of learning that not even the party big-wigs really

knew his stuff.[11] No, it was not the actual content of his work, not his reformulation of the already current ideas of Guenther, Clauss, Schultze-Naumburg, and several other Nazi philosophers that was so important. It was the elevation of these ideas to the rank of official party doctrine, their definitive canonization, that counted. But why all this emphasis on art?

I have said in the last chapter that the dictator recognized art as a particularly useful instrument of social integration. Then, again, we have seen art corrupted into a weapon of aggression on the road to world conquest. And now, in Alfred Rosenberg's hands, it became an important medium for the creation of a new mythology. We may well ask whether these demands are contradictory. It is certain that they have one thing in common: in each case art is deprived of its autonomy and made a means toward an end. The individual objectives each time may differ, but they are related as a succession of interdependent steps with cumulative effect.

In the experience of the present generation total integration of the individual into the texture of collective society inevitably creates such an accumulation of dynamic energy that it needs to be directed toward aggressive expansion, if it is not to devour itself or destroy its leaders. The secret of the dictator's power lies to a large extent in his genius for tapping the hidden reserves of unused personal energies, for mobilizing the latent emotional forces of each individual, for awakening and directing frustrated spiritual desires. From here stems the need for a 'myth,' the replacement of genuine religion by a synthetic creed. Totalitarian integration is impossible without control of spiritual needs, unthinkable without the substitution of a conveniently controllable idol for the image of God in the heart of man. Here, ultimately, lies the greatest usefulness of art to the dictator.

Here, also, is the reason Adolf Hitler's personal obsession with art was not of such paramount importance as it might seem. It was not, as some observers have remarked, the main reason for the Nazi art program. We have just witnessed the genesis of the ideas behind the program and their strong, independent roots. Actually, in their fundamental meaning, these concepts are not

even typically Nazi. They are typically totalitarian. The images that are used, the names of the idols and their supposed ancestry in history have a specific Teutonic coloring in Nazi Germany. But a relatively simple process of substitution of another set of idols and of another imagery is sufficient to demonstrate the fundamental identity of the Nazi art program with that of Soviet Russia, for instance, or of other totalitarian systems.

The narrow coinciding of the future Fuehrer's own ideas about art with those of his prophets is perhaps amazing. But it is an exact reflection of Hitler's successful anticipation of every other element of the Nazi doctrine. It is part of the mystery of his success.

The Masterbuilder Adolf Hitler

Hitler was obsessed by art during his whole life. It is necessary to understand just what kind of role painting and especially architecture played in his personal life. But it is also necessary to understand that this personal preoccupation of his was not the mainspring behind the art program of the Nazis, however much it may have stimulated and influenced its course. The role of art in twentieth-century dictatorship would have been essentially the same without Hitler's special interest — as can easily be seen in other dictatorships. Hitler's unhappy love for art undoubtedly caused more elaborate articulation. It probably sped up certain programs and magnified somewhat the scale of operations. For this reason the biographical facts are important. 'How it happened I myself no longer recall, but one day I made up my mind that I would be a painter, an artist.' [1] There was violent opposition from his father, 'but I put my threat into practice. I thought that if my father once saw what unsatisfactory progress I was making at the "Realschule," he would willy-nilly grant me my dreamed-of happiness . . .' He failed in school and never graduated. After his father's death he lived aimlessly with his mother until at the age of eighteen, around the year 1907, he ran off to Vienna, with a thick bundle of drawings under his arm, to apply for admission to the Academy's painting class. But he was refused for lack of talent. He next tried for admission to the Academy's Architecture School. Architecture, he later declared, was his real love. At the picture

gallery in Vienna he ignored the paintings, fascinated by the pomp-ous building that housed the Hapsburg art treasures, and by the gingerbread splendor of the Opera House, the House of Parlia-ment, the whole obsolete and empty pretense of late-nineteenth-century building. At the Architecture School he was again refused admission because he had not graduated from high school.

These early failures cut him deeply and in a sense his entire career can be seen as a single attempt to prove to himself and to the world that his father and the Academicians were wrong, that he was indeed a superbly talented architect.

He clung to the idea of an artistic career through the bitterness of utter poverty and loneliness, supplementing his meager earnings by shoveling snow, begging, and working on building lots.

He drew and painted — for the shopkeeper on the corner he made a poster in oil, advertising talcum powder; a Santa Claus selling bright-colored candles and Saint Stephen's Church over a mountain of soap . . . He was not able to draw a human form or even a head from nature . . . His products are precise stereotypes, rather geometric in effect, not always with a very happy distribution of light and shade. The human figures sometimes thrown in are a total failure. They stand like tiny stuffed sacks outside the high, solemn palaces.[1]

His preference for architecture asserted itself even here, in these miserable attempts to earn a livelihood. He had a friend, a man by the name of Reinhold Hanisch, alias Fritz Walter. Picture post-cards of the Burgtheater or the Roman ruins in Schoenbrunn Park were turned out by Hitler in quantity for Hanisch to peddle around in taverns and fairs. Later on they quarreled over a some-what more elaborate view of the Vienna Parliament which Hitler thought was worth a hundred Kronen and which Hanisch sold for ten; for this he was condemned to seven days' imprisonment on Hitler's charge of embezzlement.

In the spring of 1913 Hitler moved to Munich. There the self-styled 'building-technician' rented a furnished room. He made cheap little watercolor drawings, hand-painted picture postcards, and worked occasionally as a technical draftsman and house-painter.

In France during the First World War Hitler produced color drawings of buildings hit by artillery shells; these showed a Philistine precision and neatness and an undeniable eye for structure (fig. 1).[2]

The notorious Fritz Wiedemann, who served as Nazi-German Consul-General in San Francisco remembered Private First Class Hitler. When Wiedemann was arrested after World War II on his private estate in Bavaria, he recalled that as Adjutant of an Army Headquarters in France during World War I he needed someone to paint his dining room. Hitler volunteered for the job and, according to Wiedemann, soon after that became his orderly. Seventeen years later Wiedemann visited the Fuehrer at the Reichschancery and reminded him of their earlier encounter. Hitler replied: 'If Germany had not lost the war, I would not have become a politician, but a great architect, such as Michelangelo.'[3]

In Landsberg prison, after the first abortive Ludendorff Putsch, he drew an arch of triumph.[4] This is most revealing. The triumphal arch is the classic symbol of successfully concluded aggression; it is the permanent, concrete expression of rejoicing over the final defeat of the enemy. It is probable that the Landsberg drawing was only one, perhaps an especially early one, in a long series of sketches and drawings made by Hitler during his life. Some of these he may have dashed off hurriedly when discussing his plans with his companions. Others may have been executed more carefully. It is likely that they became more concrete and perhaps more detailed as he gained influence and power. They were a significant part of his planning. After he assumed power, he referred to this architectural planning of his on many occasions. In this connection he always spoke of years of intensive preparation. The actual program, which he initiated so promptly, betrays careful and intensive preparation indeed.

Hitler's tendency to draw when in a defiant and aggressive mood is illustrated by a characteristic episode. On his road to power he had brought suit against a Social-Democratic newspaper editor who had printed something derogative about his financial sources. Hitler sat in court with bent head, before him a scrap of paper on

which he was drawing the heads of his adversary, the latter's lawyer, the presiding judge, the usher, and the journalists present at the hearing. He refused to speak up. When challenged by the defense, he snapped back: 'You will hear my speech when it suits me, and I can assure you right now that you will not enjoy what you will hear!' [5]

On the early posters announcing his appearance at political meetings, he was called 'the Painter Adolf Hitler.' He personally designed the early flags, banners, and emblems of the Nazi party.

Once in office, Hitler delivered passionate harangues on art at the annual party conventions — quite unlike our own political leaders. His first full-dress art lecture was delivered on 5 September 1934, during the sixth annual party convention in Nuremberg. He also used every other opportunity — foundation-stone layings, openings of exhibitions, archaeological congresses, the Olympic games — to appear publicly as the supreme taste maker. Printed together, the Hitler speeches on art would make a good-sized volume. [6]

It would be tedious to the extreme to attempt even the briefest digest of what he said on these occasions. He was a diligent disciple of Guenther and Schultze-Naumburg and of a poet by the name of Dietrich Eckart. This man had followed in the footsteps of Count Gobineau and of Houston Stewart Chaimberlain; he had made himself an eager prophet of the Nordic myth, passionately devoted to the 'protection' of the Aryan principle against 'Judaeo-Christian corruption.' It was he who taught Hitler how to write and to speak. His personal style had a considerable influence on Hitler's way of expressing himself. When he died in 1923, his place as Hitler's intellectual mentor was taken by Eckart's friend Alfred Rosenberg, whom Hitler promptly appointed editor-in-chief of the *Voelkische Beobachter*.

Hitler loved to talk for hours on end. His 'great culture speeches' were accepted as gospel truth by the entire party machine and the official opinion makers. They were reprinted in full, excerpts were circulated, significant sayings were singled out for quotation on art calendars, posters, and pin-ups. What Hitler said and wrote was preposterously bombastic, full of half-truths and contradictions, as

trivial and pedestrian as his own drawings. Also, in these speeches he delivered himself of some of the most shameful boasting perpetrated in the twentieth century.

Again and again he expressed his preference for architecture as the mother of all other arts and as the favored vehicle for his own creativity. His behavior as an untutored youth in the Viennese picture gallery, barely conscious of the paintings but fascinated by the building, remained exactly the same after he became Chancellor of the Reich. Early in 1934 Hitler visited the Kronprinzen-Palais in Berlin to see a show of paintings by an unimportant protegé of his friend Rudolf Hess.

Once there, the visitor went on, beheld the examples of expressionist art, but kept his mouth shut, asking no questions, satisfied with derogatory gestures. He glanced out of the windows and remarked on the neighboring buildings, the Zeughaus, the Wache, the Staatsoper and not until he found some designs by [the Architect] Schinkel, did he become extremely lively and now he was the one to instruct his silent retinue.[7]

As the Masterbuilder, Hitler saw himself as the incarnation of the idea of the Nazi state, a concentration of all power in his person, himself the mainspring of all energy and activity. The physical planning and construction of all buildings, of the cities, of the entire state, with him as the Masterbuilder was a completely natural concept to him. From his person was to flow all constructive energy, shaping temples with himself as the god, buildings that were to crown cities each of which would be oriented along a central axis. Over broad avenues of approach the masses would assemble to worship. The cities were to be connected with a network of superhighways, main arteries which with their ramifications and outlets would embrace every town and village, where every house, every well, every grape arbor would become a symbol of Nazi strength.

Like all his other notions this one, too, was obsequiously accepted and enlarged upon by his followers. Goebbels liked to refer to him publicly as the Masterbuilder of the Reich. A large painting of Hitler as sculptor-architect (but incongruously wearing his high boots and uniform, gloves in his hand, in the pose of a victorious general) was exhibited at the official Munich art exhibition of

1939. Handwritten dedications in books that were presented to him by doting admirers called him Artist, Architect, Masterbuilder.

The books in Hitler's personal library, today in the care of the Library of Congress,[8] give us important clues to the nature and extent of his art interests. This collection is at least as eloquent in what it lacks as in what it contains. Among the sixteen art books in this library there are only three that do not deal primarily or exclusively with architecture or city planning and housing, and of these three the one by Professor Schultze-Naumburg is the work of a professional architect. But none of these books, with the one exception of the work by Ludwig Roselius, has the remotest connection with what we call 'modern' architecture. Hitler hated modern architecture and he persecuted the modern architect.

The list tells us also what he did believe in. Twelve of the sixteen books deal with architecture and building in Germany or by Germans. The only exception to this are four volumes concerned with some aspect of classical or Renaissance architecture. But then again, three of these four books play up the mutual interaction of classical antiquity and Germanic culture. The only book in this collection devoted to the work of a foreign architect, Hans Sedlmayr's treatise on Borromini, is the work of an art historian with strong Nazi leanings, as we shall see later on.

Wille Hermann's book on ancient Germanic houses of worship is outright trash, typical of the deliberate falsification of European archaeology and art history that was practiced, especially by the SS. The volume on the history of Berlin, issued by the Lord Mayor to celebrate the capital's 700th anniversary, dealt with a topic especially dear to the Fuehrer's heart. His interest in the architectural history of Berlin was well known among the higher ranks of the party and it caused the preparation of a preposterous gift for Hitler's fiftieth birthday. This exorbitant tribute, a blatant dictatorial corruption of the printing press, is worth discussing in greater detail later on.

The three volumes in the Hitler library on current domestic architecture (the books issued by Schwarz, Feiler, and Bitz) all emphasize the practical, economical, and technical aspects of build-

ing and they all treat primarily of low-cost housing. Hitler's practical bent is also documented by the fact that he kept in his library only a single volume from a handbook of several volumes, the one that dealt with architectural design and composition.

All in all, these books reflect Hitler's interest and bias with remarkable accuracy. He is obsessed by the national element in architecture. He wants to prove Germanic superiority by linking it up with the universally recognized culture of classical antiquity. He has no place for modern art or for the contributions of any other people anywhere in the world. Also he is interested in the practical side of building and in low-cost housing.

One book in his library has a very special significance. It is a little volume from the well-known Insel-Verlag series, a short story by Josef Ponten, entitled 'The Master,' first published in 1919.[9] This book, inscribed by an unidentified donor on 28 August 1934 'To the great Masterbuilder of the "German Cathedral," Adolf Hitler,' shows more signs of intensive reading than any other book I have seen in the Hitler collection. Frequent underscorings and marginal accents permit an unusual insight into the Fuehrer's mental feeding process.

And what is this story about? It is the tragic final chapter in the life of an incompetent latter-day German architect who is in charge of one of the great historic cathedrals. He discovers a serious structural weakness that will soon cause the collapse of the eastern part of the building, but he is unable to find a means of averting the catastrophe. He decides to let the disaster run its course, but to save himself and his immediate family, his job and reputation. He therefore conceals his certain knowledge from everyone, but he is found out by his alienated wife. He introduces to his family as a prospective son-in-law the new apprentice, blond, blue-eyed Gottlieb, a boy of remarkable talent and ability, who has found the real source of the danger. The wife Berta discovers that her husband plans to use the intuitive knowledge of this youngster, with whom she falls in love, as the instrument of saving the cathedral and his own position. The boy, however, refuses to communicate his knowledge to his master. Even the innocent wiles of

the daughter, with whom he in turn falls in love, are unable to sway him from his intention of exposing and dislodging the master. The master then murders him by causing the collapse of a part of the scaffolding, but collapses himself when confronted by his wife, at whose behest he commits suicide by staging another accident in the scaffolding of the cathedral.

Here are some of the passages that Hitler marked with his pencil:

With diligence alone [Gottlieb replies to the master, who has enlarged upon the value of diligent application] no musician has ever written three notes of the kind which grip the kidneys, and no architect has designed the arch of a window which makes the heart jump with its fine and bold lines. Everything that is good is intuition. Diligence belongs to man, but intuition comes from God.

'Art is man's way of re-creating the world after God,' says Gottlieb to Frau Berta. 'I had the intuition,' confesses Gottlieb. On one page Gottlieb raves against the stupidity and emptiness of incompetent officialdom, which will appropriate, exploit, and steal the ideas of the talented underprivileged and will incorporate them into their own plans and pass them along as their own invention. There is about a page of this and in the margin is a succession of ever more emphatic strokes, a faithful seismograph of Hitler's mounting excitement. On the very next page a veritable battery of strokes surrounds the following outbreak of Gottlieb (fig. 2):

To steal from someone's brain is worse than stealing his money. For money one can always earn again, but an artistic idea, that is a gift! And why does this happen to me? Only because I was unable to attend the famous school, and instead had to create everything from within myself. Because my parents were so unscrupulous as to leave me as an orphan in the world and to steal away prematurely from this stage of fools and criminals. Because I was unable to get the official stamp of approval, the title of architect.

A little farther on Gottlieb repeats himself and Hitler again underscores his words: '. . . because I am not academic, do not have the stamp of approval.'

It is almost superfluous to point out the significance of Hitler's underscorings. He identifies himself with Gottlieb, the under-

privileged genius whose lowly origin has denied him education and the approval of society, but whose artistic intuition has revealed to him the means of saving the cathedral. The cathedral, in Josef Ponten's story, is of course the symbol of the German Reich, undermined by the lost war and threatened from the East through the November revolution of 1918. It is no mere accident that this story was first published in 1919, no more than a few months after the debacle of the old Empire.

This, however, is not all the evidence to be gathered from the little volume in the Fuehrer's personal library. He had identified himself with Gottlieb, taken sides with him, recognized in him a symbol of his own destiny as he saw it. Nevertheless, no one who reads the story today would have the slightest difficulty in discovering that not Gottlieb but his antagonist, the Masterbuilder himself, resembles Hitler in many significant ways. In other words, we see Hitler running away from himself, unwilling and unable to recognize his own image, to look himself in the eye.

Unscrupulous behavior in the face of impending doom, the desire to save his own skin at the expense of the community, is one important parallel between Hitler and the Masterbuilder in the story. Hitler sits in the bombproof shelter of the Chancery while all Germany is in flames. Like the Masterbuilder Hitler eliminates dangerous rivals by murder. Suicide is the final solution of both Hitler's dilemma and the Masterbuilder's. There are also striking resemblances in attitudes and opinions. 'So you were not in France, Master, if I may inquire?' Gottlieb asks. 'No, I am a German. I do not need the Frenchmen.' 'You mean to say that you have not seen the French Cathedrals?' 'No. Did you not hear me?' 'But how strange. I do not understand this.' 'I am a German, as I have already stated.'

The Masterbuilder's pronouncements on the qualifications of an artist are so close to Hitler's own utterances that one is tempted to consider them an important influence, perhaps a direct source. They are the typical rationalizations of the mediocre artist, of the man without real talent. 'Diligence is the moral element in the world, and wise men have said that genius is diligence.' These are

the words of the Masterbuilder in the story. And here are excerpts
from Hitler's speech at the opening, on 10 December 1938, of the
Second Official Exhibit of Architecture and Arts and Crafts:

> The people shall see in the development of these works what immense
> diligence is necessary for the designing of such mighty buildings . . .
> What you see here is not the result of one day's labor, but of years of
> immense diligence, a working through of the problem to the last . . .
> Today I wish to thank especially those artists, even though their indi-
> vidual names cannot be mentioned, who have devoted themselves with
> infinite diligence and with unparalleled devotion to these tasks . . .

These remarks are not uttered in close proximity to each other;
they are scattered throughout his speech, the true thread of its con-
tinuity, and are very plainly the projection of his own limitations.

The other important idea conveyed to the people in his speech,
which, needless to say was widely reprinted and quoted, is as clear
an articulation of the idea of dictatorial architecture as one could
hope to find anywhere.

> These works are not exhibited in order first to draw conclusions about
> the possibility of their execution from the judgment by the public, but
> to show to the people, namely to the artists as well as to the patrons and
> the broad masses, those works which, destined to be built, are already
> being executed or are completed.

Criticism, he emphasizes, is useless and dangerous. It has driven
many great artists to bitterness, even to death. If the people appre-
ciate the diligence and conviction with which these buildings have
been executed 'they will stand in worship and awe before these
monumental buildings, and they will also be trained in accordance
with education for our own artistic conceptions.'

He also underlined his own share. 'In the works shown in this
exhibition lies the labor of many, many years — planning which
in part, as far as my own person is concerned, goes back for decades.'
He said this in December 1938 — which would indicate that his
own planning started at least as early as the end of 1918. He wanted
to reserve for himself complete control of everything. There were
to be no deviations from his example and no rivals were to be
tolerated. Only very little individualism was permitted. 'Artists

must get to know each other's works already in the growing stage if one wants to give an epoch the impress of a uniform style.' It was his boundless egotism and his vanity which caused him again and again to insist on buildings of 'such a uniform character that in coming centuries one can easily recognize it as a work of the German people and of this our epoch.'

Those who commission buildings, too, must be 'co-ordinated.' He declares that he expects to reject many of the plans that will be submitted and he openly admits what excuse he will use to turn down what does not suit him. 'Do it over again! This is not thought through enough! Think it through more!' he will say.

Architecture served Hitler in at least three important functions. First, it was a vehicle of self-assertion. Over and over again it permitted him to prove to himself and to the world at large that those who had rejected him early in youth were wrong, that he really was a genius. Second, he could take vengeance on the society that refused him. Orthodox, classicist architecture, the kind of building he consistently demanded, became in his hands a remarkably effective weapon of destruction.[10] He appropriated its seemingly unassailable authority, corrupted its traditional dignity and nobility into a terrific weapon. With it he fiercely stamped out every genuinely contemporary and progressive expression of his own generation in his own time and place. He killed the natural cultural life of twentieth-century Germany by brutally forcing back the hands on the clock of evolution. This often-used image is a perfectly correct description of his operations. Thirdly, and perhaps most important to him, architecture served as the most effective, because the most public and most permanent, instrument of self-glorification.[11]

In his speech, to refer back for the last time to this eloquent document, Hitler criticizes the Protestant Cathedral in Berlin because of its limited seating capacity in a city that is inhabited by three and a half million Protestants and in the capital of a country with about forty million Protestants. 'The capacity of this cathedral,' he explains, 'is 2450 seats, which are numbered and in which thus the most prominent families of the Reich were supposed to fit

in.' In the same vein he derides the building of a theater with 1200 seats in a city of 150,000 inhabitants. Such criticism is indeed revealing. Only one type of public assembly building makes sense to Hitler. What he wants, of course, is a temple that will draw the entire population of a city into participation in the official celebrations of his party. He wants an arena to which the whole nation can send masses of representatives to listen to his speeches and to worship him.

This is exactly what he had planned and what he proceeded to bring about.

Hitler worked closely with his architects. He liked to be photographed in their company, seriously discussing blueprints or bending knowingly over scale models. Such pictures, carefully posed for public consumption, were frequently taken by Heinrich Hoffmann [12] and printed in newspapers and magazines (fig. 3).

An off-the-record, intimate close-up of Hitler in his role of Masterbuilder came to me by a lucky chance. There are in my possession photostats of the secret notes taken by two members of the staff of Albert Speer, Hitler's favorite architect after the death of Paul Ludwig Troost. These two men, Professor Walter Brugmann and Engineer Willi Schelkes, accompanied the Fuehrer one afternoon on a tour of inspection of models and plans prepared by Speer in connection with his remodeling of Berlin.

The inspection, on 15 March 1941, started at the Chancery in Berlin, in a special hall that was devoted to the display and study of architectural models. Hitler walked from exhibit to exhibit, alternately approving, making suggestions here and criticising there, sometimes delighted, sometimes indifferent. He must have been completely familiar with the general lay-out and the all-over planning of the Berlin of the future, because he was observing what progress was being made, focusing his attention on minute details. He voiced apprehension lest the architectural frame around the doors of a hall was too heavy and might cause the room to look too small. The towers of the Stadium building must be equipped with anti-aircraft guns.

About four o'clock in the afternoon Hitler left the Chancery

and went over to Speer's headquarters, the 'Generalbauinspektion' on Pariser Platz, adjoining the Brandenburg Gate. He was accompanied by Speer, Professor Brugmann, the younger Bormann, probably the son of the administrative head of the Nazi party, and Schelkes. Later on Dr. Brandt, Hitler's personal physician, joined the group.

The Fuehrer liked Speer's severely regimented plans for Peenemuende, where the V-bombs were to be put into mass production. Schelkes observed and recorded his reactions closely. Hitler specially liked the models of the buildings along the projected North-South axis in Berlin and the 'Runder Platz.' 'One could feel how he got warmed up.' Speer remarked that these plans were ready to be executed. Hitler heartily agreed. In obvious elation he turned to Speer and exclaimed, 'Now at last all ought to be convinced. In view of such work, can there still be faultfinders who do not agree with the remodeling of Berlin?' Speer allowed that there were none.

As he went on, Hitler expressed regret that all these magnificent ideas could not be executed at once, because that nitwit ('dieser Depp') Churchill was taking up one third of his time. He showed considerable concern over the possibility of aerial attacks. He discussed the construction of extra-heavy ceilings for top stories of certain important buildings and he suggested the addition of anti-aircraft installations wherever possible. 'Flak is the decoration of our time,' he announced sententiously.

He looked at the model of a soldiers' monument by Professor Kreis and liked the idea of putting up some cannon there. 'Berlin should be full of such military mementoes; that's part of its character.'

He spent over three hours in Speer's office and then drove on to the Reichstag, the old Wilhelminian Parliament building, which stood gutted by the conflagration Goebbels had secretly staged there on 27 February 1933. There, too, had been installed a special hall with large architectural models. He walked slowly around the models. Beaming with satisfaction and pride he slapped Speer on the shoulder, 'Magnificent!' He sat down to examine the models at eye level. 'We must devote ourselves with complete fanaticism to

the solution of this piazza . . . This must become the most mag-
nificent thing in the whole of the world!'

Speer felt that the old Reichstag building, faithfully reproduced
in the model, was a disturbing element. Could not the restoration
of its interior be postponed? Would the building not form an ob-
struction at the end of mass meetings when huge numbers of people
would be leaving the piazza at once? Speer gave a little laugh as he
argued that the Reichstag should be torn down. The Fuehrer an-
swered playfully in his native Austrian dialect that he was not
convinced ("Sell glaub i net'). He took another look: 'One day
this house will be venerable because Nazis have fought there. I,
too, have fought in it. If I tear it down, one could say of me that I
was petty. My successor perhaps can tear it down, not me.' He
went on, with mounting elation. He slapped his thigh — the same
motion that started him off on his notorious jig before the news-
reel camera at Compiègne when word of the surrender of France
was brought to him in 1940. 'We shall win the war,' he exclaimed,
'but we shall secure victory through our buildings, which will
make Germany the center of Europe.' He said this while gazing at
the model of the crossing of the East-West and the North-South
axis in the center of the Berlin of the future, itself the center of
the Reich, which in turn was to become the center of Europe.
'These buildings,' he went on, 'should convince the world that
Europe does not consist of a hodgepodge of ridiculous little states!'

The Fuehrer approached the models from another angle. He
again pointed out locations for anti-aircraft guns. Once again his
eye fell on the old Reichstag building. Speer asked innocently if
he should not lift the model out of the set. 'You seducer, you!' Hitler
coyly replied. 'How high is that hall there?' he asked, pointing to
the dome of the new assembly building. 'Over three hundred meters
[approximately 900 feet],' replied Speer, who went on: 'It's a mat-
ter of honor that it will not be less.' Hitler laughed and replied:
'That's the proper spirit. That's the way to think. Three hundred
meters, that's the height of the Obersalzberg above Berchtesgaden.
Put anti-aircraft guns on the towers' (fig. 5).

Several times he stressed the height of the projected buildings.

Nothing must detract from their massive impressiveness. 'Before they [the foreign diplomats] come to dance attendance on me, they shall sink to their knees first!'

Comment is hardly necessary. All this is too eloquent to need interpretation, except perhaps for Hitler's preoccupation with anti-aircraft emplacements. 'Flak is the decoration of our times' is a neat piece of rationalization. He is still convinced of victory, his conscious mind is still preoccupied with building as an expression of triumph. His increasing fear of destruction from the air still takes the form of positive planning of defense installations. At this time, in the spring of 1941, the destructive urge still lies dormant in his subconscious. It will not rise to the surface until he realizes and has to accept as a fact his own inescapable doom.

Toward the end of February 1944, Dr. Frank was summoned to Hitler's Eastern headquarters. During the interview Hitler got up, walked to the window, pressed his forehead to the pane, and gave a deep sigh: 'Ah, to build! To be able to build! My God, to be able to build again!'

Nothing illuminates the neurotic nature of this building urge of Hitler's so sharply as the simple reminder of how much this same man destroyed. Total architecture and total war, concentrated construction and utter destruction, lived side by side in Hitler's brain, where they were closely linked. What he built up with the right hand he tore down with the left. While he planned one, he prepared the other. It is impossible today to read what Hitler said and wrote about architecture and city planning, to examine the photographs from the seemingly endless reservoir of blueprints and models, and to behold both the Nazi buildings in ruins and those still standing today, without the constant realization that the same man caused both their creation and their ruin. His stubborn refusal to admit defeat when there was no possible chance of victory left for him caused the destruction of many of Germany's historic treasures. The U.S. strategic bombing survey has established the fact that nearly 80 per cent of heavy bomber damage to German cities was inflicted after D-Day, that is to say within the last year of a war that lasted nearly six years!

How intimately the constructive and destructive drives were intermingled in Hitler's personality can also be seen in his art speeches. In one of his official talks he discussed the so-called 'degenerate' artists.

These fellows claim that they see nature that way. We should examine their eyesight. If they are really afflicted with defective vision, we can only be sorry for these poor creatures. We must make sure that they do not pass on this defect to their children. But if they only simulate this distortion, then it becomes a matter for the Ministry of the Interior, and steps must be taken to instigate prosecution against such individuals.

The hopeless limitation of Hitler's understanding of the visual process can best be realized if contrasted with an 'Introductory Comment' written by John Dos Passos for a portfolio of George Grosz drawings entitled *Interregnum:* [13]

Your two eyes are an accurate stereoscopic camera, sure enough, but the process by which the upsidedown image on the retina takes effect on the brain entails a certain amount of unconscious selection. What you see depends to a great extent on subjective distortion and elimination that determines the varied impacts on the nervous system of speed of line, emotions of color, touchvalues of form. Seeing is a process of imagination.

On the shelves of Hitler's own library a pseudo-scientific treatise on the nature of vision could be found not far away from a treatise on sterilization. There is also one *How To Recognize a Neurosis.* Hitler cut open only the pages of the first half of the first chapter.

He remembered his artistic ambitions when he drew up his last will. In the comparatively brief document, now in the National Archives in Washington, D.C., the bequest of his collection of paintings to the Supermuseum of Germanic art, his pet project for his native Linz on the Danube, occupies a conspicuous place:

The paintings in the collections which I have bought during the years have never been acquired for private purposes, but always exclusively for the creation of an art gallery in my native town of Linz a. d. Donau.
It is my heartfelt desire that this legacy shall be fulfilled.

How characteristic Adolf Hitler was of the totalitarian artist-statesman can be seen with particular clarity when he is compared with a great democratic leader, such as his American antagonist, Franklin Delano Roosevelt. It is perhaps no mere coincidence that Roosevelt loved trees, planted them, and encouraged the use of living green whenever possible, while Hitler hated trees, agreed to the cutting down of the historic Linden trees in the heart of Berlin, demanded rigid plains of solid stone for the Koenigsplatz in Munich. More important is the contrast between Hitler's deliberate and highly systematic planning methods and those of our late President:

In the use of his faculties [writes Frances Perkins] Roosevelt had almost the quality of a creative artist. One would say that it is the quality of the modern artist as distinct from the classical artist. The name for it in the graphic arts is automatism. It describes an artist who begins his picture without a clear idea of what he intends to paint or how it shall be laid out upon the canvas, but begins anyhow, and then, as he paints, his plan evolves out of the material he is painting. So Roosevelt worked with the materials and problems at hand. As he worked one phase, the next evolved.[14]

Creative improvization was not Adolf Hitler's method, neither in the conduct of war nor as Masterbuilder of the New Europe. What he did was always part of a carefully laid plan, which was carried out step by step with rigid precision, according to a well-thought-out timetable.

The Organization of Total Control

T HE INTERESTING THING about the way in which the art doc-
trines of the Nazis were put into action is the absolute de-
termination and the unrelenting attention to the minutest details
with which the program was established and carried out. What the
prophets of Nazi ideology had proclaimed Hitler fulfilled. He
turned the most reckless phantasies, the wildest flights of his am-
bitions, his most violent hatred and aggressiveness into hard reality,
made them the law of the land. The organization created by Hitler
and the men around him is a perfect model of total absorption of
the entire art life of a great country into the fabric of the state. It
is an excellent demonstration of what life in a totalitarian society
really means.

It will be remembered that I compared the Nazi art doctrines
to a poisonous concoction injected into the organism of German art
life, where it produced prompt and significant reactions. It caused
the near-paralysis of certain parts of this organism and it stimulated
a hectic growth process in others. The 'negative' and the 'positive'
elements of this program were closely interrelated and both were
developed with absolute precision and thoroughness.

The program was not initiated abruptly and was not at once
carried out to the fullest extent. Such a procedure would have con-
tradicted Hitler's innate sense of timing, his deep-seated belief in
following the line of least resistance, his instinctive tendency to
tackle one problem at a time whenever possible.

Three stages are clearly discernible in the articulation and execution of the Nazi art program. The first of these stages coincides with Hitler's rise to power and it ends in January 1933, when he became Chancellor of the Reich. This was a period of ideological combat and of consolidation, the forging together of separate energies and drives, their unification into a single direction and a single purpose. It was during this period also that the crystallization of the doctrines into an officially codified creed took place.

The second period ran from January 1933 to midsummer 1937. During these first four years of the regime the laws were written and passed, the organizational machinery was set up, tested, and improved upon. It was the beginning of important public works, the initial phase in the absorption of all creative energies for the purposes of the state. It was also a period of experimentation, when frontiers and borderlines were defined and some of the initial errors corrected.

The third stage began in midsummer 1937 with a decisive tightening of the reins, a heightening of the speed of every activity. It was a time dominated by the desire to achieve as much as possible before the beginning of the war, to effect compact and total consolidation. This period led into the war years without a noticeable change of direction and without a sudden change of speed. The total-war effort gradually absorbed more and more of the energies of the country, in every phase of its life. But it is significant that it never wholly wiped out the cultural program of the Nazis. Their operations in the arts were never completely interrupted, and some very important projects were initiated in the midst of the war and pursued to nearly its very last days.

IDEOLOGICAL COMBAT

It is my belief that nothing helped Hitler so much on his way to power as the fact that he was always underestimated by his future adversaries, those on the next higher level of hostile territory that he had to conquer. The prophets of racism and of racist art sounded to most of us in the Weimar Republic like lonely fanatics, condemned to everlasting frustration. Frustration was indeed the

powerful stimulant that set them going, but they felt quickly the response from entire classes of a seriously uprooted society. Nothing was so harmful as the shrugging off of these peculiar manifestations as 'the harmless lunatic fringe.' This is a lesson well worth remembering.

So many of us, young and old, who believed in the reality and in the future of a genuine democratic republic in this Germany after the First World War missed one important fact: these mad prophets were gathering around them significant audiences of ever-mounting size. One also could not foresee then to what extent certain types of scholarly and fundamentally non-political criticism of modern art would contribute to the political capital of the Nazis.

Professor Worringer's rather shortsighted and erroneous proclamation of the catastrophic end of expressionism, discussed in a previous chapter, is an example. Another more important instance is the case of the art historian Otto Grautoff. The very title of the book he published soon after the end of World War I, *Demolition and Construction of Form in the Plastic Arts*,[1] is suggestive of his pessimistic attitude toward the art of his own time. In his next book, which appeared two years later,[2] he went further:

The disintegration of artistic form in painting, the dissolution of the pictorial form, the arbitrary, fortuitous and unorganic articulation of aboriginal utterances on canvas, panel, or paper cannot be called an artistic aim . . . This is the ultimate ruin of an art form, the gradual disintegration of which from Rembrandt and Goya to the futurist painters [he decries].

He attacked the portrayal of the Demonic in the works of the expressionists Heckel, Beckmann, Kirchner, Kubin, and of Meidner, whose simple religious faith was beyond doubt, as we have seen (pages 24–5). Yet, said Grautoff, 'they saw others with an evil eye, in every soul the diabolic. They emphasized it, underlined it, described human beings in their blackest hour . . .' Obviously, Grautoff was unable to distinguish between worship and exorcism of the evil principle.

Suddenly he speaks of the awakening of the 'Nordic,' to which

he devotes a whole chapter. In another chapter, on 'Art and the New State,' he praises the dictatorship of one man or of a small minority. He believes that a great architect like Albert Messel should have been made architectural dictator to enable him to impress his style on a metropolis. The architect Peter Behrens, Grautoff feels, failed because he never had a street façade to work with, or a great piazza to plan.

Grautoff also confounds expressionism and political radicalism in a mistaken identification. He cites an obvious exaggeration of Eckardt von Sydow: 'Whoever fights passionately for expressionistic art must logically profess his allegiance to the Socialist Republic, to the revolutionary state' — a verdict in which the Soviet commissars would hardly concurr.

Grautoff also believes in the paramount importance of architecture and in the special emphasis on the arts most closely connected with it, namely architectural sculpture, monumental painting, portraiture, mosaics, and gobelins. Finally, he declares that the artists can do useful work only when 'directed and carried by the spirit of their time and inebriated by the blood of their people.'

It is perfectly true that every one of the points just mentioned can be called typically totalitarian. Yet I believe it is also true that Professor Grautoff would have been indignantly surprised if at any time he had been identified with the Nazis.

Paul Ortwin Rave in his vivid account of the struggle of those years [3] posed some important questions:

> How could it happen, so we must ask ourselves, that the very few who did not like a certain kind of art fought so passionately against this art and that when they themselves came to power and sat on the high horse, they sought completely to suppress and to eradicate it? And that they succeeded in bringing about this reversal?

They succeeded through their ability to sense the emotional void in the feelings of the masses, to anticipate and direct their reactions. They were masters at the art of manufacturing stereotyped concepts of what art was and was not supposed to be and at substituting these concepts for any genuine personal experience.

Professor Rave reminds us of the existence of certain organizations that accepted and promoted the teachings of the fanatics. The emphasis on the 'Nordic' element in German culture was propagated by the so-called 'Werdandi-Bund' as early as 1900. Its tone was still moderate enough to attract to its membership such renowned authorities as the scholarly Henry von Thode. After the First World War there was increasing bitterness and aggressiveness. Modern art soon became a favorite target. The famous international exhibition of contemporary art at Dresden in 1926 and the important 1928 exhibition at Duesseldorf were denounced in a letter to President Hindenburg as 'inferior and degrading, insults to the heroic German army and its leader' by no less than seven different super-patriotic associations. As a consolidated move against the progressive tendencies in German art life a group of about a hundred nationalistic newspapers subscribed to an anti-Semitic art-news service, which was known originally as the *Bartels-Bund-Korrespondenz* and subsequently as the *Deutsche Kunst-Korrespondenz.*

Typical of the growing resentment of modern art in segments of the German public that were then in no way connected with National Socialism was a society in Dresden called the 'Deutsche Kunstgesellschaft.' Under the literary guidance of a woman by the name of Bettina Feistel-Rohmeder,[4] the membership of this society, made up of pan-Germanic, aggressively patriotic, and militaristic circles, was a typical cross-section of groups hostile to modern art and reactionary political groups as they exist in many societies. It would not be too difficult to name the corresponding groups in contemporary America, and to quote from their denunciations of modern art in the years after the end of World War II.

In 1929 the National Gallery in Berlin managed to raise substantial funds for the acquisition of a series of magnificent paintings by Vincent van Gogh. They were intended for the museum's representative department of modern art in the Kronprinzen-Palais. 'Flaming protest' was lodged against the purchase by the Munich chapter of the Reichsverband bildender Kuenstler (Federal Association of Artists), which demanded that all available

funds be used 'to save German artists from misery.' This protest, too, has a familiar ring to it.

The dismissal of a museum director on the grounds of his support of progressive, modern artists occurred in Germany as early as 1 April 1930, when Hildebrand Gurlitt, the director of the museum in Zwickau, lost his post. The support of his case by some fifty German museum directors, who declared it their particular task to encourage contemporary German art, soon proved fatal to about half their number.

Professor Schultze-Naumburg found support in one of the near-Nazi governments of a German territory long before January 1933. He was able to persuade Frick, the notorious Nazi leader who headed the government of Thuringia, to eliminate the works of Barlach, Klee, and Feininger from an exhibition in Weimar and to paint out the frescoes of Oskar Schlemmer on the premises of the former Bauhaus in Weimar, which had since moved to Dessau.

There were attacks of increasing violence and viciousness against the progressive, internationally minded art policies of the German Foreign Office. The art affairs of this office were in the capable hands of the farsighted and cultured Dr. Johannes Sievers. His activities contributed greatly to the rising respect for German art on the international scene. Under his sponsorship there was active participation in many foreign exhibitions in Europe and America. These international exhibitions became the targets for constant attacks from nationalistic and National Socialist anti-Semitic newspapers.

Counterattacks were of no avail. Paul Renner, the famous creator of functional typography in Germany and designer of the sans-serif 'Futura' type, wrote a courageous book entitled *Kulturbolschewismus?* [5] He tried in vain to expose the anti-Semitic denunciations of modern art for the absurdities and falsifications of fact they were. He showed the groundlessness of the political attacks against modern architecture. He defended individualism against collectivism, humanism against materialism. It was too late. The defense had lost its case long before it had begun to marshal its forces.

EXPERIMENTATION AND CO-ORDINATION

The art policies initiated promptly after Hitler became Chancellor of the German Reich on 30 January 1933 were the inevitable consequence of the ideological demands made by him on his way to power. They were designed as an absolutely airtight control mechanism that would leave no loopholes anywhere. The focal point of the system was the Reichskulturkammer (Reichs Chamber of Culture), established in 1933 under the wing of Dr. Joseph Goebbels' Ministry of Propaganda and Popular Enlightenment, with Staatsrat Hans Hinkel at the helm.[6]

Along with the press, radio, theater, motion pictures, music, and literature the arts were organized into a Kunstkammer (Chamber of Art). Not only were there divisions for painting, sculpture, and architecture, but interior decoration, landscape gardening, the arts and crafts, the graphic arts, art and antique dealers, art publishers, and every sort of professional organization were provided for.[7] There was a slot for everybody and everybody had to belong if he wanted to exhibit, buy materials, join a professional group, receive commissions — in short if he wanted to go on making a living. The so-called racially inferior and the politically unreliable were excluded. Some of them were sent the dreaded 'Arbeitsverbot,' explicit orders to stop working altogether at their art, even in the privacy of their own homes.

It is not surprising that the membership of the Art Chamber grew rapidly and reached considerable numbers. By the end of 1936 it included 15,000 architects, together with 730 interior decorators and 500 landscape architects; 14,300 painters, 2900 sculptors, 2300 arts-and-crafts workers, 4200 graphic artists, 1260 designers, 2600 art publishers and art dealers — a total of 42,000 men and women. Regular annual conventions of the Art Chamber offered opportunity for reviewing progress and releasing favorable publicity.

The Art Chamber was a federal bureau with headquarters in Berlin and with regional offices in every one of the 32 major political divisions of the Reich. The most active officer of the organiza-

tion was its president, the ambitious busybody, Professor Adolf Ziegler in Munich, who succeeded the first president, Professor Eugen Hoenig, on 1 December 1936. He was assisted by a business manager, a tyrannic, Philistine bureaucrat named Walter Hoffmann, operating from Berlin.

One of the most far-reaching authorities vested in the Chamber of Art was its control of exhibitions. No art show could be held without official approval. Permission was granted only upon submission of an application, on which the nature of the event had to be described, with proof of the racial and political acceptability of the artists involved. In cases of evasion the police were authorized to intervene.

Characteristic of the way in which the activities of the Art Chamber were interlocked with those of other major agencies was a special department for the art activities of the Kraft durch Freude (Strength through Joy) organization.[8] This huge welfare and recreation agency for the working people of Nazi Germany embarked upon what was undoubtedly the largest, best-organized, and at the same time most strictly regimented art-appreciation and art-education program ever launched. The creation of an aesthetically enjoyable atmosphere in the factories and offices throughout the land was the special responsibility of the Schoenheit der Arbeit (Beauty of Labor) Division of the Deutsche Arbeitsfront. This German Labor Front was the vast concern which had been superimposed upon and had devoured all labor unions. It had its own building division and a special bureau, Das Deutsche Handwerk (German Crafts).

Alfred Rosenberg's empire found its most elaborate expression in his appointment, early in 1934, to the 'Custodianship of the Entire Intellectual and Spiritual Training and Education of the Party and of All Co-ordinated Associations' (Ueberwachung der gesamten geistigen und weltanschaulichen Schulung und Erziehung der Partei und aller gleichgeschalteten Verbaende). His organization had its own fine-arts division, the Hauptstelle Bildende Kunst im Amt Rosenberg. One of Rosenberg's most important

functions was the editorship of the lavishly illustrated official art magazine *Die Kunst im Dritten Reich,* later restyled as *Die Kunst im Deutschen Reich.*[9]

The extent to which Heinrich Himmler and his SS pursued cultural ambitions is not generally known. This is due partly to the deliberate camouflage of the gigantic Ahnenerbe (Ancestors' Heritage) Foundation of the SS, with which a chapter of this book will be concerned.

It would be possible to go on and name other major and minor organizations in Nazi Germany that were concerned with one aspect or another of the art life of the country. The story of the shameless art lootings, both official and private, of the Nazi leaders and organizations, told so well elsewhere, is not dealt with in these pages. Even if we leave out the special agencies active in the wholesale pillaging of the occupied countries and in the confiscation of the collections of Jewish and other owners considered enemies of the state, a detailed listing of all organizations concerned with art would include nearly every office of party and state.

Huge applause greeted Hitler's statement, made at the 1937 party convention, that 95 per cent of the national treasure of a people consisted of its cultural achievements and only 5 per cent of 'the so-called material assets.' What Hitler was also thinking, but not saying, was that the creative potential of a people was of crucial ideological importance and therefore worthy of the most careful supervision and guidance.

One aspect of the art policies of National Socialist Germany that remains to be explored is their application in the occupied territories. From what I have been able to observe, the procedures in Holland and in Norway would be of particular interest.[10] In Germany itself, it was easier to create a set of entirely new control organs than it was to absorb some of the traditional government agencies concerned with art. The most important of these old agencies was the Ministry of Culture, which had administrative responsibility for the teaching of art in universities, academies, and schools and for state-owned museums. During the early years of the Nazi regime the Ministry of Culture tried to steer a somewhat moderate

course and to exercise a restraining influence on the more violent manifestations of cultural barbarism. There were certain people on the staff of the Ministry who were supporters of what might be called a cultural resistance movement.

The new Minister of Culture, Bernhard Rust, followed the official party line and reiterated the Goebbels insistence on art as the reflection of the 'folk spirit.' But such department chiefs as Dr. Wolf Meinhard von Staa and the museum specialist Dr. Hans Werner von Oppen, a former disciple of Edwin Redslob, tried to stem the tide of fanaticism. Their influence was partly responsible for the fact that during the first year of the new regime many expressionist and abstract painters could still exhibit in Berlin while elsewhere in Germany their works were already condemned as 'degenerate.'

When open rivalry broke out between Ministers Rust and Goebbels, Goebbels won out on the incorporation of the teachers and the faculties of art schools into the Art Chamber,[11] but he was defeated by Rust on his demand that museum curators, too, ought to join the Goebbels machine.

It was this rivalry that made it possible for one museum director to evade the jurisdiction of the Chamber of Art. Professor Emil Waldmann in Bremen fought a courageous and partly successful delaying action by turning an organizational weakness into strength. His museum was the property of a private cultural organization and as such was due for incorporation into the Art Chamber. But Waldmann argued that the chief activity of the Kunstverein of Bremen was the maintenance of the museum, which thus belonged under the Ministry of Culture rather than the Propaganda Ministry.[12]

An outspoken protest against the Nazi policies was staged by a group of Berlin students in July 1933 under the leadership of Dr. Fritz Hippler, in which students at the University of Halle joined. But they were quickly shouted down.

Among those who resisted the Nazi interference to the very end were the art dealers Alex Voemel in Duesseldorf and Guenther Francke in Munich.

The over-all record of the resistance is not quite clear. A certain ambiguity resulted from a peculiar and highly significant situation: namely, a flirtation between modern art and National Socialism. What happened reminds one of a somewhat similar situation at the beginning of the Weimar Republic in 1918. The same tentative and temporary merger between the political and artistic revolutionary forces had taken place in Soviet Russia and in Fascist Italy. We shall see something of the sort happening again in the Soviet zone of occupied Germany. In each case there are, of course, special factors that differentiate these situations from each other. But they seem to recur with such regularity that one is justified in recognizing this repetition of a pattern as more than a mere coincidence. We are beginning to see that each revolutionary change in the history of society favors a brief, experimental co-operation of politically and artistically radical forces. This association always seems to rest largely on mutual misunderstanding — one obvious reason for its brief duration.

In the case of National Socialism the question arose whether expressionism was not a typically German, 'Nordic' affair and therefore to be encouraged by party and state. Dr. Bruno E. Werner saw an element of preparatory relationship between expressionism and the current Nazi revolution.[13] A similar course was followed by other journalists and writers, such as the art critic Walter Horn, who was promptly summoned to SS headquarters and questioned by the Hauptsturmfuehrer who was the head of its art department. But in those early years a certain amount of digression was still possible. The poet Gottfried Benn's [14] defense of expressionism appeared in 1934 as part of an ambiguous sociological study of art entitled *Art and Power,* which also contains an address in honor of the Italian futurist Marinetti. Even such a pronounced Nazi paper as *Der Angriff* still defended expressionist artists such as Christian Rohlfs and Emil Nolde.

The works of the sculptor Ernst Barlach came in for a good deal of attention in this ideological tug of war. Emil Nolde, the painter, was one of the very few progressive artists who actually joined the party and was dumfounded when later on he saw himself relegated

to the limbo of degeneration. One man in particular had tried to represent the work of Emil Nolde and of the expressionists as the great fulfillment of Nordic-Germanic art; this was Dr. Max Sauerlandt, formerly director of the museum in Hamburg. He believed stubbornly in the possibility of reconciling the artistic revolution and the new political orientation. When he realized the extent of his error he died in deep unhappiness and despair. His lectures were edited posthumously by Harald Busch,[15] a young SA man interested in modern art, who labored under the same delusion. Busch lost his post as Director of the Kunsthalle in Hamburg when he included two paintings by the German Jewish impressionist painter Max Liebermann in an exhibition held in the fall of 1934.

When Goering visited the Kronprinzen-Palais he took open offense at the paintings of the Norwegian Edvard Munch. He brushed aside the attempt to persuade him that these paintings were something characteristically Nordic.

The position of Dr. Joseph Goebbels was not quite so unequivocal. His personal interest lay more in the direction of theater, radio, and motion pictures than of the fine arts. But he liked and had around him some works of the expressionist school, especially still lifes by Emil Nolde and sculptures by Ernst Barlach. This is perhaps the reason why during the early years the Art Chamber participated in some of the courtship of modern art. The official Art Chamber magazine, *Die Kunstkammer,* published some works by artists soon blacklisted as degenerate. For instance, a beautiful stone relief by the sculptor Waldemar Raemisch was published in the June 1935 issue. Only fifteen months later the Art Chamber declared another relief by the same artist as 'intolerable,' because 'it shows humans of such an inferior racial type that they must be considered as falling under the concept "degenerate art." ' [16] Such unorthodoxies caused the rather premature death of the magazine in 1936, when it was superseded by Rosenberg's *Die Kunst im Dritten Reich.*

Goebbels was quick to sense the passing nature of this tenuous union. It was he who officially abolished art criticism on 29 November 1936 at a full-dress meeting of the Reich's Chamber of Cul-

ture in Berlin's Philharmonic Hall.[17] Only factual comment and straight reporting of artistic events were henceforth permissible. This act, the official prohibition of individual taste, heralded the beginning of a new phase in the operation of the Nazi control machinery.

A month earlier, on 30 October to be exact, the modern section of the National Gallery at the Kronprinzen-Palais in Berlin was officially closed. This institution, the most representative German museum devoted to contemporary art, had fought a valiant battle under a number of changing directors in defense of its ideals and of the principle of freedom of artistic expression.[18]

Other museums had to surrender much earlier. The first instance of ruthless interference took place in Karlsruhe, where the director, courageous and able Dr. Lilli Fischel, was dismissed in 1933. The new director at once set a fatal example of disgraceful humiliation of contemporary art. He opened an exhibition called 'Regierungskunst von 1918 bis 1933' (Government Art 1918 to 1933). Impressionistic and expressionistic paintings were displayed with derogatory labels, which also announced the prices paid for these works during the inflation of the 'twenties but omitted dates of purchase. One dollar, it must be remembered, was worth several million marks, and the false impression was created that preposterous amounts of the taxpayer's money had been spent.

Soon the Karlsruhe example was followed in other cities, notoriously so in Stuttgart, where an exhibition called 'Novembergeist, Kunst im Dienste der Zersetzung' (November Spirit, Art in the Service of Disintegration) was shown; in Nuremberg, where a 'Chamber of Horrors of Art' was displayed; in Chemnitz and in Dresden, which had on exhibition 'Spiegelbilder des Verfalls in der Kunst' (Reflections of Disintegration in Art).

The early dismissal of Dr. Gustav F. Hartlaub from his post as director of the museum in Mannheim was accompanied by sinister pageantry. Hartlaub had been warned of what was brewing and had hidden some of his paintings in a cellar. But they were found and put on a wagon, which toured the streets of the city. On one side of the wagon was the painting of a Jewish rabbi by Marc

Chagall, on the other a large photograph of Hartlaub and a poster announcing what these pictures had cost the citizens. In an exhibition entitled 'Kulturbolschewismus' the paintings were badly hung, without frames. Items were added that had never been publicly exhibited, such as works acquired through special funds for the support of needy artists.

One of the most capable and deserving museum curators was Carl Georg Heise, now in charge of the museum in Hamburg. Since 1920 he had been the director at Luebeck. His unceasing efforts for the most dignified conservation of historic treasures, for the encouragement of local traditions in the fine old Hansa town on the Baltic, and his valiant support of progressive art were duly recognized by reasonable elements of the community even after his dismissal.[19] But this did not prevent the most ignominious personal molestations. He was falsely accused of misappropriation of funds and immoral conduct; his every move was spied upon by informers. In September 1933 he was advised to 'resign of his own wishes' — which he refused to do, demanding a definite statement of reasons. It developed that there were no political objections to his regime, but that his support of Nolde and Barlach was untenable. The city official in charge of culture was a Senator Burgstaller, formerly a parson. He would keep Heise waiting for two hours although he had no other visitors. One time the reception was most cordial. 'My dear Heise, I am sure you must understand why we could not keep you on. It just could not be done. Look here, I need your help and advice. As you know, I am no expert in art matters but I have to appoint a successor for you, a man who will carry on in your spirit. Whom would you suggest?' Heise named four or five men whom he considered suitable for the post. Soon after that he met one of the men from the Senator's office, who grinningly told Heise: 'Don't you see? Those of course were the names which I had to cross off the list of candidates immediately.' The Luebeck museum, hitherto in the hands of a private association, fell under state management in March 1934.

The director of the famous Folkwang Museum, founded in Hagen for the special support of contemporary art and later moved

to Essen, was replaced by a fanatic SS man, Count Baudissin.

These dismissals, which usually took the form of enforced re-tirement with half-pension pay, were legalized by the infamous Gesetz zur Wiederherstellung des Berufsbeamtentums (Law for the re-establishment of professional officialdom) of 7 April 1933. Its victims included such men as Dr. Edwin Redslob, who was dis-missed from his post as Reichskunstwart on 1 March 1933, and Dr. Johannes Sievers at the foreign office. Sievers had first to undergo the humiliation of having to open an exhibition of Ger-man graphic art, held in Milan in May 1933, in the company of one SA man and one SS man, sent along as watchdogs. The dis-missals also affected a number of art historians at universities and museums. The first artists to be relieved of their teaching posts at art academies were Carl Hofer and Paul Klee.

During all this time the battle of the printed word continued with unabating fanaticism. Soon after Hitler's rise to power there appeared a particularly vicious distortion of values from the pen of an art historian named Eberlein. *What Is German in German Art?* was the title of his malicious treatise. Alfred Rosenberg celebrated his ideological victory in a triumphant pamphlet in 1934.[20] The SS started its official magazine, *Das Schwarze Korps*, in 1935. From the first to the last issue it echoed the official art policies, with con-stant attacks on the 'Jewish-Marxist' distortions of modern art, with glorifications of prehistoric pagan remnants, and with chauvinistic boasting of the superiority of German art of all ages. The physical removal of all the most valuable monuments of contemporary ex-pression from the eyes of the German public was heralded in the book of an insignificant painter named Wolfgang Willrich, whose badly organized and distorted attacks appeared in 1937 as *The Cleansing of the Temple of Art*.[21]

TIGHTENING THE REINS

'From now on we are going to wage a merciless war of destruction against the last remaining elements of cultural disintegration,' shouted Hitler on 18 July 1937.

Should there be someone among them who still believes in his higher destination, well now, he has had four years' time to prove himself. These four years are sufficient for us, too, to reach a definite judgment. From now on — of that you can be certain — all those mutually supporting and thereby sustaining cliques of chatterers, dilettantes, and art forgers will be picked up and liquidated. For all we care, those prehistoric stone-age culture bearers and art stutterers can return to the caves of their ancestors and there they can apply their primitive international scratchings.

These were the words with which Hitler opened the inaugural exhibition at the newly completed House of German Art in Munich. The day before, on 17 July, the Chamber of Art had celebrated its second anniversary in solemn convocation. Propaganda Minister Goebbels had denounced the tyranny of Jewish art criticism of the last three decades and had underlined again and again the role of the Fuehrer and the importance of his art speeches. Professor Ziegler, the President of the Chamber, had admonished his listeners to forget the tragic fate of some of the individual artists and to 'grasp the impact and the importance of the great historic process.' If the rules of National Socialist art policy had been applied with full rigidity four years ago, there would have been catastrophes of the spirit and the soul, he piously announced.

The following day saw the opening of another exhibition which Ziegler and a group of assistants had assembled at Hitler's personal command.

VI

———

Operation 'Degenerate' Art

O N 8 JULY 1937, quite without warning, Professor Adolf Zieg-
ler arrived at the Kunsthalle in Mannheim with two as-
sistants and brandished a piece of paper with Goebbels' signature
on it. Professor Ziegler, Nazidom's number-one painter, was known
to the opposite faction as 'The Master of the Pubic Hair' for his
meticulously detailed nudes. He was authorized by a special order
from the Fuehrer to 'secure' all paintings and sculptures of 'de-
generate' German art since 1910 that were in the possession of the
Reich and of any of its Laender or individual municipalities.[1]

What happened in Mannheim was typical of Professor Ziegler's
procedure wherever he went. The confiscated items were to be
shipped to Munich for an exhibition at which examples of 'de-
generate' art would be publicly displayed and derided. The party
operators collected paintings, sculptures, and drawings by such
men as Wilhelm Lehmbruck, Franz Marc, Max Beckmann, Carl
Hofer, George Grosz, and Willi Baumeister, and also by foreigners
such as André Derain, Edvard Munch, Alexander Archipenko, and
Marc Chagall. The operation was nation-wide and wholesale. Six-
teen thousand works of art — paintings, sculptures, drawings, and
prints — by nearly 1400 different artists were gathered up. Com-
plete and final destruction of a whole culture was the intention.

No specific definition of 'degenerate art' was enunciated for
this operation, but certain principles of selection are easy to recog-
nize from the kinds of work that were condemned. The Nazis swept

up the drawings and paintings of Jewish artists and any works depicting Jewish subject matter; they took any painting that betrayed pacifist sentiments and any war art not in line with the officially prescribed heroic spirit (they took Otto Dix, for instance);

A page from the Catalogue of Prints of the Kunstgewerbe-Bibliothek in Berlin-Dahlem, showing the confiscated items crossed out.

and they confiscated expressions of socialist or Marxist doctrines; works showing 'inferior racial types,' such as the Barlach creatures or Otto Mueller's gypsies; all German expressionist painting and sculpture, including the work of their old party member Emil Nolde; abstract art, especially that done by the men who had been connected with the Bauhaus. 'Impertinent attacks on our culture and our national art treasure, promoted by a number of swindlers motivated purely by political, propagandistic motives' — these were the words with which Hitler characterized modern art.

The exhibition of 'degenerate art' opened in Munich in the summer of 1937 and was still open when the Fuehrer delivered his lecture on art at the Nuremberg Party Conference that year. Every possible device was used to pillory the exhibits. All the

shameless tricks developed four years earlier in the Karlsruhe, Mannheim, and Nuremberg displays were now repeated on a grand scale. The pictures were hung without frames, closely jammed together to make a clutter, and the labels that were appended to them were of such a slanderous nature that even the Fuehrer is supposed to have ordered some of them changed after he had completed his own preview. Price tags showing the amounts paid for the pictures in drastically devaluated German currency were appended without explanation, in order to scandalize the taxpayers (fig. 33).

The exhibition attracted huge crowds, not only party members and masses of the curious and the casual but also large groups of friends of modern art, who could do no more than pass through the halls in utter silence with faces of stone. At least one wealthy collector, hitherto interested only in traditional values, was won over to modern art by the powerful appeal it exerted even in the hour of its deepest humiliation.

A catalogue was issued for the occasion,[2] designed to underline the effect of the exhibition: provocative juxtapositions of pictures and slogans on the right hand pages and running comment and an excerpt from a Hitler art speech on the left. The most interesting thing about this catalogue is its fraudulent identification of progressive art and political radicalism. This is the avowed intention of the catalogue and the main point of attack. To prove the point there were reprinted statements on art by radical left-wing writers. Two things are interesting: not one of the people cited is a well-known or important artist; not one of the quotations is later than 1921; most of them are dated 1914 or 1915. In other words, these statements were garnered first from the period of infancy of the twentieth-century revolution in the arts, and second from the brief period of courtship between progressive art and political revolution. We have examined carefully this phase of the early years of the Weimar Republic and have seen how short-lived it was, how full of misunderstandings, how insignificant the political influence exercised by the artists as a group. But in 1937 there was no organ of public opinion left inside Germany that could have pointed out

the fallacy in this accusation against modern art. The exhibition was a resounding victory for the Nazis, not only at the time and in Germany but also, and more so, because of the long-range effect of this type of reasoning.

Professor Ziegler and his committee worked on a generous scale. They amassed more than a hundred works by the sculptor Lehmbruck; between two and three hundred examples each of Dix, Grosz, and Corinth; between three and four hundred by Hofer, Pechstein, Barlach, Feininger, and Otto Mueller; more than four hundred Kokoschkas, five hundred Beckmanns, six hundred Schmidt-Rottluffs and Kirchners, seven hundred Heckels, and more than a thousand Noldes. In addition they confiscated the works of some non-German artists — paintings by Cézanne, Picasso, Matisse, Gauguin, Van Gogh, Braque, Pisarro, Dufy, de Chirico, and Max Ernst.

Very few works of art in public collections escaped. At the Kronprinzen-Palais two of the floor attendants managed to hide Erich Heckel's much-attacked *Madonna of Ostende* between two doors, and after the raid was over they telephoned the artist to hide the painting away somewhere. Such occurrences were rare exceptions. Ziegler's men were extremely thorough. At the print gallery in Stuttgart the single leaves of each objectionable artist were fished out of otherwise neutral portfolios.

Museums in western Germany suffered the heaviest losses. The Folkwang Museum in Essen, the Municipal Collection in Duesseldorf, and the Hamburg Kunsthalle each lost more than nine hundred works of art. The National Gallery in Berlin, the Berlin Print Cabinet, and the museums in Frankfurt and Breslau each lost from five hundred to six hundred works.

But the Nazis had other motives besides the protection of German culture against 'the poisoning influence upon public opinion' of this type of art. On 31 May 1938, some months after the collecting had been completed, a law was passed over the signatures of Hitler and Goebbels legalizing the seizures and making provisions for the further exploitation of the booty. They disposed of their

loot with exactly the same cold-blooded calculation with which they utilized the gold fillings from the teeth and the ashes from the bones of their gas-chamber victims.

All items of international value were sold outside of Germany, and a final report was made to the Fuehrer by the Propaganda Ministry. It is possible that the figures were tampered with to conceal 'unofficial' transactions, but according to the report they netted more than 10,000 pounds, nearly 45,000 dollars, and about 8000 Swiss francs. A major portion of the confiscated art was sold in Switzerland at a public auction held in the Theodor Fischer Gallery in Lucerne on 30 June 1939. Some of the proceeds were used to buy what the Party considered desirable examples of German national art for Hitler's Linz Museum — nineteenth-century Romantic pictures for the most part, with a dreamy landscape by Caspar David Friedrich as the star item. Other examples of nineteenth-century German art were acquired by barter. More than thirty paintings by members of the expressionist school, with nearly two hundred prints and sculptures thrown in for good measure, were bartered for a single painting by a man named Oehme. The 'worthless' paintings, namely, those that seemed to have no barter or sale value, had already been sorted out. They were burned in the spring of 1939 by the Berlin Fire Brigade.

Before the disposal of the booty had actually got under way, Goering took a look at it. His haughty eye fell with favor on some paintings by Van Gogh, Gauguin, Marc, and Munch, and he made off with them for his private collection. Unlike Hitler, who practiced his preachments about the value of German art above all other art, Goering's digestion was never upset by the 'international poison' that he himself devoured in such generous helpings.

There were several leaks; the meshes of the dragnet were rather wide. Professor Heise, whose museum in Luebeck did not escape the confiscations, said to me in 1950: 'What I thought especially cheap in this operation was the fact that one was offered these pictures right away for repurchase. I was secretly offered virtually all the museum paintings confiscated in Luebeck. One or two of them I was able to buy, others I got friends to purchase.'

GEMÄLDE UND PLASTIKEN
MODERNER MEISTER
AUS DEUTSCHEN MUSEEN

Braque, Chagall, Derain, Ensor, Gauguin, van Gogh, Laurencin, Modigliani,
Matisse, Pascin, Picasso, Vlaminck, Marc, Nolde, Klee, Hofer, Rohlfs,
Dix, Kokoschka, Beckmann, Pechstein, Kirchner, Heckel, Grosz,
Schmidt - Rottluff, Müller, Modersohn, Macke, Corinth,
Liebermann, Amiet, Baraud, Feininger, Levy, Lehm-
bruck, Mataré, Marcks, Archipenko, Barlach

AUSSTELLUNG

IN ZÜRICH

Zunfthaus zur Meise, vom 17. Mai (Mittwoch) bis 27. Mai (Samstag) 1939

Eintritt: Fr. 3.—

Täglich geöffnet von 10—12 Uhr und von 2—6 Uhr (Sonntag nachmittag geschlossen)

IN LUZERN

Grand Hôtel National, vom 30. Mai (Dienstag) bis 29. Juni (Donnerstag) 1939

Eintritt: Fr. 3.—

Täglich geöffnet von 10—12 Uhr und von 2—6 Uhr (Sonntag geschlossen)

AUKTION IN LUZERN

Grand Hôtel National, Freitag, den 30. Juni 1939, nachmittags 2.15 Uhr

AUKTIONSLEITUNG: THEODOR FISCHER, GALERIE FISCHER, LUZERN

What became of the 'degenerate' artists themselves, the men who were considered enemies of the state and traitors to the national cause? Many more of them survived than one would have guessed, but they survived in isolation, cut off from other artists, unable to communicate with their friends, living constantly under the threat of the concentration camp, deprived of the tools of their trade and of space in which to work. They went underground. They found a few friends who continued to buy their work, a few dealers who secretly sold for them, a shopkeeper here or there who was willing to take risks to give them without ration cards a few paints and brushes, and sometimes a few disciples who wanted to learn. But the isolation from other painters and from any kind of appreciative public had a paralyzing effect: a damming up of the sources of creation.

Worse than actual danger and physical hardship was the feeling of living constantly as a suspect. This was what the artists complained about most bitterly after the war — this atmosphere of disapproval, of having to live against the stream of all the life around them in seemingly endless, hopeless isolation. But they carried on. Carl Hofer was the first painter to be thrown out of his teaching post at an academy and he was strictly prohibited from painting. There is the story that Gestapo agents came to his house and felt his brushes to see if they were wet. Nevertheless, he continued to paint, and to sell.

Karl Schmidt-Rottluff, one of the founders and leading masters of expressionism, was singled out for incessant persecution. He had a friendly doorman, who warned him every time the agents presented themselves downstairs, and sometimes he managed to hide in a closet the canvas he was working on. He had to dodge stool-pigeons who posed as customers for a portrait to tempt him into a commitment. He, too, never ceased to work.

The abstract sculptor Karl Hartung was able to carry on behind locked doors. It was a lonely life, the doorbell rang seldom — 'isolated as though one were living in the catacombs.'

Occasionally, a courageous dealer would bring a handful of people together. Once the Nierendorf Gallery staged a night lec-

ture about the 'degenerate' sculptor Gerhard Marcks. The affair was crowded and a repeat performance was scheduled, but word got out and the second lecture had to be canceled.

Willi Baumeister, Germany's most widely recognized abstract painter, also managed to carry on. During my visit to his home in Stuttgart on 18 November 1950, he dictated to me spontaneously an account of his existence during the years of persecution.

I was a Professor at the Frankfurt art school. In 1932, as a result of the activities of the well-known architect and architectural theoretician Schultze-Naumburg, who fought mightily against everything modern, I was attacked in the newspapers. Something characteristic happened to me. The Stuttgart art gallery offered to buy one of my paintings. This was around Christmas 1932. I sent them something, one might call it semi-abstract. Six weeks or so later the Director wrote back and asked if he could not exchange the picture for something a little more representational. I complied with his wish but soon another letter arrived, asking for a picture still less abstract. Thereupon I took from my parents' home one of my very early works, of 1912 perhaps, a landscape I had painted at the age of 18, strongly influenced by Cézanne. This picture was accepted, but hung not in the gallery itself but in one of the offices of the State Library.

After Hitler's election, news of the dismissals was passed along by word of mouth. My name was at the top of the faculty list. Our Frankfurt chief, Professor Wiechert, was pensioned off and the new man sent me a rude letter of dismissal on 31 March 1933. Next day there were mysterious chalk marks at my door, the day after that the lock had been tampered with so that I lost control over my belongings there. My wife was expecting a baby and I arranged to move to the house of my parents-in-law in Stuttgart.

At once there was a cooling off among friends and acquaintances against the man who had been signaled out for dismissal. The dismissal was bad, but the social ostracism that followed was worse.

I now earned my living as a typographic designer, but cautiously, so as not to get too well known and not be too active. I continued to paint behind closed doors. Hitler's speeches had the effect of renewing dangerous aggressions against modern painting. My pictures were removed from the state and municipal galleries of Germany. The ostracism increased step by step until 1937–8. An especially dangerous man was Count Baudissin, appointed by Hitler to the directorship of the magnificent Folkwang Museum in Essen. He demanded that 'degenerate' paint-

ings be removed from the private collections as well. That was about the worst that could happen to the painters and it was most depressing. Soon after that Ernst Kirchner shot himself in Davos. Oskar Schlemmer told me that Kirchner's suicide was directly connected with the appearance of Baudissin's article.

Städtische Kunstgewerbeschule Frankfurt am Main

Die Direktion

Frankfurt a. M., den 31.März 1933
Neue Mainzerstrasse 47 Fernsprecher 24396

Auf Anordnung des kommissarischen Oberbürgermeisters habe ich anstelle des beurlaubten Prof. Dr.Wichert die Leitung der Kunstgewerb schule übernommen.

Ich teile Ihnen mit,dass ich auf Ihre weitere Lehrtätigkeit an der Kunstgewerbeschule verzichte. Unter dem Vorbehalt der fristlosen Kündigung im Falle entsprechender gesetzlicher Ermächtigung wird Ihnen das Gehalt noch für die Monate April und Mai gezahlt werden,doch ersuche ich Sie,sich jeder Amtshandlung zu enthalten und Ihren bisherigen Arbeitsraum bis 8.April zu räumen.

Der kommissarische Direktor:

[signature: Berthold]

Herrn

Professor B a u m e i s t e r

H i e r

Fuchshohl 26

Baumeister's letter of dismissal from his art school in Frankfurt.

The constant utterances of Hitler, Goebbels, and the others sapped our energies and paralyzed us. This general paralysis and the results of increasing pressure were the reason for Oskar Schlemmer's illness, and also the cause of his death.

After the war started, things became especially uncomfortable be-

cause one had to show that one was working. In 1938 my friend Heinz Resch, the architect, had recommended me to a paint and varnish factory in Wuppertal, for whom I took on some jobs. They had a research institute for painting technique and now I worked for them on a monthly salary.

I had no public. No one knew that I continued to paint, in a second-story room in utter isolation. Not even the children and the servants must know what I was doing there. I carried the key always with me.

My friends in Wuppertal, Oskar Schlemmer among them, sent me humorous letters and postcards from time to time, with paste-up pictures and surrealist texts. I sent them, rather naïvely, a cartoon, cut from a U.S. newspaper, of an electric chair with Hitler on it. Suddenly I was summoned to Gestapo Headquarters. I was confronted by the Gestapo censor with my entire correspondence for the last year and a half. Thank God, Hitler in the electric chair was not among the intercepted letters. I extricated myself by writing a long report to the Gestapo, explaining that these were plans for a book dealing with color modulation and patina, in connection with an especially resistant paint for the camouflaging of tanks and pill boxes.

It was not until after the beginning of the war that I had my first visitors. We opened the boxes in the basement and I showed my pictures.

Terrible was the idea that one would never again be able to show such pictures in public. In 1943 I had to stop painting altogether, because my next-door neighbor was an SS general. A captain of the SS was billeted in my own room. All the pictures had disappeared, but if one happened to turn up by chance, I told the captain that it was a camouflage experiment. I still had a studio, which I did not dare to enter. It was then that I began to make illustrations, *Gilgamesch* and *Salome,* as a little personal revenge against this anti-Semitic business; finally Shakespeare's *Tempest.* They all were made in 1943, but published much later, after the war.[3]

Yes, there was an uncorruptible core of creative integrity. The story of Willi Baumeister's life, typical of a group that has never been counted or listed, proves it. Nothing so strongly documents the sincerity and seriousness of these expressionist and abstract painters and sculptors as their urgent desire and their need to carry on against overwhelming odds. Above all this is a testimony not only to their character but to the validity of their art.

VII

Nazi Painting: A Study in Retrogression

I T IS PERFECTLY CLEAR what the Nazis did away with. But what
did they put into the gaping void that resulted from their opera-
tions?

Their claims were exorbitant and they embarked upon all sorts
of feverish activities. But the achievements are meager indeed when
compared with the claims and when measured in terms of genuine
artistic accomplishment. It is incredible what a fuss was made over
such obvious banalities as Professor Ziegler's nudes, that for the
sake of this coy mediocrity the work of Carl Hofer, for instance,
was thrown into the ash can (figs. 10, 12).[1]

A faintly apologetic undertone can occasionally be perceived in
some of the official comments. 'This is only the beginning — give
us time — the real thing is yet to come' crop up here and there.
We are to hear exactly the same tune ten years later from the mouths
of the communist propagators of social realism in the Soviet orbit.

It is possible that Hitler's raging assaults upon modern art at
the opening of the 1937 gala exhibition in Munich were motivated
at least in part by an inkling of how insignificant this exhibition
really was. Preparations had been most elaborate. It was an event
that had been planned for many years. When Alfred Rosenberg
had opened an exhibition of selected masterpieces of Nazi painting
in 1934, he had announced that the purpose of the show was that
it should serve as a testing ground for the future great exhibitions
in the Haus der deutschen Kunst. He admitted that something was

still missing but he was confident that these first steps would lead toward the desired results. Hitler himself had ordered a comprehensive display of the best contemporary art for the 1937 event instead of the modest retrospective exhibit the museum experts had recommended. At the last minute, when the jury had completed its selection, Hitler appeared and insisted on the inclusion of certain of his favorites. He also eliminated some eighty works that he considered insufficient. 'I do not tolerate unfinished pictures!' he shouted.

And what did the visitor see in this exhibition and in the illustrated catalogue he took home with him? [2] What he saw there was exactly the kind of paintings my parents would have looked at in the Glaspalast exhibitions thirty or forty years earlier on their way through Munich to a holiday in the Bavarian Alps. There were portraits of generals with uniforms studded with decorations, abbots with crosses, romantic seascapes, romantic landscapes, genre paintings of nineteenth-century life in the provinces, peaceful cattle grazing among the willow trees on the plains or on the mountain slopes; there were peasants in the fields, pictures of sunshine filtering through the leaves, peasants saying their prayers at mealtime, peasants plowing, peasants in their Sunday best (fig. 22). What he saw were symbols of a serene life, rendered in a realistic idiom borrowed from a generation which, indeed, had seen such peace. The only difference was the presence of a certain number of World War I combat scenes and some Nazi heroes, but they, too, were painted like warriors of the Franco-Prussian War. And there were, of course, the nudes, single and in groups, with and without stockings, with and without swans, standing, lying, symbolic, suggestive, and always with a thin veneer of prim virtue.

There was nothing new, nothing spontaneous, nothing unexpected. There was going to be no change. From the first to the last Nazi painting remained the same. It never developed, it stayed fixed at a point of evolution that had been reached in the second half of the nineteenth century. Every official exhibition, every catalogue, every article and book tells the same story.[3]

Surgical removal of every spontaneous young growth forced nour-

ishment into half-dead branches and produced a luscious flowering
of yesterday's second- and third-rate forgotten talents. One has to
remind oneself forcefully that these things were actually the work
of living men and women, so much do they look like the products
of a bygone day.

This illusion was deliberately fostered in print. Yesterday's
sources and today's results became as one. The Nazi magazines —
including many media not primarily concerned with art — all fol-
lowed the same pattern. They all carried pieces about German
Renaissance art, about Duerer, Altdorfer, and Cranach, about the
romantic painters, Caspar David and the others, about the masters
of nineteenth-century realism and a few twentieth-century prophets
of folk-art, especially the Tyrolian Egger-Lienz.

It is perfectly true that all this conformed rather strictly to the
Fuehrer's personal taste in painting. What this taste was is seen
very clearly from the kind of thing Hitler wanted included in his
pet project, the supermuseum of German art at Linz on the Dan-
ube, where he had lived as a child. On 1 August 1940, Party Chief
Bormann wrote an illuminating letter to the museum director
Hans Posse, whom Hitler's art dealer Karl Haberstock had recom-
mended for the Linz project:

> The Fuehrer desires for the new Linz gallery not single pieces by
> painters of the Munich school, but of the best known ones, Gruetzner,
> for instance, he wants complete little cabinets. The Fuehrer is of the
> opinion that in fifty to a hundred years the painters of the Munich
> school will far exceed their present evaluation. Should the Linz gallery
> prove too small for the pictures the Fuehrer wishes to donate, he will
> perhaps build a second building in which sculptures can be placed
> along with paintings . . .[4]

Gruetzner, a small-time nineteenth-century artist belonged, with
Waldmueller, Defregger, and others, to the Austro-Bavarian school
of genre painting. What these artists showed — satisfied peasants
and small-town folk of the Alpine region in their daily pursuits
and Sunday entertainments — was the milieu Hitler's own child-
hood had lacked. This was the image of what life should have been
but was not for the small boy who was sent to the tavern by his

anxious mother to beg, threaten, drag home the father who again had drunk more than he could manage. Some inner voice must have whispered to Hitler that if only he could secure sufficient quantities of the 'gemuetliche' paintings and assemble them in Linz, he might somehow rewrite his own life story.

There is no denying the fact that Hitler's taste was formed under particular circumstances and that this taste was a very strong influence in German art life. But it could not have been so widely accepted if it had not met the wishes of broad masses of the people, who felt exactly the same secret longing for the good old days in the threatening hostility of the postwar world. They fell for the mirage and forgot what greater hazards, what much more terrible adventures they were letting themselves in for.

Nor was there anything particularly German about all this. The demands for 'social realism' in Soviet Russia and in the Soviet orbit of influence have produced precisely the same kind of painting. To be sure, the costumes and the scenery are of a different variety, but the style, the colors, the whole treatment, and the atmosphere are identical.

It is the fixation upon the illusion of a secure, serene world, conspicuously formulated by the naturalistic painter of the later nineteenth century, that accounts for the static nature of the painting fostered in the totalitarian state. In the case of Nazi painting the only change possible was a shift in subject matter and in the regional origin of the painters singled out for exhibition and publication. Danzig, Austria, the Polish campaign, France, Norway, Russia — all were duly recorded with oil on canvas. Every territorial acquisition or conquest was promptly reflected in the art magazines.

'Combat art' became more important as the war absorbed more and more energies. The organization of German combat artists was excellent, as was to be expected. Thanks to the efforts of Professor Gordon W. Gilkey this stage of Nazi painting has been thoroughly explored and a large and fully representative collection of paintings, drawings, and some sculpture brought to Washington after the war.[5]

It was in 1941 that Hitler, who had always shown a liking for the studio paintings of World War I, ordered the Chief Command of the German Army to organize a staff of uniformed artists to follow the German military exploits. Luitpold Adam, himself a World War I combat painter, was put in charge of the Kriegsmaler und Pressezeichner-Propaganda Ersatz Abteilung, Oberkommando Wehrmacht (War Painters and Press Artists, Propaganda Replacement Section, Chief Army Command) in Potsdam. From there, artists could be sent out on special assignments and to follow special campaigns. The group was increased to a membership of forty-five artists. The screening of these men before final assignments is similar to Ziegler's special artist's encampment at the Reich's Academy for Physical Culture in 1938 (see page 100).

The artists were all presented with painters' problems requiring quick powers of conception and observation as well as of catching the impression of the situation in rapid sketches. Adam took his men to the near-by training field of the Potsdam School for noncommissioned officers, where combat actions were staged. An infantry regiment in adjoining barracks also acted as models for anti-tank-gun unit crews, machine gunners, et cetera. Not far away was the drill field of a medium-caliber artillery outfit, where studies could be made of these weapons during activity or disuse. Especially gifted artists went to Doeberitz to make drawings of the tanks, or were detached for engineer or other training. For an exact working knowledge of weapons, all kinds and calibers were borrowed and sketched. A horse with saddle and bridle provided studies of how to ride and lead a horse.

The organization was revamped in the spring of 1942 and enlarged to include eighty combat artists. It was now called Staffel der Bildenden Kuenste, Propaganda Abteilung, Oberkommando Wehrmacht (Echelon of Fine Arts 'Propaganda Dept.' Army High Command). The artists would go out to the front for three months at a time, then return to the Potsdam headquarters for another three months' period, during which finished paintings were made from the combat-area sketches.

Large groups of paintings were produced showing where German soldiers had been, characteristic types of peoples in front areas in foreign lands, as well as of all races and types of people who had opposed the

German soldiers in the front lines. In this way the entire description of the war crystallized more and more out of the complete picture achieved by the German war painters [explained Herr Adam to Professor Gilkey].

The navy and the air force, too, had their war-art program, organized according to the seventeen military and the nine air districts into which Germany was divided. Even the SS controlled a small number of combat artists, the Waffen SS 'Kurt Eggers' group.

The results of all these activities were freqently exhibited in Germany and in some of the occupied countries. Regimental histories, campaign stories, and many popular publications were illustrated with the work of these combat artists.[6] In a typical collection of this sort, entitled *Fire and Color*,[7] the editor praises war art as an expression of the totality of life and reality, as the symbol of the successful reintegration of art onto the total consciousness of the people.

One characteristic feature of Nazi painting which must not be overlooked was the emphasis on technical accomplishment. It is very understandable that in such a narrowly prescribed and monotonous routine all questions of craftsmanship and raw materials came in for much attention. Various research institutes were active, historical investigation of painting technique was carried on, and many claims for especially long-lasting results were brought forth.

Applied painting was greatly encouraged by state patronage. The union of architecture and painting was hailed in a series of ambitious mural projects. Elaborate mosaics and tapestries were produced.[8]

Meticulous attention to technical details added an illusion of authenticity to the imitation of the old masters. Werner Peiner's pseudo-Brugel landscapes (fig. 9),[9] Ziegler's 'Dutch' flowerpieces, the near-obscenities of Sepp Hilz's Venuses — these were diligently executed with a solidity worthy of more important projects.

These tendencies are also very clearly marked in the graphic arts produced in Nazi Germany.[10] Technical proficiency, special attention to the minutest details, endless repetition of Albrecht Duerer's *Meadow Piece* and his animal drawings, nursing mothers in the manner of Schongauer, hardy warriors à la Burgkmair — this

was all that was left of the strength of Rudolf Koch and of the other powerful individuals of the Weimar period.

This pitiful mediocrity was all that remained of the socialist art program, of the demand for 'art for the people and by the people.' After the Revolution of 1918 the progressive artists of Germany had quickly retreated from any concerted political effort. The Nazis had taken up the call. They set out to conquer the future. What they harvested were the dregs of yesterday.

In einem kühlen Grunde da geht ein Mühlenrad, mein' Liebste ist verschwunden, die dort gewohnet hat.

Linoleum cut by Georg Sluyterman von Langeweyde, exhibited in the official Nazi art exhibition of 1939.

The Peculiar Mission of the Sculptor

A VERY SPECIAL ROLE awaited the sculptor in the Third
Reich. His natural domain, the human figure, was a
medium admirably suited for the solid manifestation of the Nazi
ideal. In his speech at the opening of the Haus der deutschen Kunst
in 1937 Hitler made this very clear: It was the task of German art
to consolidate the racial structure of the German people as the
ultimate fulfillment of the Greco-Nordic tradition.

The new period of today is working on a new type of human being.
Tremendous efforts are being made in countless fields of life to elevate
the people, to make our men, boys, youths, the maidens and the women,
healthier and thereby stronger and more beautiful. And from this
strength and this beauty pours forth a new feeling of life! Never was
humanity in its appearance and its feeling closer to classical antiquity
than today. Competitive sports and combat games are hardening mil-
lions of youthful bodies and they show us them now rising up in a form
and condition that have not been seen, perhaps have not been thought
of, in possibly a thousand years . . . This human type which we saw
appearing before all the world at last year's Olympic games in its shin-
ing, proud, physical strength and beauty, this human type is the type
of the new time.

He managed to forget the remarkable Olympic record of his future
ally, Japan, and the superior performance of the American Negro,
Jesse Owens, which had forced him to rush away from his seat at
the arena to avoid the handshake.

What the prophets of racism had demanded of art a decade ago

was now becoming hard reality. It is obvious that the sculptor who could render this new human type in monumental proportions and in durable stone and bronze would have a particularly important assignment. Hitler had more to say about all this two months later, at the cultural conference of the Nuremberg party convention on 7 September 1937.

The sculptor of classical antiquity, who endowed the human body with form of wonderful beauty, has given to the whole world beyond his description an idea of what according to later, so-called exact scientific research is correct, that is to say, is real.

Two millenniums and a half before us this stonecutter foresaw, from his environment, the human body in such a way that today, according to all discoveries of our anatomic research, it must be declared natural in the highest sense. In that lies the meaning of what we describe with the word 'art,' the faculty of overtaking the reality of a time, that is of the present time, through seeing and forming, and to render it with means especially adequate for such a task.

This confusion of cause and effect, the inability to distinguish between nature and its creative and idealizing interpretation by the artist at one time and its scientific interpretation at another, this naïve acceptance of the concept that the whole universe fits forever into man-made rules, is typical of Hitler. His utterances would be completely uninteresting if they had not come from the man whom history placed — for a time — in a position of highest authority.

It is perfectly clear that the Fuehrer's words were heard and were fully understood by Arno Breker, Nazidom's number-one sculptor. Upon the completion of Speer's building of the new Reich's chancery, which featured his figures and reliefs in prominent locations, Breker wrote:

A powerful beginning, a grand scale, an overpowering result proves that the obsessed will to immortalize National Socialist Germany in indigenous cultural creations is realizing itself in a grandiose manner.[1]

These words fit Breker's sculptures perfectly. They are the complete, literal fulfillment of what his Fuehrer demanded. They also represent artistic corruption on a grand scale — perfect subordina-

tion of an artist's talent, of his imagination and his creative powers to a political creed. We need examine only his earlier work — sensitive drawings, subtle portraits of women, or a head such as the one of Nugochi — to realize to what extent Breker, spurred on by an overambitious wife, prostituted his considerable talents.[2] It is impossible to examine closely the 'Kameradschaft' relief, for instance, without painful realization of the dual purposes of each pressure of his thumb into the pliable clay. He not only models the muscle of a male body to recapture the classic Greek image but also shapes each part so as to express a paroxysm of wrath and vengeance. Actually, he overstates his case to a degree that deprives his work of any real power: there is a great deal of noise but very little said after all (figs. 16, 17). The empty pathos, the bad acting of this so-called monumental sculpture are evident in his *Dionysos* statue. Monotony and boredom governed an assembly of his and his colleagues' figures in the 1939 sculpture hall at the Haus der deutschen Kunst.

The popularity, wealth, honors, birthday presents from the Fuehrer, and the gift of enormous studios built on attractive sites from public funds were also enjoyed by Professor Josef Thorak.[3] Thorak's model for a big monument to the workers of the Autobahn, the super-highway that spanned the entire country from north to south and from east to west, shows the similarity of his sculptures to Breker's muscle men — the same political symbolism of the naked male body in aggressive poses, and, if that was possible, an even coarser, more boastful brutality. The hackneyed phraseology of the Thorak stance of strength and aggressiveness is also obvious in his reliefs for the new building of the Reichsbank. His innate vulgarity is revealed in the illustrated invitations he sent out for the house-warming party at his new studio in Baldham near Munich. Visitors to the Paris World's Fair of 1937 may remember Thorak's giant figures at the German pavilion. 'Where is the professor?' asked a visitor to his studio on one occassion. 'Up in the left ear of the horse,' replied an assistant. Thorak was not the only Nazi sculptor who confounded bigness with greatness (fig. 15).

Breker and Thorak were the most conspicuously successful Nazi

ANSCHLIESSEND ERFOLGT DIE EINVERLEIBUNG DER BEIDEN KINDER VIKTUSIAS, WELCHE ES VORZOGEN WÜRDIG VERZEHRT ALS DURCH MAUL- UND KLAUENSEUCHE VON IRDISCHEN SEIFENSIEDERN VERARBEITET ZU WERDEN.

FÜR DEN SITTLICHEN HALT DER ANWESENDEN IST GESORGT.

Invitation for Thorak's house-warming party.

sculptors — Breker earned over 90,000 Reichsmark in 1938, more than Goebbels had made in 1935, 1936, and 1937 (although Goebbels did not declare his income from royalties). They were of course not the only ones to bask in the sunlight of munificent state patronage. Kurt Schmid-Ehmen, particularly successful with his huge Nazi Eagle, shared with these two the honor of exemption from military service in 1940. There were many and substantial inducements to sculptors who were willing to toe the line.

The connection between art and sport, one of Hitler's pet notions, was especially encouraged by a government that was vitally interested in breeding strong, healthy specimens for the realization of its plans of military aggression. Sport was the seemingly harmless training ground, and art the most convincing and most effective means of demonstrating the obtainable ideal and the preferred type for the propagation of the race (fig. 24). In September 1937 Professor Ziegler, the President of the Chamber of Art, invited all German artists to submit entries to a preliminary selection for the Olympic art competition of 1940. He was planning early and thoroughly. Sculptors were permitted to send in full-round figures, reliefs, and plaques, showing sports events, practice, or movement but not the body in repose, unless it exhibited athletic characteristics. The following year, in September 1938, Professor Ziegler announced a unique plan in a circular sent to all members of his Chamber. Two groups, each made up of two sculptors, four painters, and two commercial artists, would be selected for participation in a special encampment for artists at the Reichsakademie fuer Leibesuebungen (the Reich's Academy for Physical Culture).

> Through this measure I want to give an opportunity to those artists who are especially interested in the themes sport offers for artistic creation to become acquainted with all branches of physical exercise, thereby to guarantee in the future a correct, sportsmanlike representation in their creations.

Each group was to spend eight weeks at the physical culture center.

Still more important inducements were the tremendous opportunities for conspicuous performance and the very handsome rewards offered by the state through its grandiose public works. Long

ago Hitler had planned state patronage of the arts on an enormous scale and he lost no time in translating his ambitious dreams into reality. It was from architecture, naturally, that sculpture was to derive its chief function.[4] Contemporary critics and commentators hailed the new opportunities for the sculptor. They pointed out that in the preceding decades lack of official patronage had doomed many important projects, which never passed beyond the clay-model stage, that the art of stone carving had nearly died out, its place being occupied by the more intimate, more personal bronze cast. Above all, the new architecture of the Bauhaus school was dismissed as cold, utilitarian constructivism, which had no feeling for space and human proportions and would therefore not tolerate sculpture.

Georg Kolbe, the great German sculptor, defended modern architecture. He pointed out that Mies van der Rohe had repeatedly used his own figures in happy combination with modern buildings. If the new architect used unadorned, flat wall spaces, he did so intentionally and for good aesthetic reasons. Merely decorative additions, he wrote indignantly, were not the real task of the sculptor.

Taken by itself, this stand would seem to place Kolbe in opposition to the official Nazi doctrines. Actually, he was not in opposition, was not a member of a small but valiant group of culturally resisting elements. Nor was he, on the other hand, an outright Nazi-sculptor as were Breker and Thorak. The position of this undoubtedly great sculptor was an in-between one, neither quite 'white' nor yet really 'black,' an extraordinary case of ambivalence.

Not long before his death, I met Kolbe in Berlin, late in 1946. He bemoaned the fate of the sculptor who could not get into an airplane and flee from tyranny, but was tied by the sheer physical weight of his figures. They embodied his life work and he could not abandon them, especially not the incompleted ones. Yet he had not done badly under the Nazis. His income was high and he did execute official commissions. The records of the Art Chamber show that he was expected to help decide which new sculptors were to be admitted, that he received official studio visits from strength-through-joy pilgrims and official congratulations from state dignitaries on birthdays and anniversaries, that he was given scarce work-

ing material and ample fuel during hard winters so that his models would not freeze and he could go on working.

To what extent did he suffer these things to be done unto him and for him, and how actively did he himself participate? The titles of his sculptures and the organizations for which he sometimes worked indicate a mild sort of co-operation. A *Youthful Warrior* here, an *Athlete in Repose* there, a soldier's memorial for Stralsund, a guardian for an anti-aircraft installation in Luedenscheid — a typical borderline pattern. A comparison of this work with what he produced in the thirties is revealing.[5] There are, for instance, his *Einsame* (The Lonely One) of 1927, with a diffidence and asceticism reminiscent of Lehmbruck, and the beautiful, imaginative *Night* of 1926. Against these, the *Junge Streiter* (Young Warrior) of 1934, for instance, or the *Verkuendung* (Revelation) of 1937 shows a decided 'awakening,' a turn from introspection and self-containment toward extroversion, a certain amount of aggressiveness and a hint of brutality in the male physiognomy (figs. 13, 14).

Can we say that Kolbe would have gone this way anyway, regardless of political events? That he was not greatly deterred from a path upon which he and others with him had long ago embarked? It is difficult to answer this. There is evidence of a certain amount of external influence, of some response to what was going on politically. In justice to him, however, we shall have to admit that in seeking his way onward from Rodin and Maillol, 'upward' as he saw it to an ever-mounting intensity of feeling and expression, he was not primarily or decisively prompted by national, racial, or political motivation.

The most revealing insight into Kolbe's own concept of his task as a sculptor can be gained from what he wrote about his *Zarathustra* of 1943.

It is a relief that this figure finally found its form. To be sure, perhaps I had wanted to climb yet beyond this. This is as far as my strength has carried me, and this fulfillment is up to now my freest position in the realm of the male body. A high plane has therewith been entered.

The name, the title is absolutely necessary for the public — little as I

need it myself. The great, powerful man who liberates himself, that was the task, that also was the way to my own freedom. Zarathustra is the commonly understood symbol.[6]

What Georg Kolbe wanted as a sculptor did coincide with and fit into the Nazi program. Most of his work lent itself very tidily to Nazi demands and nomenclature.

In this, Kolbe was not an isolated case. His influence on the younger generation was tremendous. There was a host of young men and women who followed in his footsteps. This is by no means surprising, since the road was both attractive and safe. Kolbe also lived in essential harmony with the German sculptors of his own generation, those born between 1865 and 1880, in pleasant, often close personal relations and community of ideals. Like Kolbe, Richard Scheibe and Fritz Klimsch [7] took their start from the German sculptor Hildebrand and, in France, from Rodin and Maillol. Under Kolbe's leadership they and many others sought expression mainly through the harmoniously beautiful bodies of youthful male and female nudes. It was an idealization of nature essentially in the classical tradition, but in contemporary articulation. Conflict and tragedy, strong characterization, and deviation from the norm of nature were avoided — altogether an approach that appealed to fairly broad audiences among the culture-conscious.

In German sculpture this group was the dominating one long before the Nazis came to power. The other progressive school, later to be denounced as 'degenerate,' was important but a distinct minority. Lehmbruck had died in 1919, Ernst Barlach was fighting a lonely battle, Kaethe Kollwitz worked only occasionally in sculpture, and men such as Gerhard Marcks or Ludwig Gies commanded attention among fairly limited audiences.

In the field of painting the exact opposite was true. There the leadership lay in the hands of the expressionist school and the other *avant-garde* groups. There were no artists of the caliber of a Kolbe, and devoted to corresponding ideals, among the German painters in the days of the Weimar Republic.

The suppression of the minority group of sculptors under Hitler is clearly reflected in the case history of the leading book on German

sculpture. In 1934 the Rembrandt-Verlag in Berlin published this important work by Alfred Hentzen, one time a curator at the Kronprinzen-Palais and since the end of the war director at Hannover. Hentzen did full justice to Lehmbruck, Barlach, and the other progressive sculptors. A new edition appeared in 1935 but was impounded by the Gestapo when a third edition was to appear. In its stead, however, the publisher brought out a book by Bruno E. Werner, which in addition to a full account of the Kolbe school and the outright Nazi group still contained brief references to and one picture each of Lehmbruck's and Barlach's work. But even this was too much for the SD (Sicherheitsdienst, Himmler's Security Police), which banned the book and removed it from bookstores and public libraries.[8]

All in all, the Nazis had an easy time in enlisting sculptors for their purposes. They not only found fanatic apostles for their creed among ambitious second-rate talents but they were able to utilize well-established and broadly recognized artists with very little direct pressure.

The whole thing seemed easy and natural. The official policies, clearly defined and vigorously propagated, played directly to the instincts of the broad public, flattered them, included them, told them what to feel and how to act.

Fritz Klimsch's elegant and noble-looking nudes were easy on the eye. His *Schauende* (Gazing Woman), cast just slightly over life size, was a particular favorite. One casting could be seen on the wall of the terrace of the Rasthaus am Chiemsee, the lakeside resort on the Autobahn approach to the Bavarian Alps. Many American families, staying at the Chiemsee rest center during the occupation, saw her sitting there, looking over the lake. Every visitor to the 1940 exhibition of German art in Munich was delighted to recognize her in a painting called *Die Kunstzeitschrift* (The Art Magazine) by Udo Wendel. This picture is a completely realistic self-portrayal of the artist and his home circle, almost photographically correct and detailed. It was as though the spectator at the exhibition were being invited to visit the home of the young painter, with his open collar and sleeveless pullover; to meet his father, the pen-

sioned official, earnestly looking at an issue of the magazine *Die Kunst im Dritten Reich;* and his mother, severe, but with a hint of warmth, looking at another copy of the magazine opened upon a reproduction, clearly recognizable, of the Klimsch nude. Smug self-satisfaction is the keynote; the German family taking its afternoon culture, obedient to the Fuehrer's wishes. One thing, of course, is missing. The young man is still a bachelor; in this regard he has not yet done his duty. But the family is looking at the Klimsch sculpture. Is it too far-fetched to read a meaning here which is not expressed in the title and which was perhaps not conscious in the mind of the painter? Can we not say that in addition to the obvious things we are being shown here, we are also witnessing the family assembled to pick the approved model-A bride from the mail-order catalogue? (figs. 20, 21)

Propaganda is always most effective and therefore most dangerous when it strikes into the subconscious layers of the mind, imperceptibly coloring, influencing, and forcing emotions and reactions.

———

Total Architecture

THE STORY OF Nazi architecture seems to me utterly fantastic. As the pieces fit together into a coherent picture, it is next to impossible to believe that these things really came to pass. They were not merely a feverish dream but, for a time, hard reality. The story is not a complicated one; on the contrary, the ideas behind it are simple. They are in fact so bare of artistic originality and real intellectual content, so naïvely dilettantic for the most part, that it is difficult to understand how so little could have been made to go so far. It was intense fanaticism, total obsession, utter 'hybris' which carried these plans through to realization.[1]

THE MEANING OF TOTAL ARCHITECTURE

The most important thing to understand about the Nazi architects is that these men were not merely creating certain structures that were needed, or that they thought were needed. Every building they planned or constructed was also part of a master plan for the rebuilding of the entire city in which it stood. But that was not enough. Every city was to be fitted into a gigantic pattern, a project that envisaged the complete remodeling of the whole of Germany in the Nazi image. Every house, every bridge, every tree was destined to become a monument to the power, glory, and beauty of the Third Reich. This sounds incredible. But these were indeed the intentions of Hitler and of those around him. And this was the idea which the people, that is, most of the people, embraced with

enthusiasm; the idea they brought into reality with characteristic thoroughness and precision. It was, in fact, total architecture.

I find it impossible to free myself from the notion that Adolf Hitler and the men around him really did tempt the Almighty, who took frightful vengeance and destroyed what they had built. Their structures were hastily put up in the course of a few years. They were meant to stand for eternity. Many of them lasted less than a decade; others now serve purposes quite different from the ones for which they were designed.

'Total war' is a familiar concept. The term was coined deliberately by the leaders of totalitarian Germany to harden their own people and to intimidate the enemy. The words 'total architecture' were never used. Yet that is exactly what this orgy of planning, this astonishing amount of actual building added up to.

Total architecture and total war, as we have seen, lived side by side in Hitler's brain. Constructive and destructive drives were inseparably linked in his character. Much of the seemingly peaceful building, the Autobahn, for instance, was carefully planned for double duty in peacetime and in war. The network of superhighways actually aided the final conquest of Germany by the Allies. The Autobahn ring round the German metropolis was the reason that, much to the surprise of the Berliners, the Russian armies entered the capital of the Reich from the southwest instead of from the east. This conquest of Berlin, paradoxically aided by its own highways, was only the ultimate seal of the catastrophic collapse that Hitler must have recognized as a possibility very early in his career. His stubborn refusal to end the war when its continuation was plainly useless caused not only the destruction of many of the Nazi buildings but also a great deal of irreparable damage to the historic and artistic monuments that Hitler had appropriated and monopolized as symbols of the triumph of the German race.

At the core of Hitler's planning were always the 'community buildings,' the Bauten der Gemeinschaft, a term conveniently taken over from the days of the Weimar Republic, when the concept had originated and was developed. The Nazis had only scorn for these efforts, which were recognized the world over as valid and effective

social pioneering of the first order. They could not quite ignore the achievements of their predecessors in their thoroughly and efficiently co-ordinated architectural literature. Passing tribute had to be paid to such pioneers as Tessenow, Schumacher, and Muthesius, but it was always added that the Weimar period of 'decadent, parliamentary liberalism' had not offered to these men the full opportunities they deserved. The Nazis often resorted to Marxist arguments. They found there convenient ammunition with which to attack much of the architecture of the Weimar Republic as a manifestation of 'private capitalistic business life.' Fairly early in his career, in his Kulturrede of 1935, Hitler said:

> As long as the characteristic traits of our big cities of today are department stores, bazaars [he probably meant the much maligned 5 & 10 cent stores], hotels, and business buildings in the form of skyscrapers as their most prominent visual accents, we cannot talk of art or yet of real culture.

One might be more tempted to give Hitler credit for saying something here with a good deal of truth in it if history had not demonstrated just what kind of 'culture' he propagated. 'To symbolize the life and power feelings of the man of today after centuries' was to be the function of the new cultural nerve center in the Nazi city, according to the official literature. The Nazis appropriated and corrupted Bruno Taut's concept of the City Crown, the Stadtkrone, developed by him in 1919 as a people's palace, a great democratic civic and community center to symbolize the city's life, a substitute for the ancient cathedral. The Nazi City Crown, by contrast, was to serve not democratic but autocratic purposes. To be erected always in durable stone, the assembly halls, theaters, sports arenas, and other representative buildings were to be permanent monuments to the power of one party and to the one man who held the reins. 'New city centers are to be created, new architectural focal points of such magnitude that they will dominate all private building. In the new designing of the city centers the solution of all other city-planning problems is of necessity included.' [2]

Here is the pure dogma of architecture and city planning in the dictatorship. These city centers were to set the tone for all future

buildings, they were to be the true expression of the will of the people, of their unified community. The buildings in these centers were to be placed around a representative plaza, which was always to be aligned with an enormous avenue of approach along a central, dominating axis, decorated with sculpture and ornamental plantings. All this was seen as developed from and as the permanent expression of the first manifestations of the party: 'Flags, flagpoles, grandstands, the conical beams of searchlights, these were the first building materials.' The tradition of the mass ceremonies of the French Revolution was merged with classicist city-planning ideas. Back of all this, the geometric patterns of ancient Greek cities, especially of Priene, were studied, published, and circulated.

And which were the communities to be redesigned in this fashion? Eventually, of course, all German cities and towns would have to be made over; but there were certain priorities. Nothing is more characteristic of the Nazi mentality than their choice of communities to be redesigned. An important feature was the renaming of the selected cities, or, rather, the affixing of new labels. Berlin, the 'Capital of the Reich,' came first, with Munich, 'Capital of the Movement,' a close second. Nuremberg, the 'City of the Party Conventions,' Stuttgart, the 'City of Germans abroad,' Hamburg, 'City of Foreign Trade,' Gratz, 'City of the People's Revolution,' are examples of localities signaled out for special treatment. Certain newly created projects were known only by such labels — the 'City of the Strength through Joy Cars' (where the famous Volkswagen were made), for instance, or the 'City of the Hermann Goering Works' (the big mining project at the northern slopes of the Harz Mountains) (fig. 6).[3]

It must be understood that these projects were not undertaken as isolated, separate plans. They were all connected with each other and conceived as parts of a nation-wide network. There were not only the remodeled existing communities and the specially designed new cities but also broadly scattered networks of special institutions outside the cities and towns. One must remember that after assuming power, the Nazis abolished all the traditional governmental subdivisions of states and principalities and substituted a

new system. The unit of this new division was called a 'Gau,' (a word with nationalistic, Nordic associations), each with a 'Gauhauptstadt,' its capital. Every one of these provincial capitals was to be redesigned as an administrative and ideological nerve center. Wagner's Bayreuth, Goethe's Weimar, Hitler's Linz were thus incorporated into the system.

Next, a network of ideological-indoctrination centers was created, the 'Ordensburgen' (Castles of the Order), where specially chosen youths were trained as the future leaders of the National Socialist Party and State. In many of these structures the grim brutality of the regime is powerfully expressed. The peculiar blend of asceticism and sensuality in the ideals of the 'order,' the menacing sense of being set apart as an aristocracy of crude power speak eloquently in the choice of the sites, in the placing and style of the buildings.

Excellent opportunities for the centralized planning of co-ordinated buildings all over the Reich were also provided by the needs of the army and, particularly, the air force.

Finally, the youth hostel, that wonderful outgrowth of the pre-World War I youth movement, and greatly fostered in the Weimar Republic, was absorbed, and corrupted, in the Nazi system. A dense network over all of Germany was envisaged, each hostel no more than about 16 miles, or a day's hiking distance, from the next one, and each providing both shelter and ideological-training opportunities.

These plans alone are ample evidence that Nazi architecture was indeed total architecture. But, incredible as it may seem, the idea was carried even further. It is true that literally the whole of Germany was to be redesigned. This plan found expression in certain key concepts which in turn gave birth to a special terminology. The words used were either old ones endowed with a new dynamic meaning or entirely new ones. 'Raum' (space) is the over-all dimension of this new creative process, 'heimat' (home or homeland) its meaning and content, and the 'Kulturlandschaft' (Culture Landscape) the desired result.

In the architectural thinking of all times the concept of space

has played an important role; but in the minds of the Nazis its meaning was extended beyond the individual building or group of buildings to the entire nation. Space became a target, something to penetrate, to occupy, to possess. It is no chance that during the war this word was used in nearly every military dispatch. It was actually a strategic concept. Architecture became an instrument of conquest.[4]

'Heimat' actually means someone's home, the place or region he comes from, where he was born, has spent his childhood, the place he longs for when he is homesick. The Nazis again expanded the meaning in a chauvinistic, racial way. As they used it, the word 'heimat' became an equivalent for the whole of Germany. The word also was endowed with mysticism; it was a secret charm that represented everything good in life and something with which to cure all evils. It was the magic source of all vitality and strength.

The Culture Landscape was the image of ultimate fulfillment. The entire physiognomy of the land, the work of nature and of man alike, the creations of all generations, past, present, and future, were to become one single monument of National Socialist achievement, strength, and power. Blood and soil, 'the aboriginal inherited characteristics and the aboriginal forces of the soil, determine the physiognomy of a people's homeland . . . The power of the races is the progressive element in the growth of a Culture Landscape — the power of space is the conservative force. Their co-ordinating struggle forms the physiognomy of the homeland.' [5]

Intimate study, careful preservation, and lavish publication of historic monuments became important means of mobilizing these forces. The medieval German walled towns, especially, were given new significance. Although they contained abundant Gothic elements and were far removed from classical Greek building, they were paradoxically upheld as models to be imitated. Even more important was the role assigned to the ancient villages and farmsteads. Their regional variations in north and south, east and west were used as the patterns for an enormous volume of new building.

The concrete, visual circulatory system of this new organism was the magnificent Autobahn, the network of superhighways, con-

structed under the supervision of Fritz Todt [6] and his labor army. The Autobahn was the first of the ambitious plans to see virtual completion. Its landscaping was carefully co-ordinated with the existing topographical features of the territory it transversed. Its really superb bridges were hailed for their 'uniform design in which the idea of the Reich finds a convincing expression . . . gateways to the East and West — fortunate completion of Germany, whose vital arteries they guide across to the territories returned to the homeland' (fig. 7).

The role of architecture in providing not merely practical instruments but also monumental symbols of conquest is clearly expressed here. This same idea governed yet one other network of special monuments, namely the soldiers' memorials in and outside of Germany. 'Totenburgen' (Castles of the Dead) was their new label.

On the rocky coast of the Atlantic there will grow up grandiose building structures, facing West, eternal monuments of the liberation of the continent from British dependence and of the unification of Europe under its German heartfolk. The severe, noble beauty of the soldiers' cemetery at Thermopylae is at the same time a symbol of the German spiritual inheritance of the ancient hellenic culture. Massive towers stretching high in the Eastern plains will grow into symbols of the subduing of the chaotic forces of the Eastern steppes through the disciplined might of the Germanic forces of order.[7]

In the minds of the planners the wall between planning and execution became transparently thin. Blueprints, elaborate three-dimensional models, and actual buildings were continuously published in a dazzling mixture of excellent photographic reproductions. Everybody was to share in this orgy of planning and building. With complete power concentrated in one hand the dictatorship had every right to feel that the fulfillment of its most exorbitant wishes was merely a matter of time — barring outside interference, of course.

PARTY BUILDINGS

It was in Munich that the long-prepared plans were first translated into actual reality. Conditions were especially favorable here. First,

the old medieval city at the foot of the Alps had been remodeled in the nineteenth century by that romantic classicist, King Ludwig II of Bavaria. The existing layout offered a convenient frame into which to fit the new projects. The magnificent old Koenigsplatz, flanked with world-famous museums, was just the kind of setting Hitler was looking for. He had had his eye on the site for many years. Secondly, Munich was the place where Hitler's decisive battles on the road to power had been waged. Here was 'the capital of the movement.' It so happened, and it was probably more than a mere coincidence, that the old 'Brown House,' the Nazi Party's first official home, was very near the Koenigsplatz, on the main axis which ran straight through it and onto the beautiful Karolinenplatz. This axis is crossed at right angles by the Arcisstrasse, and on this undeveloped flank arose two massive administration buildings in stern classicist style. Between them were placed two small open porticos of square columns, which housed in neat rows the stone sarcophagi of dead stormtroopers, killed during the early battles of the party (fig. 39).

The architect Hitler chose for the execution of this plan was Professor Paul Ludwig Troost (fig. 3). Troost was at heart a conventional Philistine of mediocre talent. He was a classicist who hated modern architecture. What he had done well were expensive and expensive-looking buildings and interiors for individuals and groups who wanted to demonstrate their wealth and solidity — private villas for industrialists, wine restaurants, and the interiors of the new North German Lloyd vessels, which ran from Bremen to New York. The great social hall of the *Europa,* for instance, which created a sensation when the vessel was first moored to its New York pier, was the work of Troost.

Troost worked as 'thoroughly' and 'diligently' as Hitler demanded. He produced classicist buildings of stodgy and massive impressiveness, with immense halls and stairways. They are spacious, mechanically efficient, and completely inhuman. Their very orthodoxy makes them pitifully overgrown caricatures of their noble protoypes. Like the rest of his buildings they returned to the traditional concept of the street façade as a major architectural

element. Their keynote throughout is ostentation and power con-
sciousness.

The other major project Troost developed was the 'House of
German Art' on the Englische Garten, the fine old park in the
heart of Munich. Hitler himself had laid the cornerstone for the
building in October 1933 during the first 'Day of German Art.'
The elaborately carved hammer which, he boasted, would serve
for all the cornerstone layings of the great buildings of the Third
Reich broke in two, and only the mighty flourish of the band and
the singing of the national anthem dispelled the effect of the pro-
phetic incident.

Troost did not live to see the completion of the building,[8] but
the work was finished by his long-time assistant, Professor Leonhard
Gall and Troost's widow, Gerdy, who was also given the title Pro-
fessor (fig. 4).

The building was solemnly dedicated by Hitler on 18 July 1937,
simultaneously with the opening of the first annual exhibit of Ger-
man art there. Hitler stressed the fact that the plan for a new art-
exhibition palace in Munich was an old one. He revealed his fear
that after the 1931 fire, which destroyed the famous old Crystal
Palace in Munich, his political adversaries, still in power, might
have got ahead of him on this important and rewarding project.
A public competition had been held for it. Professor Troost, Hitler
told his audience, had made some plans even then.

Nevertheless he did not submit them to the Jury even as competitive
designs, and only — as he bitterly explained to me — because of his con-
viction that it would have been quite useless to submit such work to a
forum to which all lofty and decent art was only a horror and which
saw the Bolshevization of our entire German, and thereby also of our
entire cultural life, as its highest and ultimate purpose.

Troost's 'lofty' and 'decent' structure was quick to attract popu-
lar satire. 'Bahnhofshalle von Athen,' 'Weisswurstbahnhof,' 'Kunst-
bahnhof' (Athens Railroad Station, Sausage Terminal, Art Sta-
tion) were the nicknames which the people of Munich promptly in-
vented for the dull structure.

After Troost's death the mantle fell upon the shoulders of Albert

Speer, a man of altogether different caliber. Quite likely, in his time and place, this man was given greater opportunities and more tasks to plan and execute than any other individual architect in the twentieth century. It cannot be said that he did not make the most of them. His career, until the collapse of Nazi Germany, was an amazing pattern of ever-widening responsibilities and achievements.[9]

He took orders from Hitler only, was himself an extremely able executive who could work well and harmoniously with others. He had an exceptional ability for arousing the enthusiasm of his associates and subordinates, for sustaining interest and vigorous performance, and for co-ordinating and integrating widely separated energies and operations.

Albert Speer was born in 1905. Architecture was his chosen profession. The first big official commission was given him by Hitler in 1934, when he was assigned the task of developing the vast grounds just outside of Nuremberg, where the annual party conventions were being held. He built the German Pavilion at the Paris World's Fair of 1937. On 30 January of that year he was appointed General Building Inspector for the Capital of the Reich, with extraordinary powers and appropriations.[10] The master plan for Berlin that he developed and started to execute was sweepingly simple. It could have been conceived only by a mind fully conscious of the backing of the highest authority of the state, aware of complete power and clearly defined priorities. The plan was really nothing more or less than a rectangular cross, made up of a north-south and an east-west axis, within rings of concentric circles. With the exception of the western half of the east-west axis, which closely followed existing avenues, much of the plan was arbitrarily superimposed on the extremely complex metropolitan organism. There had been many plans for the remodeling of Berlin under the Hohenzollerns, and the basic radial and concentric scheme has been common in city planning since Haussmann's work in Paris in the 1860's. The supreme authority of the Nazi state, vested in the single person of Adolf Hitler, who had complete confidence in Albert Speer, pushed these plans more vigorously than any previous

regime could have done. As a first step Speer remodeled the old Bismarckian Chancery in Berlin in 1938. Early the next year he reported the completion of the western arm of the east-west axis.

His jurisdiction was gradually extended to the planning of other cities and his influence was felt in all city-planning projects throughout Germany. The planning of the 'City of the Strength through Joy Cars' was his responsibility and so were Peenemuende, the V-Bomb city on the Baltic, and important projects in Hesse. He was in continued and close touch with Hitler over the Fuehrer's pet project, Linz on the Danube, and, of course, Berlin. Speer was also head of the special bureau, 'Beauty of Labor,' in Robert Ley's Labor Front.

After the beginning of the war he became increasingly useful and important in the war-production field. When Fritz Todt, then Minister of Munitions, died in an airplane accident, Albert Speer succeeded him. Gradually, he became Director of War Production, Director of Water and Power, and Plenary General for the Supervision and Reconstruction of Bombed Cities. In 1943 he played an important role in the councils of the top Nazis. Goebbels' diary is full of references to Speer, on whom he relied again and again as an emissary to the sulking Goering, whom Goebbels wished to draw back into the fold. He also saw in him a staunch ally in presenting to the Fuehrer his own point-of-view on the further conduct of the war.

How good an architect was Albert Speer and how good were the buildings he erected? It seems to me doubtful whether Albert Speer was himself a corrupt architect in the sense in which, let us say, the sculptor Arnold Breker was corrupt and in which even so great a sculptor as Georg Kolbe allowed himself to be infected. I find no evidence that Speer, who was not quite thirty when the first big Nazi commission came to him, abandoned any ideals to which he had previously dedicated himself. I do not see where he betrayed his better self, where he impaired his integrity in what he did. He believed in Hitler, accepted him as his master and friend, and executed what was demanded of him with a great deal of skill and ability.

It is necessary to concede all this. But it is equally necessary to recognize that his buildings, for the most part, were built on exactly the same formula and have many of the same weaknesses as the ones built by his predecessor, Paul Ludwig Troost. They are inhuman, cold, and aggressive. The New Chancery in Berlin is perhaps not quite so trivial and imitative as Troost's Philistine masterpieces, but Speer's structures, too, lack individuality and originality. They, too, are imitative classicism. More even than Troost's buildings they were designed with special emphasis on the façades, conceived as vast perspectives to be seen from rapidly passing motorcades. Very properly it could be argued that such criticism applies to much official building in many parts of the world, in Soviet Russia, Italy, and even our own United States. Architecture-conscious residents of Washington, D.C., will point with unholy glee to certain buildings that they feel are plainly influenced by Speer. But while such structures no doubt exhibit a similar traditional classicism, mechanically stretched out to proportions demanded by their purpose, they lack the peculiar flavor that Speer imparted to the Hitler Chancery in Berlin: a mixture of ancient Hellas with the sober, severe Prussian classicism of Schinkel, and, on top of that, the gaudy, lavish incrustation of Nazi symbolism. The effect is dull and rather oppressive. It is also a little sinister. There is always the hint of a barbaric cult, the scent of the Minotaur (fig. 8).

Albert Speer did know how to work with space. He was a clever stage designer on a monumental scale. His temporary decorations of the Unter den Linden on special occasions, his sense of pageantry on a colossal scale — the marshaling of huge masses of humanity in the great arenas at Nuremberg, for instance, the use of banners, flags, searchlights — these things he handled with extraordinary skill. Here he was original. Here he gave visual, organized expression of the totalitarian ideal. It is probably correct to say that this purposeful designing under the open sky, this filling of a permanent architectural framework with masses of humanity, went beyond the example set during the French Revolution or by the Soviets in Moscow's Red Square.

One other thought presents itself at this point. The Hitler build-

ings were alternatingly called 'Buildings of the Fuehrer,' 'Community Buildings,' and 'Buildings of Faith.' What really was the nature of this strange, barbaric cult that Hitler was establishing in worship of his own person? History does not relate too many instances of such self-deification, at least in modern times. And the very temples of ancient Greece that were so important to him as models were of course dedicated to the worship of many gods ruling serenely and sublimely from Mount Olympus. The adaptation of their temples to the Nazi cult is a complete fraud. The mythology on which it was based, or rather, which was synthetically allocated to its support, was a shoddy edifice. To designate Hitler's structures as community building is correct only in a very special sense, skillfully defined by Konrad Heiden: [11]

> The communal and the essential is always that the public ceaselessly collaborates, until that stage is reached which one could call inner transpiration: being perfectly imbued by the feeling that one is merely one piece of a single community of will, of faith, of deed if necessary, welded into one. In Hitler's assemblies there is no longer an audience, there are only participants.

This was the true meaning of the party-buildings program and of the city planning that grew from it. Nothing proves this so conclusively as the almost complete omission of residential building and public housing from the enunciation of the official program and the orthodox party literature. Here would have been the most fertile ground for the cultivation of a genuine community program.

What the People Got

'Private building,' according to Speer, 'is of such fundamental importance that we hardly need to speak of it.' Actually he and others did what was necessary, but to Hitler and his immediate entourage private housing seems somehow to have been ideologically uninteresting.

Robert Ley, the Minister of Labor, on the other hand, went in for exorbitant promises: 'We shall give you dwellings with plenty of light, air and sunshine!' After heavy air raids on Berlin the

bombed-out people would say to one another: 'Well, now we've got our houses with plenty of light, air, and sunshine!'

Unlike the housing projects of the Weimar Republic, which were planned and executed with great ingenuity, originality, and care, many of the Nazi buildings were put up hastily and badly. Moreover, special groups, such as the SS, munitions workers, and various members of the armed forces, were continuously being given preferential treatment.

A good deal of housing was, of course, completed by the Nazis. Their economy, based on organization for total war and world conquest, called for this. There was considerable technical study of the methods of economical construction.[12] In many essential features the example of the Weimar Republic was followed closely. It is highly improbable, however, that today's expert on modern housing would be able to discover anything original or progressive in the style of Nazi housing. On the contrary, the same retrogressive tendencies were at work which forced the development of painting into reverse gear and which molded the official buildings in the image of classicist absolutism.

The Nazis knew of course how much they were indebted to the pioneers of modern housing in the 1920's. They always said that these men were denied the real opportunities they had deserved. They would stress the evil effects of industrialization, the loss of craftsmanship, the *laissez faire* of a selfish bourgeoisie, the impotence of parliamentary liberalism. Then they would go on and include in this verdict the whole of twentieth-century modern architecture, treating it as one more manifestation of the disoriented and impotent age of liberalism. They could not quite overlook the truly revolutionary character of this architecture. But they interpreted it not as a valuable artistic revolution, as a genuine fresh start, but merely as political propaganda. In other words, they attributed to their adversaries many of their own motives and intentions. They saw in modern architecture the 'betrayal' of German culture by international Jewry, ignoring the fact that the ranks of modern German architects had included no more than a modest

percentage of Jews. Modern architecture to them was an instrument of the Bolshevistic world revolution. They were perhaps not aware of the fact that the government of the USSR was in hearty agreement with them in their hatred of modern architecture.

One feature in particular attracted Nazi wrath: the flat roof. In their eyes it was the one element that summed up and symbolized all that they hated. With singular vehemence, quite out of proportion to its significance, it was attacked as an 'Oriental' (meaning 'Near Eastern') characteristic. It was eradicated from practically all buildings in Germany. The flat roof has been criticized elsewhere in the world by those opposed to modern architecture, but nowhere has it drawn upon itself such concentrated fire as in Nazi Germany.

Public housing under the Nazis took the form of a return to the tight little high-gabled houses which had resulted originally from medieval town planning. These small houses were now erected row upon row in endless repetition, each in its separate yard — a complete reversal of the modern ideals developed in the Weimar Republic. The Nazis denounced these ideals as the breeding ground of 'Wohnmaschinen' (dwelling machines) but what they fostered was much worse.

The Nazi housing style was a fulfillment of the demands of the racists. It is no accident that by 1934 Dr. Hans Guenther, one of the most prominent prophets of racist art, had published a book warning against the dangers of urbanization.[13] Schultze-Naumburg's early demands were answered beyond what he had anticipated. Resettlement of the proletariat in the suburbs or, if possible, in rural areas was practiced in terms of fake peasant homesteads. The same policies accounted for the strong encouragement of the arts and crafts, as we shall see presently. There is a startling paradox in this insistence on the individual home, on the handmade object, on the revival of peasant culture in a regime which owed its rise to power to the use of the mass media and which sought to conquer the world by technological superiority.

What Hitler and the other Nazis concerned with public housing demanded was an expression of the national heritage, of the racial

characteristics of the German people, in their building. They saw the incarnation of this heritage in the medieval walled cities and in the old homesteads of the peasants on the land. The survival in any country of such treasures is indeed a priceless heritage and their care and preservation are a delightful and rewarding responsibility. Much had been done in Germany before the Nazis came to power. For instance, the most careful and loving restoration of the ancient core of the city of Frankfort on the Main was accomplished by a special department of its magistrate. This was the same administration under which Stadtrat May built his 'Roemerstadt' and the other low-cost housing developments that brought him international fame. The Nazis pursued the preservation of the ancient cities and farmsteads with vigor and systematic thoroughness.[14]

The objectionable part of these otherwise praiseworthy activities was their ideological underscoring. The house of the peasant, so went the official dogma, is the purest incarnation of the ancient tribal genius of the people, and hence the most important cultural root of a nation's building. House and garden, utensils, customs, and costumes, in characteristic regional variations, are the most faithful living manifestation of the ancient, pagan, Aryan heritage.

The role of the Christian Church was completely ignored. Its enormous spiritual, emotional, and educational influence throughout more than a thousand years was ignored. Likewise, the architectural role of the Church edifices, from cathedral to parish church, their dominant position in hundreds and thousands of cities and villages, was absolutely denied. Here again was the revival of vague, primordial memories into a barbaric present-day cult.

The architecture of the old peasant houses was used also as a weapon of conquest. The only valuable ethnological elements in the vast stretches of land held by the slaves to the east and the southeast of Germany, so the argument went, were the German colonizers and settlers. By virtue of their superiority all the lands were rightfully theirs. The German conquest was the 'return to the homeland' of these territories. One of the chief devices in dramatizing this argument was the peasant homestead. In popular exhibitions,

on posters, and in the magazines the location of these communities, the architectural classification of the buildings, and their connection with indigenous German building types were demonstrated through murals, pictorialized maps, and scale models.

This whole deliberate cult of folkloristic building traditions had an enormous influence on the current building activities in the Third Reich. Albert Speer's own home on the Obersalzberg, the Goering log cabins at 'Karinhall,' and his Rossitten hunting lodge — the last two stretched to the proportions of palaces — were built in this style. There were also public-housing developments in suburbs and rural districts, social halls and homes for factory workers, rest and training centers for railroad men, tourist inns, a great number and variety of army, navy, and air-force installations, and innumerable youth hostels throughout the land, all of which blossomed out with thatched roofs, wooden balconies, hand-hewn oaken beams, and wood paneling (fig. 23).

Baldur von Schirach was one of the few people bothered by the incompatibility of these tendencies with the theory that German art was the fulfillment of classical Greece. He had to perform some pretty strenuous ideological gymnastics in a speech given on the occasion of the celebration of the opening of eighteen new youth hostels, the raising of nineteen roof trees, and the laying of nineteen cornerstones.[15] He resorted to the concept of 'space' as an important educational force.

> Through educational space we must lead the people of our community, but especially the youth, toward that uttermost honesty and truthfulness which will make them into sterling champions, in the insistence upon their cultural living demands, of the feeling of style acquired in their youth . . . Even the most modest space unit created by human effort can become a symbol of eternal beauty through the spirit that conceived it. Repeatedly the Fuehrer has called our youth buildings exemplary in this sense. I believe that we have rightly understood his architectural will in so far as we did not take over the exterior example of the Koenigsplatz for our work, but sought to fulfill our modest work in the spirit of its creators, in obedience to the inner law of this lofty space . . .

Earlier in this speech von Schirach had warned against some of the dangers of the regional style in architecture:

The suburban villa of Berlin in a peasant village is no doubt nonsense. No lesser nonsense, however, is the whitewashed Tyrolean peasant house transplanted to a Berlin suburb.

Such warnings are an interesting acknowledgment of existing abuse. But even where the location might conceivably have justified the resort to local peasant traditions, the purposes of the buildings presented stylistic problems that were frequently not solved. Defects developed here that were closely paralleled by the defects of the Nazis' classicist buildings. The functional requirements of Troost's Haus der deutschen Kunst were basically incompatible with the natural proportions of a Greek temple, and the 'Athens Railroad Station' was the result. Among the youth hostels, the armed-forces installations and the special training schools built in the local peasant style, we very frequently find the same absurdly mechanical inflation of the natural proportions of the original models. A great many of these buildings are monuments only to the basic incompatibility of their form and function. They are the products of reactionary sentimentality; they, too, look backward rather than forward.

CORRUPTION AND IMMUNITY

Was all architecture in Nazi Germany bad architecture? We have seen that it in no way justified the exorbitant claims made by the regime that it was a powerful new expression of a new way of life. On the contrary, we found most of it trivial, superficial, and, above all, imitative and unoriginal. Certain buildings, we have to admit, were effective expressions of the Nazi ideology. To call these good architecture would require an almost superhuman degree of detachment for anyone not in sympathy with these ideals. From the point of view of pure achievement certain of the projects, especially the Autobahn, are remarkable performances. The painfully slow progress of similar projects in a democracy, the cumbersome administrative machinery, the delays and interruptions might make one a little envious of what a totalitarian state can accomplish. Is it necessary to remind ourselves what price has to be paid for such efficiency? Can we overlook the fact that the kind of supreme, concentrated authority that alone accomplishes such miracles must

inevitably attempt to control as tightly as possible every other phase of public and individual existence?

Again, was there any building which escaped the ideological pressure of the totalitarian state? Yes, there was some. We can find certain isolated instances of fortunate accomplishment, an individual building unit here, an interior there, where talent found an opportunity for a happy solution. Far more significant, however, were some entire groups of buildings and projects that turned out well. We find first-rate architecture among the smaller, more intimate youth hostels, and especially among the social buildings for workers. Certain workmen's rest centers in industrial areas or those for the employees of federal services, post office, and state railroad escaped the exaggerated folkloristic treatment. Some of these dining halls and sleeping quarters breathe a pleasant, intimate spirit of unpretentious comfort and relaxation. Certain hospitals were built in a most effective combination of efficiency and good taste. Werner March's Olympia Stadium and the Reichssportsfeld [16] fit their purpose beautifully. A number of fine churches were built. Some of the military installations turned out well. The air force in particular commissioned excellent administrative layouts. Many Americans learned to appreciate the architectural qualities of the headquarters of the Luftgaukommando (Air District Command) of the greater Berlin area in the beautiful Zehlendorf suburb. After the war these buildings served as headquarters for the U.S. Military and Civilian Administration. The air force headquarters in Kiel is built in the same rather dignified, neutral style, which forms an agreeable contrast to the ostentation and aggressiveness of the official party buildings.

Probably the finest architecture in Nazi Germany was commissioned by industry. These structures are quite unaffected by the Nazi influences; they appear to have remained completely immune to ideological penetration. Their design is linked in unbroken tradition to the excellent developments in industrial architecture that began early in the twentieth century and came into full bloom under the Weimar Republic. In this one field progress continued unhampered.

The Autobahn remains as a decidedly positive achievement. Some of its bridges are really superb, both technically and aesthetically. They are the one kind of building in which modern techniques and appearances were not only welcomed but stressed — so much so that parts of the Autobahn system seem almost anachronistic in the Hitler picture.

There are two main reasons why not all of German architecture under the Nazis succumbed to their corrupting influence. The first reason is a political one. Certain groups in the Third Reich were so powerful and influential, so necessary to Hitler and his regime in the accomplishment of his aims, that for a while they succeeded in escaping complete 'co-ordination.' Big industry is certainly one of these groups. Many of its leaders had helped Hitler to power in their attempt to stem the mounting tide of communist expansion. Hitler was indebted to them and he remained dependent upon them to a certain degree. Within limits, industry in turn enjoyed a certain degree of freedom and independence of action. The solution of the architectural problems in industrial construction did not have to comply with ideological demands.

A somewhat similar position was enjoyed by the armed forces. A battle of epic proportions was waged between Hitler and the army over the preservation of its independent authority throughout most of the Nazi regime. The 20th of July, 1944, the date of the abortive attempt on Hitler's life, was the climax of this struggle. It found its expression in architecture, especially in the neutral, non-Nazi style of much of the building program of the air force. The Church in many instances continued to fight for its independence, and this battle, too, is reflected in its architecture.

The other reason for the existence of some good architecture in Nazi Germany is found in the nature of the medium. Unlike painting and sculpture, architecture is not a 'free' art. It serves a number of definite purposes. Potentially monumental in scale, it is nevertheless applied art. The degree of corruptive influence of Nazi ideology can be seen as inversely proportional to the degree to which a building serves a practical purpose. Corruption is strongest in the representative buildings of the party which serve primarily

ideological purposes. It is weakest in buildings with a maximum
of practical purpose, such as industrial structures or roads and
bridges. Church architecture — nonutilitarian yet incorrupted —
is an exception.

It can be said that the Nazi ideology affected German architec-
ture adversely wherever it was vulnerable, but there were certain
areas that remained immune to corruption, regardless of how hard
the Nazis tried to co-ordinate them. Architecture as a whole ap-
pears to be somewhat less vulnerable to totalitarian corruption than
are painting and sculpture. Painting, it would seem, lends itself
to complete, and sculpture to almost complete, corruption. In com-
paring the degree of corruptibility of the various media we must
of course take into account the fact that architecture is by its very
nature exposed to public view. You cannot hide nonconformist
building as you can paintings and sculptures. Only the corruption
of officially encouraged or tolerated painting and sculpture can be
measured and compared with architecture. The outlines of a new
biological law of artistic creation seem to show themselves in these
observations. If such a law has validity, it would follow that those
arts that are even more closely tied up with utilitarian purposes,
namely the so-called 'arts and crafts,' the design and production of
useful objects, must exhibit an even higher degree of immunity
to totalitarian corruption. Was this the case in Nazi Germany?

X

Gestapo in the Gift Shop: The Story

of Arts and Crafts

ONE OF THE STRANGEST documents ever to come my way was one I found in the files of the U.S. Documents Center in Berlin-Zehlendorf. It is a report by the SD, the Sicherheitsdienst (Security Service), a branch of Himmler's Gestapo, which kept constant watch over any possible weak points or ruptures in the fabric of the Nazi state. One of its chief modes of operation was the continuous sampling of public opinion. The results of these surveys were incorporated in special reports which were circulated to the various political leaders. For instance, in January 1942 the SD handed over to Hitler a report on defeatist tendencies in the German high command, in connection with the freezing to death of masses of soldiers on the Eastern front. To cite another example, Joseph Goebbels wrote in his diary on 9 March 1942: 'I read a detailed report from SD and police regarding the final solution of the Jewish question,' to which he added, a few lines later '. . . the situation is now ripe for a final solution of the Jewish question.' [1] And what was the subject of the SD report in the U.S. Documents Center, written probably during the same month, March 1942, in which the one on the 'final solution of the Jewish question' was being prepared? It is concerned with the poor taste of objects of art offered for sale through various retail channels:

Lately, reports come in from all over the Reich, complaining that during the war inferior art products are increasingly offered. In art galleries, but especially in glassware, furniture, picture-framing, picture-postcard, and similar stores great quantities of these inferior objects of art are increasingly offered for sale . . . There is a lot of complaining, in the working classes and the less well-off groups, about the prices of so-called arts-and-crafts objects . . . Through this flood of inferior products, among other effects, all efforts toward a positive art education of broad masses of the population are again and again frustrated . . . Because of the mass invasion of inferior products there is apprehension over a serious aberration of taste among the population, which will interfere, for years to come, with all positive art education of state and party . . .[2]

The report attempted to fix the responsibility for the deplorable lack of taste. It focused attention on the question of membership in the Reich's Art Chamber. Its department No. VII embraced all workers in the arts and crafts, along with their professional associations, exhibiting bodies, and artists' groups. Department VIII included all art-galleries and antique-shop owners, art publishers, and art auctioneers. The SD report quoted the artists as those especially dissatisfied with the state of affairs. How was it possible, they asked, that the majority of the producers of these artistically inferior objects were members of the Art Chamber? 'There is much astonishment in art-loving circles of the population that the numerous producers of inferior art objects, through the granting to them of membership in the Chamber, were thus given express permission to produce such cheap junk.'

The SD had made its report in pursuit of its normal duties. The development and maintenance of artistic standards, the beautification of objects of everyday life — these matters were part of the stated policy of National Socialism. A lowering of standards anywhere, a loosening of the tightly knit fabric of control at any one point could endanger the cohesion of the whole. The totalitarian state could not tolerate laxity anywhere. Wherever necessary, the SS, Gestapo, and police moved in as a matter of course. To the observer in a democratic country this picture of the policeman officially enforcing good taste in the gift shop around the corner is

grotesque. In the totalitarian state it becomes perfectly natural.

The acceptance by almost the entire population of this type of governmental control is also significantly documented in this report. It speaks of the complaints as arising among both artist and lay circles in Styria in the Alps, in Hesse, Bielefeld, Thuringia, Karlsruhe, Kiel, Duesseldorf, and in many other regions and towns. These people may have enjoyed letting off a bit of steam at the expense of their government and perhaps the artists felt some personal and professional jealousy. But there is no doubt that the people in general accepted government responsibility in these fields. They had accepted the doctrines and expected to see them lived up to.

Of primary interest is the degree to which the arts and crafts responded to all the official Nazi coddling, to this constant shower of attention by the various organs of the state. We should know a little more about the official policies, the ideological demands, and the actual mechanism of encouragement and control. Government participation in the arts and crafts was of course not new with the Nazis. It was a typical feature of cultural life in pre-Hitler Germany and it was and still is both a tradition and a practical reality in most European countries. The Nazis simply took over; they injected themselves into the existing structure, and they added their own agencies.

The Chamber of Art cultivated the arts and crafts with the same intensity it applied to other creative fields. Late in 1937, for instance, Professor Ziegler created a special working committee of German arts and crafts, the Arbeitsgemeinschaft des deutschen Kunsthandwerks.[3] This committee was to concern itself with artistic standards, and be the liaison between commerce and industry; it was to supervise the training of retail dealers and the creation of sales outlets and to encourage participation in fairs and exhibitions. 'This committee will work in close understanding with me,' ordered the Nazi art boss.

In March 1939 Ziegler announced an important project during a reception at Schloss Schoenhausen near Berlin, where arts-and-crafts exhibits were a recurring feature.

Everywhere today we can observe how an understanding for tasteful creation of practical objects of everyday use is increasing, how appreciation for work that has beauty and style is growing among ever-widening circles of our population, and how the demand for quality products for domestic needs and cultural living in the homes is mounting. However, there is a demonstrable lack of means to make it easier not only for the layman interested in model products but also for the retailer, acting as middle-man between producer and consumer, and for the architect, entrusted with interior furnishing and decoration, to select from the wealth of offerings the most beautiful and most suitable objects in terms of material, style, and execution. I have therefore ordered the 'Kunst-Dienst' (Art Service), in collaboration with the various interested organizations and the most eminent experts, to edit a *German Standard Manual of Products*.[4]

This manual, the *Deutsche Warenkunde,* was indeed an ingenious instrument. It was a looseleaf, illustrated catalogue, a standard inventory of all objects of domestic use that measured up to rigid requirements of material, workmanship, and artistic style. Each object was illustrated, material and technique of manufacture were described, the price was given, and its producer identified by name and address. Here was the most complete realization by governmental decree of a project that has been repeatedly attempted in other countries and societies — in the United States, for instance, in exhibitions and catalogues sponsored by the Museum of Modern Art in New York.

There were still other official attentions to the arts and crafts. Rigid control and lavish encouragement always went hand in hand in the Third Reich. Through the official building program funds were made available for the other arts. Money was made to flow not only to city planners and architects but also to painters of frescoes, mosaic makers, tapestry weavers, to landscape architects, to interior decorators, and to the entire field of the arts and crafts. This was attained mainly through an exceedingly simple act of legislation which decreed that a specified percentage (2 per cent, I believe) of all funds appropriated for public building had to be spent on the embellishment of each structure with, say, sculpture, ceramics, or metal work.

Yet another important means of public encouragement was the official exhibitions of the arts and crafts. There was a never-ending stream of minor and major exhibitions throughout the years.[5] The arts and crafts were made part of the official annual architecture exhibitions in Munich. The 'First German Architecture and Art Craft Exhibition' was held there at the Haus der deutschen Kunst in the winter of 1937–8, the second one in the same place the following winter. These exhibitions were very carefully laid out. The catalogue [6] contained an exact plan, with a red 'leader line' showing the visitor exactly how to proceed from hall to hall and from case to case. Every item of course had a number by which it could be identified in the catalogue.

The list of exhibitors gives an astonishing picture of combined individual and corporate sponsorship. Government at various levels can be seen here actively participating both as a sponsor of training schools and as the actual manufacturer of arts-and-crafts objects. The list of participants included not only a large number of individual artists and small and large firms but also academies, arts-and-crafts schools, master-, model-, and trade schools of municipalities, regions, and states. States and cities were also represented through various special production units, such as workshops for china, majolica, and amber, and through their planning and construction bureaus. The Nazi Party was represented by its Hauptamt fuer Volkswohlfahrt (Central Bureau for the People's Welfare); the Bund deutscher Maedchen (Association of German Maidens); the Reichsjugendfuehrung (Reich's Youth Administration).

The doctrine of blood and soil provided the ideological basis. An article describing the second annual exhibition in Munich included the following words:

In this field of art the center of gravity has shifted more toward the inner core, toward the beginning, the genesis. It is no longer the finished product which, isolated from its natural origin, tries to convince us as merchandise, and is set before us in its respective fashionable garb (which claims to express a 'new style'); rather, the work represents a backward connection, in such a way that in the finished piece there become visible and tangible all the thousand form-giving manipulations by

which it was fashioned from material provided by nature and grown by nature. As one holds the finished piece in one's hands it becomes a piece of molded nature, it appears as a bridge toward the elementary world of creation. For who does not feel in the shape of the flat silver bowl the shining coolness of the metal wrought from the earth? And before a wooden vessel, before a weatherbeaten sturdy oaken wardrobe or a light table of birchwood there opens up suddenly in extended perspective the road back to where this piece of fashioned wood still stood as a tree in the forest . . . Nature reaches with its arms into our urban dwellings.[7]

This is perhaps rather extravagant language, but the idea behind it is not really original. People all over the world enjoy the beauty and strength of the materials the good earth provides, although not many would care to parade their feelings in just such terms. The Nazis acted as though they alone had discovered, or rediscovered, these things. Their official line closely resembles their version of the history of architecture. Nineteenth-century industrialization, they claimed, killed off the arts and crafts and it was the Nazis who revived all these things. For the most part they simply ignored everything that had happened from the moment the first continental European read something by John Ruskin or William Morris sometime in the 'nineties right down to the establishment of the famous Wiener Werkstaetten, the Deutsche Werkstaetten, or the 'Werkbund.' Occasionally these things would be damned with faint praise as useless efforts in a world already doomed and rapidly approaching final disintegration.

Wood in particular was claimed by the Nazis as the typical material of the Germanic race. 'Only the Nordic race has achieved such perfection in the treatment of wood and only it possesses such a decided feeling for the beauties that lie in the material, in the grain and the color of the various kinds of wood.'[8] It is hardly necessary to remind the reader of what Celtic and Slavonic people have done with wood, to mention the totem poles of the North American Indian in Alaska, the ebony carvings of the African Negro, the Buddhist sculpture of India and China, and the masks of ancient Japan.

Not all the official Nazi writing about the arts and crafts was

ideological. The German Labor Front had a department on handicraft which issued a remarkable volume of text and illustrations,[9] with separate sections on ceramics and glass; metals; woodwork, braiding and toys; weaving, lace, embroidery, and leather, each edited by an expert in that field. Only the author of the introduction to the woodwork section found it necessary to 'toe the line.' All the other articles were written in a completely factual vein without any ideological references whatsoever.

A certain deviation from the official party line seems to have been tolerated, or at any rate it managed to get by, in unofficial publications about the arts and crafts. Walter Passarge's *Deutsche Werkkunst* is an example.[10] The work of a professional art historian, art pedagogue, and museum man, it conforms generally to the official ideology. But Passarge does manage to give full credit to the fundamental efforts made in the arts-and-crafts field under the pre-Hitler regime of Germany. A peculiar inconsistency in an otherwise strong official line about the arts and crafts was that Hitler himself ignored them almost completely. They did not provoke him one way or the other and he left it to the specialists to co-ordinate them into the program.

Ziegler and his subordinates at the Art Chamber and other officials concerned with Nazi art life exerted themselves to the full extent of their imagination and power. But curiously enough, they did not get very far. Somehow or other, the arts and crafts did not yield much to their persuasion. The actual products were not too much influenced by all the talk and all the coddling. The work went along pretty much as it had before Hitler. It did not offer opportunities for indoctrination, it resisted corruption to a remarkable degree. We have just observed certain weaknesses and gaps in the official ideological approach. These were probably not the results of mere oversight. One strongly suspects that they reflect certain 'difficulties' inherent in the material itself. It appears that the arts and crafts do not respond very favorably to ideological treatment.

Within the arts and crafts, as was the case with architecture, there were, of course, differences from one type of work to another. The

ideological influence was strongest in the products that called for some type of free representational treatment and for the application of symbols and emblems. Woodwork, as was to be expected, proved most vulnerable. Nothing could be more corrupt, for instance, than a woodcarved wardrobe made by Klara Ege and commissioned by a group of SS men as a birthday present for their local leader.[11] It was covered with swastikas, runic inscriptions, life-symbolizing roosters, tripods, and every other conceivable nonsense. The actual carving was lifeless and flat, and the piece of furniture a stodgy and apish imitation of traditional peasant work (fig. 30).

Along with the influence of folk art the rigid classicism of Nazi architecture made itself felt, especially in the Munich area, where Professor Troost's example was hard to avoid. Frieda Thiersch, the technically superb hand binder of the Bremer Presse, well known to bibliophiles in many parts of the world, fell completely under this influence.[12] The design and gold-tooling of her specially bound dedication copies, diplomas, slip cases, and guest books for the Fuehrer and other party bigwigs (many of which were gleefully 'liberated' by curio-seeking GI's in 1945) were perfect adaptations to hand binding of Troost's heavy representative style. Troost and members of his staff were also consultants to a Munich arts-and-crafts firm, the Vereinigte Werkstaetten fuer Kunst im Handwerk. Their pompous boardroom interiors enjoyed top billing at the official exhibitions. This work and other work in a similar style provided the dominant note, with the folk-art style a close second. The third most important style represented in the Munich exhibitions was of a vaguely historical nature, playing on medieval and Renaissance motifs, with an occasional Oriental touch added. About midway on the scale of importance, to judge from the reproductions in the official catalogue, were groups of objects competently produced in what might be called a neutral contemporary style and products that were decidedly modern in spirit. A small number of items were done in a somewhat modernized version of classicism, while a few of the things are hard to fit into any particular category.

It would be a mistake to base an appraisal of the arts and crafts in Nazi Germany only on the evidence of the official Munich catalogues. Ideological pressure was particularly strong there and it certainly influenced the selection of the material featured in the exhibition and reproduced in the catalogue. A very different picture emerges from an examination of other sources.

A volume published by the German Labor Front [9] contains approximately 200 full pages of excellent halftone reproductions, including historical examples and some objects produced in the Scandinavian countries, in Hungary, and in Italy. How strong was the Nazi influence on these things? In measuring the degree of ideological corruption of the objects shown I have attempted to classify them into the same categories of style suggested by the Munich catalogue. Historical items produced in earlier centuries and objects done outside of Germany were omitted from the tabulation. The jewelry, too, was left out, because it seemed to defy classification. The remaining items can be roughly grouped as follows:

Modern	67
Neutral contemporary	31
Folk art	30
Period and Oriental	23
Traditional, representative "boardroom"	18
Modernized classicism	2
Nazi representational and symbolic	2

One can say that the folk art, the 'boardroom,' and the Nazi representational and symbolism groups show direct influence of Nazi ideology in varying degrees. Not every item in each of these groups is necessarily affected. But even if we were to assume that this is the case, these groups total up to only 50 out of 173, or up to 30 per cent at the most — a very low figure, compared with the other arts. There are entire sections, the ceramics, the glass, and the metal craft, which present nearly unbroken sequences of stylistically and technically first-class performance (fig. 31).

A similar analysis of the arts and crafts reproduced and discussed in Passarge's book [10] shows an even lower percentage of potential

and actual infection, less than twenty per cent. Here, too, the glass, the ceramics, the china, and much of the metal work make an excellent showing by any standard of judgment.

For purposes of comparison it would be interesting to express the degree of corruption of the other arts also in percentages. There are no statistical surveys or exact numerical counts available for such an attempt. Perhaps a rough estimate, based on years of observation, can be submitted. My guess is that the figures would be approximately as follows:

Painting	80–90 per cent
Sculpture	70–80 per cent
Architecture	40–60 per cent
Arts and Crafts	20–30 per cent

These figures, I believe, suggest a hitherto unrecognized law: the law of immunity of the arts to ideological corruption. Its real significance lies in the fact that it is typical not only of the Nazi regime but also, as we shall see, of any totalitarian regime. It offers an important clue to the fate of the arts in any twentieth-century dictatorship. Above all, this law has important implications for the future.

———

The Archaeologist in SS Uniform:
Planting the Nazi Time Bomb

ART AS A WEAPON AGAINST CHRISTIANITY

IN MAY 1945, immediately after V-E Day, I was sent to Leipzig on a psychological-warfare mission concerning German publishing. Visits to bookstores were fascinating adventures. The booksellers were ready for their new masters. The Nazi-propaganda books had been packed up and stored away, neutral literature occupied the center of attention, and a few battered volumes of hitherto banned authors were pulled out from under the counter.

A charmingly illustrated book of Christmas carols caught my eye with its beautiful color work, clear notation, and attractive typography. It was almost unbelievable that this book should have been printed and published only a few months ago, amid the bombing and turmoil of total war. But the title page clearly and unmistakably bore the date 1944. It was called *Soon Now It Will Be Christmastide, a Christmas Carol Book for the German Family.*[1] I was a little surprised. Our analysis of enemy broadcasts had shown a decided tendency to ignore Christmas as much as possible. Goebbels, we learned later, when his diary was published, had written on 18 December 1942:

The Christmas program for radio and the press has been submitted for my okay. We are limiting ourselves to only a few broadcasts and editorials dealing exclusively with Christmas. It won't do for the peo-

ple in these difficult times to fall too much for the sentimental magic of these festive days.[2]

Yet here were these carols before me. It was really a lovely book to look at, with its delicately tinted pictures. There were snow-covered pine trees, the animals of the forest, snow men, gift-bearing Santas, horses and sleds, apples and nuts, and 'Pfefferkuchen' — all the familiar trimmings. All of them? Something was missing somewhere. What was it?

At my billet that night I took another look. The songs did not seem very familiar. I recognized Matthias Claudius and Wilhelm Hey of fable fame among the authors, but many old-time favorites were missing. Where, for instance, was *Silent Night, Holy Night?* I turned to the index and found that *Stille Nacht, Heilige Nacht* was not included, nor were any of the other Christmas carols that I had known as a child. But wasn't that *O Tannenbaum* there on page 23? Sure enough: 'O Tannenbaum, o Tannenbaum . . .' but no, that was not it; it went on quite differently, altogether another song.

Neither did the pictures look so good any longer. They were a little too cute, too pseudo-Bavarian, too self-consciously folksy, altogether too blond and blue-eyed to ring quite true.

Gradually, it began to dawn on me what had happened here. There was an introduction by a young man who, I later learned, had been the leader of the Nazi Youth Choir of the Berlin Radio, and had taken orders from Baldur von Schirach, the supreme leader of all Nazi youth. This introduction furnished the key:

For the family and for its singing and playing this book has been fashioned. For old and young it tells of snow and ice, of the animals of the forest, of the green pine trees, of the stars in heaven, of all living nature between the dark days and the miracle of the growing light. It brings old and new fairy-tale songs, poems and narratives of Ruprecht and the Christmasman, songs of the cradle and of Christmas, and it thereby wishes to contribute to the right celebration and to deepening the significance of our most beautiful German festival, Christmas . . .

Christmas without Christ, that was the meaning of it. It was a very clever deception, skillfully designed to take in parents and

children in search of a carol book. It had even taken in the book-seller, who had failed to clear it away; it was so very nearly like what one had always known. There was even a cradle pictured in it, but it was an empty one, and the words that went with it spoke only of a mother sewing and a man building the cradle next door and some vague perfume of flowers in the room (figs. 26, 27).

The importance of this case is hard to exaggerate. Here is an excellent, tangible example of a seemingly harmless, casual jug-gling of symbols and values which actually is an extremely sharp weapon.

Before the war some examples of hate propaganda in German children's books had reached the United States. These books were issued by that raving madman, Julius Streicher, publisher of the *Stuermer* and Gauleiter of Nuremberg. One was entitled *Trau keinem Fuchs auf gruener Heid' und keinem Jud bei seinem Eid* (Trust no fox on the green heath and no Jew's oath) . . . It was so obvious and so hideously ugly that one almost had to smile. It seemed too crude to be really dangerous.

The little Christmas-carol book was far more subtle and far more dangerous. It undermined emotions, beliefs, and attitudes that still stood in the way of universal acceptance of National So-cialist doctrines. Pictures and text here attacked attitudes and habits that might still furnish the basis for some spiritual resistance or at least psychological indifference to the regime.

The clever and dangerous thing about such a book is the fact that it is not a direct attack upon Christianity. Christmas, the tradition and the institution, too firmly entrenched in German family life to make its prompt elimination profitable or even possible, must remain respected. But the inner core of its Christian meaning had to be destroyed and a new meaning supplied.

The basic, avowed mythology of National Socialism is not the love of one's neighbor but the superiority of one particular breed, the Nordic superman. Ancient pagan, pre-Christian mythology must be revived artificially to elevate an arbitrary doctrine from the realm of reasoning into the realm of believing. Where this creed and its synthetic mythology cannot be propagated openly, it must

be insinuated under a false label. It must appear sufficiently similar in its outward appearance to the old beliefs to allay suspicions and prevent rejection on first sight.

This is the exact formula by which our nice little Christmas book was concocted. There must be no Nazi emblems. The harmless trimmings, the things about Christmas that attract the children, are all retained. There are also some vague allusions to motherhood and the cradle — a tapering off of Christian symbolism. These elements are mixed with pagan symbols, which in turn are implanted on the lingering memories of pre-Christian folklore. There is, of course, no Santa Claus, no saint, but first a snow man made from the snow that Frau Holle, the old woman up above who shakes out her bedding, sends down to earth, together with her faithful servant, Knecht Ruprecht, a sort of old-time friendly bogeyman. He is followed by 'Christmasman,' who is also an old-time favorite of German children. But these men are no longer angels from heaven, servants and heralds no longer of Christ but of Nature and a vague sun cult centering around the winter solstice.

In high SS circles, among certain aristocratic families in the entourage of Himmler, for instance, it was actually the twenty-first of December rather than Christmas Eve or the twenty-fifth that was celebrated with all solemnity in homes decorated in a sophisticated version of Bavarian peasant style, with runic formulas carved into the woodwork. The wives would receive modern replicas of newly excavated Germanic fibulas as cherished gifts from their SS husbands. This was the pattern to which German family life was to be converted, away from every possible vestige of genuine Christian life. This was of crucial importance and had to be done with caution and skill, not suddenly and brutally, but by means of an emotional fifth column.

It cannot be emphasized sufficiently that all these efforts were not casual by-products of the main political doctrines. The surprise or the indifference with which many people today are witnessing the vigorous resurgence of National Socialism in Germany only proves that somehow the world is still underrating the Nazi indoctrination of the German mind despite all that has been said

and written on the subject. We still have not understood properly the methodical thoroughness, the cunning subtlety, the dreadful consistency with which the leaders of National Socialism seized hold of the souls as well as of the bodies and the minds of their people. Their battle against all traditional religious beliefs, and especially against the allegedly Jewish heritage of Christianity, has been far more successful, far more lasting in effect than we have realized. In this battle, art assumed a particular importance; it proved a very effective weapon in the hands of the Nazis.

One important reason for the enduring success of these ideological campaigns is that they were so often aimed at the subconscious layers of the minds of the people. By continuous infiltration of cultural propaganda, so skillfully disguised as to be recognizable only to especially alert intellects, the most damaging, long-range effects on the mental apparatus and the emotional functions of the average individual in the Nazi state were achieved. This was the Nazi time bomb, perhaps their most awesome weapon, which would outlast the life span of the wartime leaders and survive the military and political defeat of the regime.

Now what about the role of art in this subconscious infiltration? Obviously, we are no longer concerned with contemporary art, but have moved to the sphere of art scholarship, of interpretation and evaluation of historic manifestations. It may surprise the reader to see the art historian charged with political and ideological tasks. Yet there are a number of reasons why this was indeed an inevitable step. The first of these is the simple fact that the totalitarian state projects itself into every aspect of life. Secondly, the insistence on the alleged 'racial genius' of a people as the mainspring of its creative achievement called for a genetic substructure. In the ideological conversion of the history-conscious German middle classes, with their traditional respect for scholarship as well as for the trappings of learning, the introduction of the historical dimension was an inevitable necessity. These considerations alone would be sufficient to explain the inclusion of art history and with it of archaeology and the pre-history of art in the Nazi program. Yet I think there is one more reason as potent as all the others put together,

namely the particular usefulness of art history in the battle against Christianity.

The full story of this battle does not belong in these pages and it is indeed something that deserves more than passing reference. It is hardly necessary to emphasize again that Christianity, in spite of various attempts at circumvention and compromise, was something that the Nazi state could not tolerate. It was its most formidable international enemy, probably considered by the leaders even more dangerous to the regime than communism. Yet the frontal attack was too costly, as was readily discovered. Christianity was too firmly entrenched among the German people, not only as a religious belief but also as a social organism and, especially, as a source of custom and habit, to permit a successful direct campaign. An attack upon its spiritual core could easily backfire. Obviously, an indirect campaign was indicated, aimed not so much at the person of the Saviour and the essence of his teaching as at the outward manifestations of Christian religion, its mythology, ritual, festivities, and attendant customs. The particular effectiveness of such a campaign, the Nazis realized with a sure instinct, lay in its capability of alienating, gradually and almost incidentally, all those to whom Christianity was a matter more of form than of content — in other words a majority of the people. The resulting vacuum had of course to be filled with a different, new religion.

The main line of reasoning in establishing such a thing was a very simple deduction from the dogma of the Nordic-Aryan-Superman. The superior ancient Germanic tribes, the Nazis asserted, had had a superior religion. It was a sun worship and a cult of nature and fertility, centered in the rhythm of day and night, of the seasons, of conception, birth, and death. All members of the Nordic super-race were mystically united in these beliefs. It is a power

. . . which earlier had been effective in one gigantic space — from India to the pillars of Hercules, from Greenland to Sicily — but which still knew its center to lie in one, single 'pole': in the North Pole, the Polus Arcticus, as Wolfram calls it in the Wartburg contest; a power which united the humans of the most diverse regions and nations, but of the same race and origin.[3]

This power, in the Nazi view, had been corrupted, falsified, and obscured by Christianity:

> Foreign birds dropped the seed of the pernicious Mistletoe upon the thriving branches [of the tree of German folkdom]. The pale herb sank its devouring sucker roots into the healthy wood and sent up its luxuriant clusters in the ailing crown.[4]

It was in this connection that Charlemagne, for a period of time, was considered a special villain. He was branded as the slaughterer of the Saxons, the one who had sacrificed precious Nordic blood to establish his Holy Roman Empire. Hitler, who admired Charlemagne's empire-building qualities, did not agree with this doctrine, but it was nevertheless a broadly accepted revision of history. It led to some curious jobs of retouching and attempts to re-establish long-forgotten rites. For instance, in a forest near Verden on the Aller River, traditionally the place where Charlemagne 'butchered' 4500 Saxons, the Nazis were setting up 4500 large stones to honor their memory. Each German region was to contribute a stone. At enormous costs and from as far away as Styria in the Austrian Alps the huge stone slabs were carted to the forest and set up along the winding paths and in the river meadow, stone after stone, in never-ending monotony.

In spite of the so-called betrayal of the ancient cult by the adherents of Christianity, the Nazi ideologists believed that the true religion had never completely died out. One had only to know how to look in order to find traces of the ancient rites almost everywhere. They lived on among the people in the guise of fairy tales and folklore and especially in the culture of the peasant. This culture was not, the Nazis taught, a belated imitation of the leading classes of society, as the decadent scholars of the age of liberalism had declared. On the contrary, it had very much its own life, springing mystically from the ancient roots of the Nordic cult. It survived everywhere, in a sort of semi-disguise, in all forms of folk art, in legends, fairy tales, songs, dances, costume, folk wisdom and nomenclature, household gear, village layouts and building styles. It continued to live on behind Christian symbolism and Christian

folk art. The early church had adopted the ancient rites and the signs and emblems, had appropriated them, depriving them of their original meaning and substituting its own, new interpretations.

The political role of the art expert in all this is now perfectly apparent. He was the specialist who knew the monuments and the documents, who understood their language and had the skill and the training to reinterpret the signs. It is now obvious also that the little Christmas-carol book was indeed concocted according to a carefully developed formula. It was based on a fanatically one-sided reading of history. This is not the place for a detailed comparison of the method by which early Christianity converted paganism and the Nazis' way of reconverting Christianity to paganism. The important thing is that here, too, as in so many other fields, they threw the gears of forward evolution into reverse; they tried to force the course of history backward.

HEINRICH HIMMLER'S AHNENERBE FOUNDATION

After the war there were brought to a number of American libraries certain volumes published under a little-known imprint, the Ahnenerbe. These books were duly accessioned and catalogued by the experienced and skillfull librarians of the Library of Congress and the New York Public Library. In every instance the cataloguers in these institutions failed to record the fact that the books were published by the SS. This failure was exactly what Heinrich Himmler and Wolfram Sievers, the minister of culture in Himmler's personal SS empire, had intended. Actually, no reasonable person would blame the cataloguers, because there is no clear indication of the SS connection in any of these books. The only hint of such a tie-up is a Himmler quotation at the beginning of each volume:

A people lives happily in its present and future so long as it is conscious of its past and the greatness of its ancestors.

One has to know the story of the incredible Ahnenerbe organization to appreciate the real purposes and powers behind a seemingly innocuous imprint.

Very few people, inside or outside of Germany, know the full history of the Ahnenerbe Foundation. It is told here probably for the first time in public print.[5] The familiar image of the iceberg applies rather neatly to this institution — the part that protrudes above the surface of the water and is exposed to view is only a fraction of the total, dangerous mass. The size and shape of the visible portion are no true indication of what lies beneath the surface.

The part of the Ahnenerbe that the German public was allowed to see was the books and periodicals published by this formidable organization.[6] Each of the volumes carries, in addition to the Himmler motto, the following statement of the aims of the Foundation:

THE GERMAN ANCESTORS HERITAGE, Inc., BERLIN, has the task:
1. to explore space, spirit, and deed of the Nordic Indo-Germanism;
2. to formulate the results of this research in a lively manner and to convey them to the German people;
3. to call on every fellow-countryman to co-operate in this task.

The Ahnenerbe was not always the actual publisher of these volumes. Most items on their list had their own publishers, usually a well-known, established firm with some degree of scholarly reputation, such as Carl Winter's in Heidelberg, which can be rated as the equivalent of an American university press. The Ahnenerbe, in other words, appeared in the role of the sponsor, approximately in the manner of an American foundation.

The basic purpose of all the publications was the creation of a new, synthetic religion, resurrected from various remnants of the old Germanic, pre-Christian cult. The survival of this ancient religion against the corrupting influence of the Christian Church was always the underlying theme, and art history was employed as the main device to demonstrate the survival. It was a very specialized and a very limited kind of art history, one that neglected practically all aspects except iconography. Material and workmanship of a given monument, its individual style and character, the creative personality behind it, and its relationship to other works of art and other schools, these things were almost wholly neglected by the SS archaeologists. What they were concerned with was seeking out

and collecting the surviving elements of an older, pre-Christian culture in all kinds of Christian monuments and to interpret this survival as a proof of superiority.

These SS scholars never worked backward from the factual evidence before them toward the reconstruction of the older cultures. The work was always based on an arbitrarily assumed but perfectly developed and fixed canon of pagan Germanic art. The approach was always the same and the results always turned out exactly as required, regardless of what kind of material was studied.

There was never any clear division between fact and fancy, between propagandistic intent and objective evidence. A certain amount of new information — only a specialist could tell how much — turned up here and there in this work, but its value to the unbiased observer is greatly diminished, if not totally obscured, by the processing of this information along predetermined ideological lines. What a certain Hans Strobel had to say about the working principles he employed in his study of peasant customs [7] applied to all these Ahnenerbe publications. He spoke of the necessity

of demanding peasant mentality and 'Weltanschauung' as the basis for our scholarly work about peasant customs. When this is achieved, then we have created the possibility of making our scholarship serve the people and contribute constructively to our future. That is to say, we must definitely put an end to 'objective' and unworldly 'scholarship' which merely states facts, so that we may build a popular, political scholarship which has the strength and courage to evaluate . . .

This is as clear an abdication of the scholarly ideal of the search for truth as one could wish to obtain anywhere.

A ludicrous example of how these principles were applied in all earnestness by SS 'scholars' is provided by a document in the Library of Congress. There is in the Print Division the record of an art-historical expedition of two SS men — a typescript in two volumes, carefully illustrated with mounted and captioned photographs. It bears the title *Altreligiöse Ausdrucksformen des Schwabenlandes* (Old religious forms of expression in the Suebian country) and its

authors are the SS Brigadeführer K. M. Weisthor and Obersturm-
führer Ruppmann. It is the latter who is credited on the title page
and in the introduction with the actual work of photographing
the works of art and of describing and interpreting them. With
these two went a professional scholar, a Dr. Veeck, Director of
the Wuertemberg Antiquities Collection (Wuertemberg. Alter-
tumssammlung) in Stuttgart. The group covered 6500 kilometers
in less than a month, recording what they thought were sur-
vivals of ancient pagan mythology in Christian disguise.

In the Church of the Cistercian Monastery of Maulbronn, for
instance, they noticed the fine fifteenth-century woodcarvings on
the choir chairs. One of these scenes, the sacrifice made by Cain and
Abel, was duly photographed and described as follows:

Cain and Abel, above them Godfather.

The picture is interesting in regard to the representation of Cain and
Abel. Cain as a genuine Germanic man brings a sacrifice of fruit. Abel
as an elegant, well-dressed, and smooth-shaven man sacrifices the ani-
mal. In contrast to the Christian conception the artist has here put into
the picture his feelings according to the dictates of his blood.

Another example of their discerning scholarship is the interpre-
tation Obersturmführer Ruppmann gave to a frescoe in the Brun-
nenkapelle in Maulbronn. This is what he discovered:

On this picture is shown how a man has growing out of him instead of
his reproductive organs the tree of life. Here the artist has symbolized
that in the act of procreation lies 'The Eternal Renewal.'

It is not difficult to see in the photograph that the decorative
foliage in which this hairy wild man with the curved nose is play-
fully climbing around is not a tree and that it is certainly not sprout-
ing out of his loins but is growing up from underneath, like Jack's
beanstalk. Here is a nice little demonstration of the skill of the
SS scholars in finding what they wanted to find. In this particular
instance it was a clear case of wishful seeing, probably in more
than one sense.

Emblems and signs were particularly important to the SS scholars.

The men indulged in perfect orgies of sign-reading. The swastika is only one of a number of emblems arbitrarily appropriated by the Nazis and charged with a special meaning.

The ancient symbols, asserts von Zaborsky in his Ahnenerbe volume, were created by our forefathers 'long before a disciplined word art gave poetical formulation to the myths which the Edda has handed down to us . . . They are immediately understandable as language and script and with one symbol they signify connections which in verbal expression would need a sequence of sentences . . .'

What was behind all this busy writing and publishing? Even today very few people outside of Germany know that SS men were not only members of the Gestapo and concentration-camp guards but also ambitious art historians and archaeologists. Few Germans knew the exact meaning of this activity and the lengths to which the intentions were carried out; but the connection between SS and archaeology was recognized and accepted. I remember an encounter with an elderly Berlin art dealer after the war, whom I had to see on Monuments, Fine Arts, and Archives business. Only that morning I had come across someone of his name in the files, who I thought might have been his son. 'Did you have a son in the SS?' I asked him. 'Why, of course,' he replied, 'where else could he have been? After all, he was an archaeologist.'

It all started with Heinrich Himmler's having been a schoolteacher and one especially interested in German antiquities, in the pre-history and early history and archaeology of Germany. There is a deep-rooted tradition in German education that a teacher of the young should be a scholar first and a pedagogue second. To be promoted to a university post in recognition of scholarly contributions was the secret ambition of many a rigid disciplinarian who enforced his rule with the rod to save himself time and trouble. He often took out his frustrated ambitions on his helpless victims. Himmler was such a schoolteacher and his ambition was boundless. By 1935 the chief of the German police and head of the SS had established his position as one of the strong men of the regime, a man of destiny with a firm grip on the future. The time for steady

consolidation and increase of his powers had arrived. Now also was the time for the realization of his cultural ambitions. A curious greed for cultural prestige was one thing the Nazi chiefs had in common, although it took different forms with each of them. There was hardly a Gauleiter who sooner or later did not blossom out as an art connoisseur. Himmler's instincts and their realization were unique in that they combined the pursuit of a personal hobby with an extremely efficient program of ideological indoctrination. There were rivals in this field, Alfred Rosenberg, for instance, and various agencies and offices which he would have to cut down to size. Himmler saw himself as Germany's top ranking disciplinarian, the all-powerful teacher with the rod, not only in charge of the political police but also a sort of supreme watchdog over what people should believe. He wanted to be the twentieth-century re-incarnation of the Praeceptor Germaniae, the supreme apostle of the ancient creed brought back to fearful reality. He continued his studies of German pre-history, read and collected books in the field, inspected sites, and cultivated the experts. He also published an occasional article from his own pen, for example, one on east German medieval castles.[8]

The creation of the Forschungs- und Lehrgemeinschaft Ahnenerbe was Himmler's attempt at the systematic submission of virtually all branches of German science and scholarship into the service of Nazi ideology. It was also aimed at driving the rivals out of the field. Organized as a gigantic research foundation with huge appropriations and a highly specialized and diversified program, it was founded on 1 July 1935 and incorporated on 19 November that same year. In 1937 no less a distinguished academician than the Dean of the Philosophical Faculty and later Rector of Munich University, Dr. Walther Wuest, became its president and curator. He was given the rank of SS Hauptsturmfuehrer. Wolfram Sievers, whose career is worthy of some further attention, was business manager of the vast enterprise (fig. 28).

The stated aim of the Ahnenerbe Foundation was the systematic exploration of the northern Indo-Germanic race and its achievements. This was to be accomplished by the unified co-ordi-

nation of all separate disciplines of letters and sciences bearing
upon the 'living space,' spirit, achievements, and heritage of the
Indo-Germanic people. In particular, the following steps were taken
to promote this program:

1. The establishment of a large number of teaching and research insti-
 tutions.
2. The assignment of research projects and the sending out of scientific
 expeditions.
3. The publication of scholarly and scientific works.
4. The holding of annual scientific conferences at Salzburg in connec-
 tion with the Festspiele.

All in all, about forty-five research institutions were either
launched or projected.[9] Of the more than forty men called to head
these institutions, nineteen held the rank and title of both Professor
and Ph.D., and nineteen more were Ph.D's. Many of the men were
also given ranks in the SS. A vast library and archives were located
at No. 16 Puecklerstrasse, Berlin-Dahlem, and there were other
libraries in Munich, Salzburg, and Detmold. There was a photo-
laboratory and a model-making and museum workshop.

An excellent over-all view of the vast enterprise is afforded by
the official table of organization, reproduced on pp. 152–3 from the
only copy, slightly defective, I have been able to locate. It will be
noticed that the Ahnenerbe had special departments to work in
the Netherlands, in Belgium, and in Norway. The diversity of the
program is truly astonishing. It included linguistics, ethnology,
geography, prehistoric excavations, place names, trade and hall
marks, folk songs and costumes, Indology, Germanic law, runes,
symbols and scripts, tribal emblems, folk tales, fairy tales and
myths, archaeology, Germanic musicology, astronomy, biology,
genetics, entomology, geological time measurements, nuclear phys-
ics, explorations in Central Asia, applied geology, botany, animal
geography and history, cave research, paleobotany, osteology, popu-
lar medicine, and so on. There were also the mysterious depart-
ments 'P' and 'H.' About one hundred men alone collaborated in
a research project dealing with the place of forest and tree in Ger-

manic culture and history. An enormous staff made contributions to an atlas of German folklore.

We see now that the publication program, while clearly anchored in the research activities and designed for the same general purposes, reflects only a part of the total program. The pursuit of art history and archaeology is identifiable at first sight in only a few of the listed units. A careful study of the activities shows, however, that the interpretation of artistic monuments and documents by means of archaeological and art-historical methods played a very large role indeed.

Before the war, archaeological excavations and expeditions were foremost among the projects sponsored by the Ahnenerbe. In 1935–6 an expedition was sent to Scandinavia to make casts of prehistoric rock inscriptions. Professor Dr. Jankuhn of Kiel University supervised excavations in Schleswig-Holstein from 1938 to 1940. From 1938 to 1942 prehistoric material was excavated in Unterwisternitz in Moravia. In 1938 and 1939 the Tibet expedition of Dr. Ernst Schaefer took place, resulting in a much publicized motion picture [10] and several publications, which again carried no clear indication of the part played by the SS. The extensive collection of scientific specimens brought home from Tibet included living specimens of horses and of wild grasses brought back for crossbreeding with domestic strains in order to increase the country's resources for the coming war.

Excavations were also made in several regions of Germany and in occupied territories, wherever there was a good prospect of turning up Germanic material. All other evidence was studiously neglected. Professor Grohmann, the noted art critic, told me an illuminating incident in this connection. In 1942 Prince Frederick of Sachsen-Altenburg, a professional art historian, was invited by an SS General in Dresden to participate in the excavations in southern Russia, on the Crimean peninsula, and elsewhere. In many ways this was a tempting offer, but when the Prince heard what exactly was expected of him, he became skeptical. A watertight case for the pure Indo-Germanic origin of the culture of the vast region

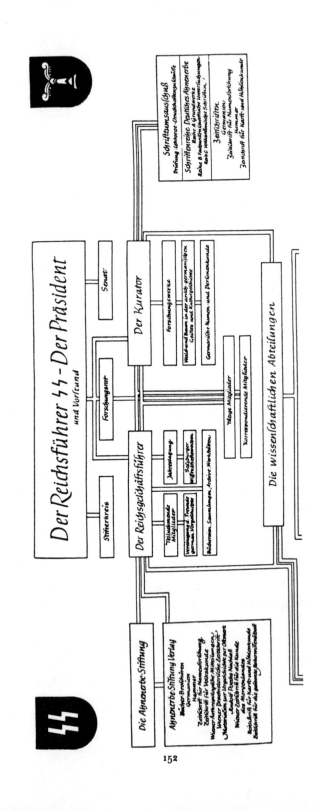

Der Reichsführer ⚡⚡ – Der Präsident
und Vorstand

Stifterkreis

Senat

Forschungsrat

Der Reichsgeschäftsführer

Der Kurator

Freundes- und Mitglieder

Jahrestagung

Forschungswerke

Vereinigung d. Freunde germ. Vorgeschichte

Salzburger Wissenschaftswochen

Wald- und Baum in der arisch-germanischen Geistes- und Kulturgeschichte

Bibliotheken, Sammlungen, Archiv, Werkstätten

Germanische Numen- und Personenkunde

Tätige Mitglieder

Korrespondierende Mitglieder

Die wissenschaftlichen Abteilungen

Die Ahnenerbe-Stiftung

Ahnenerbe-Stiftung Verlag

Bücher, Broschüren
Germanien
Kosmos
Zeitschrift für Namenforschung
Zeitschrift für Volkskunde
Wiener Prähistorische Mitteilungen
Wiener Prähistorische Zeitschrift
Materialien zur Urgeschichte der Oberwelt
Jakob Pordes Nachlaß
Wiener Zeitschrift für die Kunde des Morgenlandes
Reichsdruck für Vorschung und Naturkunde
Zeitschrift für Naturforschung und Naturkunde

Schrifttumsausschuß
Prüfung Lektorat-Druckschriftenausschuß

Schriftenreihe Deutsches Ahnenerbe
Reihe A günstige
Reihe B Forschungsergebnisse und Erläuterungen
Reihe C volkskundliche Schriften

Zeitschriften
Germanien
Zeitschrift für Namenforschung
Namen
Zeitschrift für Kunst- und Hofkunde

152

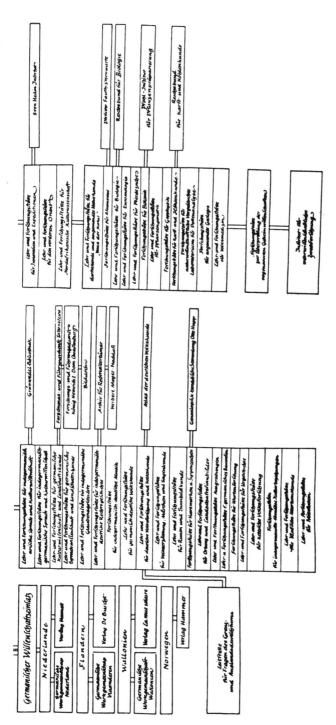

recently conquered was being built up. The project demanded the elimination of all traces of Turkish and Mongolian elements, and of many influences from Asia Minor and the Mediterranean. When he was shown photographs of the kind of thing he would be expected to turn up, the Prince declined the offer.

Himmler and Sievers did not encourage actual frauds. They preferred to work with individually unassailable pieces of evidence, fragments of truth, selected and pieced together to establish, prove, and promote one monstrous lie. They scorned scientific bungling and forgeries and, for instance, gave enthusiastic support to the establishment of a special police department devoted to the detection and persecution of artistic and archaeological forgeries. This was a neat pose. Actually there was every invitation not only to misinterpretation of authentic monuments but also to the deliberate manufacture of desired archaeological evidence. A good many stories of such manipulations were told in Germany after the last war, and it would pay a specialist to track them down. They do not necessarily involve the Ahnenerbe but various organizations and individuals. It is my impression that on the whole the SS people were too shrewd to let themselves in for actual forgeries.

The war first influenced, then altered, and finally possessed the course of the Ahnenerbe. Fifth columns of Quisling scholars and scientists propagating the Nordic myth had been planted before the occupation in the Low Countries and in Scandinavian countries. After the beginning of the war, the Ahnenerbe received in quick succession assignments for special operations in crucial territories. One group of assignments was received from the so-called Reichskommissar fuer die Festigung deutschen Volkstums (Reich Commissar for the Fortification of German Folkdom) in connection with the transfer and resettlement of Germanic minorities in the Italian South Tyrol, in southern Styria, in Laibach-Gottschee, Krain, Bessarabia, and Wolhynia. It was the task of the Ahnenerbe to collect, record, and, if possible, transfer the artistic and cultural heritage of these groups.

The Ahnenerbe was activated for Poland in 1939, for Norway Belgium, Holland, Brittany, Lorraine, and South Tyrol in 1940

for southern Russia, Lower Styria, and Laibach in 1941, for Ober-krain, Serbia, the Banat, and Luxemburg in 1942, for Macedonia in 1943. In Serbia the Ahnenerbe was granted an exclusive monopoly for excavations, which it exercised from 1942 on.

Wherever they swung into action, Himmler's archaeologists went in for the looting of cultural objects on a grandiose scale. Many millions' of dollars worth of scientific collections, libraries, archival material, archaeological finds, miscellaneous works of art, sometimes the contents of entire museums, were shipped to Germany.

The language of the documents in which these transactions were recorded is ingenious in its terminology. We found the following synonyms for plain 'looting': erfassen (take hold of), heimholen (fetch home), sicherstellen (secure), beschlagnahmen (confiscate), verlagern (relocate), durchforschen (search through), verpacken (pack), uebernehmen (take over), retten (save), aufnehmen (register), rueckfuehren (bring back), ausfuehren (export), wiedergewinnen (recuperate), kaufen (buy), entnehmen (take out), tauschen (barter), requirieren (requisition), abholen (pick up), ausschoepfen (draw off), abgrasen (browse).

With the increasing severity of the bombings the cultural activities of the Ahnenerbe gradually decreased. In 1943 the Berlin headquarters had to be abandoned and the activities were dispersed to such out-of-the-way places as Waischenfeld in Upper Franconia, Oberkirchberg near Ulm, and Mittersill Castle, Austria. Direct participation in the war effort took the place of the gradually diminishing cultural efforts of the SS scholars.

Originally, the Ahnenerbe had concentrated on the creation of scientific underpinnings for the Nazi doctrine of the superiority of the Nordic superman and on the elimination of Christian beliefs in favor of a synthetic new racial cult. During the victorious phase of the war scientific justification for the permanent incorporation of vast new territories into the Third Reich became the main task. Skillful manipulation and propagandistic treatment of historical and archaeological evidence were practiced. All regions that looked strategically attractive or desirable for their natural resources were being incorporated into Hitler's new order because invariably it

could be shown that they had been settled and cultivated originally by Germanic tribes.

Details of the third and last phase of the Ahnenerbe operations came to light during the Nuremberg trials. The role of chief organizer and co-ordinator of the far-flung network was played by Himmler's executive manager, Wolfram Sievers. Sievers had been sentenced to death by hanging on 20 August 1947 as a war criminal in Case No. 1, United States *v.* Brandt *et al.,* before the International Court at Nuremberg. By the beginning of September the sentence had not yet been executed. I interrogated Sievers on 3 and 4 September. After being informed that the purpose of the interrogation was the return of 'displaced art,' he talked freely and interestingly about the general operations of the Ahnenerbe. But his memory was disappointingly weak on any details concerning the whereabouts of any of the treasures once in the hands of his organization. He strenuously denied all responsibility for the dispossessing of cultural material anywhere. The members of his Ahnenerbe, he claimed, merely acted as experts who appraised certain objects and made lists — everything would invariably be returned to wherever it had been sent from.

Physical possession, he explained, was exercised by a completely different organization headed by a general trustee especially appointed by Himmler for the purpose, a so-called 'Generaltreuhaender,' activated in turn for Poland, Russia, and Lorraine. That to our certain knowledge — we had found the document of appointment — he himself had been this trustee did not seem to disturb him. He gave a perfect example of schizophrenic self-separation into two halves, one of which, the uncomfortable one, he would disown. When I confronted him with the fact of his irrefutable responsibility he shrugged it off. 'Himmler may have made some such appointment,' he remarked casually, 'I would not know.'

The man was good-looking in a sinister, fanatic way; there was a distinct atmosphere of evil genius about him; the phrase, 'one of Lucifer's dark angels,' went through my mind when he first entered the interrogation cell at Nuremberg, manacled to a good-natured Polish guard.

He was born in 1903, the descendent of a line of tailors, stone masons, small tradesmen. His chosen profession was the book trade; he held a series of increasingly important jobs with various nationalistic publishing firms, and, finally, with Franz Eher, the official publisher for the Nazi party and for Hitler.

He had been an ardent member of the German youth movement, joined the Nazi party in 1928, and was active in National Socialist student organizations and in Rosenberg's Kampfbund fuer deutsche Kultur. In 1932 and 1933 he worked in the household of Professor Dr. Hermann Wirth as a sort of resident research assistant. He chose Wirth, he explained on a SS questionnaire, because it seemed to him

that the deeper penetration particularly of this man's research work, which attempts to bring back to life the intellectual heritage of our ancestors in all its greatness and to lead us back to the wellsprings of our own nature, would be indispensible in the ideological battles of National Socialism.

He married in 1934 after the official medical examination had established the fact that his begetting children was racially desirable. Children arrived accordingly in 1937, 1942, and 1944. They were named Heidrum, Uwe, and Ulrike.

His entry into the SS in 1935 was occasioned by his appointment to the post of General Secretary of the newly founded Ahnenerbe Foundation, apparently upon the recommendation of Professor Wirth. Sievers was promoted to SS Obersturmfuehrer in 1937, to SS Obersturmbannfuehrer in 1940, and in 1942 to SS-Standartenfuehrer. Himmler trusted him and gave him a great deal of support and encouragement. On 1 April 1942 he promoted him to a high post in his entourage by making him a chief department head in his personal staff.

Sievers kept a careful diary of his official activities. He recorded all important telephone conversations, interviews, meetings, appointments, transfers, travels, lectures, and social events. This record fairly teems with the names of university professors and Ph.D's; the contact of the Ahnenerbe with the academic world was undeniably close and sustained over the years.

During the third phase of the Ahnenerbe operations, when the demands of total war became ever more pressing, Sievers was conspicuously associated with the more gruesome contributions of the Ahnenerbe to science. He was responsible for the management of the Institute for Military Scientific Research, which was developed as part of the Ahnenerbe from an entomological institute established by Himmler's order on 1 January 1942, the Institute Dr. Rascher in the Dachau concentration camp, and from the Institute Dr. Hirt in Strassbourg, the mysterious 'Division H' on the table of organization.

Wolfram Sievers was condemned to death for his special responsibility for and participation in experiments on living concentration-camp inmates. These included high-altitude, freezing, malaria, lost-gas, sea-water, and typhus experiments; they also led to the extermination of members of the Jewish race, selected in order to complete a collection of skulls. Wolfram Sievers was executed on 2 June 1948 at Landsberg, Bavaria.

We have fathomed the depths to which the iceberg reached. Small wonder, indeed, that Himmler and Sievers wanted to remain below the surface and wished only certain portions of the huge organism they controlled to appear before the public. Not all of what they deliberately put out for public consumption was generally accepted. Along with the willing participation of many deans and professors they also met with some resistance in the ranks of more conscientious scholars, and a good many intellectuals here and there refused to fall in line. Nevertheless, the doctrines promoted by the Ahnenerbe had a very considerable influence on the general public and particularly on the schoolteachers. These concepts helped enormously in the broad propagation of Nazi ideology, in thoroughly forming and hardening the resultant beliefs, attitudes, and customs. The overt propaganda of the SS, although perhaps not completely successful in its influence on the conscious minds of the citizens of the Nazi state, was a very serious subconscious influence. If we add to that the devious, undercover indoctrination, through intimidation, corruption, and mental perversion, of the less public aspects of the Ahnenerbe operations, we can be sure of

a very considerable over-all damage. Even under most favorable conditions it would require a good many years to undo such damage. Conditions in postwar Germany have been by no means favorable for such a task.

XII

Art Education in the Third Reich

ART EDUCATION IN Nazi Germany was employed not to develop artistic talent of one kind or another or as a means of teaching a few specialized skills; rather, it was a major force by which to influence, condition, and mold the entire personality and character of the individual in virtually all his reactions, contacts, and activities. This is the most important thing about art education in the Third Reich.

The SS had used archaeology and art history as a major weapon in their war against Christianity. Himmler's Ahnenerbe had drawn on the personnel and had borrowed the methods of established organizations, but it had created its own machinery, much of it concealed from public view; the Ahnenerbe was particularly effective in its long-range influence on the subconscious minds of the people. By comparison, art education in the existing schools and universities, its training aids supplied by specialized branches of the publishing industry, was fully exposed to the public vew. It was highly articulate in the statements of its aims and methods. For this reason such teachings were perhaps more easily rejected by those who felt indifferent, doubtful, or clearly opposed to the Nazi regime. But in one regard the official, overt art education of the Third Reich was fully as dangerous and perhaps equally lasting in effect as the influence of the SS: it was aimed at everybody, and especially at the children and the young people of the nation, throughout all the formative steps of their development. It

reached them at highly impressionable stages of their mental and emotional growth.

It is hardly necessary to dwell again on the changes brought about by the Nazis in the professional training schools for artists. Their influence on the art academies was predominantly negative in character. It consisted more in the proclamation of prohibitions, in the setting up of taboos, and in the elimination of what was considered the culturally unreliable element among the faculties than in any positive, pragmatic action. But a few observations about art education in the universities are necessary.

The Archaeologist outside the SS

Art history and archaeology in the universities were not influenced by the Nazi regime so directly or so forcefully as was the creative art life of the country or art education in the schools. Though propaganda scholars were liberally drawn from the ranks of university people by the SS, this did not mean that the whole of art history and archaeology was absorbed into the totalitarian machine. Response to the new demands varied a good deal among faculties and professors. There was no complete surrender to the new ideology, nor, indeed, was there such a thing as complete and sustained resistance on the part of any entire unit. It was a case of in-between, a desire to compromise and appease, to get by with a minimum of involvement, and to retire on neutral islands. One thing certainly is clear: outspoken antagonism to the regime, resistance to its all-absorbing tendencies, was decidedly less frequent among art historians than among the creative artists.

The record of German archaeology during the thirteen years of Hitler's reign shows this pattern quite plainly. Archaeology enjoyed a certain culture prestige; it had about it an aura of aristocratic patronage and high international connections. The Nazis recognized this. How else are we to explain the curiously vacillating and uncertain official treatment that the 'German Archaeological Institute,' the leading professional organization, received at the hands of the new rulers? The men of the Third Reich were obviously wary of compromising themselves in the eyes of the world

in dealing with a well-established field of such decided traditions and international connections and one in which German scholars had made valiant strides. The Archaeologische Institut des deutschen Reiches, with branches in Athens and Rome, in Cairo and Constantinople, had been under the Cultural Department of the German Foreign Office. This connetcion was discontinued in 1934. The Institute was placed first under the Ministry of the Interior, then under the Ministry for Science, Education, and Popular Education. Theodor Wiegand, the president, was nominated a member of the State Council by Ministerpraesident Goering; he was decorated by the Fuehrer and was received by Hitler, Goering, and Ministers Rust and von Neurath. There was no immediate change in the work of the Institute. Its management wanted nothing so much as to remain on good terms with the new rulers, while conducting its business and getting along with its work with as little interference as possible.

Many German archaeologists may have hoped that a generally polite and mildly co-operative attitude toward the regime would buy them independence and the chance to preserve their scholarly integrity. But here, too, the tightening of the reins made such a course untenable. The coming of the Olympic Games to Berlin in 1936 and the concurrent excavations at the original site of the games in Olympia drew German archaeology into the limelight of big-time publicity.

> Scholarship today goes to work with new points of view and with new research objectives. The questions about the early history of Olympia, its games and cults, about folk and tribal connections have been newly posed. The search for the answers can be furthered by the broadening and deepening of the excavations . . .

wrote Walter Wrede in his report on the excavations in the Institute's yearbook. These are cautious words, but their meaning is quite clear. They mark not the complete surrender of ancient and honorable archaeological scholarship but the gradual infiltration of Nazi ideology.

The same year, 1936, that saw the Olympic Games and the excavations in Olympia brought further ideological pressure. Even

before the advent of the new regime there had been increased interest and activity in northern European prehistory. Now, in 1936, Minister Rust made substantial new allotments in support of east German research. Studies of runic inscriptions, of prehistoric mining, and of the early settlement of the German East, Viking remains on the Baltic coast, Professor Jahnkuhn's Danewerk excavation, the SS excavations at Glauberg, lower Saxon urn cemeteries, early medieval castles, Roman importations into unoccupied ancient Germany, and other similar projects were now reported from year to year.

The Institute's Rome office turned its attention to monuments of Germanic migrations in Italy. Private collections and the contents of the Italian museums were searched and lists made of Langobardic and Austrogothic remains. There was heightened activity during the years 1941, 1942, and 1943, when the 'friendly occupation' of Italy offered splendid opportunities for the pursuit of these projects. The second secretary of the Rome office, S. Fuchs, made a personal report on his research work to Heinrich Himmler.

Italy was not the only country where the traces of early Germanic tribes were pursued. Franconian antiquities were studied in occupied France, Visigothic remains in friendly Spain. Excavations were undertaken on the Balkan peninsula in collaboration with the Allied government of Bulgaria.

In appraising this record of German archaeological activity during the Third Reich one recognizes that there was no immediate surrender to the new masters and their methods, nor indeed, was there integrated resistance. From the start there were compromises. Appeasement was the chosen policy. With the slow but steady rise of ideological pressure there was a gradually increasing dilution of the ideal of scholarly objectivity and integrity, a growing tendency to use scientific methods and archaeological evidence one-sidedly, to prove a foregone conclusion. The ultimate aim, again, was the reinforcement of the Nazi myth of the Nordic superman. About this there can be no question.

The pressure was of course especially strong in the field of prehistoric archaeology. The Ahnenerbe policies were paralleled

within traditional academic channels and by rival party organiza-
tions. The Amt Rosenberg was the responsible top authority here.
Dr. H. Reinerth, called to the Berlin Chair for Prehistory in 1934,
was director of a special federal bureau, the Reichsamt für Vorge-
schichte im Amt Rosenberg. At the same time he was a member
of the official censorship bureau of the party and exerted his in-
fluence in the field of prehistoric publication, which included
virtually all school and textbooks printed in Germany. Reinerth
was also director of a private federation, which through his official
connections and the name Reichsbund für deutsche Vorgeschichte
assumed a semi-official character. Reinerth also published the
lavishly illustrated monthly *Germanenerbe*.

The record of German art history is rather similar to that of
archaeology. In some ways the fine-arts scholar, unless he was in-
terested in twentieth-century art, was in a less vulnerable position
than the archaeologist. What he had to offer was just a little less
important to the Nazi ideology than were the results of prehistoric
and archaeological research. More islands of neutrality on which
he could take refuge were available to the art historian. The
result of all this was not so much corruption as stagnation and
reaction. German fine-arts scholarship, forcefully confined to
German art, became rapidly provincial to a marked degree. When
international contacts were slowly re-established after the war, a
condition of utter isolation and intellectual parochialism was dis-
covered by the experts of other countries. There were some excep-
tions, of course, but they were indeed few and far between.

This condition of intellectual stagnation, the result of highly
exaggerated nationalism, did not mean inactivity for the art histor-
ian. On the contrary, there were continuous demands upon his
services in connection with the deliberate popularization of art
history, with the use of art appreciation as a social cement. The
protection of artistic monuments, too, had a decided place in the
Nazi scheme of things. The preservation of the 'ancestral heritage'
of German art treasures required a variety of services not only
from the professional members of the Monuments Protection

Service but also from many general art historians. Training courses, practical field work, and summer camps for those concerned with the protection and conservation of art treasures were carefully organized. These tasks assumed mounting urgency with the increasing intensity of aerial warfare. The story of the dispersal of movable art treasures into safe hiding places and their dramatic discovery and salvage by the Allied forces is a familiar one.

Less well known is a special project, recognized only by a small circle of experts as the 'Fuehrer Project,' which is well worth talking about. This 'Fuehrer Project' has no parallel in the history of art. It was possible only in a totalitarian state.

THE 'FUEHRER PROJECT'

In the spring of 1943 there was growing concern among German art historians and curators of historic monuments about the bomb damage threatening the treasures in churches, castles, and palaces that could not be moved to a safe hiding place. Fresco paintings on walls and ceilings were especially vulnerable. Was there any insurance against their total loss and obliteration? Would it not be possible to make color photographs of all these treasures? Such a project would produce a unique record, far more accurate and reliable than any existing black and white photographs, and incomparably more complete than the few color photographs already in existence. In the case of frescoes totally destroyed, such photographs would constitute a priceless repertory from which reproductions in print could be made for all possible purposes. The pictures would also prove invaluable for the future restoration of damaged frescoes. But the plan would make sense only if it could be carried out on the broadest possible basis, if it included all monuments of value anywhere in what was then Greater Germany, and if it could be done promptly and with the most skilled and experienced manpower available.

There was only one way to accomplish all this. The road pointed clearly to the Fuehrer. He must be told about the plan. His reaction, when he heard of the project, was enthusiastic and he im-

mediately adopted the plan and started to push it with character-
istic vigor and an equally characteristic disregard for all impending
difficulties.

On a certain Tuesday in April 1943 he issued the order to go
ahead and demanded delivery of the first pictures on the Friday
of that very same week. In particular he wanted color photographs
of the frescoes on the ceiling of the Library at St. Florian and
from the Golden Hall in Augsburg's City Hall. This was, of course,
a perfectly impossible order, but strangely enough, the pictures
were duly delivered on Friday, to Hitler's immense gratification.
Color photographs of those frescoes were, of course, already in
existence before Hitler gave his order. This fact was perhaps con-
cealed from him by the people who had proposed the scheme, in
order to impress him with their efficiency; or perhaps he had mis-
understood the statement that pictures should be made like the
ones at St. Florian and Augsburg. At any rate, he never doubted
that his order had been literally obeyed and that his mere words
had achieved the seemingly impossible.

The technical expert chosen to head the enterprise was Dr.
Hans Cuerliss of Berlin, a man of long and varied experience in
the photographing of art.[1] As the head of an Institut fuer Kulturfor-
schung (Institute for Cultural Research), founded in 1919, he had
made successful documentary films of Max Liebermann, Lovis
Corinth, Kaethe Kollwitz, Alexander Calder, and many others. In
1933 his organization had been changed to an Institut fuer Kultur-
filme (Institute for Cultural Motion Pictures) and placed as a
member of the Motion Picture Chamber under the jurisdiction of
Goebbels' Propaganda Ministry. It was the art department of this
ministry, in the hands of Dr. Biebrach and Dr. Hetsch, that was
officially charged, on 6 April 1943, to proceed with the project. Its
designation as a 'Fuehrer-Auftrag' and the order to deliver one
copy of each color photograph into Hitler's hands secured top
priority for the operation.

A budget of one and a half million Reichsmark was appropriated
by the Ministry of Finance. According to the estimates of the
Monuments Protection Service, frescoes in 500 buildings, in Ger-

many and Austria, in occupied Czechoslovkia, and in Poland, were to be photographed, 50 to 100 pictures in each building, or an estimated total of 50,000 exposures. There were to be five copies of each. The pictures were to be Agfa-Color transparent positives. In addition, approximately 1000 larger and more costly pictures were to be made, by a three-color separation process ('Bernpol' or 'Duxochromie'), of all objects of outstanding artistic and art-historical significance. This was to be undertaken at the special request of the Fuehrer and with the full support of Minister Goebbels.

The operation ran from April 1943 to April 1945.[2] According to Dr. Cuerliss, five copies each of up to 28,000 exposures, a total of about 120,000 pictures, were made by 300 photographers, organized in 49 photo-teams. These included Dr. Paul Wolff of Leica fame, Dr. Lamb of Munich, who acted as a representative of the group in discussions and meetings, and a good many youngsters, including Dr. Cuerliss' son Peter, who was brought back from military service in France. Dr. Lamb was in charge of the photographing of the Tiepolo frescoes in the Wuerzburg residence. His work there took about nine months and cost in the neighborhood of 80,000 Reichsmark.

Things went well at first, but by autumn of 1943 trouble started to develop over faulty emulsions furnished by the I. G. Farben Industry's Agfa works in Wolfen. A meeting was held in Vienna on 13 and 14 January 1944. Representatives of the Propaganda Ministry and the Ministry of Education, twenty photographers, representatives of the I. G. Farben Industry, and two color experts discussed the experiences and progress to date and the technical and economic difficulties encountered. Another, smaller meeting was held in Berlin at the Propaganda Ministry on 4 May 1944. Actually, although they never admitted this in so many words, the heavy bombing was hindering production with sharply increasing severity. In view of the difficulties, it is surprising that the efforts were continued almost until V-E Day and that a total of about 120,000 pictures of more or less acceptable quality was produced.

The material seems to have survived to the present day without

appreciable losses. According to Dr. Cuerliss, most of the color
transparencies are now kept in the art departments of the Uni-
versities of Mainz, Tuebingen, and Freiburg i.B., and also in
the Denkmalspflege (Monuments Conservation) Offices in Munich
and Stuttgart. Some of the material has found its way to the
National Gallery in Washington, D.C., where it can be studied and
borrowed.

It could conceivably be argued that only the supreme authority
of a dictator could have made such a project possible, that we have
here a proof of the socially beneficial power of a culture-conscious
totalitarian regime.

It so happens that this very same power asserted itself in a
decidedly antisocial manner in another, somewhat similar pro-
ject, the story of which furnishes the neatest possible illustration of
the complete perversion of a potentially great instrument of cul-
tural democracy, namely the printing press.

The Greatest Possible Perversion of the Printing Press

This story begins in the city of Berlin on a morning in March 1939.
A summons to Nazi headquarters was never a pleasant experience
for a non-party member. It was with decidedly mixed feelings that
the director of one of Berlin's quality printing and publishing
houses presented himself at the Propaganda Ministry that morning.
He had been called there by the so-called 'German Propaganda
Atelier,' a division of the Goebbels Ministry. A patently impossible
task was demanded of him. On 20 April, less than two months hence,
Hitler would be celebrating his fiftieth birthday. The Gau Berlin
of the Nazi Party had planned a very special gift for this occasion,
skillfully calculated to please the Fuehrer by playing up to the
Masterbuilder's most ardent artistic ambitions and by flattering
him in the most exorbitant terms. The Berlin party chiefs had dis-
covered that a Dr. Franz Jahn had worked for years on an archi-
tectural history of Berlin. He had stressed the role of the Prussian
monarchs in laying out their capital, thus setting the stage for
some of Hitler's most extravagant projects. His manuscript was
ready for the publisher. Even more wonderful, this man had

located all important existing drawings, prints, and maps of historic old Berlin; he had made an inventory of the capital's iconography stored away in the city's numerous galleries, museums, archives, and libraries. All this material was now to be made into one monumental publication. The pictures were to be reproduced in color and as nearly as possible in original size, in the most faithful manner and by the best processes available. Large portfolios were to be made for these plates and the text was to be printed and bound as a separate volume. All this was to be completed in about six weeks' time.

Our friend, of whom these demands were being made, was not pleased. A genuine democrat, with a record for non-co-operation of which he was justly proud, he had no intention of accepting this job. The obvious course open to him was refusal on the grounds of insufficient time. But his protest was without avail. 'You can't refuse, because you are under official orders,' he was told. 'We are going to commandeer every plant in and out of town, every photo-engrapher, gravure and collotype printer you need. Pick the best process for each plate. We are hereby authorizing you to use every printing and binding facility needed to complete the job in time for the Fuehrer's birthday. Funds are unlimited. Don't worry, no one will dare to refuse such a job!' Our friend gasped when he heard the further conditions: 'There is to be one copy only of this work. One copy for the Fuehrer, that's all. You are to destroy every proof after it has served its purpose and every plate after you have pulled the final impression. Do you understand, one copy only! A detachment of SS guards will be attached to you to watch at your plant and at every other plant where you place orders on this job. They will strictly enforce these orders.' The publisher, who had been resigning himself to an inevitable fate, stiffened: 'That is impossible. I will not allow SS on my premises. You can do with me what you like.' Somewhat to his surprise the men yielded. They realized, of course, that they needed him, and the SS guards were canceled. Our friend now tried to reason with these men. One copy only of such a valuable work was an absurdity. The enormous cost — it would run to well over 100,000 marks — was not justified

unless other copies were printed. A limited edition, say one hundred copies, could be produced for practically the same money. This, after all, was why one used the printing press — to produce a number of identical copies of a given document. Printed in a small edition, this priceless collection of architectural documents would become available for city planners, architects, historians, for libraries and museums, a most valuable contribution. 'On the contrary,' was the reply, 'the great value will lie in the fact that only Hitler will have a copy.' 'But why not then print a small edition and keep it locked up until after Hitler's death?' 'No. One copy only,' was the final verdict.

Our friend printed two copies, nevertheless. The work was completed on time — over two hundred plates in twelve large portfolios, and one smaller volume of text. Hitler's copy was destroyed, probably in one of the fires that raked the buildings of the Reichschancery. The other copy is intact, it survived in the hands of the printer, Kurt Hartmann of the Gebrueder Mann printing and publishing house in Berlin. Since it is probable that a considerable number of the originals, from which the plates were made, were destroyed during the war, Hartmann's personal courage saved priceless documents of the architectural history of one of Europe's great capitals.

THE BATTLE OF THE TYPE FACES

The story of the graphic arts under the Nazis furnishes not only a demonstration of complete perversion of the printing press but also one of the most ludicrous examples of cultural opportunism.

It was not difficult to foresee that in the search for racial symbolism the Gothic alphabet would prove especially useful. Gothic style, in architecture as in sculpture, calligraphy, and printing, had long been appropriated by German chauvinists as a nationalistic symbol. The international origin and role of Gothic art were conveniently forgotten. The fact that Gothic type as a regular body face had survived only in central and northern European countries furnished welcome reinforcement of the myth of the Gothic alphabet as a Nordic symbol.

Since every child had to learn how to read and write, and since everybody wrote and read daily, the total elimination of the Roman alphabet was a fruitful theme for cultural propaganda. The campaign found expression in the use of stickers with slogans admonishing everyone to use Gothic letters. Competitions in Gothic lettering were held among school children and art students, and

Deutſche Schrift
iſt für die Auslandsdeutſchen eine unentbehrliche Schutzwehr gegen die drohende Entdeutſchung

Deutſche Schrift
iſt Ausdruck und Teil deutſchen Volkstums

Fühl **deutſch**
Denk **deutſch**
Sprich **deutſch**
Sei **deutſch**

auch in der **Schrift**

Laß Tür- und Firmenſchilder nur deutſch beſchriften, Geſchäfts- u. Familienanzeigen nur in deutſcher Schrift drucken.

the prize-winning results were published in the magazines, on calendars and showcards.

Italic type, belonging to the Roman family, was made a scapegoat. In publications on the conservation of the ancient villages and towns (see note 14, Chapter IX) one read the following instruction: 'In the illustrations good and bad examples were contrasted with each other. In order to avoid errors and to emphasize the differences with special clarity, the captions for the good examples are set in Fraktur [a Gothic type], those for the bad examples in *Italic type*.'

The owner of a well-known private press, Professor Christian Heinrich Kleukens in Mainz, who in the 'twenties had set his ambitious World Edition of Goethe in sans-serif type and in Bauhaus style, now changed over in the new volumes to Gothic. The publishing house of Heintze & Blanckertz in Berlin, specializing in writing and lettering patterns and materials, devoted the issues of

its quarterly, *Die zeitgemaesse Schrift,* to the propagation of Gothic. To honor the five-hundredth anniversary of Gutenberg's invention in 1940, the Germanisches Nationalmuseum in Nuremberg held an exhibition of 'Writings as a German art.' [3]

Suddenly, on 3 January 1941, Deputy Fuehrer Bormann issued the following directive from the Obersalzberg: [4]

NATIONAL SOCIALIST GERMAN LABOR PARTY
 THE DEPUTY OF THE FUEHRER
 CHIEF OF STAFF Munich 33, pro temp.
 Obersalzberg, I, 3, 1941

CIRCULAR LETTER
(not for publication)

The following is brought to general attention by order of the Fuehrer: To consider or to designate the so-called Gothic script as a German script is wrong. In reality the so-called Gothic script consists of Schwabacher-Jewish letters. Exactly as they later on took possession of the newspapers, so the Jews residing in Germany took possession of the printing shops when printing was introduced and thus came about in Germany the strong introduction of the Schwabacher-Jewish letters.

On this day in a conference with Mr. Reichsleiter Amann and Mr. Printing Plant Owner Adolf Mueller the Fuehrer has decided that Roman type from now on shall be designated as the normal type. Gradually all printing products shall be adjusted to this normal type. As soon as this is possible textbook-wise, in the village schools and elementary schools only Roman shall be taught.

By order of the Fuehrer Mr. Reichsleiter Amann will proceed to change over to normal script those newspapers and magazines which already have a foreign circulation or the foreign circulation of which is desirable.

(Signed)
M. Bormann

Comment is almost superfluous. One should perhaps point out that the 'Schwabacher' was a relatively late variant of Gothic type which came into favor during the Renaissance and was used along with the more generally employed Fraktur.

The real reason for this incredible decree, the peculiar flavor of which I have tried to retain in the translation, is indicated in the last paragraph. Goebbels was afraid that the use of Gothic type

would interfere seriously with his foreign propaganda, which — almost a year before Pearl Harbor and before the attack on Soviet Russia — enjoyed high priority. The harmless name 'Schwabacher' furnished, again, the necessary scapegoat.

STRAIT JACKETS FOR THE YOUNGSTERS

By far the most telling documents of totalitarian art pedagogy are the drawings made by young children in the public schools. Reproduced here are some drawings made by Berlin school children between the ages of 6 and 12, during the war and within two years after the war. They are reasonably typical of most of the work done almost anywhere in Germany during that period (figs. 34, 35).

It will be seen that the pictures are drawn, not painted. Where color is used it is either applied in line by crayons handled as if they were pencils or added to drawings as a supplementary element. The lines are straight, precise, and sharp. There is much use of the ruler, for street curbs, houses, vehicles, even searchlight beams. Everything is neat and clean; there is a general atmosphere of orderliness and discipline. There are hardly any flowing forms or curves, especially in the compositions. Symmetry prevails and so do straight verticals and horizontals, neatly cutting each other at right angles. People march more than they walk. Or they seem to stand at attention. So do the flowers in the garden, the trees in the forest, and the chimneys on the housetops, always lined up like soldiers on a parade ground. Individual symbols are mechanically repeated without variation. Soldiers in trenches, men walking or skating, trees and flowers, windows in the houses, curtains in the windows are marshaled in seemingly endless repetition. The drawings are always carefully and diligently worked out, and they are finished down to the last detail. Every fencepost, every window pane, every brick in a wall or tile on a roof, every pine needle on every branch of every tree is set down. Often, lines that turned out too weak have been gone over, the outlines of figures are often meticulously retraced.

These children's drawings are tragic documents. One can feel behind so many of them — in bits of personal observation here,

in intimate little touches of humor and naïveté there — an urgent
desire for individual expression. But it is very obvious that these
personal touches were not encouraged; they merely got by.

There is also a great fear in all this orderliness, an escape from
chaos into neatness. True enough, the catastrophe of total war
witnessed by these children accounts for much of this fear. But
these drawings seem to betray an even deeper anxiety than im-
mediate terror caused by the air attacks. A frightened servility, an
eagerness to keep in line, the constant and prolonged fear of falling
out of step are written all too clearly in many of these drawings.

One of the most striking characteristics of the children's draw-
ings in Nazi Germany is their similarity in practically all parts of
the country. Their amazing conformity speaks eloquently of the
uniformity of methods, of the rigid discipline under which they
were produced. There is no evidence anywhere of free experimenta-
tion, by either teacher or child, in this direction or that; everything
is obviously done according to precisely developed rules. This was
true not only of the way in which the children were taught to ex-
press themselves but also of the choice of subject matter.

The themes of the drawings were always community experi-
ences, never personal statements. Wherever we look, we always find
the same topics, invariably assigned as group projects. Political
celebrations, flag raisings, and anniversaries furnished the themes
for many of these projects. So did the various holidays, theatrical
performances, carnival celebrations, and harvest thanksgivings.
Models and maps of the homesteads, of villages and small towns,

sometimes of whole regions were produced. Posters for campaigns against waste, spoilage, and damage or for civil-defense measures were worked out. Individual family crests and emblems were studied, copied, and combined into genealogical tables of entire clans and communities; genealogical tables were also made of all the houses in a given street; illustrations of Grimm's fairy tales and elaborate descriptions of forest, trees, flowers, and wild and domestic animals abounded. Every effort was made to draw the child away from himself, to absorb him into an impersonal, corporate society.

Art education in Nazi Germany had its own Fuehrer, an ambitious and extremely articulate little man named Robert Boettcher. Within the framework of the Nationalsozialistischer Lehrerbund (National Socialist Teachers Association) he was appointed as the top-ranking authority for art education in the Reich. He presented himself to his former colleagues at a convention in Bayreuth, held from 6 to 9 February 1936 at the House of Education there. He immediately proclaimed the Fuehrer principle and laid down the law to the assembled art teachers. He told them that from now on he was giving the orders and that anyone who did not like it could get out — unless he himself should lose the confidence of his superiors, a possibility that was extremely unlikely, as he very well knew.

I will not dodge any clear answer. But I do not intend, and this I emphatically want everyone to understand, to make these questions and my opinions about them a subject of discussion in the manner of liberal and democratic assemblies. This does not mean that I could not be talked to about subordinate questions and details; but it means that the stated directives must be accepted and the work must be made to conform.

Very soon after Hitler came to power, Boettcher had staked his claim with a book on art education in the Third Reich.[5] He completely accepted the orthodox art doctrines of the Nazis and applied them to the field of art education.

Art and religion [he wrote] must become powerhouse and basis of all school work — in accordance with the role of religion, art, language,

custom et cetera as aboriginal functions of our people — because our national character, its racial feeling, its religiosity, and its leadership are most clearly documented in its art and its religion. The concept of art in this connection must be understood in its broadest sense. By works of such art we understand everything which contains the soul-treasure of our ancestors, that is to say the literature and the plastic arts as expressed in utensil and tool, in picture, sculpture, and building; we include in it all cultural treasures which document in artistic form the creative strength of German blood.

He defines the function of art in national life. Above all, he sees in it a social cement. Art must become a crystallization point for the whole intellectual life of the country. Not only the gap between art scholar and creative artist must be closed but also that between both art scholar and artist on the one hand and the people on the other. The artist must become the servant of the people. His task is to manifest the collective mentality of the people. Art must not be overly concerned with form; formal elements must not become important criteria of evaluation. Boettcher demands 'deepest thought content . . . serving aesthetic and intellectual problems . . .'

Boettcher also sees art as a means of combating social unrest, a sort of bromide for the masses. 'Aesthetic feeling and enjoyment are especially important elements in quieting down and pacifying the nation.' Guided tours through museums and exhibitions have a beneficial effect upon the unemployed. Art is a means of overcoming the class struggle, he emphasizes again and again.

Art also has important socio-economic functions. By eliminating unrest and by pacifying the nation it becomes valuable in strengthening its productive capacity and this is essential since 'the greatest possible increase of the products of labor is necessary if we are to reconquer the world markets, in sharpest competition with all the people of the world, for the products of German industry and German craftsmanship . . .'

Since art is an important stimulant in promoting patriotism and religion, it must stay away from the obscene (no definition given). It teaches how to enjoy the beauties of nature, of the landscape,

of home and fatherland. It enhances the appreciation of German fairy tales, folk sagas and myths, German history and heroes, German religiosity.

These ideas are all to be found in Boettcher's book, not in one sequence but distributed here and there throughout the volume. Although some of his most exorbitant demands and his most extravagant ideas were indirectly and mildly refuted in a book published the following year by a man named Paul Fegeler-Falkendorff,[6] Boettcher marched along and got what he wanted.

In 1937, one year after he was appointed dictator of German art education, he developed a comprehensive educational blueprint in which he embodied his ideas and formulated specific plans and procedures. He published this in the official art magazine of the National Socialist Teachers Association, *Art and Youth*.[7] The following year he became the executive editor of this magazine, replacing the old editor, Erich Panitzke, whom he asked to stay on as a sort of understudy.

It is not difficult to conceive of the kind of art education that would result from these teachings. When Boettcher published his book in 1933, he had not had time to apply his ideas very thoroughly to practical art pedagogy and to develop the kind of system he later promoted in his official capacity. But he allowed an occasional glimpse of the kind of teaching he foresaw — for instance, when he enlisted the art teacher as a propaganda agent for racial biology.

Art is always a reflection of a people's character. Not only in content, but foremost also in the elements of form it is bound up as closely with the soil as with the blood, and it is therefore an essential task of the art teacher to demonstrate these connections which are often very hard for the layman to recognize and to realize what fateful consequences do result for a people on one side from racial mixtures and slavish subordination under foreign races and cultures and, on the other hand, from keeping the race pure and closely connected with its maternal soil.

In due course he translated what he believed into specific directives to his art teachers. For instance they should join in the folklore research efforts.

Together with their pupils they must search indefatigably in the darkness of the attics, in hidden chambers, in the almost desiccated river bed of oral tradition, in the contents of old chests, and so on, to save what can still be saved over into our own time. Embroidered cloths, patent letters, tiles, toys, painted plates, costumes, every sort of house decoration, doors, furniture, painted cupboards, wood carvings, baking molds, masks, they all deserve the most lively interest.[8]

Boettcher explicitly proclaimed the totalitarian ideal: 'The new aim of education and the domination of life and school by the idea of totality are of the most far-reaching future importance for the art teacher and his teaching.' But now we come upon a very peculiar paradox. This same man demanded from his teachers the greatest respect for the child's individual expression and its own characteristic pattern of growth. He specifically rejected representational art as a mere scientific skill, which, he explained, might have a place somewhere in the curriculum but does not belong to art education. True art education must be based on an understanding of the child's point of view.

We must take pains to study the nature and the phases of development of the child's picture language, and from this — not from the point of view of the adult — we must judge the products of the children and respect these laws in such a way that we build our teaching upon them.

Yes, the Nazi art pedagogues pretended to accept the teachings of the liberal reformers of the Weimar Republic. Their attitude toward the efforts of German art educators before Hitler's arrival to power is an exact parallel to that of the Nazi architects, the city planners and the men of the arts-and-crafts movement toward their predecessors. They all had to acknowledge, halfheartedly and grudgingly, that they could not get along without the foundations laid by the men of Weimar, but they always hastened to explain that these were pioneers whose lonely voices rang unheard in the wilderness, solitary stars in a naughty world, struggling against impossible odds. And they all corrupted the ideals of these men as they made use of their ideas.[9]

We have seen in our discussion of the new art pedagogy in the

Weimar Republic (pages 33–4) how close to authoritarian practice some of the men had already drifted toward the end of that period. It was not very difficult for Robert Boettcher and his teachers to take over the theories of Gustav Britsch from the hands of disciples who were already well on the way toward cultural regimentation. But by still emphasizing the importance of the child's own way of seeing and of expressing himself and by trying to retain this in the classrooms the Nazi art pedagogues created an insoluble dilemma.

How was their leader going to reconcile the irreconcilable? How was he going to demand both the highest respect for and encouragement of the child's natural creative instincts and his complete absorption into totalitarian society? The answer is simple — he never did. He never managed, nor did he ever try, to fit together pieces that did not belong together. They were simply two different, completely unrelated concepts with which he operated.

The German children's drawings reproduced in this book show clearly that the Nazi art teachers paid mere lip service to the ideal of self-expression and to respect for the independent creative and formative powers of the child. If they took these admonitions seriously, if they studied child art in its own right, it was often only the better to take hold of the children in their care and to get them to perform all the more efficiently according to the prescribed lines.

All children had to travel by identical stages along the same road toward the universal and final goal of naturalism. Scattered through various articles in Boettcher's magazine are ready-made formulas for the drawings of such objects as 'man,' 'tree,' or 'ship,' at each stage of development. There were also all sorts of useful hints and recipes. Technical emphasis was on manual dexterity, on learning how to cut silhouettes out of black paper and how to mount them on white paper; how to make folded cutouts; lettering; how to build all sorts of models; the carving of human figures, animals, and decorations out of wood and how to paint them; pictorialized map-making and wall-decorating; the making of masks and costumes; painting chinaware and furniture; textile printing, and so forth. The instructions were clear and easily followed and there were models and patterns for almost everything. No wonder that work of an astonishing degree of competence and effectiveness was produced under these conditions.

We get a vivid picture of the role of the Nazi art teacher as a sort of drill sergeant on the march to realism in the report of one of them: [10]

I begin every nature study with a walk, during which the pupils observe all sorts of plants, grasses, and trees. Chestnuts attract our main attention, because in form and structure they show especially clearly how things are connected. Every pupil first looks at the trees for himself. After a while we talk over what we have observed: trunks and branches, the arrangements of blossoms and leaves, colors and forms. A branch is broken off, so that every boy has a chance to examine blossoms and leaves in exact detail . . . After we have thus spent almost an hour, we go back to school and begin our work.

The boys are given the task of painting or drawing a chestnut branch. According to age and talent of the boys the branches are drawn immediately from nature or from memory . . . If there are boys (in a group which is directed to work from memory) who want to work directly from nature, I let them go ahead. But I make certain reservations here, because often pupils speak up now who have not paid attention earlier during the nature observation or those who prefer to work this way from mental laziness . . . The drawing and painting of chestnut branches makes up only a small part of the nature study — in the course of the summer the boys also draw and paint grasses, plants, and flowers . . . All work is supplemented by the contemplation of nature

studies by Duerer, Altdorfer, and other German masters, which show very impressively that one must delve deep into nature in order to create a work of art . . .

Here were the first steps on the road that led always to the same goal for everyone. The sense of participation in the corporate enterprise was heightened outside the classroom through the activities of the Hitler Youth. 'All roads lead to Hitler' was the theme hammered into the minds of the youngsters when they saw, for instance, an exhibition of the Autobahn project. At the same time they were taught respect for the 'Heroes of Labor,' who made these miracles possible. Indoctrination through the medium of art was carried on in the Hitler Youth through visits to museums and castles and by frequent pilgrimages to the sites of ancient Nordic remains (figs. 36, 37).

This indoctrination of the individual did not stop at the elementary or high-school level. It was carried over into adult life in the best-organized art-education program for adults the world has ever seen. Never before anywhere had there been such thoroughly organized and sustained efforts to bring fine-arts exhibitions to the factories and to provide the men and women of the laboring classes with opportunities for workshop participation. The Labor Front, through its 'Strength through Joy' organization, was mainly responsible for this program.[11] It is literally true that before the war every individual in Nazi Germany was continuously exposed to some form of officially sponsored art activity (fig. 25).

One of the chief media through which this continuous barrage of cultural indoctrination was leveled at the citizen in the Third Reich was the periodical press. There were a number of popular art magazines, every issue full of pictures, many brightly colored.[12] But articles on art were printed also in nearly all the issues of every other kind of periodical, from the SS *Schwarze Corps* to the illustrated weeklies and the daily papers. The fare was identical everywhere, prepared to a precise formula. Ancient Nordic remains, Gothic sculpture and architecture, German Renaissance painting, German nineteenth-century romantic and genre painting, and the

current offsprings in the Haus der Deutschen Kunst were the staple products served up again and again.

Art education in Nazi Germany — whether it was actual workshop experience or art appreciation, whether at the childhood or the adult level, whether it was painting or modeling or woodcarving — always had one and the same objective: to make the person a better Nazi, a more obedient, more efficient, healthier bee in the beehive, a more energetic ant in the ant heap.

III

SOVIET INSISTENCE

AND WESTERN DILEMMA

XIII

The Postwar Situation

IFE IN POSTWAR Germany was full of surprises. The survival of progressive art in spite of the Nazi oppression was one of the earliest discoveries made at the end of the war. When the first Americans interested in art arrived on the scene of destruction they were amazed to find that the Nazis had not succeeded in stamping out the hated 'degenerate' art. In the Berlin studio of the sculptor Karl Hartung they found themselves surrounded by abstractions akin in spirit and intent to the work of Henry Moore and of other artists of international renown. Before the war Hartung had lived in Paris, and the seeds planted then had come to fruition in secrecy and seclusion (figs. 44, 45).

In 1946, the abstract painter Theodor Werner and his wife showed some American visitors a letter from an old friend and patron in the United States. It was the first word Werner had received from his friend since the war had ended. It was, in fact, a letter of consolation. How sad it was that Werner had been kept from his painting for all these years. But Werner's room was filled with pictures he had produced since the end of the war and of photographs of paintings he had finished while the war was still raging. Werner had lived through the war in Potsdam in a house that, as it turned out, lay in the line of heavy-artillery fire during the battle of Berlin. All his wartime work had gone up in flames, except for some photographs of his paintings. But he had been able to carry on secretly. The fact that Werner, one of Germany's most important

abstract painters, had lived in Paris before the war and was hardly known in his own country had made it easier for him to continue working than for most of his colleagues (figs. 42, 43). But in spite of the most rigid controls Karl Schmidt-Rottluff, Carl Hofer, Willi Baumeister, Ernst Wilhelm Nay, and many others had carried on their work to the very end of the war.

Respite from Tyranny

It was inevitable that the artists who had lived haunted lives as enemies of the state and 'traitors' to the national cause should have anxiously awaited the end of the war. Only the end of the Nazi regime would grant them escape from their fearful isolation. As they emerged, one by one, from their hideouts in the ruined cities, they appeared to us like prisoners suddenly released from solitary confinement.

On one occasion I witnessed the breaking of the dam. Theodor Werner had been asked to speak to a group of American and German friends of art. 'Is Painting Still Possible Today?' was the topic he had chosen for the occasion that was to be his first contact with the public in more than ten years. As soon as he started, he forgot where he was. He talked as one possessed, pouring forth in one elemental, overpowering outburst what had lain bottled up in him for so long. He spoke without interruption for two and a half hours to a motionless, spellbound audience.

Werner was talking at a meeting of the 'Prolog' group, an informal organization of Americans living in Berlin who met regularly with non-Nazi artists.[1] We discovered that except in the case of a few old-timers these men did not even know of one another, and that they had forgotten how to speak to each other. Before our eyes and sometimes with our help they rediscovered the joy of communicating with a fellow artist.

A high degree of integrity and sincerity was found in the work of most of the progressive artists who had survived the Nazi period.[2] There was also a great deal of technical competency. Nothing superficial and unessential could have survived the intense heat of trial and persecution. At the same time the material and spiritual diffi-

culties these men had had to face had left their mark. They spoke as individuals, with subdued articulation, and generally in a minor key. There was subtlety and a great deal of graphic skill, rich surfaces, loose, dynamic draftsmanship, little precision and attention to detail. The colors, too, were subtle, with a marked preference for soft and subdued shades. Direct illustrations of the scenes of destruction and details of everyday life were rare. There was a small group of caricaturists, led by the gifted young Paul Rosie, who drew on the Berlin postwar scene much as George Grosz had done after World War I. But with most of the others, comment on and reaction to the current situation were indirect. The timeliness of the work is implicit. For instance, though Renée Sintenis still models and draws her graceful animals, they are no longer happy colts but creatures haunted and hunted.

Another great surprise on the postwar scene was the development of an intense interest in all art affairs on the part of the general public. It is difficult to exaggerate the acuteness of this concern, this fervor of inquisitiveness and receptivity. The pros and cons of modern art, especially of abstract art and of surrealism, were debated with determination and enthusiasm. Newspapers devoted to these questions an amount of space that was incredible by our standards. Questionnaires were sent to the public by museums, galleries, and publishers, and the returns showed intensity and breadth of interest. Young and old alike were eager to receive what the isolated artists were only too willing to pour forth. Many young men and women who had had no contact with any art except what was officially acceptable crowded into lecture halls to hear about modern painting; galleries (and many had sprung up since the war) were filled with customers and sightseers alike. Art books and art magazines sold out the day they appeared in bookshops. Museums and city administrations vied with each other in giving exhibitions, nearly two hundred of which were held in 1947 alone in the U.S. zone of occupation and in Berlin.[3] There was no question about the meaning of all this activity and interest. Here were the obvious symptoms of a severe case of artistic starvation, caused by an acute aesthetic vitamin deficiency.

Art life in Berlin especially amazed everyone who came to the city after the war. Large posters announced exhibitions and lectures on modern art. People crowded each other before the show windows of galleries that had quickly sprung up among the ruins of the once fashionable Kurfuerstendamm. Art schools were filled to capacity.

The former Berlin state museums, once in possession of some of the most valuable and extensive collections assembled in the public trust, found themselves sorely crippled by the wartime destruction of their buildings, by evacuation of their treasures to other zones, and, last though not least, by extensive confiscations of their remaining treasures on the part of Soviet raiding parties after the fall of the city. But even so the museum administration was struggling hard to keep in the public eye and to maintain its prestige by exhibitions of a few selected historical masterpieces, highlighted by skilled and experienced showmanship.

The collapse of the party machinery in 1945 left the Berlin artists without an organization for the distribution of ration cards for food and artists' materials. Here the city government, the Magistrat, stepped in at once by creating district art offices in the various boroughs of the metropolis. The Russians were at that time the only occupying power in Berlin and their ideas on the value and importance of the artist were reflected in the system they introduced. There were three types of ration cards; the best were reserved for famous artists, the second for newspaper cartoonists and stage designers, the third for the run of the mill.

The Berlin Magistrat saw and seized an opportunity for active support of the artists in its charge by engaging in a systematic exhibitions program. Wherever suitable space became available, the various district offices organized prompt and effective displays of the works of painters and sculptors in their boroughs.

Here came to light the work of the 'shutter artists,' the men and women who had secretly continued their painting and modeling in the loneliness of their homes. They were joined by a new generation in its first tentative steps, young people who had had neither time nor materials to do more than a little sketching on the mar-

gins of letters to their friends. The established masters managed to bring to these first exhibitions some of their canvases salvaged from hiding places and bomb-proof shelters. Expressionism witnessed a distinct revival. It was like the return to consciousness after a long stupor. 'Where am I? Where was I? What was it I tried to do before this thing happened that separated me from myself?'

Gradually, it became possible to bring in work from other countries, sometimes with the official, but more often the unofficial, help of members of the occupying powers. The art department of the Zehlendorf Magistrat, for instance, was able to show in its Haus am Waldsee the paintings of young Henry Koerner, the first American art show to be opened in Berlin, and, later on, an exhibition of American children's drawings, sent from many schools and organizations in the United States.[4] Such offerings were eagerly received and fervently discussed, especially by the younger generation.

The young people in postwar Germany were in an especially difficult position. After years of spoonfeeding on Nazi photographic realism they were suddenly brought up against a bewildering variety of *isms*. Their helplessness and confusion led some observers to believe that the young people of Germany were 'opposed' to modern art. This was repudiated with cold figures in an interesting experiment conducted by the art publisher Kurt Hartmann along the lines of an American public-opinion survey. He was the publisher of a series of 'art letters,' small and inexpensive monographs on individual monuments of historic fame. After the war he inserted a questionnaire in which he asked, along with other questions, if the readers would welcome the inclusion of works of living artists. The answers were decidedly revealing. Men between the ages of 15 and 75 answered, women between 16 and 58. Of the total, 75 per cent voted 'yes' for modern art, 18 per cent 'no,' and 7 per cent had no opinion. But from among the men aged 28 to 35 a full 40 per cent were against modern art. The women of the corresponding age group showed no such antagonism. These figures reveal very clearly that those men whose important formative years coincided with the success of the Nazi regime were still violently

opposed to modern art. The younger people, on the other hand, and especially those in their early twenties, asked specifically and urgently for information on living artists.

Progressive art in postwar Germany has received splendid support from the various levels of government. The municipalities, especially, have followed a policy of positive encouragement and support. The city of Cologne has built a house for sculptor Gerhard Marcks and the Cathedral has been given bronze doors by the once 'degenerate' sculptor Ewald Mataré. Hamburg brought Oskar Kokoschka from London to paint the portrait of its burgomaster, Brauer. West Berlin has established a municipal art competition and has organized several important exhibitions, including that of the Bauhaus painters originally shown in Munich [5] and the first display of the newly founded 'Deutscher Kuenstlerbund, 1950.' Municipal galleries in many other cities, in Karlsruhe and Mannheim, for instance, have begun to fill the gaps left in their collections of modern paintings by the Nazi confiscations. Semi-private museums in such cities as Hamburg and Bremen have followed a progressive policy of exhibitions and purchases. In 1951 the Kestner-Gesellschaft in Hannover sponsored a wonderful display of outdoor sculpture in connection with a large horticultural exhibition, ingeniously demonstrating harmonious use of extraordinarily varied sculptural forms in different settings.[6] Dr. Alfred Hentzen, the capable director, also organized a traveling exhibition of modern color prints, which found wide reception and a ready sale.

Nearly all important modern painters who have survived the Nazi oppression are in responsible teaching positions, and a few mature new talents, along with many young people of promise, are continuing free experimentation in the modern idiom.[7] The Werkbund, whose pioneering efforts in architecture and applied design started early in the century and were interrupted by the Nazi regime, was re-established after 1945. The Werk-Akademie in Kassel is doing some of Europe's most ingenious teaching in applied design and the arts and crafts. The seat of the government in Bonn, the Bundeshaus, which stretches along the banks of the Rhine, is

a magnificent modern structure by Professor Hans Schwippert of the Duesseldorf Academy.

When Hans Schwippert planned the interior decoration of this new Bundeshaus, he assembled a large number of paintings by living artists for the delegates to choose for their offices. He was amused to observe just who the people were who selected the most articulate examples of non-objective paintings: a conservative diplomat of the old school, a delegate from the headquarters of the orthodox Catholic Bavarian Ministry of Culture, a Social Democratic teacher, and one man from the more radical left wing. Obviously, there are no very clear party lines recognizable in the acceptance or rejection of modern art.

The artistic record of the Social Democratic party, one of the largest in Germany, is also by no means clearly oriented in one direction or another. The socialist burgomasters in some of the large cities, for instance, are progressive in taste but they are handicapped by the lethargy or timidity of their rank-and-file administration men. In matters of reconstruction and city planning one hears of similar complaints. There is an atmosphere of fatigue, a desire not to stick one's neck out in a situation that is becoming more and more complicated.

The Unpleasant Surprise

Anyone in or outside Germany who read in the meteoric rise of the star of progressive art a sign of genuine democratic conversion of the broad masses was mistaken. It was easy enough to commit such an error of judgment, at least in the initial phase of the occupation. Anybody who knew the Nazi art program, who understood to what extent the Third Reich had identified itself with reactionary art, was bound to interpret the enthusiastic reception of progressive art as a liberal political attitude. Moreover, there can be no doubt whatsoever that the Nazis — following Goebbels' direction to go underground — kept extremely quiet at first. It really looked for a while as though they were through, once and for all. It took many months for the fanatic adherents of National Socialism to come out into the open again.

The first real indication of the difficulties involved in a real democratic reorientation came to me in December 1947. A group of military-government employees and dependents had organized an unofficial one-day conference on art education in Berlin. We were able to show examples of the work of American children from many parts of the United States and to describe the conditions and methods by which these spontaneous, free expressions had been achieved. We got enthusiastic support from some of our genuinely democratic German friends. Said Kurt Hartmann in his address:

Every serious effort to understand works of art through visual training must of necessity result in a development of the personality toward individualism. The capacity for independent vision and independent hearing is the necessary prerequisite for independent thinking. Here is the most powerful weapon that exists against the terrible dangers of mass hypnosis, the fearful consequences of which have been so convincingly demonstrated in Germany.

Some of the older members of the audience were a little sad. 'All this we know. This is what we were brought up on, what we tried to do as long as we could.' But there were other reactions, too.

We learned more of this when a group of art teachers from the Berlin schools invited us to a meeting at which they were going to show what they were now trying to do. We thought we might see some new efforts at free experimentation, but it soon became apparent that all they wanted was to justify their stand and to go on as before.

One man spoke of reading one of Andersen's fairy tales over and over again to his class of twelve-year-olds. He drilled the story of Thumbelina into them until they knew it by heart. It was not surprising that the resulting drawings which he proudly exhibited, were almost identical: the big round circle of the waterlily, repeated by each of the two dozen children in the class.

Someone else spoke up. Would it not be a good idea to let a child choose his own theme? 'Whenever I have let a child pick his own subject, I have found that nothing but a watery soup comes out,' was the prompt answer from another of the teachers.

A small soft-spoken woman got up. She explained that she was

not a professional art teacher but a child psychiatrist. In her work
with disturbed children she had found that letting them draw was
the best way she knew of getting them to open up. That was why
she had come to the meeting. She asked for permission to show a
group of drawings made by the youngsters she had worked with.
The projector was still in place and she proceeded to throw on
the screen the most exciting and revealing series of children's draw-
ings I have ever seen. If ever there was a group of children likely
to show signs of emotional disturbance it was in Berlin after 1945.
The little lady started systematically with the youngest and went
on to the older age levels. In one drawing there was a row of houses
with a clump of trees in front. A bright-red line tore across the
paper from the trees to one of the windows. 'This was the cry I
heard at night in my bed from the park in front of our house,' the
child had explained.

This was too much for the art teachers. 'Enough of this . . .
This has nothing to do with normal children . . . Stop this non-
sense' were the shouts that drowned out the psychiatrist; the plug
was pulled and the image disappeared from the screen.

An experience such as this was only the beginning. There have
been slowly increasing signs of hostility to individual free expres-
sion in art.

Intolerant attitudes find various means of expression. The writ-
ing of both anonymous and signed letters to the press, to museum
directors, to the artists themselves, is one form of attack. 'You are
over seventy years old now, why don't you die and stop making this
trash?' said a letter to Carl Hofer. The director of the Hamburg
Kunsthalle, Carl Georg Heise, received a letter that went some-
thing like this: 'I am not a Nazi and I and my friends think that
Hitler and his gang deserve all the tortures of hell which they
are undoubtedly experiencing now. But we think that he ought
to be spared at least one or two of the worst tortures for having
freed us from the monstrosities which you, sir, are again foisting
on the German people.' Professor Heise also received a letter from
a group of reactionary local politicians in connection with a col-
lection of paintings he had assembled for the decoration of the

headquarters of the Hamburg delegation to the federal government. 'Why don't you show these paintings here in Hamburg, and while you are at it, why don't you put some labels on them, so that we can see what's in these pictures,' they wrote, with thinly veiled mockery.

Students in the Technical University in Berlin, many of them from the Soviet sector, demanded the removal of modern paintings from the examination room because 'they had a distracting influence and caused wrong answers.' A Berlin hotel manager, who had hung some non-objective paintings by good artists in his lobby, was forced by his customers to take them down.

The all-important question seems to me to be in what direction indifference and hostility toward modern art in Germany are moving today; whether they are going along at a steady pace or are gaining volume and sharpness. Many first-hand observers with whom I have talked insist that these unfavorable reactions, ranging from indifference to ironical condescension and outright hostility, are no different in Germany from Philistine attitudes anywhere else in the world. Such complacency does not seem to me justified. The Nazis' deliberate and prolonged activation of all such attitudes into a political dogma of the first magnitude has undoubtedly had a profound effect. I find it impossible to believe that such attitudes have survived independently from association with the Nazi ideology. Today they are perhaps still a rear guard. In connection with the steady rise of neo-fascist political organizations in Western Germany, however, they could very quickly assume a different meaning and importance. They could lead right back into a situation of totalitarian tyranny. That is the reason why it is so important to find out whether or not these attitudes are gaining ground.

Unfortunately, there is some evidence that they are. The thing that lends greater significance to these various symptoms of intolerant aggression is the return to favor of Nazi painters and sculptors. The very same men who only a few years ago were the violent protagonists of Hitler's racial, social, and political doctrines are now de-Nazified and happily installed in prosperous persuit of their

professions. They can be found especially in Bavaria and in the northern Rhineland, around Duesseldorf and its neighborhood. Arno Breker, Hitler's number-one sculptor, is retained by an industrial concern as an art director. Paul Maria Padua, famed for his painting of 10 May, the date of Hitler's reoccupation of the Rhineland, some time ago had a one-man exhibition in Krefeld. Werner Peiner, favored in all Nazi exhibitions for his smooth and meticulous compositions in the old-master technique, and Sepp Hilz, the painter of the Bavarian 'Peasant Venus,' have been given renewed support. Not only that, but these men have again joined various organizations, they are again appearing in the limelight, and, incredible as it may sound, they are given official backing. Josef Thorak, whose huge and brutal muscle men earned him Hitler's personal friendship, was interviewed by Dr. Gilbert, the prison psychiatrist at the Nuremberg trials, soon after the end of hostilities. Thorak proposed immediately to make a figure of 'Art throwing off the shackles of Tyranny' and proceeded at once with its execution. During the Salzburg Festivals in 1950 he was given a one-man exhibition. Posters advertising the event could be seen in the town halls of the same Bavarian communities for which he had recently made public fountains and saints' statues. Only his death in 1952 put a stop to his renewed rise to fame and fortune (fig. 18).

Official sanction has not been lacking. From 20 October to December 1951, Josef Thorak, Sepp Hilz, and 125 other painters and sculptors of Nazi fame have been permitted by the Bavarian Ministry of Culture in Munich to exhibit their works in the same Haus der Kunst where not long ago they displayed their triumphant mediocrity for the greater glory of National Socialism. The exhibit was vigorously attacked in many daily papers of Western Germany. From Berlin, the 'Deutsche Kuenstlerbund, 1950,' which includes Germany's best artists, sent a protest which contained the following statement:

Nobody will want to pay back in their own coin these pillars of the Third Reich and deny them work and exhibition. But the protection of the state appears to us highly questionable. We should deeply regret it if from Munich, once a center of art and about to regain this position,

there should issue forth once more that evil reaction which has exposed the culture of our country to ridicule. Art cannot be de-Nazified!

There are many people in Germany who feel apprehensive about another measure of the Bavarian state — the appointment of Hans Sedlmayr, former Nazi art historian from Vienna, to the post of full professor of art history at Munich University. His extremely clever and sophisticated book, *Loss of Vital Center*,[8] is a mordant attack against modern art from the point of view of the most orthodox and authoritarian clerical dogma. He is one of the most controversial figures in German art life today, severely criticized by the modern artists under the leadership of Willi Baumeister of Stuttgart,[9] but nevertheless Sedlmayr is in a position of great influence.

Nowhere is the growing force of this hostility felt more keenly than in Berlin, which is in close proximity to the Iron Curtain. Carl Hofer, in a letter written in 1951, said:

One wants to forgive and forget, but the others do not forgive and forget. It is they who make use of that liberty which gives them public leave to destroy liberty. The fascist Hydra again raises its head, cautiously first, then with impudence, since it is possible to do this with impunity . . . Those who are able to perceive these things feel how similar, down to details, is the current mood to that of the 'twenties. What did Goebbels call out to his faithful ones when the catastrophe was approaching? 'Conceal yourselves . . .' And behind all this is the tragic complication that today one needs the very same evil elements which one fought against only yesterday. For they are the only ones fit for battle, they alone wish to fight, and with an after-thought which is without precedent on the stage of world history. We in Germany are gazing as though hypnotized at the bear, while the hyena at our backs creeps up unnoticed.

CULTURAL POLICIES OF THE WESTERN ALLIES

Could the occupying powers have done anything after the war to prevent the reassertion of Nazi influence on German art life? That is a difficult question to answer. Perhaps this would have been possible if the policies and programs of 1950 had been initiated

five years earlier. Perhaps we missed our opportunity to strike when the iron was hot.

This is an important question. Under the special conditions prevailing in Germany after twelve years of totalitarian dictatorship the return of artistic likes and dislikes fostered by the Nazis has a decided political significance. We cannot separate aesthetic and political creeds in Germany after they were so forcefully welded into one by the Nazis. A clearly defined and promptly enacted art program for occupied Germany would not by itself have been sufficient, of course, to bring about a genuine democratic reorientation of the German people. But the absence of a program in this one field is a good example of similar omission in many other fields. We emphasized politics and economics. We neglected, in the beginning, the cultural matters. History may very well show that this was a costly oversight.

Of the Western Allies the French were the only ones who immediately understood the importance of an active art program. Guided by proximity, natural instinct, and hard-earned knowledge, they knew at once what was needed. As soon as it was feasible, they sent exhibitions of contemporary French art, which were enormously effective. In bombed-out Berlin, which still housed several million people, the exhibitions of modern French painting and sculpture were the first messengers from another world. These exhibitions made a deep impression wherever they were held. From the start, the French central and regional 'Officiers des Beaux-Arts' worked closely with German museum curators, art scholars, and pedagogues.

Monsieur Eydoux, at the French Headquarters in Mayence, emphasized how important it was that restitution personnel work separately from cultural-reorientation officers. It was not fair, he felt, for the same organization to demand both surrender of illegally acquired art treasures and co-operation in the staging of a French exhibition.

The Division of 'Affaires culturelles' has its own branch of 'Relations artistiques,' with separate sections for the fine arts, motion

pictures, radio, and musical performances, and a liaison department. It publishes an excellent magazine on cultural life in Germany today.[10]

The British program was similar to that of the United States in that its chief emphasis at first was on the restitution of the Nazi cultural loot and the protection of surviving artistic monuments from further destruction through neglect and misuse. These were the only official activities authorized for the Monuments, Fine Arts, and Archives officers in the British Restitution Branch. For the first three years no exhibition could be sent to occupied Germany from England. The first shows were organized in 1947 by the British Council. During that same year the exchange program of cultural personnel was started. It was not until 1948 that a Cultural Relations Branch was formed.

In the United States zone of occupation there was no department of military government directly responsible for the reorientation of German art life until about 1948. The basic objectives of the military government were stated in a directive issued by the Joint Chiefs of Staff and dated 10 May 1945 (revised). It included the following passages:

The principal Allied objective is to prevent Germany from ever again becoming a threat to the peace of the world. Essential steps in the accomplishments of this objective are *the elimination of Nazism and militarism in all their forms . . . and the reconstruction of German political life on a democratic basis.*

A co-ordinated system of control over German education and *an affirmative program of reorientation will be established* designed completely to eliminate Nazi and militaristic doctrines and *to encourage the development of democratic ideas.*

. . . You will endeavor to obtain agreement for *uniform and co-ordinated policies with respect to (a) Control of Public Information Media in Germany . . .*

These directives were not applied to German art life. Obviously American policy makers had never heard of the Nazi art policies and they cannot have had any idea of the deep impression the Nazis had made in this field.

Literature, music, theater, and radio were the concern of the Information Control Division. Educational institutions in general were under the Education and Religious Affairs Branch, later a part of the Cultural Affairs Division of OMGUS. But the Monuments, Fine Arts, and Archives Section was in the Economics Division, as part of the Restitution Branch. It was strictly limited to matters of property, to the restitution of the Nazi cultural loot, and to the protection of monuments. It was warned off the cultural-relations field in no uncertain terms.

Slowly, from about 1948 on, these weaknesses were eliminated through a new, active cultural-relations program, including officially sponsored publications [11] and valuable experiments with popular art education programs, such as those initiated in the museums of Nuremberg and Karlsruhe. However, both the exchange-of-persons program and the exhibitions in the 'America Houses' were still operating under rather restrictive directives.

What did the Soviets do in the art field?

German Art behind the Iron Curtain

I N NOVEMBER 1947 the Soviet Haus der Kultur in Berlin issued
invitations to a public lecture by Lieutenant-Colonel Dym-
schitz and two of his subordinates on 'Soviet Art and Its Relation
to Bourgeois Art.' Special seats in the front row of the crowded
lecture hall were reserved for Allied personnel and for a few promi-
nent Germans. One felt very conspicuous and had the uneasy sen-
sation of being watched. The speakers seated on the platform coldly
eyed their audience with a mixture of suspicion and arrogance.
Lieutenant-Colonel Dymschitz shot quick little glances about him
as he began to explain his thesis in excellent German.

What he said was quite simple. It was a mistake to think of an
Iron Curtain. Soviet culture was not only heir to everything that
was valuable in the cultural history of Russia, it was also open to
every worth-while artistic effort anywhere in the world today —
provided only that the effort was genuinely democratic and truly
socialistic. He explained what he meant by that. Art must be for
the people and of the people. It must be simple enough to be under-
stood immediately by everyone, and it must clearly carry the mes-
sage of social progress. Realistic in style and content, it must con-
tribute to the building of the new, revolutionary, anti-capitalistic
world order. In his opinion, no other form of art was acceptable.
Surrealism, abstraction, and every other non-realistic expression
was worthless. Art that did not fit into the required pattern was
individualistic, capitalistic, bourgeois, snobbish, and decadent.

The complete assurance and outright arrogance with which Dymschitz uttered these pronouncements left his audience convinced that no possible room for argument remained. The rest of the world would unquestionably have to come around sooner or later to accepting these demands for a new social realism in art.

The effect of his remarks was rather frightening. His irreconcilable attitude (repeated without variation by his assistants), with its clear implication of a cultural world conquest, came as a shock to many. The German art leaders in the audience accepted the talk calmly: 'Exactly like the Nazis — from the ideas down to the very wording,' was their verdict. Some of the members of Allied cultural missions, however, who had still believed in the possibility of intellectual understanding, or at least in the value of open discussion, were extremely disillusioned.

The Soviet art program in Germany had at first sight looked rather good, especially in comparison with the meager or nonexistent directives of the Anglo-American occupation program. From the start, the Soviets had encouraged the artists, giving them official recognition and preferential economic support. Art schools had received early attention and assistance. The first major postwar exhibition of German paintings had been held in Dresden, in the late summer and autumn of 1946. Although Soviet officers had shaken their heads at some of the abstract paintings of Adolf Hoelzel, Paul Klee, Willi Baumeister, Fritz Winter, and Lyonel Feininger, and at the surrealist work of Edgar Ende, Karl Kunz, and Rudolf Schlichter, there was no official interference. A general artists' congress was held in connection with this exhibition. A year later, also in Dresden, the first official conference of German museum directors was called in order to discuss the urgent new tasks that awaited the curators. The university curriculum had also been carefully analyzed in the light of the new demands created by the postwar situation. The Soviet-licensed German press had been instructed to play up art and to underline the official Soviet directives.

Conditions seemed quite favorable for the development of the trends that would be most valuable in the art life of postwar Ger-

many: indictment of the Nazis' cultural policies, rediscovery of the so-called 'degenerate' German art before Hitler, contact with new developments in the outside world, and, of course, new growth in Germany itself. Some of the most effective graphic denunciations of the Nazi regime by postwar artists were being published in the Soviet zone.[1] The rebuilding of the new theater in Weimar, with an interestingly unconventional fresco by Hermann Kirchberger, was in progress. In Halle plans were under way for the reopening of Moritzburg Museum as a representative museum of modern art. Here was another instance of the 'flirtation' between progressive art and the early phases of a new regime.

In the light of Dymschitz's pronouncements, much of the earlier enthusiasm among German artists in the Eastern Zone appeared premature, and the optimism of outside observers hardly seemed justified. Here was a clear indication of the real motive underlying all this official encouragement of the arts — the enlistment of art and artists in another totalitarian program.

Subsequent developments have shown ample justification for these apprehensions. The Soviet-inspired and Soviet-controlled art policies in the Eastern Zone of Germany provide an interesting, tangible example of what is bound to happen when the Marxist doctrine is applied dictatorially to the field of artistic creation. The ultimate test of such an experiment, of course, lies in the results obtained, and these are not difficult to demonstrate.

First, however, it is necessary to explain the mechanism by which the policies dictated by Moscow are formulated in Germany, and how they are applied. Lieutenant-Colonel Dymschitz was apparently chosen for the specific task of providing the ideological foundations of these policies and browbeating any opposition into subdued silence. His lecture at the Haus der Kultur in the fall of 1947 was only the opening blast. A year later he followed through with a series of violent newspaper articles in the Soviet-licensed *Taegliche Rundschau*,[2] which resulted in a heated discussion in the daily press and a public debate at the Humboldt University in Berlin. After a final summarizing article, published the follow-

ing year,[3] Dymschitz disappeared completely from the scene, possibly because his usefulness had been exhausted.

These Dymschitz articles are important documents, well worth studying. Their underlying theme is an attack upon the so-called 'formalistic' tendencies in German painting. The term 'formalistic' is used as a derogatory description of all painting that presumably is preoccupied with aesthetic and stylistic problems at the expense of content. Formalistic painting — which includes all kinds of expression, abstraction, and surrealism — is, according to Dymschitz, an individualistic indulgence, the decadent reflection in art of decadent, reactionary, bourgeois society. The frequent anxiety of the formalistic artist, his preoccupation with pessimistic and problematic themes are symptoms of his isolation in an already doomed society. The truly democratic artist, by contrast, is intimately associated with the life and struggle of the working class and happily reflects its cheerful and successful struggle in the building of a new order. For an artist not to be understood by his contemporaries is a terrible tragedy, to be avoided at all costs. 'General and uniform principles of a truly democratic, healthy, and progressive artistic creation' must be worked out. 'An artistic entity represents a firm union of content and form under the leadership of content.'

The articles show considerable irritation with Picasso, at once a decadent formalist and a believer in communism. Dymschitz goes to great lengths to summon him and other stray sheep back to the fold. He tries to distinguish sharply between formalistic artists who are reactionaries at heart and those misguided souls who, though genuine socialists, have nevertheless somehow succumbed to decadent capitalistic art forms. Formalistic German painters, he explains, are alien to the tradition of German art, which has always been full of high ideals and has frequently reflected progressive ideas and social ideals.

The articles met with considerable opposition. The Colonel's opponents tried to demonstrate, among other things, that in the not so distant past realism in painting had been explored to the

Line cut by Herbert Sandberg.

limits of its possibilities, and that a return to it carries with it a serious danger of artistic reaction; that so-called 'formalism,' on the other hand, is the result of genuine artistic revolution and is truly progressive in nature; and that insistence on realism curtails the necessary process of significant abstraction and important generalization. None of these arguments made the slightest impression

on Dymschitz, who refuted every point without yielding an inch. The uncomfortable suspicion arises that both the controversy in the daily press and the public debate at the Humboldt University were staged merely to lure the opposition into the open, the better to silence its dissenting voices.

Some of those who had entered into the discussion came from the very ranks of the German communist artists. The most important of these was Herbert Sandberg, veteran communist youth leader, who had spent ten years in the concentration camp at Buchenwald, printing there a series of black and white sketches with homemade pigments.[4] After the war he was editor of the satirical Berlin weekly, *Der Ulenspiegel*. Writing to the *Taegliche Rundschau*,[5] Sandberg agreed that 'absolute subjectivity as the starting point of artistic creation' was something he and the other socialist German artists were opposed to, and he asserted the willingness of this group to strive for a new content in art which would correspond to 'the great tasks of our time.' But he also stated that content, in his opinion, included not merely the subject of a painting but all the elements of what a painter had to say as well as how he said it. 'We believe,' he explained, 'That the artistic condensation of social reality corresponds to the conditions prevailing at each period' and is therefore subject to continuous evolution. Not only the development from Daumier to Kollwitz but also the language of form from impressionism to Chagall are significant reflections of the times.

If ever an art clearly signalized in a prophetic language of form its corresponding epoch, with all its repercussions and movements, and if ever it expressed the meaning of its period through valid symbolism, it was modern art, which had been attacked again and again by the petty bourgeois who found it uncomfortable . . . Formalism in art [Sandberg further suggested] does not mean non-objective painting, but merely superficial, purely arbitrary, and soulless formulations.

He defended Carl Hofer (who had been a special target of Dymschitz's attacks) as a good painter. He also emphasized, as had others in the course of the discussion, that not only was it the artist's responsibility to approach the people but that the people, too, should

make an effort when looking at a painting — just as they made an effort when listening to Beethoven or Prokofiev.

Herbert Sandberg's attempt at moderation and reconciliation [6] did not succeed. Early in 1950 he succumbed to pressure and publicly renounced his views in an article entitled 'Some Self-critical Remarks,' [7] which furnishes an exact parallel in the cultural field to the tragic political self-accusations at the Soviet trials.

There can be no doubt that the official art policy in the Soviet Zone is one of rigid enforcement of a narrow formula — a cultural dictatorship closely related to that of the Nazis in respect to both what it fosters and what it prohibits. The fate of the Moritzburg Museum in Halle is a case in point. It was reopened as a museum of modern art in October 1948, about a month before the Dymschitz articles began to appear in Berlin. Once a mecca for friends of progressive twentieth-century painting, the museum had suffered severe losses under the Nazis. Many of these losses, including Emil Nolde's *Last Supper*, were, of course, irreparable. But the new museum administration, together with the city of Halle and the regional government, had made considerable efforts to fill in the gaps. The old collection of German painting from the romantic to the impressionist schools was supplemented by work of a remarkable group of expressionists, including Schmidt-Rottluff, Heckel, Kirchner, Pechstein, Otto Mueller, Klee, Marc, and Feininger. Otto Dix's formidable war triptych was lent to the museum, and the current school of Halle, as well as the wider circle of central Germany, including Berlin artists, was represented.

But this program was in direct contrast to that of Dymschitz, and trouble developed almost from the start. There seems to have been a series of attacks, probably officially inspired, demanding either that the paintings be labeled as degenerate examples of bourgeois decadence or that many of them be removed outright. The director of the museum, Dr. Haendler, had to flee; he was succeeded by a Dr. Kahns, who suffers from seriously defective eyesight. According to later reports, he, too, was replaced. By autumn of 1950, under a new administration, the modern section of the museum was reopened and the controversial paintings were again on view.

The case of Hermann Kirchberger's mural for the National Theater in Weimar is another example of cultural intolerance. This mural and two columns with mosaic decorations were created by Professor Kirchberger of the Weimar Art Academy for the re-built theater, which was opened in 1948. From the start the SED (Socialist Unity Party), the leading communist party in the Zone, had objected to the mural. The party inspired a newspaper cam-paign against it, which started in Berlin, was taken up by the local papers, and culminated in the summer of 1950 in demands for its removal. Concurrently the Kulturbund (Cultural Association for the Democratic Reconstruction of Germany) was directed to stage a 'democratic' discussion of the mural, in which an especially radi-cal group of SED laborers from one of Weimar's suburbs actively participated. As a result of these demonstrations, the mural was covered with a cloth hanging and by now may have been removed altogether.

Another example of forceful elimination of every art manifesta-tion not in strict conformity with the official directions is the cover-ing up of the large fresco of the veteran communist Horst Strempel in the Friedrichstrasse Railroad Station in Berlin.

It is an inevitable law for the dictator that he must never allow his prohibitions to create a cultural vacuum. He must neatly coun-terbalance his cons with corresponding pros. There is great simi-larity in the kind of art officially fostered by the Nazis, the art of Soviet Russia, and the painting officially promoted in the Soviet-dominated German Democratic Republic. In each case, the in-sistence is on realism, on immediate, general comprehensibility of the artist's statement, and on an optimistic, cheerful outlook and the reflection of a happy social order without problems. The only real difference between Nazi art and that sponsored by the Soviets lies in the choice of some of the subject matter. There are also certain rather subtle differences of style. On the whole, both Nazi and Soviet Russian paintings are closely akin to the naturalis-tic school of the late-nineteenth century. Much German art in the Soviet Zone today also tends in that direction, but not all of it. Until a while ago some artists worked in a slightly more progressive,

less rigid, less meticulously photographic manner. But this slight margin of difference has since been eliminated.

Early in 1951 the official line was again laid down in no uncertain terms in two articles in the *Taegliche Rundschau* from the pen of one 'N. Orlov.' [8] He repeats Dymschitz's arguments with even-greater dictatorial assurance.

> For the artist as well as the scientist it is very important to be familiar with progressive philosophical views. The study of dialectic and historic materialism will open new horizons to artists and will help them to overcome the retrogressive, narrow-minded, subjectivistic, false, idealistic view of the reality that surrounds them . . . The fight against every influence of Western decadence and the cult of ugliness in the art of the German Democratic Republic is an important social task. One must not show as deformed and primitive the labor activists or those persons who have been called by the working class and by the people to the helm of the new democratic state.

The parallel with the Nazi doctrine is obvious. If we substitute 'Aryan' for 'Proletarian' the differences become negligible. Orlov repeated the Nazi insistence on the integration of art and people and he linked it with the current demands for political unification. 'With its program for the cultural development of Germany, its rooting of the culture in our people, the government will give a living, convincing example to the whole of Germany.' Hitler had said: 'If the German artists only knew what magnificient plans I have in store for them, they would cease to oppose me.' Orlov boasts that '. . . the Government of the German Democratic Republic has taken unprecedented measures for the future of national German science, culture, and art.' Like Hitler, the Soviet commissar emphasizes the importance of the national element in art, he demands the same cult of long-established values. Here is the same totalitarian demand that its artists speak 'in an art language comprehensible to the people.'

Orlov speaks about American art, of which he has obviously only the vaguest knowledge; to him it is the incarnation of cosmopolitan, imperalistic, cultural barbarism. In American art, as in American literature and motion pictures, 'the leading roles are played by

gangsters, thieves, murderers, prostitutes, sadists, and even the insane, along with monsters, wandering skeletons, and corpses' — in Orlov's view, 'a manifestation of the misanthropic, anti-democratic, and pathologic character of imperialistic society.' Goebbels had very often said much the same thing about America.

The truly shocking parts of these articles are those in which the author turns upon the German artists in Eastern Germany today, upon the very people who had tried to live up to the official directives. One by one he reproaches the artists, the magazines, and the publishing houses in the Soviet orbit of influence. Like an angry and peeved schoolmaster he castigates them publicly for 'not following the directives thoroughly enough,' for still promoting 'decadence and disintegration, mysticism and symbolism,' for 'lagging behind in fulfilling the postulates of life and the conditionings of concrete reality.' He even finds it necessary to attack Kaethe Kollwitz. She must not be considered the mother of proletarian art in Germany, because she was preoccupied with the sufferings of the laboring classes and thus she misunderstood their great and happy social mission.

The most complete source for the official likes as well as the dislikes in the Eastern Zone is the now defunct magazine, *Bildende Kunst*. Carl Hofer, initially one of its guiding spirits, withdrew when the increasing cleavage between East and West required every cultural leader to take an unambiguous stand. The editors must have had a rather difficult time. Their chief dilemma lay in the fact that there was no German artist of stature who fitted the official demands. There was a natural limit to the amount of Soviet Russian painting that could be reproduced in the magazine. This explains why the painter Max Lingner was immediately heralded as the protagonist of the new social realism when he returned from Paris in 1949. Otherwise, it was necessary to fall back on the great dead — Kaethe Kollwitz, Barlach, and Zille. It was of course possible to present Breughel, Daumier, Courbet, Manet, Meunier, and Toulouse-Lautrec as social realists. Cézanne, Van Gogh, Gauguin, Matisse, and Chagall could be reproduced — often in full color — if the text either was sufficiently critical of their failure to support

the Marxist revolution or explained carefully just what qualities might be admired in otherwise decadent bourgeois artists.[9] Picasso remained a special problem. But what about the current German painters and sculptors, especially those of the younger generation?

Here lies the crucial point of the entire experiment. It was all very fine to learn that in the summer of 1948 a big power plant, the Braunkohlen-und-Grosskraftwerk Hirschfelde, invited students of the Dresden art academy to spend some months at the factory 'in order to become acquainted with the world's work and the problems of our time.' But when we saw the lifeless, stereotyped, picture-postcard sort of thing produced and exhibited by three of the students, we knew the futility of such artificial attempts to bridge the gap between artist and workman.

Even more disastrous were the results of a much publicized competition, 'Our New Reality,' sponsored jointly by *Bildende Kunst* and the FDGB (Freie Deutsche Gewerkschaftsbund), a sort of federation of trade unions. The selections were published in June 1949, with the announcement that the first prize had been withheld because none of the entries submitted had measured up in content and artistic merit to the required standards. Georg Leese of Berlin won the second prize for an oil painting, *Workmen's Discussion* — a frightfully mediocre outline drawing filled in with pseudo-Van Goghian brushstrokes.

Such examples, to which many more could be added, supply ample evidence that the most insistent official demands for progressive creation will inevitably produce the very opposite: a sterile, artistically retrogressive performance.[10]

Once in a while something will happen that seems to contradict this picture of a repressive and reactionary cultural dictatorship in the Soviet satellite state of Eastern Germany. Invariably, the outcome of such happenings confirms the picture.

A comprehensive exhibition of the work of the sculptor Ernst Barlach was opened in the German Academy of Arts in East Berlin on 14 December 1951 in the presence of Prime Minister Grotewohl. Academy President Arnold Zweig emphasized that this was not only a memorial but also an atonement for the sufferings and persecu-

tions the once 'degenerate' artist had suffered under the Nazis. The event was celebrated in the Eastern German press, and Barlach was hailed as a 'patriotic and humanistic German artist.' [11] 'Even today the guilt weighs on us, that in our lack of understanding we have not duly honored the works of Ernst Barlach . . . This convincing and beautiful exhibition in the German Academy of Arts atones for a large part of this guilt . . .' [12] 'A giant to be discovered' was the headline of one article. [13]

Only two weeks after the opening a very different note was struck in the official mouthpiece of the Soviet control organs. 'Ernst Barlach,' wrote Professor K. Magritz in the *Taegliche Rundschau,* [14]

belongs to those German artists of the last fifty years who have exercised a great influence on Germany's intelligentsia. The ideas that came to life in his drawings, woodcuts, lithographs, sculptures, in his plays and novels, express mainly the anti-democratic tendencies of one section of the German Intelligentsia . . . His aesthetic theories served to justify the creations of a considerable number of artists who succumbed defenselessly to the anti-humanistic tendencies of Imperialism . . . His art is mystical in content, anti-realistic in its form. It is strongly dominated by anti-democratic tendencies and is an example of the crisis of ugliness in art.

One question might be asked at this point. Are the demands made upon art and the artist really official policy, are they really important parts of a political program? Or are they not perhaps relatively unimportant by-products, reflections in a minor field of an ideological struggle that is actually being waged on a quite different level? I believe that the evidence already cited shows that the Soviet dictatorship is as vitally concerned with the arts as was the Nazi state. But additional proof is not lacking. We need only examine the agencies within the East German government, in the party, and in the numerous semi-official organizations to discover that nearly every organ that wields power and influence in the German Democratic Republic is concerned in one way or another with the arts. One must inevitably conclude that totalitarian communism has a healthy respect for the arts, that it feels it necessary to exert very strict control over this as over all other forms of cul-

tural life, and that it needs the support of the artist for the achievement of its aims.

Even the briefest enumeration of the agencies concerned with art is awe-inspiring. The exact organization of the Soviet administration, before and after the establishment of the East German Republic, is difficult to summarize. It included, and probably still includes, posts for men concerned specifically with museums, artistic creation, and art education. The German Democratic Republic of course has its own Ministry of Culture in Berlin, the Ministerium fuer Volksbildung. This Ministry has separate departments for arts and letters; Dr. Gerhard Strauss was the chief for fine arts until 1 April 1950, when he was put in charge of a department for the rebuilding of Berlin — which bears the main responsibility for the current demolition of the old Hohenzollern Castle.[15] Each 'Land' (region) of the Republic likewise has its own Ministry of Popular Enlightenment, with departments for arts and letters. There is also a special Department for Popular Enlightenment in the East Berlin Magistrat, with a separate art department.

Next come the mass organizations, membership in which is practically a necessity for everyone who wishes to get along. The FDGB, already mentioned, has branches in all the regions and districts. Until the autumn of 1949, Group 17 of this organization was devoted to arts and letters. At that time a purge of the more liberal elements seems to have taken place, and much of its influence was absorbed by the Kulturbund zur Demokratischen Erneuerung Deutschlands, already discussed in connection with the debate over the Weimar Theater mural. This Kulturbund, with Alexander Abusch and the poet Johannes R. Becher associated with its management, is quite powerful. It acts as a sort of cultural police, supervising exhibitions, controlling bookshops, and having charge of the so-called Intelligenz-Karten, the extra ration cards for co-operating members of the intelligentsia. It also concerns itself with professional artists' organizations and with the distribution of artists' materials. The National Front and the Association for German-Soviet Friendship are two other mass organizations that make continuous demands upon the time and efforts of the culturally creative citizen in Eastern Germany. Furthermore, there is the FDJ,

Freie Deutsche Jugend (Free German Youth), a well-organized and extremely busy organization which trains and maintains the Junior Activists — young fanatics who work in the factories, on the collective farms, and in schools and universities.

I saw an excellent example of how the FDJ works in the art field. In the corridor outside the fine-arts seminar of Humboldt University in East Berlin is a large bulletin board on which is posted the wall newspaper the FDJ issues wherever it operates. This particular issue contained plans and directives worked out by one Gerhard Kapitaen, a student of fine arts and ardent member of the SED, for his fellow student members of the FDJ unit. Kapitaen proclaimed that a new method of study, the sociological approach in art history, should take priority over every other method. For the winter semester 1950–51 he ordered his student group to study the role of art in Marxist society, with required readings. He promulgated these plans without consulting either the faculty or his fellow students, but he cited a speech by Walter Ulbricht, General Secretary of the SED Party, as his authority. Moreover — and this was perhaps the most important part of the program — student Kapitaen announced that participation in this FDJ group activity would receive the same academic credit as attendance at lectures and seminars. This means, quite simply, that a student can compensate for scholarly and academic weaknesses by political activity, with, of course, the implication that non-participation in the political group could count against him.

Membership and active participation in the FDJ, the FDGB, or other mass organizations carry heavy influence in admission procedures and in the distribution of scholarships in universities and art schools. The amount of 'social service' performed by each applicant is also carefully weighed. How often did a candidate join a youth choir to entertain farm laborers during the last harvest? How many cultural lessons did he teach to factory workers last winter? The thoroughness of his ideological training is also tested in both written and oral entrance examinations. 'What is the difference between corn (*Kitsch*) and trash (*Schund*)?' 'Corn is art in poor taste; trash is American mass production,' is the kind of answer expected here. 'What is the difference between the United Nations

forces in Korea and the East German People's Police?' 'The United Nations forces in Korea are the instruments of ruthless capitalistic warmongers; the People's Police are the guardians of peace,' is what one must answer in order to be accepted. Artistic ability has become only one of the many criteria for admission, and ranking fairly low on the list of requirements.

Similar demands are made of the teachers and mature artists. Professor X in a small East German university has heretofore taught his art lectures and seminars without interference. But he has a large family and in order to be on the safe side he has joined the Kulturbund. One day a young man appears, who tells him, 'You must become a member of the board.' X refuses; he is too busy and much too young. Two days later the young man returns. 'Just because you are young, we need you.' Since he now faces the alternatives of prison, concentration camp, or deportation, he gives in. A few days after this, a woman reporter, accompanied by a press photographer, appears for an interview. 'Please let us have your opinion of the atom bomb.' The interview is printed below his photograph, and in the eyes of his colleagues and his community he has become an 'activist.'

There are weekly indoctrination courses in art schools and museums, attended by cleaning women and directors alike. Special political-training encampments are held periodically at Potsdam or Klein-Machnow near Berlin; there, artists and teachers are told how to paint and what to teach. Painters must produce a certain number of propaganda pictures — huge portraits of the leaders, for instance — and must help in the production of election posters, banners, and large-scale transparencies; they must sell certain quotas of lapel-pin versions of Picasso's 'peace dove' in a given period; they must be members of the mass organizations, must volunteer to lecture to and entertain workers and peasants, must collect signatures outlawing the atomic bomb.

These pressures have resulted in a steady stream of refugees from the ranks of the intellectuals and artists to the Western Zones. There are few who have not considered this step, and many have taken it when conditions were favorable. I know several cases of

men who tried to stay, tried to work things out somehow, but who sooner or later left in haste. This steady migration has created such serious vacancies in the ranks of all professions traditionally recruited from the middle classes that the government has been forced to adopt very deliberate and extensive counter-measures. These have taken the form of economic enticement. The lure of economic security, of well-paid jobs, free housing, free fuel, special rations, special pensions, free schooling for children, scholarships and grants — this is the government's answer to the problem.

On 31 March 1949, the Cultural Plan, sponsored by the German Economic Commission, was passed. It bears a lengthy title: 'Regulation for the conservation and the development of German science and culture, the further improvement of the position of the intelligentsia, and the enlargement of its role in production and public life.' [16] Besides appealing to the bourgeois classes to take advantage of the considerable funds appropriated for this very extensive program, the Plan also made a special appeal to the working classes to accept the necessary co-operation of the intellectuals. The old German Academy of Science was enlarged and financially strengthened, a new Academy of Arts was created, and a special cultural fund was set up. In 1950 a second law, with further reinforcements and appropriations, was passed.

A new State Art Commission was created in September 1951. Its membership roster does not include a single name of distinction. In his opening speech, Prime Minister Grotewohl declared that 'art must mobilize all energies against the mental preparation for American imperialistic war — the whole of society must claim for itself the right of art criticism . . .' A solution 'can be brought about only by an energetic turn in the direction of realism, by the complete penetration of artistic conception with the ideas of the people . . .'

The art policies of Government and Party in the Republic of East Germany are significant not only because they show such striking similarities to the Nazi policies but also because they are a faithful reflection of the art policies of the USSR.

Art in Soviet Russia

THERE ARE VERY FEW people left today who do not know that the Soviet Russian government is extremely hostile to all aspects of modern art.

The striking similarity of the art policies of the Soviet rulers in Eastern Germany and those of the Nazis is an important sign of this hostility. But it could conceivably be argued that these policies are really German in origin, that they are a part of the Nazi heritage. The basic question here is this: Are the art policies of first the Nazi government and then of the Soviet dominated rulers of Eastern Germany due primarily to national characteristics or are they an integral part of totalitarian society everywhere?

WAS NAZI ART TYPICALLY GERMAN ?

Certain characteristics of the Nazi program undoubtedly reflect national traits. I am sure one is correct in thinking of its exaggerated patriotism, the excessive self-centered nationalism, as something typically German. And the combination of this with the mystic belief in heredity, in the all-pervading power of blood and soil, the insistence on a brutal kind of agressive racism, is typically Nazi. Again, in the thoroughness with which this whole ideological structure was translated into a political program, the precision and the discipline with which it became a practical reality, in every phase of artistic creation and experience, there is indeed something typically German. But on the other hand there are important, in-

deed very important, elements of the Nazi art program that not only closely resemble but are virtually identical with the art programs of other totalitarian societies.

In the art of Italian Fascism, which has not been observed very carefully in this country,[1] we find the same insistence on classical architecture. The only difference here is that Rome, and not Hellas, was the great model. But there were the same desire for authentication and a similar neglect of the modern idiom in building. Classical architecture was the tangible evidence of the revival of the ancient empire.

Sculpture in Fascist Italy did not have ethnological or biological connotations. Hitler never succeeded in persuading Mussolini to adopt a more severe racial policy, which in Italy would indeed have been more absurd even than it was in Germany. But Fascist sculpture did stress realism and heroic strength, in the equestrian statue of the Duce, in the portrait busts of the Fascist leaders.

In painting, too, there was strong insistence on realism, and all artists were directed to adopt a popular idiom, to talk to the masses; they were warned against being highbrows.

On the whole, these policies were less rigidly applied in Fascist Italy than in Nazi Germany. There was a prolonged honeymoon between Fascism and certain experimental art forms — the futurist Marinetti's flirtation with Fascism, for instance. It was not until 1935, thirteen years after the march on Rome, that regulations were issued which absorbed the artist into the texture of the corporate state. Even then the pressure, although all-pervasive and inescapable, was applied less directly than under the Nazis. There was apparently very little, if any, direct destruction or persecution of modern art. One important reason for this seems to be the fact that in the 'twenties Italian art as a whole had not ventured very far beyond impressionism.

It might interest the reader to learn of something that happened in the Argentine a few years ago. There is nothing very unusual about a cartoon poking fun at modern art, such as the one that was printed in a Buenos Aires paper in 1949. We might find very much the same sort of thing in the *New Yorker*, any week. But this

particular cartoon was reproduced as the final blast against modern art in an official pamphlet issued by the National Ministry of Education. It is entitled *El Arte Morboso* and its author is none other than El Señor Ministro de Education, Professor Oscar Ivanissevich. Many times in these pages I have had occasion to point to a

period of alliance between modern art and the totalitarian state. Nowhere is this so clearly marked as in Soviet Russia. Soviet art in the early stages, between 1917 and, let us say, the beginning of the 'thirties, presents an aspect very different from that of today. It was indeed revolutionary, experimental, and highly original. The history of Soviet art from the early 'thirties to the present day shows a process of gradual deterioration, of increasing desiccation of genuine artistic vitality.

The Mésalliance between Modern Art and Communism

There lives today in the Connecticut hills a man whose life is a vivid testimony to the basic incompatibility between the progressive artist and totalitarian society. He is the constructivist sculptor Naum Gabo, who left Soviet Russia early in the 'twenties. In the course of a conversation I had with him in the spring of 1952, from which he has allowed me to draw in these pages, he told of his experiences.

The story of modern art in Russia under communist rule, he explained, cannot be understood without some knowledge of what happened early in the twentieth century. Russia had been in the *avant-garde* of modern art since 1911, but it was cut off completely from the western world with the beginning of the First World War in 1914. One of the very early collections of progressive French paintings, including those of Matisse, Picasso, and others, had been assembled in Moscow. It was Tschoukin, wealthy patron of the arts, who collected these paintings and established a gallery that is still in existence. The gallery has been nationalized, and another collection, by Morosov, has been joined with it. It is now known as the Museum of Western Art.

In the early days artists such as Marinetti and Mattisse came to Russia, Mattisse painted murals in Tschoukin's mansion. The naturalistic, academic art of nineteenth-century origin was dying out in Russia before 1914. There was a whole new school of young, modern artists — cubists, futurists, and other groups — in St. Petersburg as well as in Moscow. These artists were progressive not

only in their work but also in their whole way of thinking; even though they were not members of the communist party their sympathies were with the Revolution.

The Academy professors had run away with the White Army when the Revolution started, and the young, modern artists took their places. They started the 'Vchutemas,' workshop groups which attempted the integration of artistic creation and building construction. The school in Moscow became an important center where exhibitions, group discussions, and public non-political meetings were held.

The first communist leaders in Russia were people of Western education. Men such as Lunacharsky, who in 1918 became the commissar for cultural matters and education in Lenin's cabinet, were idealists. But there was a strong preoccupation with the civil war, and cultural matters were not given a very high priority. Lenin visited the art school in Moscow once, but he admitted quite openly that he did not understand modern art, that it was none of his business; he said that it was up to Lunacharsky to concern himself with these matters. Lunacharsky had enough intellectual tolerance to leave the artists alone and, for the time being, to let them do as they pleased. He had under him several commissars for the various branches of cultural activity, for the theater, music, and so on. The art commissar was D. Sterenberg. Lunacharsky met with strong opposition in the party. The majority of the party members were not in agreement with the modern artists, but they still tolerated them. Characteristic of the mounting opposition to Lunacharsky's aims were the difficulties Gabo and Pevsner experienced in the attempt to print a *Manifesto* in which they stated their artistic credo. They succeeded in getting it published only after surmounting the most serious obstacles.[2]

Until 1921 the Moscow school went on working and maintaining its progressive standards, but after the White Army was beaten, a wave of refugees, including most of the Academy professors, came back and the communists liked their art. By the end of 1921 the workshops had been reorganized, the young, progressive artists

had been pushed out, and the academic painters had replaced them. But even before this, there had developed a split within the ranks of the modern artists, with certain groups demanding art as propaganda.

Lunacharsky and Sterenberg planned an exhibition of contemporary Russian art in Berlin, which would help to re-establish the lost contact with the western world and would show Russia's artistic contribution during the years of war and revolution. The preparations for this exhibition offered Gabo a welcome opportunity to go to Berlin. After a frank discussion with Lunacharsky, he left, six months before the opening of the show — never to return to his native land.

The exhibition opened in Berlin in the fall of 1922, at the Galerie van Diemen. We can see from the catalogue [3] that a serious attempt was made to give fair representation to the great variety of schools then active in Russia. Along with some examples of traditional naturalism and of impressionism, we find expressionism, cubism, the beginnings of surrealism, abstraction, montage, and constructivism. We get a sense of variety, of freshness and vitality.

Commissar Sterenberg, in his foreword to the catalogue, called the exhibition 'the first real step toward *rapprochement.*' There had been previous attempts in this direction, and the year before a book on contemporary Russian art had been published in Vienna,[4] which featured works of Marc Chagall and Alexander Archipenko. Sterenberg explained in his foreword that

Russian art is still very young. It was only after the October Revolution that the broad masses of the population were able to approach it and thus to install new life into the official and dead art which in Russia as in the other countries was recognized as 'Grande Art.' At the same time the revolution has opened up new perspectives for Russia's creative forces, by giving the artist the opportunity to carry his creations out into the streets and the market places, thus enriching him with new ideas. The embellishment of the towns — their character completely changed by the Revolution — and the demands of new architecture necessitated as a matter of course new forms of construction, and, most important of all, the artists no longer worked each for himself, hidden

in his corner, but they entered into the closest contact with the broad masses of the population, which accepted avidly what was offered them, sometimes with lively enthusiasm, sometimes with sharp criticism.

These were brave words, born of the same enthusiasm and utopian vision that had fired the imagination of the progressive artists of Germany after the 1918 Revolution. The Soviet commissars who came to visit the Berlin exhibition were annoyed. They went home and made their complaints. More to their liking was a very different statement about the function of the artist, pronounced during that same year, 1922, by the Association of the Artists of the Revolution.[5] 'It is our duty to mankind,' so read their manifesto, 'to perpetuate the Revolution, the greatest event in history, in artistic documents. We render a pictorial representation of the present day; the life of the Red Army; the life of the workers and peasants, the leaders of the Revolution, and the heroes of labor.'

The growing rift between progressive art on the one side and incipient 'social realism' on the other was accurately reflected three years later in the observations of Louis Lozowick.[6]

Modern Russian artists [he wrote in 1925] are much bolder in their theorization owing to their leaning on the state. The Soviet government acted on the assumption that a new art can be the work of a new man, himself the product of a new social system. Their policy was based on this assumption and they attempted to solve the art problem in a practical way—perhaps in the only practical way possible — in the way implicit in the assumption. [Such efforts, however, were] not crowned with immediate success. External and internal complications . . . new economic policy, restoring to private property and initiative certain of its former privileges [stood in the way] . . . There is a growing demand for portraits, landscapes and genre pictures. The demand is met by the older schools, which are reorganizing their semi-defunct groupings, arranging exhibitions, and becoming in general assertive. All this had a decided effect on the radical artists, for though the Soviets still aid art and artists in various ways . . . such aid is of necessity more limited than formerly. Compelled to shift for themselves the less resolute among the radicals either have turned to other fields or have gone abroad to join the modernists' ranks in Berlin, Paris, Prague. Not a few, however, are still at their posts, certain that the present crisis in art is only temporary; that it is destined to be liquidated . . .

The reader will hardly need to be told that it was not the threat
to modern art but modern art itself that was liquidated.

It is true that the process was gradual. There were certain retarding
and neutralizing influences at work, which for a time concealed
the bitter truth. For intance, in an exhibition of Russian art held
in Philadelphia in 1934–5 [7] one could still see a few modern paint-
ings alongside a number of canvases marking the transition toward
social realism and a solid group of typical examples of this new
trend.

In Soviet Russian art, as in the art of Nazi Germany, what could
be called the 'Law of varying susceptibility of various artistic media
to ideological corruption' can be observed. In other words, we can
notice in Russia as we did in Germany that ideological pressure
was most effective on the free arts and less noticeable in the ap-
plied arts. Progressive tendencies in Soviet Russian art were more
quickly and more thoroughly liquidated in painting and sculpture
than in architecture or in the graphic arts.

In the graphic art of Soviet Russia these developments can be
shown with particular clarity. Western observers, such as the inter-
nationally minded editor of the Gutenberg Yearbook, were quick
to take notice when the constructivist teachings of the progressive
Russian artists were applied with singular effectiveness in posters,
magazines, brochures, and books.[8] The art of wood engraving has
deep and ancient roots in Russia.[9] In the 'twenties there arose in
Soviet Russia a magnificent new school of modern wood engraving,
with such men as Vladimir Favorsky, Alexej Kravčenko, S. Yu-
dovyn, and P. Staronosov producing sparkling masterpieces of
xylography.[10]

Perhaps the most valuable social contribution of these artists
was their participation in a novel publishing experiment of far-
reaching importance: the production of a long series of inexpensive
picture books for children, printed at government expense and
sold for a few kopecks.[11] These little volumes in paper covers,
printed both in black and white and in color, in wood engraving

and by lithography and offset, were the first of their kind in the modern world. Shown outside of Russia at the International Graphic Arts Exhibition in Leipzig in 1925, they quickly stimulated artists and printers in France, Italy, and the United States. The WPA booklets and the Teachers' College Picture Scripts,

Wood engraving by Vladimir Favorski for *The Book of Ruth,* Moscow, 1925.

Pen-and-ink drawing, Moscow, 1950.

Wood engraving by P. Staronosov, Moscow, 1930.

which in their turn were the forerunners of the juveniles of the Whitman Publishing Company in Racine, Wisconsin, and of Simon and Schuster's Little Golden Books, owe a debt of gratitude to these Soviet artists of the 'twenties.

But that was long ago. Nothing illustrates so drastically the complete desiccation of art in Soviet Russia as a direct comparison of what the state allowed the artist to design for a children's book in 1930 and what it demanded in 1950.

The last time the *Gutenberg Jahrbuch* printed an article about Soviet graphic art was in 1929,[12] a piece on Ukrainian book illustration, which even then foreshadowed the turn toward regional nationalism and social realism.

I vividly remember the exhibition of Current Soviet Wood Engraving that opened in Baltimore during the war, under the aus-

pices of the National Council of American-Soviet Friendship. I had expected to find at least some glimmer of the fire that had once burned so brightly. There was nothing left but ashes, an empty shell of technical skill.

We have, however, to make one exception in such a verdict about Soviet graphic art. Political caricature somehow escaped emasculation. Especially during the last war, Soviet Russian artists made brilliant caricatures of their Nazi enemies.[13] The 'Kukrynisky' trio, made up of *Ku*prianov, *Kry*lov and *Ni*kolai Sokolov, is probably the best known of this form of art. Kukryniksy cartoons were shown in London as part of a major exhibition of Soviet graphic art held early in 1945 at the Royal Academy of Arts.[14] The exhibition was interesting as a pure and simple pictorial record of the Russian war effort, at home and at the front, from the factory girls stitching parachutes to a scene of tracer bullets piercing the night sky over an amphibious landing, the ruins of Stalingrad suburbs, and the victory fireworks over the Kremlin towers. There was a high level of illustrative draftsmanship and considerable mastery of graphic technique. The qualities praised by Professor A. A. Sidorov in his foreword to the exhibition catalogue were '. . . severe simplicity, restraint, and austerity . . . truthful documents, full of righteous anger . . .'

These prints are primarily documents and as such have their justification. They are not so very different from similar documents produced in most of the other belligerent countries during World War II. But there is one very important distinction: they represent just about all that was going on in Soviet Russian art. Very little else was produced and even that was exclusively documentary in character. This was the art officially demanded, the only kind of expression tolerated.

Formulation of Official Demands

Now what about these official demands? What were they like, how were they formulated, and what did they prescribe? The interesting thing about the official aesthetics of the communist state is the fact that they are separated by such a wide gap from actual performance.

As in Nazi Germany, there is a tremendous discrepancy between theory and practice, sometimes admitted, sometimes glossed over, sometimes denied.

One of the earliest available enunciations of the role of the artist in the new Soviet state is a conversation between Lenin and Lunacharsky,[15] which took place probably in the winter of 1918–19. Lenin had summoned Lunacharsky and had asked him if there were not artists around who were hard up and needed support.

I am talking of sculptors and to a certain extent, perhaps, of poets and writers. The idea I am about to explain to you has been in my mind for some time. You remember that Campanella says in his *City of the Sun* that the frescoes which decorate the walls of his imaginary socialist city serve as an object lesson to youth in natural science and history, rouse their sense of citizenship, and, in short, play a part in educating and bringing up the younger generation. It seems to me that this notion is far from naïve and might, with certain modifications, be adopted by us and put into practice now.

Lunacharsky recalls: '. . . the idea of directing and using art for such a lofty purpose as the propaganda of our great ideas struck me at once as extraordinarily tempting.'

Above all, Lenin wanted propaganda through monuments:

'I regard monuments as still more important than inscriptions; we might have busts, figures, and, perhaps, bas-reliefs and groups.' He recommended a series on the forerunners and theoreticians of Socialism: 'Take a list like this and commission the sculptor to make temporary monuments — of plaster, even, or of concrete. The important thing is that they be understandable to the masses, that they catch the eye . . .'

There is also the record of a conversation between Lenin and Clara Zetkin,[16] in which he said:

Our workers and peasants are deserving of something more than circuses. They have gained the right to true, great art. For that reason we are first of all introducing the broadest popular education and training. It will lay the basis for culture, of course on condition that the question of bread be solved. On this basis a truly new, great, Communist art should grow up, which will create a form corresponding to its content.

Lenin was aware of the great gap between the fulfillment of such ideals and the actual conditions he saw around him. Luna-

charsky once again recalled some words of Lenin: 'What do we lack in order to build our socialist state? Our land is vast and wide, the power belongs to us. What we lack is culture, culture among the leaders, culture among communists.'

Lunacharsky quoted these words in an important speech, given toward the end of his life, in which he developed his own ideas and demands.[17] This was no longer a tolerant and liberal expression but a sharp and forceful defense of state art in terms of a completely materialistic concept of culture. He asks:

Can the dictatorship of the proletariat influence culture, influence its tempo, direction, the character of its development? . . . Can culture whose development depends upon the pressure of the material process and which in its highest spiritual spheres has its own laws, be regulated by one of its parts, namely by organized human knowledge in the form of the state and again, in its acutest manifestations, in the form of the dictatorship of the proletariat?

After citing, and rejecting, the objections to such a cultural dictatorship raised by the 'bourgeois' and 'capitalistic' critics, he clearly answers in the affirmative:

The proletarian state seeks to elevate to the level of socialist culture the backward toiling masses, to create for the first time an opportunity for a truly human culture. The effect of the proletarian state on art is beneficial . . . All the aims of the Soviet state and of the Soviet state alone are creative aims, emancipative and constructive aims in the widest sense of the word . . . To point out the direction in which the artistic forces, the artistic attention, the artistic talents should be directed is a natural conclusion from our entire system of planning. We thus are very well aware of the fact that we have the right to interfere in the development of culture, beginning with the development of machinery in our country and electrification as part of it, and ending with the direction of the subtlest forms of art . . . All these measures we are employing to regulate creative art, both proletarian and the art of those following the proletariat, and to put a stop to artistic work among the direct enemies of the USSR — this entire school of influences, from repressions to the greatest care of the artist, to comradely concern about him, to giving him support, to penetration of his laboratory — all of them are good and necessary.

This speech is the clearest enunciation of the Soviet doctrine of state control of the arts that I have been able to find. The doctrine has remained basically unchanged through the days of the Cominform and its director, Andrei Alexandrovitch Zhdanov, and on to the present day — regardless of how many times and by whom it has been repeated and reinterpreted.[18] The only things that have been added are specific and more detailed directions for each form of art fostered by the state, and prohibitions and liquidations of undesirable expressions.

THE TIGHTENING OF THE REINS

The early 'thirties, when Lunacharsky stated his ideas with such decisiveness, witnessed the same process of 'tightening of the reins' that took place in Nazi Germany in 1937 after four years of the Hitler regime. This phase of heightened control and more stringent direction of the arts came correspondingly later in Soviet Russia, after about fifteen years. Its tardiness can probably be explained by the fact that, as was frequently admitted by Soviet leaders, the early years of the regime were so taken up with civil strife and basic economic rehabilitation that in the early days cultural control did not receive a very high priority.

A typical reflection of the stricter course of artistic regimentation is seen in the review of a 1933 exhibition. 'Fifteen Years of Art in the USSR.'[19] It speaks frankly of 'the backwardness of the art of painting as compared to the advancement of Socialist construction . . . The national forms of the Socialist content of the paintings exhibited are very poorly developed. This is exceedingly regrettable.' The article explains that during the early period of communism 'the party had to throw all its forces into the then raging civil war and could pay only the most cursory attention to the fine arts . . . Special organizations with a clear understanding of the foundations of art in the revolution were altogether lacking . . . The party adopted a waiting policy with respect to the art of painting, as bourgeois influence was still strong . . . The various schools of painting, the Futurist-Cubist's primarily, threw themselves into

the breach with great enthusiasm.' But 'the vast majority of the artists had not the slightest conception of Marxist-Leninist teachings . . .' They were not the only sinners, however. 'The Realists, Naturalists, Impressionists of this period stood aloof from the daily struggle of the proletariat.' Only a few painters are praised — Kustodiev, for instance. 'In his *Mayday* the victorious march of the Leningrad workers, filled with the joy of life, is shown with splendid craftsmanship and coloring. His *Bolshevik*, symbolizing the party as the leader, guide, the central force of the revolution, in the full consciousness of his powers, waves the flag not only over the Soviet Union but over the entire world.'

The note of increasing nationalism, coupled with demands for cultural world conquest, is present also in another document of the early 'thirties, an article entitled 'Leninism and Art.' [20] Here we find the official lineage of Soviet aesthetics, the deliberate linking of the so-called art doctrines of Marx and Engels with those of Lenin and on to Stalin, with full references to official party documents, organization, and resolutions.

Of special interest in this article is a critical review of various artists' associations, which are denounced for having escaped 'during the dismantling of the as yet not completely destroyed forces of the bourgeoisie and kulaks in literature and art, a process which it was necessary to carry on to a definite finish.' We learn that 'by the decree of the Central Committee of the Communist Party of 23 April 1932, all these organizations were liquidated, and instead of them were created single unions of writers, composers, and artists, with Communist fractions in them.'

We remember that it was only about a year later that Goebbels' Art Chamber was established in Nazi Germany. The Soviet policies from 1932 on show the same emphatic pressure, the same lavish encouragement, through official commissions and premiums, of one kind of art, and the fierce, relentless extinction of every other kind, which was so characteristic of the Nazi art policies after 1937.

THE BATTLE AGAINST 'FORMALISM' AND THE GOSPEL OF
SOCIAL REALISM

On the surface there would seem to be some difference between
both the negative and the positive art programs in Nazi Germany
and Soviet Russia. The Nazis prohibited 'degenerate' art, the So-
viets 'formalism'; the former was art presumed to be growing from
biologically inferior stock, the other was art considered to be un-
duly concerned with style at the loss of communicable content.
The Nazi condemnation appears to have been on racial grounds,
the Soviets' on aesthetic grounds, and hence the latter is possibly
less extraneously, more legitimately motivated. Actually, what the
Soviets saw and still see in so-called formalistic art is the expression
of a doomed society, namely, the decadent bourgeoisie. They object
not to alienation from content as such but to alienation from one
particular, narrowly prescribed content — namely, illustration of
their own social dogma. Their prohibition was directed against
everything that stood in the way of its propagation. Both the de-
generate artist and the formalist were persecuted as outcasts from
the dominating society, one on racial, the other on social grounds.
The one did not 'belong' biologically, the other was of the wrong
social class. Both the 'Non-Aryan' and the 'Non-Proletarian' were
enemies of the dictatorship. The fundamental issue in this struggle
was, and still is, that of the totalitarian state versus the individual.

The persecution was directed against exactly the same kind of
painting, sculpture, graphic art, and architecture in Soviet Russia
as in Nazi Germany. It was also motivated and expressed in terms
that were often identical. This is very easily demonstrated. One of
the most carefully thought-out and thorough Soviet attacks against
modern art was launched some years ago through the medium of
the *VOKS Bulletin*.[21] In this article a work by the English sculptor
Henry Moore, *Family Group*, is called 'a distorted picture of the
human family.' The art journals of the Western world, says VOKS,
'vie with one another in the publication of hideous incongruities,
many of them of a pathological nature.' This kind of 'art must in-
evitably become false, anti-democratic, and anti-humanistic, re-

actionary in content and decadent in form, no matter how it may try to camouflage its decay under the guise of "pure art." '

Passages such as these ought to be read out aloud to those individuals and groups in the United States who insist on calling modern art communistic.

'One of the most characteristic features of reactionary bourgeois art of the epoch of imperialism,' the VOKS article goes on, 'is its militant anti-humanism, calculated to suppress the working man's consciousness of his human worth and to convince him that he is no more than a conglomeration of mechanical parts . . . or else a biological creature possessing purely animal instincts and desires.'

Here we are at the root of the misunderstanding. The VOKS writer can no longer conceive of any artistic expression that is not a deliberate social and political statement. He can judge it only in these terms, regardless of whether this was or was not the intention of the artist. But the curious thing is that the Soviet attack collapses even when we accept the premises from which it is launched. Let us suppose the artist does show the impact of mechanization on human society, the effects of purely biological orientation on the individual. But does that necessarily mean that this is what he believes in, that this is the kind of world he wishes to help bring about? Here, again, is the inability of totalitarian aesthetics to distinguish between worship and exorcism. The artist who, consciously or instinctively, assumes the role of social critic and gives powerful expression to threats and dangers — this is what totalitarian society cannot tolerate.

When the VOKS author writes that 'by opposing his art to that of Greece and the Renaissance, Henry Moore has himself expressed the anti-humanistic principle of his sculptures,' we wonder whether he is not using a passage from a Hitler speech.

The VOKS article ends with the proclamation of the gospel of social realism:

Soviet artists openly espouse the ideas of Bolshevism, expressing the advanced ideas of the Soviet people, who at present represent the most advanced people of the world, for they have built up socialism, the most advanced form of contemporary society. As opposed to decadent

bourgeois art with its anti-humanism, Soviet artists present the art of socialist humanism, an art imbued with supreme love for man, with pride in the emancipated individual of the socialist land, with profound sympathy for that part of humanity living under the capitalist system, a system that cripples and degrades men. As opposed to decadent bourgeois art with its falseness, its rejection of a realistic, truthful reflection of life as it is, Soviet artists present the wholesome and integral art of socialist realism, expressed in profound artistic images reflecting true life, showing the struggle between the old and the new and the inevitable triumph of the new and progressive, an art mobilizing Soviet people for further victories. As opposed to decadent bourgeois art, divorced from the people, hostile to the interests of the democratic masses, permeated with biological individualism and mysticism, reactionary and anti-popular, Soviet artists present an art created for the people, inspired by the thoughts, feelings, and achievements of the people, and which in its turn enriches the people with its lofty ideas and noble images.[22]

Again, we can almost hear Hitler's voice enunciating these sentences. And again, as was the case in Nazi Germany, this official proclamation of the most advanced form of art has produced exactly the opposite — the same retrogressive, stale mediocrity that characterized the art of Nazi Germany. One need only examine side by side examples of Soviet and Nazi painting, sculpture, and architecture (figs. 38 to 41) to see how close they really are.

The dependence of current Soviet painting upon the work of nineteenth-century Russian painters has sometimes been interpreted by Soviet apologists as a sign of revolutionary fervor. The examples of realistic painting produced after 1848, such as can be seen in Moscow's Tretjakov Gallery, have been hailed as an expression of revolutionary protest against Czar Nikolaus I. The Soviet commentators of today overlook the fact that this was a bourgeois, not a proletarian, protest, and that this school of painting flourished nearly a hundred years ago. The revival of such a style is about as progressive as the application of steampower to the printing press.

There is one more question well worth considering — whether or not Soviet art of today is characteristically Russian. It can be demonstrated very clearly that social realism is not a typically Russian

art form, any more than Nazi art was typically German. We have
already seen how this gospel of social realism is being preached and
practiced in Eastern Germany. Exactly the same thing has been
happening in Czechoslovakia. In March 1949 there was held a Con-
gress of Slovak painters, sculptors, graphic artists, architects, and
theoreticians of art, and the proceedings were recorded in a pro-
fusely illustrated volume.[23] Here again we see painting that has
been completely converted into illustration. This book is virtually
a pictorial atlas of ethnological, social, and political history. One
feels as if the real purpose for which these paintings were done
was reproduction in precisely such a volume as this. Here are
the peasants at work and play, in picturesque costumes; here is
the rhythm of labor; the portrait of the leader, including numerous
busts and paintings of Lenin, Stalin, Gottwald; the village scene;
the rustic landscape; and some current events. There is no personal,
no private expression anywhere, no statement from the individual
artist to the individual beholder. Also, there is not a single work
that possesses any artistic originality. There are echoes here of
almost every important painter from Millet to Van Gogh, but none
of any later painters, except for traces of Munch here and a faint
shadow of expressionism there. Now and again one also senses a
reflection of such Swiss and Austrian painters as Hodler and Egger-
Lienz, a lingering memory of the time when the country was linked
with the West through the Habsburg Crown.

The important thing about this rustic regionalism is that it is,
as I have said, neither original nor really typically Slovak. The
costumes in these paintings are probably authentic in detail, but
are rendered in exactly the same style, in precisely the same atmos-
phere found in Soviet Armenian or Soviet Siberian paintings. The
emphasis on regional art in Soviet Russia has quite often been mis-
understood by sympathetic observers as a sign of genuine diversifi-
cation and artistic freedom. An unbiased comparison of the various
schools of painting shows that this is not the case. 'Plus que ça
change plus c'est la même chose.'

We have an eyewitness account of how social realism was intro-
duced in China — namely Derk Bodde's *Peking Diary*.[24] Three

days after the occupation of Peking by the communist forces, he wrote, in the entry of 3 February 1949:

The Chinese are losing no time in beginning indoctrination. The Peking radio has already begun relaying the Yenan broadcasts, and yesterday, in one of the poorest quarters of the city, I suddenly came upon a series of Communist woodcut posters . . .

Only a little more than three months later we find, in the entry under 20 May, the following:

A few days ago I attended a large exhibition of 'Proletarian' paintings in Central Park. Its several hundred pictures, almost all produced since the liberation, met with obvious interest and approval from the good-sized crowd, consisting mainly of plain folk. Most of them had probably never seen so many paintings before . . . Favorite themes were scenes of peasants laboring in the fields and of workers in the factories, of the People's Army fraternizing with Civilians, and of the happiness and prosperity of the future China . . . In technique most of the pictures were garish, stiff, crude, and poor in workmanship. I hardly saw a one I would really care to own.

By chance, Bodde saw another Chinese art show in Central Park that day, an 'Exhibition of Famous Painters.'

How different the atmosphere here! The technique — in some cases, at least — was delicate and graceful, and the subjects were the traditional ones of landscapes, birds, flowers, and calligraphy . . . Yet even in these technically outstanding paintings the net effect was stilted, artificial and dead. Though something of the old form lingered, the spirit was gone . . .

I believe one has to admit that without a doubt the demand for 'Art of the people and for the people' has not been met in totalitarian society. Has democracy met this challenge?

Conclusion

────

The Challenge to Democracy

I T MIGHT BE WELL to review very briefly what we have learned about art and dictatorship in the twentieth century. Our observations can be summarized as follows:

Art occupies a central position in the life of the totalitarian state.

The totalitarian state recognizes the isolation of the artist in the modern world and attempts his social integration with every conceivable means at its disposal.

The totalitarian state exercises complete control over every form of artistic activity—alike over creation, education, and appreciation.

This control is based on a highly specialized and narrow concept of the function of art.

The function of art in the dictatorship is to serve in the complete absorption of the individual into totalitarian society, to demonstrate the aims of this society, to glorify them, and, ultimately, to become the supreme expression of this society.

The dictator recognizes the desirability and necessity of reinforcing these demands by a theoretical substructure. Elaborate efforts are made to build a body of totalitarian aesthetics.

Totalitarian aesthetics are rooted solely in non-artistic concepts, in biology, sociology, politics. Art in a dictatorship is always a medium of indoctrination; it loses every trace of sovereignty.

The control the dictator exercises to obtain his ends is of both a vigorous negative and a positive nature.

Full application of these controls is preceded in each new dictatorship by a brief period of experimental adoption of progressive art forms, which are always promptly and thoroughly discarded.

The positive program of the dictatorship demands assertive, cheerful demonstration of its new social order. It insists on a graphic illustration of the constructive nature and the success of its program.

This demonstration must be achieved in a language easily understood by all. It must be read without effort by every member of the totalitarian society.

Folk art in as many regional variations as possible is especially encouraged.

The dictatorship rewards the conforming artist by lavish praise and economic privileges in the form of money premiums, official positions, free housing, preferred rations, and so on.

The positive program is characterized by a vast discrepancy between intention and result, between purpose and achievement.

The dictator continually announces the achievement of a progressive new art expression, but he is ever faced with the retrogressive and stale revivals of obsolete art forms.

The corruption of spontaneous contemporary expression is performed by artists of considerable technical skill, often with a high degree of mastery over materials and processes.

The effects of the positive program of the dictator differ widely in the various media of art. Totalitarian corruption is easiest to achieve in the free media, most difficult in the applied arts. Painting is most susceptible, and sculpture only slightly less so. Architecture offers considerable resistance to ideological corruption, and the arts and crafts are almost immune to it.

The negative control aims at the complete eradication of every form and variety of art except the one officially demanded by the state.

The totalitarian state does not tolerate individual expression of individual experience; deliberate or implied social critique; the use of symbols, ambiguity, mysticism, and abstraction. It forbids deviation from naturalistic representation beyond the stage reached in impressionism, it frowns on imaginative play and experimentation with form, color, and texture.

These prohibitions are always justified by the dictatorship on the basis of its own narrow and specialized concept of the function of art. Every art expression is viewed by the totalitarian state as having originated on the bases of its own highly limited aesthetic credo.

The question to what extent the dictator succeeds in the total suppression of undesirable artistic creation cannot be answered with finality. The experiences in Germany tend to demonstrate that there is an incorruptible core of artistic integrity that finds expression against the most formidable obstacles. We do not know if there exists a comparable artistic underground in the Soviet orbit. There probably does.

That the dictator cannot altogether extinguish the flame of individual expression, no matter how hard he tries, is in itself something of great importance. It counterbalances to a large extent the gloomy and depressive threat of total extinction of the freedom of artistic creation. But no matter how encouraging this discovery

may be felt to be, it does not lift from our shoulders the heavy responsibility that the knowledge of this oppression places there.

It is for two main reasons that the lessons to be learned from the fate of art in the dictatorship have a meaning not only for those living in a totalitarian state but also for the citizens of democracy. One of these reasons is external; it concerns our dealings with the dictatorship. The other is internal; it has to do with the threat to artistic freedom in our own society. Both are closely interdependent.

Unfortunately, it is not difficult to demonstrate that in the United States, too, there exist attitudes toward art that closely resemble totalitarian attitudes. Before we can attempt to interpret this fact, a brief summary of some of these manifestations is necessary.

No one who did not live and work in Europe immediately after the war can have full knowledge of how urgently an exhibition of contemporary American art was needed there. The victorious European campaign was the most convincing proof, if such proof was still necessary, of America's courage and energy and of her efficiency and technological skill. But current cultural expression, a demonstration of artistic creativity, was something both allies and former enemies were most anxious to have presented to them. The image of America's soul in her art, this was something yearned for by all those who had faith in democracy and the many who now encountered it for the first time.

In recognition of this very legitimate demand the State Department in 1947 sent abroad an exhibition of contemporary paintings; entitled 'Advancing American Art,' it was first shown in Prague. This exhibition was recalled by Secretary of State Marshall under pressure which originated from a number of artists' organizations of predominantly academic, conventional tendency and which was taken up by the Hearst newspapers. Representative Fred E. Busbey of Illinois attacked the exhibition in Congress on 13 May 1947. He called the show 'a disgrace to the United States.' He explained:

The movement of modern art is a revolution against the conventional and natural things of life as expressed in art . . . The artists of the radical school ridicule all that has been held dear in art . . . Without

exception, the paintings in the State Department group that portray a person make him or her unnatural. The skin is not reproduced as it would be naturally, but as sullen, ashen gray. Features of the face are always depressed and melancholy . . . That is what the Communists and other extremists want to portray. They want to tell the foreigners that the American people are despondent, broken down, or of hideous shape — thoroughly dissatisfied with their lot and eager for a change of government.

This is almost literally what the Soviet's *VOKS Bulletin* was saying that same year. Representative Busbey's voting record is illuminating. He voted against rural electrification and soil conservation, against UNRRA and the Soldier Vote. He voted for the Dies Committee, for the Taft-Hartley Bill, and for the Rees Loyalty Bill.

Next, we must mention the attacks on modern art by Representative George A. Dondero of Michigan during the Eighty-first Congress, from March to October of the year 1949.[1] His remarks were not primarily concerned with the nature of modern art, but were part of a smear campaign against what he considered the subversive, communist background of the modern artists. He made these accusations in blissful ignorance of the fact that he was attacking the same kind of artists and the same kind of art the communists hated.

Also during 1947, Leslie Cheek, the Director of the Virginia Museum of Fine Arts, found himself the target of a series of attacks by a columnist by the name of Ross Valentine, of the *Richmond Times-Dispatch*. The campaign started with an article entitled 'Unintelligible Toys for Adults,' which was launched against a loan exhibition of modern sculpture from Rodin to Gabo. In a subsequent article,[2] Ross Valentine stated:

Modern art (art en Picasserole) is being used to caricature our culture and to inspire contempt ostensibly for the hypocrisy and shame which are to be found in all cultures, but actually to destroy respect for the self-disciplined freedom under which our civilization has flourished since the signing of Magna Charta . . .
In other words, those who subscribe to these aberrations, not only in art, but in music and literature as well, contribute to the razing of our civilization so that their masters in the Kremlin may build upon its ruins and ashes a sepulcher of our freedoms . . .

Again we wonder whether the author of these lines had any idea of how closely he himself was toeing the Kremlin line.

In the *American Artist* of May 1951,[3] there was printed a signed editorial by Ernest Watson, which includes the following passages:

We have in America a sizable group of painters who comprise what might be called the defeatist school. They are the prophets of despair; their canvases drip with melancholy . . . The slogan of this school of painting seems to be: 'If there is any health in it, it can't be art.' . . . This philosophy of defeat is an importation. It has been brought to our shores from countries brutalized by militarism and impoverished by economic disaster. It came primarily out of Germany and its name is Expressionism.

Expressionism, thus born of bitterness and of national tragedy, could hardly be expected to concede anything to graciousness and to connotations of the good life. It is the voice of despair, truly the voice of defeat . . .

Is not its espousal by America something of a perversion? There are things to deplore in our land but we are not that bad . . .

What America needs, especially now, is a strengthening of our faith. The art of imported desperation does not contribute to that faith.

This was written in New York. Later in 1951, an event took place in Los Angeles, which was reported by Jules Langsner.[4]

For six weeks [he wrote] artists of Los Angeles have shuddered in a common nightmare. Reality, bordering on the grotesque, descended on them all when our City Council put 'on trial' a group of works removed from the walls of the City's Greek Theater Annual Exhibition, and brought them into City Hall, there to be held up to scorn and ridicule. Like a freak tornado, the Councilmen grabbed at large for victims, and though they thought they were tilting at 'modern art,' a number of our most respected and conservative artists suffered the anguish of being asked to 'defend themselves for creating these subversive, sacrilegious, and abnormal' pictures . . .

It was hard to believe it was really happening. Hundreds of respected, sober citizens present at the hearing heard a Sanity-in-Art witness testify that 'Modern Art' is actually a means of espionage, and that if you know how to read them, modern paintings will disclose the weak spots in U.S. fortifications and such crucial constructions as Boulder Dam.

Ordinarily one laughs at such Swiftian fantasies, but the fact remains that on the basis of this kind of allegation our city fathers attempted to do away with the entire civic art program . . .

In New York in 1952, the Metropolitan Museum of Art's exhibition of contemporary American sculpture was attacked by the National Sculpture Society in New York. A group of members of this society, including Wheeler Williams, its president, addressed a protest to the Metropolitan Museum and at the same time circulated, on 21 January, the text of this protest to an extensive list of 'men and women who are leaders in every branch of American life and culture,' inviting signatures and comments. The letter and the protest included the following passages:

Is this the culmination of American sculpture? Are you conscious of the fact that the pressure brought by certain aspects of the Modernistic Movement threatens not only art, but the fundamental freedom of our American way of life? . . .

We regard the threatening predominance of a group of an avowed negative ideology as dangerous, not only to art, but to the whole philosophy of national normalcy . . .

Unfortunately, by destroying an ideal of beauty, endeavor, and discipline in the artistic expression of a people, the very foundations upon which its national achievement rest are being undermined. The so-called 'Modern' artists claim that they represent the New Age, and the tremendous changes it has brought. We most heartily repudiate this claim, in the name of the sound, normal American people . . .

History demonstrates that no period has been free of change and conflict, but the greatness of any people has always depended on the positive expression they gave every form of national life. There have always been victims of psychiatric delusions, who torment themselves with visions of an agonizing, sordid, or abstract character, and there have always been spiritual prostitutes, prepared to take advantage of any conjunction for the sake of fame or notoriety . . .

Such an influence can but prove deeply deteriorating in a period in which American democracy is attacked from every angle by a philosophy of Totalitarianism which has permeated nearly every country in continental Europe. And in every country which fell a victim to this insidious ideology, Modernistic art proved a most effective vanguard . . .

The fallacy of this last assertion is clear to everyone who remembers the role of the progressive artist during the 1918 revolution in Germany or Naum Gabo's account of what happened to the modern artist in the early days of the Soviet regime. To call modern art an effective vanguard of totalitarianism, as the Museum of Modern Art pointed out at the time, 'is like denouncing the valiant efforts of those countries to establish democracy because they were later overcome by dictatorship.' [5]

In reviewing these various expressions of hostility toward modern art, it is first necessary to point out that none of them has been uttered without arousing criticism and opposition. The fact remains, however, that despite often intense controversy and rebuttal these attitudes toward modern art persist. They are perhaps growing in intensity.

This brings up the second point, namely whether progressive art has not at all times and in all societies met with some opposition. It is perfectly true that it has. The history of nearly every great artist is the ultimate triumph of genius over mediocrity, of courage over inertia and timidity. The postwar criticism of modern art in the United States, however, assumes a different, more threatening significance because it is not just the indifferent or annoyed or actively hostile reaction of the tradition-bound citizen toward the novel and the unusual. It is more than that. The reaction is more standardized, better organized, more consistent, and more vehement. It is a new reaction to a new situation.

We are faced with a seemingly insoluble paradox. The Nazis called modern art Bolshevistic, degenerate, Jewish. The Soviets call it capitalistic, bourgeois, degenerate. The critics in the United States call it communistic, subversive, abnormal. Obviously, these things are mutually exclusive. Modern art cannot possibly be all these things at the same time. There is only one conclusion from this absurd dilemma, and it is a matter of the greatest importance: modern art is a powerful symbol of anti-totalitarian belief. It is this by virtue of its nature as the free expression of creative forces — not as a deliberate fulfillment of any political program. It is not

the implementation of an ideology but the inevitable result of a genuine belief in individual freedom.

It could still be argued that all the hostile criticism is based on a misunderstanding, a misunderstanding that could somehow be cleared up. If we could point out to our own critics, here in a democracy, whose language they are really talking when they denounce free, individual expression in the arts, would that not be effective? Something could undoubtedly be gained by a well-directed educational campaign. It would at least help to prevent the enlistment of ignorant people of good will on the side of cultural reaction. This alone would make such an effort worth while. Perhaps this book will contribute in a modest way toward this goal. But it is hard to believe that this approach alone would resolve the entire problem, clear up the misunderstanding—if we want to call it that. The trouble lies deeper.

The attacks on free expression are prompted largely by fear of communism, one form of totalitarianism. The question is if in the effort to combat these forces we are not falling into the other extreme, a reactionary, right-wing totalitarianism.

This does not mean that we are necessarily facing in America the immediate prospect of some form of fascist dictatorship. It is not easy to make a prophecy about this. But there are forces in our society that tend in that direction. Some of these are political, to be sure. But they are aided, in an indirect, impersonal way, by certain economic pressures for conformity. These pressures, with which we are all familiar, derive to a considerable extent from the mass media of communication. These media depend on mass acceptance, and for that reason they tend to emphasize the same kind of mass comprehensibility by the broad, untutored audience groups which the modern dictators insist upon. These mass media restrict freedom of artistic expression not from any political or philosophical principal but as a matter of economic pressure. Because of this they could be seized upon by reactionary political forces as an instrument for cultural control. This is a very real possibility.

The importance of free, artistic expression to the preservation and the future growth of individual freedom is incalculable.

In an age steadily becoming more collective [writes James Thrall Soby] art remains one of the few means through which the individual will can assert itself; its function is not to record what we all now like taken together but to affirm the creative differences among us from which all will eventually gain. For this purpose a free climate is essential.[6]

The severest test to which this insistence upon artistic freedom as a valiant defense of individual freedom can be submitted is the teaching of the most sincere religious leaders of today. It is astonishing how clear are the answers of the men who are concerned with the ultimate moral values of human existence. Thomas Merton's *Seeds of Contemplation,*[7] written within the walls of the Trappist Monastery of Our Lady of Gethsemane, contains the following passages:

Many poets are not poets for the same reason that many religious men are not saints: They never succeed in being themselves . . . There can be an intense egoism in following everybody else. People are in a hurry to magnify themselves by imitating what is popular — and too lazy to think of anything better . . . How do you expect to arrive at the end of your own journey if you take the road to another man's city? How do you expect to reach your own perfection by leading somebody else's life? His sanctity will never be yours: You must have the humility to work out your own salvation in a darkness where you are absolutely alone . . .

Harry Emerson Fosdick, in *The Man from Nazareth,*[8] published the same year as Thomas Merton's volume, wrote:

Jesus' thought of every soul as infinitely precious in the sight of God was one of his incontestable characteristics. Adolf Harnack even said: 'Jesus Christ was the first to bring the value of every human soul to light.'

The lethal effect of the totalitarian state upon the creative freedom of the individual has been thoroughly demonstrated in these pages. The question now arises whether this means that every governmental responsibility in the arts is necessarily evil. Does the lesson of dictatorial art control mean that in the democracy, too, the state must be kept away from the arts?

One of the most potent arguments in favor of some kind of an

organized governmental art program derives from the political position of the United States as the leader of the democratic nations. Cultural exchange is already a powerful reality. It is an unavoidable necessity. Full participation of the American art world in international events will always remain handicapped, no matter how effectively private enterprise and subventions can be enlisted, in comparison with other nations whose artists enjoy official representation and support.

Another powerful argument in favor of a genuinely democratic governmental responsibility is the fact that the United States government is already deeply involved in the arts, is already active as sponsor, supervisor, and patron of the arts. In its own contruction program, in the decoration of its own buildings, in its various housing and planning authorities, in the production of currency and postage stamps, in its conservation, and in numerous other activities, the government is now and has been for a long time responsible for a considerable segment of the nation's art life.

In the national emergency of the Great Depression the Roosevelt administration set a wonderful precedent for the recognition of the right of the artist to enjoy the same public support and recognition granted any other profession. But taken as a whole, the attitude of the government has been more often on the conservative, retarding, and sometimes the reactionary side than on the side of the forward-looking forces.

There is some justification for the fear that the preponderantly conservative attitude of the United States government in art could be utilized to advantage by the reactionary and quasi-totalitarian forces that have made themselves so clearly felt in the postwar scene.

This is not the place for a detailed discussion of the pros and cons of government in art today. But the importance of this question does need to be emphasized. In the light of the totalitarian threat there is every reason for a thorough and unbiased study of the problem.[9]

Britain has set out on a worth-while road of experimentation which, it would seem so far, has demonstrated that a democratic government can assume important responsibilities without inter-

fering with the freedom of artistic initiative and diversity. As a successor to CEMA, the wartime Council for the Encouragement of Music and the Arts, there was created in 1945 The Arts Council of Great Britain, incorporated as an autonomous body, under the chairmanship of John Maynard Keynes. 'Co-operation with all, competition with none' was the keynote of his press conference on the day the new venture was announced. 'The arts,' he said, 'owe no vow of obedience.'

Perhaps the most valuable contribution toward the study of the situation in the United States has come from the Committee on Government in Art, under the Chairmanship of Lloyd Goodrich of the Whitney Museum of American Art and made up of a panel of three members from each of twelve leading art organizations. Under the influence of this committee the old Commission of Fine Arts, created in 1910 and now headed by David Finley, Director of the National Gallery, has started to take fresh stock of its responsibilities, and to reconsider its scope of activity.[10] The Goodrich Committee has continued to plead for a truly democratic participation of qualified members of the art world at large.

It is through these channels that practical steps toward a more conscious and more effective role of the government in art are being worked out. The most important concern is over the creation of genuinely representative advisory bodies which will guide the art policies of our government in the years ahead.

There is great hope for the future. Many valuable forces are at work toward the fulfillment of the still unanswered demand for genuine 'art for the people and of the people.' We have not lost this battle, although we have by no means won it. This demand is still a very important and a very real one. There is nothing false about it. The dictators have recognized the strength of this yearning and they have utilized it for their own purposes. They have created synthetic satisfaction and have robbed art of its integrity. They have cut off the living branches, have forced circulation back into the old dead tissues and cells, fostering a make-believe growth, a shadowy fungus reproduction of once living organs.

But we, too, have created substitutes and vicarious satisfactions.

The odds are stacked up heavily against healthy future growth of individual expression and individual experience. Freedom and variety of artistic creation, freedom and variety in the choice of artistic experience, lines of communication between individual artists and large audience groups of individual participants—these are the precious things to watch over. To guard these things against submersion and suffocation, to preserve the existing media of individual expression and experience, and to create healthy conditions for fresh new growth—that is the challenge to democracy.

Notes

I. The Lesson of History

1. In his 'Gedanken ueber die Schoenheit und ueber den Geschmack in der Malerei,' *Hinterlassene Werke,* Halle, 1786.

2. See Milton W. Brown, *The Painting of the French Revolution,* New York, Critics Group, 1938.

3. See David L. Dowd, 'Art as National Propaganda in the French Revolution,' in *The Public Opinion Quarterly,* Fall, 1951.

4. Ibid. pp. 542, 543.

5. Hans Sedlmayr, *Verlust der Mitte,* 3rd edition, Salzburg, Otto Mueller, 1948, p. 27.

6. Arnold Hauser, *The Social History of Art,* London, Routledge and Paul, 1951, p. 643.

7. See especially *The Philosophy of Art of Karl Marx* by Mikhail Lifschitz, New York, Critics Group, 1938. The Russian edition was published in Moscow in 1933. See also Francis Donald Klingender, *Marxism and Modern Art,* London, Laurence and Wishart, 1943, and John R. Martin's article, 'Marxism and the History of Art,' in *College Art Journal,* vol. XI, Fall, 1951.

8. In his *Debatten ueber Pressefreiheit.*

9. In his *Bemerkungen ueber die neueste preussische Zensurinstruktion.*

10. In Marx and Engels, *Deutsche Ideologie.*

11. In his *Zur Kritik der politischen Oekonomie.*

12. In Marx's and Engels' review of C. F. Daumer's *Die Religion des neuen Weltalters.*

13. In his *Theorien ueber den Mehrwert.*

14. Brown, op. cit., and Jean Locquin, *La Peinture d'histoire en France,* Paris, Laurens, 1912. See also Hauser, op. cit.

15. In a footnote written into a copy of C. F. von Rumohr's *Italienische Forschungen.*

16. For instance in certain excerpts from Charles Delrosses' *Ueber den Dienst der Fetischgoetter.*

17. Volumes XXII and XXIII of the *Collected Works of William Morris,*

London, New York, Longmans, Green, contain most of his important art lectures.

18. In his lecture 'Art and the People,' in May Morris, *William Morris, Artist, Writer, Socialist,* vol. 2, Oxford, Basil Blackwell, 1936, p. 388.

19. See 'Morris as I Knew Him' by George Bernard Shaw, in May Morris, op. cit. pp. xxi–xxiii.

20. Max Nordau's *Entartung,* dedicated to Cesare Lombroso, was first published in Berlin by Carl Duncker in 1892–3. George Bernard Shaw's *The Sanity of Art* was published in book form by The New Age Press, London, 1908.

II. The False Paradise of Weimar

1. Translated from the quotation in Otto Grautoff's *Die neue Kunst,* Berlin, Karl Siegismund, 1921.

2. On 30 November 1918, an association of 'Russian Progressive Artists' sent from Moscow an *Address* to their German colleagues, proposing mutual consultations and exchange of news. Quoted on page 75 of the publication cited in note 3.

3. *Ja! Stimmen des Arbeitsrates fuer Kunst in Berlin.* Berlin-Charlottenburg, Photographische Gesellschaft, 1919. A second publication of the *Arbeitsrat,* entitled *Ruf zum Bauen,* was issued in 1920.

4. See, for instance, the introduction to *Jahrbuch der Jungen Kunst,* vol. 1, edited by Professor Georg Biermann, Leipzig, Klinkhardt & Biermann, 1920.

5. An extensive study of German expressionism in painting has been prepared in this country by Bernard Myers.

6. Herwarth Walden's *avant-garde* magazine *Der Sturm* appeared first in 1910. The 'Sturm' Exhibition of 1912 was a major event in German prewar art life.

7. See, for instance, Bruno Taut, *Alpine Architektur,* Hagen, Folkwang-Verlag, 1919. See also Chapter IV, note 9, below.

8. Published in revised form under the title *Kuenstlerische Zeitfragen,* Munich, Bruckmann, 1921.

9. G. F. Hartlaub, *Kunst und Religion,* Munich, Kurt Wolff, 1919.

10. G. F. Hartlaub, *Die Graphik des Expressionismus in Deutschland,* Stuttgart, Gerd Hatje, 1947.

11. See Bruno Taut, *Die Stadtkrone,* Jena, Eugen Diederichs, 1919.

12. See *Luebecker Kunstpflege 1920–1933,* edited by Carl Georg Heise, Luebeck, 1934.

13. Ludwig Meidner, 'Vom rechten Gebrauch irdischer Gaben,' in *Der Feuerreiter, Blaetter fuer Dichtung, Kritik, Graphik,* edited by Heinrich Eduard Jacob, vol. 2, August 1923.

14. In the early 'thirties American graphic-arts enthusiasts witnessed the introduction of this medium in a series of picture novels by the young American, Lynd Ward.

15. *Das Wissen um Expressionismus. Fuehrer durch die Ausstellung der Abstrakten,* Berlin, Das Kunstarchiv, 1926.

16. An excellent description of the official art life of the Weimar Republic will be found in Paul Ortwin Rave's *Kunstdiktatur im Dritten Reich,* Hamburg, Gebr. Mann, 1949.

17. See *Mitteilungen des Reichskunstwarts,* nos. 1 and 2, published by the Reich's Ministry of the Interior, 1920; *Die kuenstlerische Formgebung des Reiches* by Reichskunstwart Dr. Edwin Redslob, Berlin Kunstarchiv (n.d.); special issue of the periodical *Gebrauchsgraphik,* vol. II, no. 2: 'Die amtliche Graphik des Reichs und ihre Auswirkung auf Kunst und Handwerk.'

18. See *Bauten der Gemeinschaft* by Walter Mueller-Wulckow, Koenigstein i. T., Langewiesche, 1929.

19. See Walter Gropius, *The New Architecture and the Bauhaus,* London, Faber & Faber, 1935; and Herbert Bayer, *Bauhaus* (1919–1928), New York, Museum of Modern Art, 1938.

20. *Die Maler am Bauhaus,* Ausstellung Haus der Kunst, Muenchen, Mai-Juni 1950, Munich, Prestel Verlag, 1950.

21. Walter Curt Behrendt, *Modern Building. Its Nature, Problems, and Forms,* New York, Harcourt, Brace, 1937.

22. See *Bau und Wohnung: Die Bauten der Weissenhofsiedlung in Stuttgart errichtet* 1927, Stuttgart, Wedekind, 1927.

23. *Die Entwicklung der zeichnerischen Begabung,* Munich, Carl Gerber, 1905.

24. Early in the Weimar Republic the new trend found recognition in an exhibition organized by Fritz Wichert in the spring of 1921 at the Mannheim Municipal Art Gallery. See G. F. Hartlaub, *Der Genius im Kinde. Zeichnungen und Malversuche begabter Kinder,* Breslau, Ferdinand Hirt, 1922.

25. Gustav Britsch never published his findings in coherent form. They were edited posthumously by Egon Kornmann, one of his followers, as *Theorie der bildenden Kuenste,* Munich, Bruckmann, 1926.

26. Dr. Leo Weismantel (ed.), *Vom Willen deutscher Kunsterziehung. Selbstdarstellungen,* Duesseldorf, Verlag L. Schramm.

27. Egon Kornmann in vol. III, 1931, of the above-named series.

28. W. Daiber in vols. v and vi, 1932.
29. Egon Kornmann, op. cit.

III. The Crystallization of the National Socialist Art Doctrine

1. See especially the following of the numerous publications of Dr.
 Hans F. K. Guenther: *Ritter, Tod und Teufel, der Heldische
 Gedanke,* 1920; *Rassenkunde des deutschen Volkes,* 1923; *Kleine
 Rassenkunde Europas,* 1925; *Rasse und Stil,* 1926, all published
 in Munich by J. F. Lehmann; and *Die Verstaedterung,* Leipzig,
 B. G. Teubner, 1934.
2. *Rasse und Seele,* Munich, J. F. Lehmann, 1926; *Die nordische Seele,*
 Halle, Niemeyer, 1923.
3. *The Revolt against Civilization. The Menace of the Underman,*
 New York, Scribner, 1922; published in German translation,
 Munich, J. F. Lehmann, 1925. For a refutation of Stoddard see
 Gunnar Dahlberg, *Race, Reason and Rubbish,* London, Allen
 and Unwin, 1942.
4. *Menschheitstypen und Kunst,* Jena, Eugen Diederichs, 1921.
5. Professor Paul Schultze-Naumburg's publications include: *Die
 Gestaltung der Landschaft durch den Menschen,* Munich, Georg
 D. W. Callwey, 1928; *Kunst und Rasse,* Munich, J. F. Lehmann,
 1928; *Kampf um die Kunst,* Munich, Franz Eher, 1932; *Kunst
 aus Blut und Boden,* Leipzig, E. A. Seemann, 1934; *Die Kunst der
 Deutschen,* Stuttgart, Deutsche Verlags-Anstalt, 1934; *Nordische
 Schoenheit, ihr Wunschbild im Leben und in der Kunst,* Munich,
 J. F. Lehmann, 1937.
6. 'Weltanschauung' is untranslatable. It means not merely a point of
 view in looking at the world but also a basic philosophy of living,
 derived from one's own concept of the surrounding universe. The
 word was used with increasing pretentiousness and arrogance by
 the Nazis in their ideological battles. Ultimately, it became al-
 most synonymous with 'Nazi outlook.'
7. See Chapter 1, note 20.
8. Paul Ortwin Rave, op. cit.
9. *Der Mythus des zwanzigsten Jahrhunderts,* Munich, Hoheneichen-
 Verlag, 1930. See also his pamphlet, *Revolution in der bildenden
 Kunst,* Munich, Franz Eher, 1934.
10. Reproductions in the *Braune Post,* no. 41, 13 October 1933.
11. See Dr. G. M. Gilbert, *Nuremberg Diary,* New York, Farrar &
 Strauss, 1947.

IV. The Masterbuilder Adolf Hitler

1. For Hitler's early career as an artist see Konrad Heiden's biography. Two translations have been published: *Hitler. A Biography*, New York, Knopf, 1936, and *Der Fuehrer*, Boston, Houghton Mifflin, 1944; I have quoted from the latter.

2. *Sieben Aquarelle*. Herausgegeben von Reichsbildberichterstatter Heinrich Hoffmann, Munich, Franz Eher, 1938. Hitler did not encourage the circulation of these drawings. He asked Goebbels to prohibit exhibitions of his work.

3. Reprinted from a Berlin evening paper in the periodical, *Bildende Kunst*, vol. I, nos. 4 and 5, 1947.

4. As told by Alfred Speer to Dr. G. M. Gilbert, prison psychiatrist during the Nuremberg Trials.

5. Konrad Heider, op. cit.

6. The texts of many of Hitler's addresses on art can be found in the several editions of his speeches. They were printed in more or less revised and condensed form in the daily press; in the *Mitteilungsblatt d. Reichskammer d. bild. Künste;* in *Die Kunst im Dritten Reich;* and as separate brochures.

7. Paul Ortwin Rave, op. cit. p. 41.

8. The Hitler Library, which is in the care of the Rare Books Division of the Library of Congress, contains the following books on art:

Johann Georg Wagner, *Probe der sechsten Saeulenordnung,* Breslau & Leipzig, Michael Rohrbach, 1928.

Hermann Wille, *Germanische Gotteshaeuser zwischen Weser und Ems,* Leipzig, Koehler & Amelang, 1933.

Ludwig Woltmann, *Die Germanen und die Renaissance in Italien,* Leipzig, Thueringische Verlagsanstalt, 1905.

Hans Sedlmayr, *Die Architektur Borrominis,* second edition, Munich, Piper, 1939 (?).

Wilhelm Paeseler, *Die Nuernberger Choerlein,* Erlangen, Palm & Enke, 1932.

D. Ing. M. Rendschmidt, *Das alte Elbinger Buergerhaus,* Elbing, 1933.

Geschichte der Stadt Berlin, Berlin, Mittler, 1937.

Heinz Johannes, *Die Athenischen Bauten der Brueder Hansen* (typescript).

Ludwig Roselius, *Reden und Schriften zur Boettcherstrasse in Bremen,* Bremen, G. A. von Halem, 1932.

Heinz Bitz (ed.), 50 *Eigenhaeuser in Bildern mit Beschreibung, Kostenberechnung und Finanzierungsvorschlaegen*, second ed., Mainz, Bausparkasse Mainz, 1933 (?).

Max Schwarz, *Ein Weg zum praktischen Siedeln*, Duesseldorf, Pflugschar-Verlag, 1933.

Curt Feiler, *Kleinwohnungsbau Typ Feiler*, Reichenberg i. Voigtland.

Franz Heberer, *Neue Werkkunst*, Berlin, Leipzig, Wien, Huebsch Verlag.

Handbuch der Architektur (IV. Teil. Entwerfen, Anlage und Einrichtung. 1. Halbband: Architektonische Komposition), Leipzig, J. M. Gebhardt, 1926.

Paul Schultze-Naumburg, *Die Kunst der Deutschen. Ihr Wesen und ihre Werke*, Stuttgart, Berlin, Deutsche Verlags-Anstalt, 1934.

Josef Ponten, *Der Meister*. Novelle, Leipzig, Insel-Verlag.

It is not possible to say with assurance that this collection represents the complete library of Adolf Hitler and that all the books he owned were brought to Washington. But it is certain that the library in Washington is not a specialized collection in any sense of the word. It contains books on many different subjects, all connected in various ways with Hitler's different interests. It is therefore reasonably safe to say that the art books in this collection are a representative sampling of his taste in that field, typical of the art books he owned and with which he was, in one way or another, acquainted.

9. Josef Ponten was the co-author of an important book, *Architektur die nicht gebaut wurde*, 2 vols., Stuttgart, Deutsche Verlags-Anstalt, 1925. This is a collection of all the most grandiose schemes dreamed up by architects from the seventeenth to the early nineteenth centuries. Some of these schemes may have influenced the bigness of Hitler's architectural planning.

10. It is significant for Hitler's taste that he was intimately acquainted with the architecture of Louis XIV's Versailles. 'He spoke . . . of the roof construction of the castle of Louis XIV as though he himself had had a hand in the glazing,' wrote Dr. Hans Frank in his memoirs of Hitler, compiled at the suggestion of Dr. G. M. Gilbert, who owns the manuscript. See Dr. Gilbert's *Nuremberg Diary*, op. cit., and his *The Psychology of Dictatorship*, New York, Ronald Press, 1950.

11. I have had an opportunity to discuss Hitler's role as 'Masterbuilder'

of the Third Reich' with Dr. Gilbert, who made the following comment:

'Hitler's reversion or regression to Classical Art was not an expression of his conventionality but a revolt against the social conventions which were at the root of his neurosis. Actually, it was society itself which he hated. The real driving force was to destroy society, which had made him feel so inferior. He was essentially nihilistic, misanthropic, and anti-social — but camouflaged these pathological tendencies by the appeal to antiquated symbols and ideals.'

12. See Heinrich Hoffmann, *Hitler wie ihn keiner kennt; 100 Bilddokumente aus dem Leben des Fuehrers,* Munich, Heinrich Hoffmann, 1932 (?), and the other numerous collections of Hitler photographs published by Hoffmann.

13. Published in New York by the Black Sun Press in 1936.

14. In *The Roosevelt I Knew,* New York, Viking Press, 1946, p. 163.

V. The Organization of Total Control

1. *Formzertruemmerung und Formaufbau in der bildenden Kunst,* Berlin, Ernst Wasmuth, 1919.

2. *Die neue Kunst,* Berlin, Karl Siegismund, 1921.

3. See his *Kunstdiktatur im Dritten Reich,* Hamburg, Gebr.Mann, 1949, which is the source for much of the material included in this chapter.

4. Her writings were subsequently published under the title, *Im Terror des Kulturbolschewismus,* Karlsruhe, C. F. Mueller, 1938.

5. Published in Erlenbach-Zuerich, Munich, and Leipzig by the Eugen Rentsch Verlag, 1932.

6. The Goebbels Ministry was officially established on 13 March 1933 by order of President Hindenburg. The functions of the new ministry were defined by Hitler on 30 June 1933. Staatsrat Hinkel was a member of Rosenberg's Kampfbund and at one time editor of its official publication, *Deutsche Kulturwacht.*

7. A law defining the establishment and the functions of the Reichskulturkammer was promulgated on 22 September 1933. The Reichskunstkammer was established as a separate entity within the Reichskulturkammer. The first fundamental regulation of its structure was published on 10 April 1935. The Art Chamber was the publisher of a magazine entitled *Die Kunstkammer,* which appeared from 1935 to 1936. An official monthly newsletter,

the *Mitteilungsblatt der Reichskammer der bildenden Kuenste,* appeared first in 1936 and was published at least until 1 December 1939. A detailed description of the Reichskulturkammer was published in mimeographed form, apparently for internal administrative use, under the title, *Die Organisation der Reichskulturkammer.* The official files of the organization and a complete list of the Berlin members are preserved in the U.S. Documents Center in Berlin-Zehlendorf.

See also the following books: Ernst Adolf Dreyer, *Deutsche Kultur im neuen Reich, Wesen, Aufgaben und Ziele der Reichskulturkammer,* Berlin, Schlieffen-Verlag, 1934; Dr. Hans Frank, 'Vorwort' in *Deutsches Kulturrecht,* Hamburg, Falkenverlag, 1936; Hans Hinkel (ed.), *Handbuch der Reichskulturkammer,* Berlin, Duetscher Verlag fuer Politik und Wirtschaft, 1937; Dr. Hans Schmidt-Leonhardt, *Die Reichskulturkammer,* Berlin, Spaeth & Linde, 1936; Dr. Karl Friedrich Schrieber, *Die Reichskulturkammer. Organisation und Ziele der deutschen Kulturpolitik,* Berlin, Junker & Duennhaupt, 1934.

The laws of the Chamber of Culture have been published in two elaborate collections: Dr. Karl Friedrich Schrieber, *Das Recht der Reichskulturkammer,* 5 vols., Berlin, Junker & Duennhaupt, 1935–7; and Schrieber-Metten-Collatz, *Das Recht der Reichskulturkammer,* 2 vols., Berlin, Walter de Gruyter, 1943.

8. In 1934 this department was part of Rosenberg's cultural empire. Rivalries between top-ranking party officials accounted for constant shifts and reassignments of functions and personnel.

9. *Die Kunst im Dritten Reich,* after 1940 *Die Kunst im Deutschen Reich,* Munich, Zentralverlag Franz Eher, 1937–44. Appeared monthly in two editions, 'A' the regular, 'B' with an additional architectural section entitled 'Die Baukunst.'

10. I should be very glad to make the material in my possession available to a qualified student.

11. Law of 15 May 1934.

12. The files of the Kunsthalle in Bremen still contain the documents of this struggle.

13. In the *Deutsche Allgemeine Zeitung,* 12 May 1933.

14. Gottfried Benn, *Kunst und Macht,* Stuttgart, Deutsche Verlagsanstalt, 1934. An attempt to reconcile Nazi ideals and modern architecture was undertaken by Alfons Leitl in his *Von der Architektur zum Bauen,* Berlin, Metzner, 1936.

15. *Die Kunst der letzten 30 Jahre* by Max Sauerlandt, Berlin, Rembrandt-Verlag, 1935.

16. In a letter of 20 September 1937 to the Berlin Bau- und Sparverein, which had commissioned the Raemisch sculptures for one of its housing projects.

17. See *The Goebbels Diaries* 1942–1943, edited by Louis P. Lochner, New York, Doubleday & Co., 1948. The art criticism of the Nazi press was studied by Gerhard Koehler in a doctoral dissertation entitled *Kunstanschauung und Kunstkritik in der National-sozialistischen Presse*, Munich, Zentral-Verlag, Eher, 1937.

18. For a detailed account of this struggle see Rave, op. cit.

19. See *Luebecker Kunstpflege* 1920–1933, edited by Carl Georg Heise, Luebeck, 1934.

20. During the same year, 1934, a courageous attack against his *Mythus* was published by the Archbishop of Cologne's Generalvikariat as *Studien zum Mythus des 20. Jahrhunderts*. Rosenberg replied the following year with his *An die Dunkelmaenner unserer Zeit*, Munich, Hoheneichen-Verlag, 1935.

21. The publications referred to in the text have the following original titles: Kurt Karl Eberlein, *Was ist Deutsch in der Deutschen Kunst?*, Leipzig, Seemann, 1933; Alfred Rosenberg, *Revolution in der bildenden Kunst?*, Munich, Franz Eher, 1934; the SS magazine *Das Schwarze Korps*, Munich, Franz Eher, first published 6 March 1935; Wolfgang Willrich, *Saeuberung des Kunsttempels*, Munich, J. F. Lehmann, 1937. See also Walter Stang's *Grundlagen Nationalsozialistischer Kulturpflege*, Berlin, Junker & Duenn-haupt, 1935, and the same author's *Weltanschauung und Kunst*, Berlin, Junker & Duennhaupt, 1937.

VI. OPERATION 'DEGENERATE' ART

1. The order was dated 30 June 1937.

2. *Entartete 'Kunst.' Fuehrer durch die Ausstellung*, Berlin, Verlag fuer Kultur- und Wirtschaftswerbung, 1937.

3. *Salome und der Prophet*, Stuttgart, Eidos-Presse, 1946; Shakespeare's *The Tempest*, Stuttgart, Gerd Hatje, 1946–7; *Sumerische Legenden*, Stuttgart, Eidos-Presse, 1947. During the war, Willi Baumeister published *Das Unbekannte in der Kunst*, Stuttgart, 1943. See also Willi Grohmann's *Willi Baumeister*, Stuttgart, W. Kohlhammer, 1952.

VII. NAZI PAINTING: A STUDY IN RETROGRESSION

1. A particularly obnoxious juxtaposition of 'good' and 'bad' painting, according to Nazi standards, was published by Dr. Adolf Dresler

as *Deutsche Kunst und entartete Kunst,* Munich, Deutscher Volksverlag, 1938.

2. *Grosse Deutsche Kunstausstellung 1937 im Haus der Deutschen Kunst zu Muenchen,* 18 Juli bis 31 Oktober 1937. Munich, Knorr & Hirth, 1937. Subsequent catalogues appeared annually in identical format.

3. See, for instance, Bruno Kroll, *Deutsche Maler der Gegenwart,* third edition, Berlin, Rembrandt-Verlag, 1937, and the numerous articles on painting in *Die Kunst im Dritten Reich.*

4. Translated from the files on the Linz project, now in the possession of the Zentralinstitut fuer Kunstgeschichte in Munich. Dr. Posse was appointed by Hitler on 26 July 1939. The preparation of the building plans was in the hands of the architect Roderich Fick.

5. The collection was assembled in Germany by Professor Gordon W. Gilkey, then a captain in the air force on a special assignment for the Office of the Chief Historian, Headquarters, European Command, in 1946 and 1947. The collection was shipped to the Chief of the Historical Properties Section at the Pentagon in Washington, D.C. Professor Gilkey wrote a detailed report, *German War Art,* dated 25 April 1947.

6. See, for instance, Walter Horn's article in *Die Kunst im Deutschen Reich,* vol. IV, no. 2, February 1940.

7. *Feuer und Farbe,* introduction by Walther Troege, Vienna, Wilhelm Frick, 1943.

8. For details see the articles 'Neue Deutsche Wandmalerei' by Dr. Bruno Kroll in *Die Kunst im Dritten Reich,* vol. III, no. 3, Munich, 1939; 'Wesen und Aufgaben der Architekturmalerei' by Hermann Kaspar in *Die Kunst im Deutschen Reich,* vol. III, no. 9, September 1939; 'Marksteine deutscher Geschichte. Zu Werner Peiners Entwuerfen' by Dr. Johannes Sommer, ibid. vol. IV, no. 4, April 1940; 'Stil und Symbolik im Mosaik' by Dr. Edgar Schindler, ibid. vol. IV, no. 3, March 1940.

9. For details about his work see E. A. Dreyer, *Werner Peiner,* Hamburg, Siebenstaebe-Verlag, 1936.

10. A typical selection is reproduced in an article, 'Zeichnung und Graphik' in *Die Kunst im Deutschen Reich,* vol. III, no. 10, October 1939.

VIII. The Peculiar Mission of the Sculptor

1. See the article, 'Symbole der Zeit' in *Die Kunst im Deutschen Reich,* vol. IV, no. 4, April 1940. See also Johannes Sommer, *Arno Breker,*

Bonn, Roehrscheid, 1943; and Heinz Grothe, *Arno Breker. 60 Bilder*, Koenigsberg, Kanter-Verlag, 1943.

2. See Charles Despiau, *Arno Breker*, Paris, Flamarion, 1942. Despiau's authorship of this work is questionable. See the article, 'Despiau' by E. Bénézit in *Dictionnaire des peintres, sculpteurs*, Paris, Grund, 1950, p. 216.

3. See the article, 'Atelier-Bauten' by Lauter in *Die Kunst im Deutschen Reich*, vol. IV, no. 8–9, August–September 1940.

4. See Werner Rittich, *Architektur und Bauplastik der Gegenwart*, Berlin, Rembrandt-Verlag, 1938.

5. See Wilhelm Pinder (ed.), *Georg Kolbe Zeichnungen*, Berlin, Rembrandt-Verlag, 1942; Georg Kolbe, *Bildwerke*, Leipzig, Insel-Verlag, n.d. (after 1938).

6. In his *Auf Wegen der Kunst*, with introduction by Ivo Beucker, Berlin-Zehlendorf, Konrad Lemmer, 1949.

7. See Uli Klimsch, *Fritz Klimsch*, Berlin, Rembrandt-Verlag, 1938, and *Richard Scheibe*, Berlin, Rembrandt-Verlag, n.d. See also 'Der Bildhauer Richard Scheibe' by Dr. Werner Rittich in *Die Kunst im Dritten Reich*, vol. III, no. 5, May 1939, and similar articles about the other sculptors in almost every issue of this magazine.

8. Alfred Hentzen's work appeared as *Deutsche Bildhauer der Gegenwart*, Berlin, Rembrandt-Verlag, 1934; the book by Bruno E. Werner as *Die deutsche Plastik der Gegenwart*, Berlin, Rembrandt-Verlag, 1940. See also Paul Ortwin Rave, *Kunstdiktatur im Dritten Reich*, p. 73.

IX. TOTAL ARCHITECTURE

1. Nazi architecture is exceedingly well documented in a series of lavishly illustrated periodicals and books. One of the most illuminating is the monthly architectural section of *Die Kunst im Dritten Reich*, published under the joint editorship of Alfred Rosenberg and Albert Speer, the top authority in Nazi building. In addition to the publications cited in subsequent notes, the following publications should be mentioned: Karl Willy Straub, *Die Architektur im Dritten Reich*, Stuttgart, Dr. Fritz Wedeking, 1932; *1. Deutsche Architektur-und Kunsthandwerk-Ausstellung*, Munich, Knorr & Hirth, 1937 (vol. 2 appeared in 1938, and so on); Gerdy Troost (ed.), *Das Bauen im Neuen Reich*, 2 vols., Bayreuth, Gauverlag, 1938–43; Dr. Adolf Dresler, *Das Braune Haus und die Verwaltungsgebaeude der Reichsleitung der*

NSDAP, third edition, Munich, Zentralverlag Franz Eher, 1939; Hans Stephan, *Die Baukunst im Dritten Reich,* Berlin, Juncker & Duennhaupt, 1939; *Bauten der Bewegung,* vols. I and II, Berlin, Wilhelm Ernst, 1939–42; Albert Speer (ed.), *Neue Deutsche Baukunst,* Berlin, Volk und Reich Verlag, 1941.

An excellent and extensive collection of photographs of Nazi buildings, models, and blueprints is in the possession of the Print Department of the Library of Congress.

A number of pre-Nazi architectural periodicals carried on publication after 1933.

2. Quoted from *Neue Deutsche Baukunst.*

3. See Gottfried Feder, *Die Neue Stadt,* Berlin, J. Springer, 1939.

4. See Hans Gerhard Evers, *Tod, Macht und Raum als Bereiche der Architektur,* Munich, Neuer Filser Verlag, 1939.

5. Quoted from *Das Bauen im Neuen Reich.*

6. See Eduard Schoenleben, *Fritz Todt, der Mensch, der Ingenieur, der Nationalsozialist,* Oldenburg, Stalling, 1943.

7. *Das Bauen im Neuen Reich,* vol. 2, p. 7.

8. See the article, 'Paul L. Troost zum 10ten Todestag' by H. A. Thiess in *Voelkischer Beobachter,* 21 January 1944.

9. See Rudolf Wolters, *Albert Speer,* Oldenburg, Gerhard Stalling, 1943.

10. The legal treatises on the Chamber of Culture, cited in note 7, Chapter V, have detailed sections on the profession of the architect, his rights and duties. The constant stream of new laws, regulations, and notices can be found in the issues of *Die Kunst im Dritten Reich.* See also Scholtz-Heilmann, *Das Recht des Staedtebauers, des Siedlungswesens und der Wohnwirtschaft,* Eberswalde, Rudolf Mueller, 1940; and Hans-Peter Meister, *Das Recht des Architekten,* Berlin, Bauwelt-Verlag, 1939.

11. Translated from the Swiss edition of his biography, Zuerich, Europa-Verlag, 1936.

12. For examples of the extensive literature on these questions see Walter Feg, *Der zukuenftige Wohnungs- und Siedlungsbau,* Hamburg, Hanseatische Verlagsanstalt, 1939; or the *Schriftenreihe des Instituts fuer Wohnungs- und Siedlungswesen* of the University of Berlin, published by Heilmann.

13. *Die Verstaedterung,* Leipzig, B. G. Teubner, 1934.

14. See Werner Lindner, Erich Kulke, *et al.* (eds.), *Das Dorf. Seine Pflege und Gestaltung,* 2nd edition, Munich, Georg D. W. Callwey, n.d.; Werner Lindner and Erich Boeckler, *Die Stadt. Ihre Pflege und Gestaltung,* Munich, Georg D. W. Callwey, n.d.

15. Reprinted in the *Mitteilungsblatt der Reichskammer der bildenden Kuenste,* 1937, No. 2.

16. See the Ministry of the Interior's *Das Reichssportfeld,* Berlin, Reichssport-Verlag, 1936.

X. GESTAPO IN THE GIFT SHOP

1. Quoted from Louis P. Lochner's *The Goebbels Diaries.*

2. Translated from a photostat in my possession.

3. Circular letter No. 10 of the President, dated 28 January 1938.

4. An excerpt from Ziegler's address appeared under the title 'Deutsche Warenkunde' in the *Mitteilungsblatt der Reichskammer der bildenden Kuenste,* vol. 4, 1 April 1939.
 The *Deutsche Warenkunde* was published in Berlin by Alfred Metzner-Verlag, 1939. The Kunstdienst, or Art Service, entrusted with this publication, was not originally a Nazi creation. It was active during the Weimar Republic as a sort of liturgical arts society. After Hitler came to power, the Art Service was first incorporated into the office of the Nazi-approved Protestant Reichsbishop and shortly thereafter was taken over by the Reichs' Chamber of Art. In 1937 it was re-established as an independent association but the Propaganda Ministry kept a watchful eye on its activities.

5. The First International Art Crafts Exhibition, held in Berlin in 1938, was hardly a genuinely international affair, but rather afforded an opportunity to emphasize national traditions and achievements.

6. Like the exhibition itself, the official catalogue of arts and crafts was a section in the annual architecture catalogue.

7. 'Deutsches Kunsthandwerk' by Dr. Wilhelm Ruediger in *Die Kunst im Dritten Reich,* vol. III, no. 1, January 1939.

8. Dr. Hans Weber in an article, 'Volkstum im Handwerk' in *Die Kunst im Deutschen Reich,* vol. IV, no. 4, April 1940.

9. Hermann Gretsch, *Gestaltendes Handwerk,* Stuttgart, J. Hoffmann, *c.* 1941.

10. Walter Passarge, *Deutsche Werkkunst der Gegenwart,* Berlin, Rembrandt-Verlag, 1937.

11. This example was the main topic of the article by Dr. Hans Weber cited in note 8.

12. See Alexander Heilmeyer, 'Zu den Arbeiten von Frieda Thiersch' in *Die Kunst im Deutschen Reich,* vol. III, no. 10, October 1939.

XI. The Archaeologist in SS Uniform

1. Wolfgang Stumme, *Bald nun ist Weihnachtszeit,* Wolfenbuettel, Georg Kallmeyer, 1945.
2. Louis P. Lochner, *The Goebbels Diaries,* p. 250.
3. Translated from Otto Rahn, *Lucifers Hofgesind,* as quoted in Werner Stief, *Heidnische Sinnbilder,* Leipzig, v. Hase & Koehler, 1938.
4. In Oskar von Zaborsky-Wahlstaetten, *Urvaeter-Erbe in deutscher Volkskunst,* Leipzig, Koehler & Amelang, 1936.
5. A mimeographed report was prepared under my direction in the Monuments, Fine Arts, and Archives Section, OMGUS, under the title, *Cultural Looting of the 'Ahnenerbe,'* Berlin, 1 March 1948. (Copy in the Library of Congress.)
6. The following information on the Ahnenerbe publications program is intended to show its over-all structure, to record certain characteristic items, and to aid in the identification of hitherto disguised SS publications in American libraries. It is not a complete bibliographical listing of all Ahnenerbe publications.

 A typical forerunner is Dr. Erich Jung's *Germanische Goetter und Helden in christlicher Zeit,* Munich, J. F. Lehmann, 1922; a second expanded and revised edition appeared in 1939.

 There were three main divisions of publications. The first contained so-called basic works, such as Walther Wuest's *Vergleichendes und etymologisches Woerterbuch des Alt-Indo-Arischen,* Heidelberg, Carl Winter, 1935; and Hermann Wirth's *Die heilige Urschrift der Menschheit,* Leipzig, Koehler & Amelang, 1931.

 The second division was comprised of the results of specialized research, such as Strobel's *Bauernbrauch im Jahreslauf,* Leipzig, Koehler & Amelang, 1936; Josef Strzygowski's *Morgenrot und Heidnischwerk in der Christlichen Kunst,* Berlin, Widukind-Verlag, 1937; Mueller's *Kreuz und Kreis. Untersuchungen zur sakralen Siedlung bei Italikern und Germanen,* Berlin, Widukind-Verlag, 1938; or Mueller-Blattau's, *Germanisches Erbe in deutscher Tonkunst,* Berlin, Widukind-Verlag, 1938.

 The third division, 'Series C,' included the popular writings: Oskar von Zaborsky-Wahlstaetten, *Urvaeter-Erbe in deutscher Volkskunst,* Leipzig, Koehler & Amelang, 1936; Karl Theodor Weigel, *Sinnbilder in der fraenkischen Landschaft,* Berlin, Alfred Metzner, 1938; and Dr. Georg Graber, *Sagen aus Kaernten,* Graz, Leykam-Verlag, 1944.

 There were also some specialized series. Two periodicals pub-

lished by the Ahnenerbe were *Germanien, Monatshefte fuer Germanenkunde zur Erkenntnis deutschen Wesens,* Leipzig, K. F. Koehler, and *Zeitschrift fuer Namensforschung mit 'Das Sippenzeichen,'* Berlin, Ahnenerbe-Stiftung.

7. In his *Bauernbrauch im Jahreslauf,* third edition, Leipzig, Koehler & Amelang, 1936.

8. In *Die Kunst im Dritten Reich.*

9. The complete list is given in the report cited in note 5.

10. Copy in the Library of Congress.

XII. Art Education in the Third Reich

1. Dr. Cuerliss, in an interview in Berlin in the fall of 1950, supplied much of my information on the Fuehrerprojekt. Additional facts were gathered at U.S. Documents Center in Berlin.

2. A detailed directive, to be signed by all participating photographers, was issued by the Propaganda Ministry on 2 December 1943.

3. An illustrated catalogue was published as *Die Schrift als deutsche Kunst,* Nuremberg, Germanisches Nationalmuseum, 1940.

4. Translated from the reproduction of the document in Karl Klingspor, *Ueber Schoenheit von Schrift und Druck,* Frankfurt, Georg Kurt Schauer, 1949.

5. Robert Boettcher, *Kunst und Kunsterziehung im dritten Reich,* Breslau, Ferdinand Hirt, 1933.

6. Paul Fegeler-Falkendorff, *Neudeutsche Kunsterziehung,* Breslau, Korn-Verlag, 1934.

7. *Kunst und Jugend,* Monatsschrift des NSLB fuer kuenstlerische Erziehung, Stuttgart, Eugen Hardt, ?–1938. Munich, Deutscher Volksverlag, 1939–?.

8. Such ideological demands upon the study of artistic monuments were not made by the pedagogue alone. He enjoyed the support of the professional art historian. See, for example, Josef Strzygowski, *Das indogermanische Ahnenerbe des deutschen Volkes und die Kunstgeschichte der Zukunft,* Vienna, Deutscher Verlag fuer Jugend und Volk, 1941.

9. See P. K. Sommer, *Kunst und Kunsterziehung, Quellen der Zersetzung und des Aufbaues,* Dortmund, 1935.

10. Herbert Reiher, 'Naturstudien in Zeichenkunst,' in *Kunst und Jugend,* September 1938.

11. See an article by Werner Kindt in *Die Kunst im Dritten Reich,* vol. III, no. 8, August 1939.

12. For instance, *Kunst der Nation,* Berlin, Verlag Kunst der Nation,

1933–?; *Die Voelkische Kunst* (ed. Dr. Walter Stang), Berlin, Kraft durch Freude, 1935–?. See also Rave, op. cit.

XIII. THE POSTWAR SITUATION

1. An important tangible result of these meetings was the publication of *Prolog I. A Portfolio of Contemporary German Drawings and Prints Selected by a Group of American and German Residents of Berlin,* 25 plates, with an introduction by Beryl Rogers Mc-Claskey and an essay by Carl Linfert, text in English and German, Berlin, Gebr. Mann, 1947.

2. See André Kormendi's article, 'What German Art Survives?' in *Art News,* October 1948, and Hellmut Lehmann-Haupt's 'Art in Germany Today' in *Magazine of Art,* December 1948.

3. Hellmut Lehmann-Haupt, 'German Museums at the Crossroads' in *College Art Journal,* Winter 1947–8, vol. VII, no. 2. See also the portfolio, *Galerie Gerd Rosen stellt aus: Moderne Kunst,* Berlin, 1947.

4. See the catalogue, *Ausstellung Henry Koerner U.S.A. Gemaelde und Graphik* 1945–1947, Berlin-Zehlendorf, Amt für Kunst, 1947. The children's drawings were exhibited there in the winter 1947–8.

5. See the catalogue, *Die Maler am Bauhaus,* Munich, Prestel Verlag, 1950.

6. A handsome illustrated catalogue was issued in connection with the exhibition.

7. See Charlotte Weidler's article, 'Art in Western Germany Today' in *Magazine of Art,* April 1951.

8. Hans Sedlmayr, *Verlust der Mitte,* 3rd edition, Salzburg, Otto Mueller, 1948.

9. See Hans Gerhard Evers (ed.), *Darmstaedter Gespraech. Das Menschenbild in unserer Zeit,* Darmstadt, Neue Darmstaedter Verlagsanstalt, for a verbatim record of these discussions during a conference held 15 July to 17 July 1950; also a pamphlet containing Willi Baumeister's address, entitled *Ansprache von Willi Baumeister in Darmstadt,* Juli 1950 (Darmstaedter Gespraeche). Verteidigung der modernen Kunst gegen Sedlmayr und Hausenstein.

10. *Allemagne d'aujourd'hui,* Textes et informations sur la vie culturelle en Allemagne, Mayence, Direction Générale des affaires culturelles, Haut-Commissariat de la République Française en Allemagne. See also the *Bulletin des Relations Artistiques, France-Allemagne,* published by the Haut-Commissariat since February 1950 at irregular intervals.

11. *Der Monat,* Eine Internationale Zeitschrif fuer Politik und geistiges Leben (Chief Editor Melvin J. Lasky, published in Berlin-Dahlem since 1949) is one of the valuable results of this policy.

XIV. GERMAN ART BEHIND THE IRON CURTAIN

1. For instance T. Otto's *Nie Wieder. Tagebuch in Bildern,* Berlin, Verlag Volk und Welt, 1949.
2. Issues of 19 and 24 November 1948.
3. Issue of 27 February 1949.
4. Herbert Sandberg, *Eine Freundschaft,* Berlin, Aufbau-Verlag, 1949.
5. Issue of 17 December 1948.
6. See his article, 'Was ist der Kuenstler — Traeumer oder Denker?' in *Bildende Kunst,* vol. 3, no. 4, 1949.
7. *Taegliche Rundschau,* 19 February 1950.
8. 'Wege und Irrwege der modernen Kunst' in *Taegliche Rundschau,* issues of 21 and 23 January 1951.
9. See also 150 *Jahre Soziale Stroemungen in der bildenden Kunst,* Berlin, F.D.G.B., 25 October–23 November 1947.
10. See the article 'Red Posters' in *Time,* 13 April 1953.
11. *National-Zeitung,* 13 December 1951.
12. 15 December 1952.
13. National-Zeitung, 16 December 1951. More recent examples of apparent relaxation of cultural controls are articles by Katchaturian and Ehrenburg, written in the fall of 1953. Their true significance as merely temporary maneuvers has been pointed out by Bertram D. Wolfe in a 'Backgrounder' (Ideological special no. 294), issued by the Central Program Services Division of the Internal Information Administration of the U.S.
14. 29 December 1951.
15. See Karl Rodemann (ed.), *Das Berliner Schloss und sein Untergang,* Berlin, Tauber Verlag, 1951.
16. *Der Kulturplan. Verordnung ueber die Erhaltung und die Entwicklung der deutschen Wissenschaft und Kultur, die weitere Verbesserung der Lage der Intelligenz und die Steigerung ihrer Rolle in der Produktion und im oeffentlichen Leben,* Berlin, Deutscher Zentralverlag, 1949.

XV. ART IN SOVIET RUSSIA

1. Mr. John Simoni, graduate student in fine arts at Ohio State University in 1952, has been working on a detailed study of the art of Fascist Italy.

2. See Naum Gabo, J. L. Martin, and others, *Circle; International Survey of Constructive Art,* London, Faber & Faber, 1937; Ruth Olson and Abraham Chanin, *Naum Gabo; Antoine Pevsner,* introduction by Herbert Read, New York, Museum of Modern Art, 1948; Naum Gabo, 'A Retrospective View of Constructive Art' in *Three Lectures on Modern Art,* New York, Philosophical Library, 1949.

3. *Erste Russische Kunstausstellung,* Berlin, Galerie von Diemen, 1922.

4. Fritz Karpfen, *Gegenwartskunst I. Russland,* Wien, Literaria, 1921. See also note 2 of Chapter II.

5. Cyril G. E. Bunt, *A History of Russian Art,* London, Studio, 1946.

6. Louis Lozowick, *Modern Russian Art,* New York, Museum of Modern Art, Société Anonyme, 1925.

7. See the catalogue, *The Art of Soviet Russia,* Philadelphia, joint auspices of the Pennsylvania Museum of Art and the American Russian Institute, 1934–5.

8. See, for example, El Lissitzky, 'Unser Buch (U.D.S.S.R.),' in *Gutenberg-Jahrbuch,* Mainz, Gutenberg Gesellschaft, 1927. A good article on the reactionary trend in architecture is Paul Willen's 'Soviet Architecture: Progress and Reaction' in *Problems of Communism,* vol. 2, no. 6, Washington, D.C., 1953.

9. See Hellmut Lehmann-Haupt, 'Russische Buchholzschnitte 1840–1850' in *Gutenberg-Jahrbuch,* Mainz, 1932.

10. See P. Ettinger, 'Bibliophilie und Buchkunst in Sowjetrussland,' in *Gutenberg-Jahrbuch,* Mainz, 1928. See also Erikh Federovich Gollerbach, *Istoriia graviury i litografi,* Moscow, 1923; Viacheslav Pavlochiv Polonskii, *Mastera Sovzemennoi graviury i grafiki,* Moscow, 1928; and Abram M. Efros, *S. Chekhonin,* Moscow, 192?.

11. A good collection of these children's pamphlets is in the Special Collections of the Columbia University Libraries.

12. V. Sicynskyj, 'Die zeitgenoessische Ukrainische Buchgrafik' in *Gutenberg-Jahrbuch,* Mainz, 1929.

13. See B. E. Efimev, *Hitler i égo svera,* 1942–43, Moscow, 1943; published in an English edition as *Hitler and His Gang,* London, 1944.

14. *Exhibition of Soviet Graphic Art,* shown under the auspices of the Soviet Embassy. Foreword by Prof. A. A. Sidorov, London, Royal Academy of Arts, 26 January–18 March 1945. See also the article, 'Sowjetische Graphik der Gegenwart,' in *Bildende Kunst,* Berlin, vol. 3, no. 4, 1949.

15. A. V. Lunacharski, 'Lenin on Propaganda through Monuments,' quoted from *Literaturnaya Gazeta*, 29 January 1933, in *International Literature*, I, 1939. *International Literature*, issued by the State Publishing House in Moscow since 1932 as the Central Organ of the International Union of Revolutionary Writers, succeeded the older *Literature of the World Revolution*. Beginning in January 1946, *International Literature* became *Soviet Literatur*.

16. Cited in 'The Artist and the Socialist Revolution,' in *International Literature*, vols. 10–11, 1938.

17. A. V. Lunacharski, 'The Role of the Proletarian State in the Proletarian Culture,' in *International Literature*, No. 4, 1934. Translated from the Russian by A. Pevsner, with the following footnote: 'Stenographic record of a speech delivered at the session of the Institute of Philosophy of the Communist Academy on Comrade Yudin's report. Owing to the illness and death of A. V. Lunacharski the stenogram was not corrected by him personally and was merely subjected to editorial corrections.'

18. See the article, 'Zhdanov on Literature and Art,' in the magazine, *Voprosy Filosofii* (Philosophical Problems), No. 5, 1951, written in commemoration of the death, in 1948, of the man who 'directed the campaign at home by which Russian nationalism was revived in the post-war period and literature, music, art and science directed to the ideological end of supporting the rebuilding and extension of Soviet power' (*New York Times*, 1 September 1948, p. 2.)

19. Bela Utz, in *International Literature*, 4 October 1933.

20. G. Brovman, in *International Literature*, No. 4, 1934.

21. In an article, 'Aspects of Two Cultures' by Vladimir Kemenov in *VOKS Bulletin*, No. 52, Moscow, U.S.S.R. Society for Cultural Relations with Foreign Countries, 1947.

22. For a more recent statement see the article on social realism in *Voprosy Filosofii*, No. 6, 1951. See also Jacob Landy's article on Soviet painting in *Problems of Communism*, vol. 2, no. 3–4, Washington, D.C., 1953.

23. *Slovenské Výtnarné Umenie na ceste k socialistickemu realizmu* (L'Art Slovaque sur sa voie du Réalisme Socialiste), Bratislava, Tvar, 1950.

24. New York, Henry Schuman, 1950.

CONCLUSION: The Challenge to Democracy

1. See the Congressional Record, 11 March, pp. 2364-5; 25 March, pp. 3297-8; 17 March, pp. 6487-90; 19 August, pp. 11811-14.
2. 'Thought Control by Infiltration,' in *Richmond Times Dispatch*, 15 November 1949.
3. Vol. 15, 5 November. The editorial appeared in a prominent position on the first page and was entitled 'The Defeatist School.'
4. 'Art News from Los Angeles' in *Art News*, December 1951.
5. In a statement released Sunday, 10 February 1952.
6. As quoted in *Modern Artists in America*, New York, Wittenborn, Schultz, 1951, p. 145.
7. Published in Norfolk, Connecticut, by New Directions, 1949.
8. Published in New York by Harper & Brothers, 1949.
9. See 'Government and Art: A Symposium,' in *Magazine of Art*, November 1950. In 1949 Ralph Elliott Purcell completed a doctoral thesis on *Government and Art in the United States* at the University of Wisconsin.
10. The Commission of Fine Arts has published the following report: *Art and government. Report to the President by the Commission of Fine Arts on activities of the Federal Government in the field of art*, Washington, D.C., 1953.

Index

Abstract art, 79, 84, 185–7, 200, 203, 221, 238, 242
Abusch, Alexander, 212
Adam, Luitpold, 92
Ahnenerbe, 70, 144–69
Airforce buildings, 124
Albers, Joseph, 30
Allied policies in occupied Germany, 196–9
Altdorfer, Albrecht, 90, 181
America Houses, 199
American art, 208, 239, 241, 242, 246, 247
Ancestors' Heritage, see Ahnenerbe
Anti-Semitism, 38, 39, 48, 66, 67, 79, 87, 119, 127
Arbeitsrat fuer Kunst, 18
Archaeology, 137, 161, 165
Archipenko, Alexander, 78, 221
Architecture, 12–14, 23, 24, 27, 29–32, 39, 45, 54, 65, 68, 106–26, 130, 133, 134, 136, 217, 223, 231, 233, 238
Argentine, 217, 218
Art
 and biology, 9
 and democracy, 235, 239, 246, 247, 248
 and politics, 24, 27, 65–7, 80, 81, 121, 197, 202, 214, 215, 233
 and race, see Racism
 and religion, 22, 24, 25, 137–44, 175, 245
 and revolution, 22–4, 26, 72, 80, 81, 120, 200, 204, 217, 220–22, 233, 239, 242, 243
 and society, 4, 9, 10–15, 16, 21, 22, 23, 24, 28, 29, 31, 40, 41, 43, 164, 176, 200, 203, 208, 213, 222, 232, 236
 and sport, 100
 and state, 28, 62, 63, 65, 128, 129, 190, 211, 212, 219, 222, 227, 228, 236, 245; see also State patronage
 as propaganda, 16, 105, 119, 141, 177, 221, 227
 as prophecy, 21, 204
 corruption of, see Corrupton of art
Art and Power, 72

Art and Youth, 177
Art chamber, see Kunstkammer
Art criticism, 77, 215; abolished, 73
Art education, 20, 33, 34, 69, 122, 128, 160–65, 173–82, 192, 193, 199, 212
Art films, 166
Art history, 141, 142, 144, 145, 148, 150, 161, 164, 165, 213, 214
Art schools, 85, 188, 201, 213, 214, 220; see also Art education
Art service, 130
Arts, graphic, see Graphic arts
Arts and crafts, 12, 15, 29, 30, 54, 68, 69, 126–35, 238
Arts Council of Great Britain, 247
Association for German Soviet Friendship, 212
Association of the Artists of the Revolution (USSR), 222
Autobahn, 98, 104, 107, 111, 112, 123, 125, 181

B

Barlach, Ernst, 24, 67, 72, 73, 75, 79, 81, 103, 104, 209–11
Bartels-Bund-Korrespondenz (news service), 66
Baudissin, Count, 76, 85, 86
Bauhaus, 21, 30, 67, 79, 101, 171, 190
Baumeister, Willi, 27, 78, 85, 87, 186, 196, 201
Bayer, Herbert, 30
Beauty of Labor, see Schoenheit der Arbeit
Becher, Johannes R., 212
Beckmann, Max, 24, 64, 78, 81
Behrendt, Walter, 31
Behrens, Peter, 65
Benn, Gottfried, 72
Berlin
 architectural history, 168, 169
 art life, 188, 190; see also Kronprinzen Palais, National Gallery
 'Capital of the Reich,' 109

Berlin (continued)
 remodeling of, 56, 57, 58, 115
Biebrach, Dr., 166
Bildende Kunst, 209, 210
Bodde, Derk, 234, 235
Boettcher, Robert, 175, 177, 178, 179
Bookbinding, 134
Bormann, Martin, 90, 172
'Bourgeois' art, 200, 203, 206, 210, 230,
 233
Braque, George, 81
Breker, Arno, 97, 98, 100, 101, 116, 195
Bremer Kunstverein, 71
Bremer Museum, 190
Bremer Presse, 134
Breslau Museum, 81
Breughel, 209
British Council, 198
British policies in occupied Germany, 198
Britsch, Gustav, 33, 179
Brown House, Munich, 113
'Bruecke' movement, 22
Brugmann, Walter, 56, 57
Buchenwald, 204
Buddenbrooks, The, 8
Bundeshaus, Bonn, 190
Burgkmair, Hans, 93
Busbey, Fred E., 239, 240
Busch, Harold, 73

C

Calder, Alexander, 22, 166
Campendonck, Heinrich, 18
Capitalism, 8, 108, 203, 233
Caricature, 87, 218, 226
'Castles of the Dead,' 112
'Castles of the Order,' 110
CEMA, 247
Cézanne, Paul, 81, 85, 209
Chagall, Marc, 75, 78, 205, 209, 221
Chamber of Art, see Kunstkammer
Chamber of Culture, see Reichskultur-
 kammer
Chamber of Horrors of Art, Nuremberg,
 74
Chamberlain, Houston Stewart, 37, 48
Chancery, see Reichskanzlei
Charlemagne, 143
Cheek, Leslie, 240
Children's books, 137-9, 223
Children's drawings, 33, 173, 174, 179,
 189, 192, 193
Chinese art, 234, 235
Chirico, Giorgio de, 81
Christianity attacked by National Social-
 ism, 121, 137-44, 160

Christmas, 137, 140, 144
'City of the Hermann Goering Works,'
 109
'City of the Strength through Joy Cars,'
 109, 116
City planning, 14, 24, 27, 32, 106, 108, 109,
 116, 118, 130, 190
Classicism, 6, 40, 50, 55, 97, 109, 117, 119,
 123, 134, 217
Clauss, Ferdinand, 38, 43
Color photographs of frescoes, 165, 166,
 167, 168
Combat art, see War art
Combat Association for German culture,
 see Kampfbund fuer deutsche Kul-
 tur
Cominform, 229
Commission of Fine Arts (U.S.), 247
Committee on Government in Art (U.S.),
 247
Communism, 9, 142, 204, 226-8, 235, 240,
 244
Communist party, 220, 229, 230
Community buildings, 107, 118
Constructivism, 221, 223
Corinth, Lovis, 81, 166
Corruption of art, 10, 32, 34, 123-6, 133-
 6, 164, 223, 237, 238
Courbet, Gustave, 209
Cranach, Lukas, 90
Cubism, 219, 221, 229, 234
Cuerliss, Dr. Hans, 166, 168
Cuerliss, Peter, 167
Cultural Association for Democratic Re-
 construction of Germany, see Kul-
 turbund
Cultural plan of 1949, 214
'Culture Landscape,' see 'Kulturland-
 schaft'

D

Darré, Walter, 41
Daumier, Honoré, 8, 205, 209
David, Jacques Louis, 4
Defregger, Franz von, 90
'Degenerate' art, 40, 41, 60, 73, 78-87, 185,
 202, 206, 211, 231
Decorative arts, see Arts and crafts, In-
 terior decoration
Derain, André, 78
Deutsche Arbeitsfront, 69, 116, 132, 135,
 181
Deutsche Kunstgesellschaft, 66
Deutsche Kunst-Korrespondenz, 66
Deutsche Warenkunde, 130
Deutsche Werkkunst, 133

Deutsche Werkstaetten, 132
Deutscher Kuenstlerbund 1950, 190, 195
Diderot, Denis, 3
Division of labor, 8, 9, 11, 12
Dix, Otto, 26, 27, 79, 81, 206
Dondero, George A., 240
Dos Passos, John, 60
Dresden Art Academy, 210
 conference of museum directors, 201
 exhibition of 1926, 66
 exhibition of 1946, 201
Duerer, Albrecht, 38, 90, 93, 181
Duesseldorf exhibition of 1928, 66
 municipal collection, 81
Dufy, Raoul, 81
Dymschitz, Lieutenant-Colonel, 200, 202,
 203, 205, 206, 208

E

East German Democratic Republic, 211–
 12, 234; see also Soviet zone, occupied
 Germany
Eberlein, Kurt, 76
Ecce Homo, 26, 29
Eckart, Dietrich, 48
Ege, Klara, 134
Egger-Lienz, Albin, 90, 234
Eher, Franz, 157
El Arte Morboso, 218
Ende, Edgar, 201
Engels, Friedrich, 5, 8, 230
Ernst, Max, 81
Essen Museum, 76
Expressionism, 20, 22–4, 27, 30, 39, 49, 65,
 72, 73, 82, 84, 206, 221, 234, 241
Eydoux, Monsieur, 197

F

Fascism, 14, 72, 217
Favorsky, Vladimir, 223, 224
FDGB, 210, 212, 213
FDJ, 212, 213
Federal Art Officer (German), 28
Federal Assoc. of Artists, see Reichsver-
 band bildender Kuenstler
Fegeler-Falkendorff, Paul, 177
Feininger, Lyonel, 18, 30, 67, 81, 201, 206
Feistel-Rohmeder, Bettina, 66
Finley, David, 247
Fire and Color, 93
Fischel, Lilli, 74
Flechtheim, Alfred, 18
Folk art, 121, 122, 134, 135, 140, 143, 144,
 178, 237
Folkwang Museum, Essen, 81, 85
 Hagen, 75

Foreign Office (German), 67, 76, 162
Forgeries, 154
Formalism, 203, 204, 231–5
Forsyte Saga, The, 8
Fosdick, Harry Emerson, 245
Francke, Guenther, 71
Frank, Dr. Hans, 59
Frankfurt art school, 85
Frankfurt congress for architecture, 32
Frankfurt Museum, 81
Frederick, Prince of Sachsen-Altenburg,
 151
Free German Youth, see FDJ
Freedom of artistic creation, 5, 6, 10, 74,
 179, 193, 234, 238, 239, 242–5, 248;
 see also Individualism
Freedom of the press, 7
Freie Deutsche Jugend, see FDJ
Freier Deutscher Gewerkschaftsbund, see
 FDGB
French exhibitions of art, 197
French policies in occupied Germany, 197
French Revolution, 4, 5, 109, 117
Frescoes, 130, 227
Frick, Wilhelm, 67
Friedrich, Caspar David, 82, 90
Fuehrer project, 165–8
Futurism, 219, 229; see also Marinetti

G

Gabo, Naum, 219, 220, 221, 240
Galerie van Diemen, Berlin, 221
Gall, Leonhard, 114
Gauguin, Paul, 24, 81, 82, 209
German Academy of Arts, East Berlin,
 210, 211
German Archaeological Institute, 161,
 162
German Democratic Republic, see East
 German Republic, Soviet Zone, oc-
 cupied Germany
German Labor Front, see Deutsche Ar-
 beitsfront
German Republic, 1918–33, see Weimar
 Republic
German revolution, 222, 243
German Standard Manual of Products,
 130
Germanenerbe, 164
Germanisches National-Museum, Nur-
 emberg, 172
Gestaltung der Landschaft, 39
Gestapo, 84, 87, 104, 127, 128, 148
Gies, Ludwig, 103
Gilbert, Dr. G. M., 195
Gilkey, Gordon W., 91

Glaspalast exhibitions, Munich, 89
Gobelins, 65, 130
Gobineau, Count, 37, 48
Goebbels, Josef, 49, 57, 68, 73, 77, 78,
 100, 116, 127, 137, 166, 168, 172, 190,
 196, 209, 230
Goering, Hermann, 73, 82, 116, 122, 162
Goodrich, Lloyd, 247
Gothic vs. Roman type, 170–73
Gottwald, Klement, 234
Government in art, 245–7; see also Art
 and state, State patronage
Graphic arts, 24, 29, 41, 42, 68, 93, 95,
 168–73, 223, 225, 226, 231
Gratz 'City of the People's Revolution,'
 109
Grauthoff, Otto, 64, 65
Greek sculpture, 6, 9, 10, 37, 38, 42, 77
Greuze, Jean Baptiste, 3
Griesebach, August, 18
Grohmann, Professor Will, 151
Gropius, Walter, 18, 21, 30
Grosz, George, 26, 27, 29, 60, 78, 81, 187
Grotewohl, Otto, 210, 215
Guenther, Hans F. K., 37, 38, 39, 43, 48,
 120
Gurlitt, Hildebrand, 67
Gutenberg Yearbook, 223, 225

H

Haberstock, Karl, 90
Haendler, Dr., 206
Hamburg 'City of Foreign Trade,' 109
Hamburg Kunsthalle, 75, 81
Hanisch, Reinhold (Fritz Walter), 46
Hannover Museum, 104
Hartlaub, Gustav F., 24, 74
Hartmann, Kurt, 170, 189, 192
Hartung, Karl, 84, 185
Haus am Waldsee, Berlin, 189
Haus der deutschen Kunst, Munich, 77,
 88, 96, 98, 114, 123, 131, 182, 195
Hearst newspapers, 239
Heckel, Erich, 18, 64, 81, 206
Heiden, Konrad, 118
Heise, Carl Georg, 75, 82, 193
Hentzen, Alfred, 104, 190
Hermann, Wille, 50
Hess, Rudolf, 49
Hetsch, Dr., 166
Hildebrand, Adolf von, 103
Hilz, Sepp, 93, 195
Himmler, Heinrich, 70, 127, 140, 144, 148,
 149, 154–8, 160, 163
Hindenburg, Paul von, 66
Hinkel, Hans, 68

Hippler, Fritz, 71
Hitler, Adolf
 architects, 56, 58, 113, 115, 195
 architecture, 45–7, 49–51, 55–9
 art collection, 60
 art criticism, 54
 arts and crafts, 133
 Charlemagne, 143
 Churchill, 57
 city planning, 24, 49, 50
 drawings, 47, 48
 exhibition of 'degenerate' art, 77, 78,
 80, 89
 fiftieth birthday, 168, 169
 Fuehrer project, 165–7
 housing, 50, 51
 last will, 60
 library, 50–52, 60
 Linz project, 60, 82, 90, 116
 Mussolini, 217
 publishers, 157
 Dr. Redslob, 29
 Schinkel, 49
 Schultze-Naumburg, 40
 sculpture, 96, 97
 speeches of, 48, 49, 54, 55, 60, 70, 76,
 79, 85, 86, 88, 96, 97, 108, 114, 208
 SD, 127
 total architecture, 107
 trees, 61
 war art, 92
Hitler as Masterbuilder, 45–61, 168
 at Compiegne, 58
 at Landsberg prison, 47
 at Vienna, 46, 49
 in World War I, 47
 in caricature, 87
Hitler Youth, 181
Hodler, Ferdinand, 234
Hoelzel, Adolf, 201
Hoenig, Eugen, 69
Hofer, Carl, 76, 78, 81, 84, 88, 186, 193,
 196, 205, 209
Hoffmann, Heinrich, 56
Hoffmann, Walter, 69
Hohenzollern Castle, Berlin, 212
Horn, Walter, 72
House of German Art, see Haus der deut-
 schen Kunst
Housing, 30–32, 50, 51, 118–20, 122
Humboldt University, Berlin, 205, 213

I

I. G. Farben, 167
Impressionism, 15, 22, 39, 217, 221, 230,
 238

Individualism, 11, 14, 231, 238, 245, 248;
see also Freedom of artistic creation
Indoctrination, 140, 149; see also Nazi
ideology, Totalitarian art doctrine
Industrial architecture, 124, 125
Industrialization, 4, 14, 16, 132
Institut
Dr. Hirt, 158
Dr. Rascher, 158
fuer Kulturfilme, 166
fuer Kulturforschung, 166
Institute for Military Scientific Research,
158
Institute of Archaeology, 163
Interior decoration, 68, 130; see also Arts
and crafts
Interregnum, 60
Italic type, 171
Italy, see Fascism
Ivanissevich, Oscar, 218

J

Jahn, Dr. Franz, 168
Jankuhn, Prof., 151, 163

K

Kahns, Dr., 206
Kampfbund fuer deutsche Kultur, 41,
157
Kapitaen, Gerhard, 213
Karlsruhe Museum, 74, 190, 199
Kandinsky, Wassily, 27, 30
Kerschensteiner, Georg, 33
Kestner-Gesellschaft, Hannover, 190
Keynes, John Maynard, 247
Kirchberger, Hermann, 202, 207
Kirchner, Ludwig, 64, 81, 86, 206
Klee, Paul, 30, 61, 76, 201, 206
Kleukens, Christian Heinrich, 171
Klimsch, Fritz, 103, 104, 105
Koch, Rudolf, 29, 94
Koenigsplatz, Munich, 61, 113
Koerner, Henry, 189
Kokoschka, Oskar, 81, 190
Kolbe, Georg, 18, 101–3, 116
Kollwitz, Kaethe, 103, 166, 205, 209
Kraft durch Freude, 69, 181
Kravcenko, Alexej, 223
Kreis, Prof. Wilhelm, 57
Kronprinzen Palais, Berlin, 46, 66, 73, 74,
81, 104
Krylov, 226
Kubin, Alfred, 64
Kukrynisky, 226
Kulturbolschewismus, 67
Kulturbund zur demokratischen Erneue-
rung Deutschlands, 207, 212, 214

'Kulturlandschaft,' 110, 111
Kunst im Deutschen Reich, Die, 70
Kunst im Dritten Reich, Die, 70, 73, 105
Kunst und Rasse, 39
Kunstdienst, 130
Kunstgewerbe-Bibliothek, Berlin, 79
Kunsthalle, Hamburg, 73, 190, 193, 194
Kunstkammer, 68, 69, 77, 100, 101, 128,
133, 230
Kunstkammer, Die, 73
Kunz, Karl, 201
Kuprianov, 226
'Kurt Eggers' group, 93
Kustodiev, 230

L

Labor Front, see Deutsche Arbeitsfront
Lamb, Dr., 167
Landscape architecture, 39, 130
Landscape gardening, 68
Langsner, Jules, 241
Leese, Georg, 210
Lehmbruck, Wilhelm, 78, 81, 103, 104
Lenin, 220, 227, 228, 230, 234
Ley, Robert, 116, 118
Library of Congress, 50, 144, 146
Liebermann, Max, 73, 166
Lingner, Max, 209
Linz project, see under Hitler
Looting of cultural objects, 155, 156, 199
Ludendorff Putsch, 47
Luebeck, religious art in, 24, 25
Luebeck Museum, 75, 82
Lunascharsky, 220, 221, 227–9
Lurçat, Jan, 27

M

Macaulay, Thomas, 15
Magritz, K., 211
Maillol, Aristide, 102, 103
Man from Nazareth, The, 245
Manet, Edouard, 209
Mannheim Museum, 74, 78, 190
Marc, Franz, 78, 82, 206
March, Werner, 124
Marcks, Gerhard, 18, 30, 85, 103, 190
Marinetti, Emilio F. T., 72, 217, 219
Marshall, George C., 239
Marx, Karl, 5, 7, 9–11, 15, 17, 38, 230
Masereel, Frans, 26
Mass communication, 244
Mass organizations (East Germany), 212,
213, 214
Mass participation in art, 4
Master, The, 51, 52
Mataré, Ewald, 190

Matisse, Henri, 81, 209, 219
Meidner, Ludwig, 25, 64
Mendelssohn, Erich, 18
Mengs, Anton Raphael, 3
Merton, Thomas, 245
Messel, Albert, 65
Metropolitan Museum of Art, New York, 242
Meunier, Constantin, 209
Millet, Jean François, 234
Modern art resented and attacked, 66, 189, 193, 194, 196, 204, 216, 223, 231, 232, 239–44
Moholy-Nagy, Laszlo, 27, 30
Monuments, Fine Arts and Archives Section, OMGUS, 198, 199
Monuments, protection and conservation, 111, 121, 164–6, 168, 198
Moore, Henry, 185, 231, 232
Moritzburg Museum, Halle, 202, 206
Morris, William, 10–13, 17, 39, 132
Mosaics, 65, 130, 207
Moscow Art School, 220
Mueller, Otto, 79, 81, 206
Munch, Edvard, 73, 78, 82, 234
Munich, 'Capital of the Movement,' 109, 112; see also Koenigsplatz
Munich exhibitions, 88, 89, 134; see also Haus der deutschen Kunst
Munich University, 196
Musuem of Modern Art, New York, 130, 243
Museum of Western Art, Moscow, 219
Mussolini, Benito, 217
Muthesius, Hermann, 108
Myth of the Twentieth Century, 41, 42

N

National Council of American-Soviet Friendship, 226
National Gallery, Berlin, 66, 74, 81
National Gallery, Washington, D.C., 247
National Theater, Weimar, 207
Nationalsozialistischer Lehrerbund, 175, 177
Naturalism, 22, 33, 91, 207, 219, 221, 230, 238; see also Realism
Nauen, Heinrich, 18
Nay, Ernst Wilhelm, 186
Nazi art program, 62, 63, 68, 70, 77, 103, 104, 190, 198, 202, 216
Nazi ideology, 62, 123, 125, 126, 131, 133, 135, 139–40, 143, 149, 155, 157, 158, 162–4, 194, 208; see also Totalitarian doctrine

Nazi party, 131, 157, 168, 188; buildings, 112–18
Nazi teachers' association, 175, 177
Nazi war against the church, 121, 137–44, 160
Nazi Youth Choir, 138
Neo-Nazism, 194, 195, 196
Neurath, Konstantin von, 162
New York Public Library, 144
Nierendorf Gallery, Berlin, 84
Nolde, Emil, 18, 24, 25, 72, 73, 75, 79, 81, 206
Nordau, Max, 15, 40
Nordic, 64, 66, 72, 73, 110, 132, 142, 143, 155, 163
Nuremberg Museum, 199
Nuremberg party conventions, 79, 97, 109, 115, 117
Nuremberg trials, 42, 156, 195

O

Olympia excavations, 162
Olympia Stadium, 124
Olympic art competition, 100
Olympic games, 96, 162
OMGUS, 199
Oppen, Hans Werner von, 71
Ordensburgen, see Castles of the Order
Orlov, N., 208, 209
Owens, Jesse, 96

P

Pacifism, 79
Padua, Paul Maria, 195
Painting, 12, 41, 45, 65, 68, 88–95, 125, 126, 136, 207, 209, 210, 214, 217, 222, 223, 231, 233, 238
Panitzke, Erich, 177
Paris World's Fair 1937, 98, 115
Passarge, Walter, 133, 135
Patronage of art, see State patronage
Pechstein, Max, 18, 81, 206
Peenenmuende, 57, 116
Peiner, Werner, 93, 195
Peking, 235
Peking Diary, 234
Perkins, Frances, 61
Philadelphia Exhibition of Russian Art, 223
Photography, see Color photographs
Picasso, Pablo, 81, 203, 210, 214, 219
Pisarro, Camille, 81
Poelzig, Hans, 18
Ponten, Josef, 51, 52
Popular art, 13, 94, 227, 235, 247; see also Art and democracy

Posse, Heinz, 90
Prague, 239
Pre-history, 141, 149, 150, 163, 164
Priene, 109
Printing press abused, 50
Prolog, 186
Propaganda Ministry (Nazi), 167, 168; *see also* Goebbels
Public-opinion surveys, 127, 189

R

Racism, 37–42, 48, 63, 96, 111, 120, 132, 141, 142, 154, 155, 176, 177, 216, 217, 231; *see also* Anti-Semitism
Raemisch, Waldemar, 73
Rasse und Stil, 38, 39
Rassenkunde, 37
Rave, Paul Ortwin, 65, 66
Realism, 180, 200, 204, 207, 215, 217, 230; *see also* Naturalism, Social realism
Redslob, Edwin, 28, 29, 32, 71, 76
Reichs Academy for Physical Culture, 92
Reichskunstwart, 28
Reichskanzlei (Berlin), 53, 56, 97, 116, 117, 170
Reichskulturkammer, 68
Reichssportfeld, 124
Reichstag building (Berlin), 57, 58
Reichsverband bildender Kuenstler, 66
Reinerth, Dr. H., 164
Religion, *see* Art and religion; *see also* Christianity attacked by National Socialism
Rembrandt, Harmensz van Rijn, 7
Rembrandt-Verlag, 104
Renaissance, 6, 32, 42, 50, 90, 232
Renner, Paul, 67
Resch, Heinz, 87
Resistance to ideological corruption, 71, 72, 101, 136, 158, 161, 163, 238
Restitution of cultural loot, 197, 198, 199
Revolution, French, 4, 5, 109, 117
German, 222, 243
Russian, 220, 221; *see also* Art and revolution
Richmond Times-Dispatch, 240
Rodin, Auguste, 102, 103, 240
Rohe, Mies van der, 101
Rohlfs, Christian, 72
Roosevelt, Franklin D., 61, 246
Roselius, Ludwig, 50
Rosenberg, Alfred, 37, 41, 42, 43, 48, 69, 73, 88, 149, 157, 164
Rosié, Paul, 187
Rossetti, Dante Gabriel, 15

Royal Academy of Arts, London, 226
Ruskin, John, 10, 132
Russia, *see* Soviet Russia
Russian revolution, 220, 221
Rust, Bernhard, 71, 162, 163
Rutz, Ottmar, 38

S

Salzburg Festivals, 195
Sandberg, Herbert, 204, 205, 206
Sauerlandt, Max, 73
Schaefer, Dr. Ernst, 151
Scheibe, Richard, 18, 103
Schelkes, Willi, 56, 57
Schinkel, Karl Friedrich, 117
Schirach, Baldur von, 138
Schlemmer, Oskar, 30, 67, 86, 87
Schlichter, Rudolf, 201
Schmid-Ehmen, Kurt, 100
Schmidt-Rottluff, Karl, 18, 24, 25, 81, 84, 186, 206
Schoenheit der Arbeit, 69, 116
Schongauer, Martin, 93
Schultze-Naumburg, Paul, 39, 40, 41, 43, 48, 50, 67, 85, 120
Schwabacher type, 172, 173
Schwarze Korps, Das, 76, 181
Schwippert, Hans, 191
Sculpture, 12, 41, 65, 68, 96–105, 125, 126, 130, 136, 190, 210, 217, 223, 227, 231, 233, 238, 242
SD (Security Service), 104, 127, 128
SED, 207, 213
Sedlmayr, Hans, 50, 196
Seeds of Contemplation, 245
Shaw, George Bernard, 15, 40
Sicherheitsdienst, *see* SD
Sidorov, A. A., 226
Sievers, Johannes, 67, 76, 144
Sievers, Wolfram, 149, 154, 156–8
Sintenis, Renée, 187
Soby, James Thrall, 245
Social realism, 88, 91, 201, 204, 209, 222, 225, 231–5
Socialism, 14, 17, 28, 190, 227, 232
Socialist Unity Party, *see* SED
Sokolov, Nikolai, 226
Soviet art exhibition in Berlin, 221
Soviet Haus der Kultur, Berlin, 200, 202
Soviet policies in occupied Germany, 200–215
Soviet Russia, 5, 14, 72, 91, 117, 120, 173, 188, 202, 207, 211, 215, 230, 235, 243
Soviet trials, 206
Soviet zone, occupied Germany, 72, 200–215; *see also* East German Republic

Speer, Albert, 56, 57, 97, 114, 116–18, 122
Spengler, Oswald, 24
SS (Schutz-Staffel), 50, 70, 72, 76, 87, 93,
 128, 134, 140, 144, 161, 163, 169, 181
Staa, Wolf Meinhard von, 71
Stalin, Josef, 234
Staronosov, P., 223, 225
State Art Commission (Eastern Ger-
 many), 215
State patronage of art, 20, 27, 29, 100, 101,
 129, 130, 131, 195, 208, 214, 230, 237
Steiger, Edgar, 17
Sterenberg, D., 220, 221
Stirner, Max, 8
Stoddard, Theodore Lothrop, 38
Strauss, Dr. Gerhard, 212
Streicher, Julius, 139
Strempel, Horst, 207
Strength through Joy, 69, 181
Strobel, Hans, 146
Stuermer, Der, 139
Sturm, Der, 22
Stuttgart, 'City of Germans Abroad,' 109
Stuttgart art gallery, 85
Stuttgart Housing Exhibit, 32
Surrealism, 187, 200, 201, 203, 221
Swastika, 134, 148
Sydow, Eckardt von, 65
Symbols, 134, 140, 143, 144, 147, 148, 170,
 238

T

Taegliche Rundschau, 202, 205, 208, 211
Taut, Bruno, 18, 108
Taut, Max, 18
Technical University, Berlin, 194
Theodor Fischer Gallery, Lucerne, 82, 83
Thiersch, Frieda, 134
Thode, Henry von, 66
Thorak, Josef, 98, 99, 101, 195
Tibet expedition, 151
Tiepolo frescoes, 167
Todt, Fritz, 112
Total architecture, 59, 106–12
Totalitarian art doctrine, 10, 14, 15, 34,
 37–44, 62, 124, 232, 237, 242; see also
 Nazi ideology
Totenburgen, see Castles of the Dead
Toulouse-Lautrec, Henri, 209
Tretjakov Gallery, Moscow, 233
Troost, Gerdy, 114
Troost, Paul Ludwig, 56, 113, 114, 117,
 123, 134
Tschoukin, 219
Type faces, 170–73
Typography, 30, 67; see also Graphic arts

U

Ukrainian art, 225
Ulbricht, Walter, 213
Ulenspiegel, Der, 205
United States, 239, 244, 246, 247
U.S. Bureau of Engraving and Printing,
 29
U.S. Department of State, 239, 240
U.S. Documents Center, Berlin-Zehlen-
 dorf, 127
U.S. Government Printing Office, 28
U.S. policies in occupied Germany, 198
U.S. strategic bombing survey, 59

V

Valentine, Ross, 240
Van Eyck, Jan, 15
Van Gogh, Vincent, 24, 81, 82, 209, 234
Vchutemas (workshop groups), 220
Virginia Museum of Fine Arts, Rich-
 mond, 240
Vischer, Friedrich Theodor, 7
Voelkische Beobachter, 48
Voemel, Alex, 71
VOKS Bulletin, 231, 232, 240

W

WPA, 224
Wagner, Richard, 15
Waldmann, Emil, 71
Walden, Herwarth, 22
Waldmueller, Ferdinand, 90
Walter, Fritz, 46
War art, 91, 92, 93, 226
Washington, D.C., 91, 117, 168
Weimar Republic, 16–34, 63, 64, 72, 80,
 107, 110, 119, 120, 124, 178, 179
Weimer Theater, 202
Weissenhofsiedlung, Stuttgart, 32
Weisthor, K. M., 147
'Weltanschauung,' 40, 146
Wendel, Udo, 104
Werdandi-Bund, 66
Werk-Akademie, Kassel, 190
Werkbund, 132, 190
Werner, Bruno E., 72, 104
Werner, Theodor, 185, 186
Whistler, James McNeill, 15
Whitney Museum, New York, 247
Wiechert, Professor, 85
Wiedemann, Fritz, 47
Wiegand, Theodor, 162
Wiener Werkstaetten, 132
Williams, Wheeler, 242
Willrich, Wolfgang, 76

Winckelmann, Johann Joachim, 3
Winter, Carl, 145
Winter, Fritz, 201
Wirth, Dr. Hermann, 157
Wolff, Dr. Paul, 167
Wood engraving, 223, 225
Working Council for Art, 22
Worringer, Wilhelm, 23, 64
Wrede, Walter, 162
Wuest, Dr. Walter, 149

Y

Youth hostels, 110, 123, 124

Yudovyn, S., 223

Z

Zaborsky, von, 148
Zeitgemaesse Schrift, Die, 172
Zhdanov, Andrei Alexandrovitch, 229
Zetkin, Clara, 227
Ziegler, Adolf, 69, 77, 78, 81, 88, 93, 100, 129, 133
Zille, Heinrich, 209
Zweig, Arnold, 210
Zwickau Museum, 67